THIS IS THE NOISE THAT KEEPS ME AWAKE

GARBAGE
WITH JASON COHEN

AKASHIC
BOOKS

Published by Akashic Books
©2017 Garbage Unlimited

ISBN: 978-1-61775-550-7
Library of Congress Control Number: 2016953899
Printed in China

First printing

Edited by Joe Levy and Akashic Books
Copyedited by Nikki Bazar and Akashic Books
Editorial and transcribing assistance by Kelsey Davis, Abby Johnston, Michael Krugman, Sarah Andrea Ruiz, Susan Elizabeth Shepard, Sherman Sherman, and Hannah Smothers
Endpaper photo by Christopher Patrick Ernst
Designed by Ryan Corey for Smog Design, Inc.

Brooklyn, NY
Twitter: @AkashicBooks
Facebook: AkashicBooks
E-mail: info@akashicbooks.com
Website: www.akashicbooks.com

Photo: Butch Vig

CONTENTS

Bands are the most twisted symbiosis. They're often rooted in and fixed at the age they met—usually in high school. It's emotionally very complicated, a compulsion that is beyond their control. Entire economies can be built around a band's dysfunction. They're locked in an existential turmoil together, and they cannot escape.

Garbage, strangely, at a more advanced age and, after they'd all done a lot of other things, locked into that kind of symbiosis in a way that normally only teenagers can. Creatively, they rely on one another. They need one another to make it work. It gelled the same way it would have had they met in high school.

—PAUL KREMEN, GARBAGE'S MANAGER

All I know is, if you call yourself Garbage, you're going to start hanging out with garbage, and the next thing you know, you will be garbage.

—CARRIE ELIZABETH ERICKSON (1920–2012)
TO HER SON DOUGLAS "DUKE" ERIKSON, 1995

A band is a funny thing.
It is intense and it is greedy.
You spend your life tending to it like you might your children.
You watch it move through all of its seasons with a strange kind of anxiety.
Perhaps as farmers who watch the weather do.
When it blooms you feel as though you do too.
When it struggles you take it personally.
When it thrives you attribute it to the efforts of everyone else.
When it fails you blame yourself.

A band is heavy.
There isn't a day you don't feel its weight around your neck.
Everywhere you go, it trails along beside you.
It becomes part of your identity.
You struggle with it.
You love it.
And you hate it.

A band is light.
When the darkness comes you can run headlong into it.
It makes all the bad stuff disappear.
It is pure, unadulterated escape.

A band is uncomfortable.
It causes problems.
It will wreck your sleep, your peace of mind, your friendships, your marriage, and your health.

A band is comforting.
When you go out into the world you feel like someone has your back.
You move as a pack.
You have your own secret shorthand that nobody else understands.
You snigger at the same jokes.
You share in one another's experiences, good and bad.

A band is good fun.
You don't keep regular hours.
You don't need to wear a suit or clock in or clock out.
You rarely work nine to five.
You don't answer to an unreasonable boss.
You can pour yourself a drink at three o'clock in the afternoon and there is no one around
 to say you can't.

A band is freedom.
It is freedom to think, act, and create.
Freedom to connect, relate, communicate.
Freedom to roam.
And it is freedom to explore all the secrets of the human heart.

In a band you can make noise.
You can make a mess. You can make mistakes.
You can travel. You can show off. You can shut up.
You can speak out or speak up for those who cannot.
It is the best thing that ever happened.
It is the most exciting, selfish, generous, surprising, reckless, challenging, revelatory,
 and celebratory thing you have ever done.

That is, if it doesn't kill you first.

—SHIRLEY MANSON

I've been in bands on and off since I was sixteen. It can become a way of life, for bad and for good. The camaraderie can be second to none, like in a gang or a family. But being in a band can take over your life, like an addiction or a rocky marriage. Those comparisons may sound like exaggerations, but they're all true in one way or another. Bands go through a lot together, it's not just about the music.

I've never chosen my bandmates strictly by how well they played or sang. I've chosen them (and they me, most likely) because of who they were, how much they loved making music, and whether or not we got on as people—simple as that. Every band I've been in has lasted as long and been as good or bad as the friendships that were formed being in that band. Bandmates are fellow travelers, and I'm not talking about touring. Every song you write, record, or perform is its own little adventure. Some take you far off the beaten path, and getting lost is part of the experience. Some keep you in familiar territory, but you notice something about that place that you hadn't noticed before. And these little adventures are more rewarding, more fun, and less scary when they're with people you get on with.

Butch and I have been in bands together since 1978, and we've been involved in some way with Steve since not long thereafter. Shirl came along much later, but when she did, it was like she'd always been there. Being friends has gotten us through the bad, and it's easy now not to think about those times too much. You need to have good people around you, and there's no guarantee you'll find them in this crazy business. The four of us found each other along the way. And, lucky us, we've made some glorious music together.

—DUKE ERIKSON

Things we've seen, they could fill a book. When we first thought about making up a band, recording was analog, and the way you found music you liked was through words on paper or radio or MTV. If you wanted to hear it again then you bought the seventeen-dollar CD. Record companies—and there were so many—would throw money at groups with just a few songs (we were one of them!) in the desperate hope that eventually one would hit it big and pay for all those posh offices, salaries, drugs, and rooms at the Four Seasons. It was a corrupt system—the amount of money handed over to ensure radio play got more and more alarming. For all I know, it still goes on. (Psst—it still goes on.) We benefited greatly at times from the way things were but I'm glad that era's over. What we've got today is better. Somehow we grew up and stayed together, and we can write new songs and tour where and when we want to and know that people will be there to see us. And they'll know every fucking word. How lucky is that?

Garbage allowed the four of us to be and live every sort of thing you or us or anybody else could imagine. We went to places none of us had ever thought we'd go, we lived like royalty (briefly, not terribly often, but still . . .), suffered through the worst that can be thrown at you, and had the best times of our lives together—often at what felt like the same instant. And we came out stronger for it—with my brothers and sister. Twenty-plus years! Not everyone gets to say that.

In every important way we have been allowed to be a band because of the people in our lives. This book would be about three pages long without everybody who chimed in—people who encouraged our odd ideas, followed us across mud-plagued festival summers, made damn sure our gear was going to work while we were holding court in the bar, helped us put out our records and pose for ridiculous photos, kept our home fires together while we were out gallivanting across the world. People who gave us our lives.

So, this is us trying to tell you about all of that. And to our families, everyone who ever worked with us, and everyone who came out to see us at all of those shows, we give a million thanks, and we promise to pay you back in the unlikely event that we are ever able to find real work. Cheers.

—STEVE MARKER

It was 1995, we were finishing our debut album, and I was stressed. A lot of music business people had told me it was a mistake to give up full-time music production to start a band. So I ignored them all and took a leap of faith.

The simplest reason was that I just wanted to be in a band with my friends. I'd been playing with Duke and Steve for several years, and now we had a new beginning with an X factor: a Scottish singer named Shirley. She seemed like a good fit for our little club of misfits. So we all took that leap.

We have shared intimate and emotional moments. We've nurtured each other, challenged each other, watched our families grow up, and dealt with life's tough decisions. We have walked onstage over a thousand times and made a glorious noise. And god, we have laughed so hard in each other's company—at each other, at ourselves, and at this crazy ride we've been on.

In Garbage I found artistic nirvana: no rules. I'm not just the drummer. I can write a song. Play guitar. Be a lab rat and experiment. Embrace mistakes. Order cocktails and make weird fucking noises. Nudge my bandmates to play a part over and over again with the promise that something sweet might emerge. And order more cocktails. That freedom—to be able to express myself in a multitude of ways—has been a liberating experience for me for the last twenty years.

And then there's this one last thing: the music. In search of our pop bliss, we like to layer our sonic palette with lots of different elements: trashy drums, heavy beats, electronica, soundtrack ambience, strange loops, fuzz guitars, pop hooks—sometimes all in the same song. It's a fascinating, all-consuming process, often surprising and sometimes exhilarating. For me, that sonic journey is like therapy. But in the end it's all about emotional connection, and it's Shirley's vocals that make the songs resonate. Her voice reminds us that we are human—her lyrics, what it feels like to be alive.

So, we write and record these songs and birth them into the world. Sometimes we get lucky: a song clicks with people and the feedback is intense. Over the years we've heard some extraordinary stories from fans: how one of our songs helped someone fight depression or get out of an abusive relationship. When a song can make that kind of impact, well, for me, it doesn't get any better.

And so I say to Garbage, to my family, to our fans, and to everyone who has shared in this experience: Thanks for joining me in that leap of faith.

—BUTCH VIG

CHAPTER 1

I HOPE THAT ALL THIS GARBAGE WILL BECOME SOMETHING BEAUTIFUL.

—BUTCH VIG'S STUDIO NOTEBOOK/JOURNAL, 1993

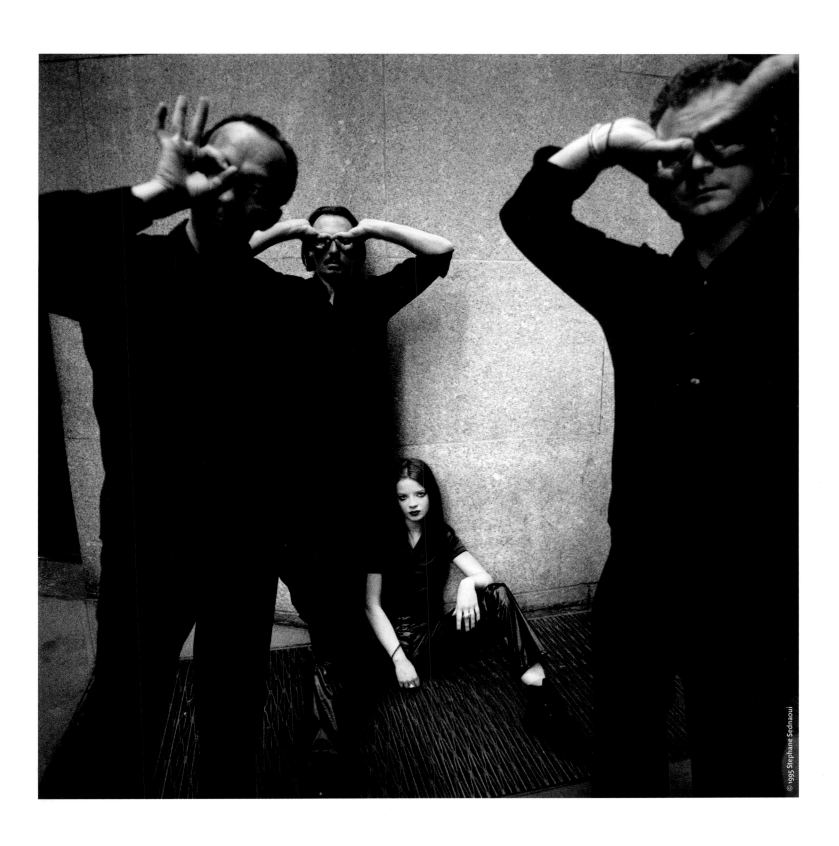

CHAPTER 1: SOMETHING BEAUTIFUL

The voice went through Steve Marker like a shock wave. It was a voice full of mystery and drama. It pulled you in. You weren't sure if you'd heard it before or if it was brand new, but either way, you wanted to know more.

It was sometime before midnight, on September 12, 1993. Marker was at home in Madison, Wisconsin, watching MTV's *120 Minutes*, the weekly video ghetto that MTV had created for punk, new wave, and alt-rock bands. On this particular night, *120 Minutes* host Lewis Largent was interviewing the Breeders—the band led by Pixies bassist Kim Deal and her twin sister, Kelley—whose single "Cannonball" had recently been released and was on its way to becoming a left-field Top 40 hit. There were also new clips from the Afghan Whigs, Nine Inch Nails, and the Juliana Hatfield Three.

None of that held Marker's attention much. What did was a video that aired just before the last commercial break. *"Suffocate me with kisses, baby,"* the song began. *"Suffocate me with burning love."* It was by a Scottish band on Radioactive Records called Angelfish. The lead singer, Shirley Manson, was completely different from the throat-shredding grunge screamers of the time. Her singing commanded attention and created new possibilities. It opened up the music around it, almost turned it inside out.

"It was like the first time I heard Patti Smith or Chrissie Hynde," says Marker. The Angelfish video for "Suffocate Me" was blurry and distorted. "You could barely see her through all the gloom, but it was clear that there was this huge presence at work."

It was the first and last time Angelfish were ever played on MTV.

<p style="text-align:center">X X X</p>

Marker was paying extra-close attention to *120 Minutes* because he and his friends Butch Vig and Duke Erikson had just formed a sort-of band. This, in and of itself, was nothing new. Vig and Erikson had played together since the 1970s, most notably in Midwest cult fave Spooner, with Marker as their roadie—until he was promoted to soundman. As producers and engineers at Madison's Smart Studios, the three old friends were always making music together between other people's sessions, under band names like Knerble Knerble, Vomit Raisins, and Rectal Drip.

Smart had become a destination studio for small rock bands that wanted a big sound, a reputation amplified after Vig produced both Nirvana's *Nevermind* and the Smashing Pumpkins's *Gish* there in 1991. *Nevermind* proved grunge could be a multimillion-selling sound. Two years later, Vig's work on the Pumpkins's breakthrough *Siamese Dream* proved that was no accident.

But neither of those was the project that would truly set the course for Vig, Marker, Erikson, and—eventually—Manson. Rather, it was a 1992 remix for the rappers House of Pain.

Previous page: a Stephane Sednaoui photo from an early Garbage publicity shoot from 1995. Aside from photographing them several times over the years, Sednaoui would also go on to direct three music videos for the band; opposite: a page from Butch Vig's 1993 studio journal describes the sudden creative bursts of the recording sessions for a project with his longtime friends and partners at Smart Studios, Duke Erikson and Steve Marker. The project would take its name from the last line here: "I hope that all this garbage will become something beautiful"; below: Marker lays down guitar tracks in Smart's Studio B mix room in 1994.

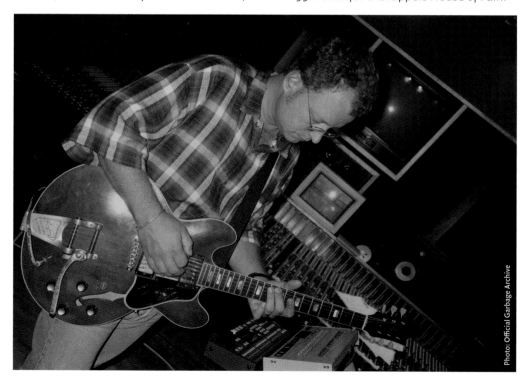

Photo: Official Garbage Archive

Today was a good day
we got a lot done, and
sometimes we'll work for days
without coming up with anything
cool, ~~and today~~ and some days we'll
work for 12 hours, and it all sounds
like shit, and then in the last hour
we accomplish more than we did all
day long ~~.~~ Strange...., but I guess you
~~and can't force~~ can't force inspiration,
and sometimes
when you least expect it, it all
falls into place. At some point ~~.~~ I hope that
all this garbage will ~~at some~~
~~point~~ become something beautiful!

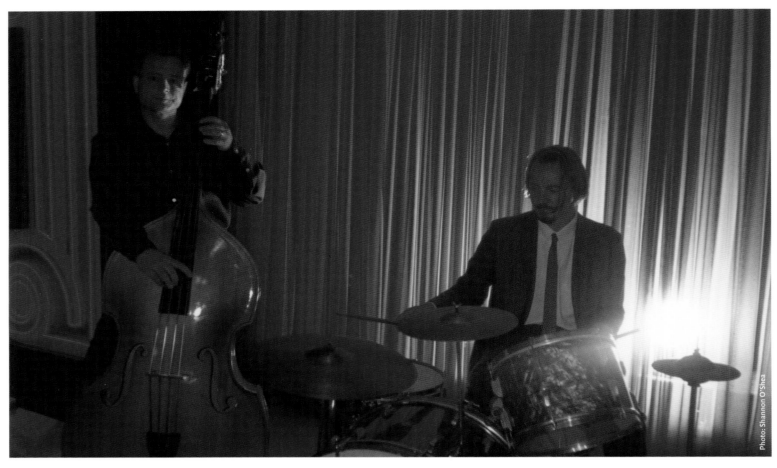

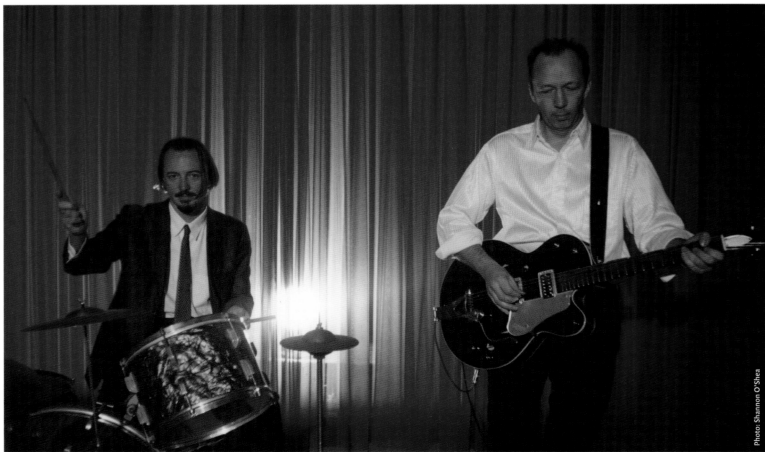

THIS IS THE NOISE THAT KEEPS ME AWAKE

After the boys faxed a cocktail-fueled demand for a record deal to their UK managers, Shannon O'Shea and Meredith Cork of SOS Management held them to it. Above: an ad placed in the October 2, 1993, issue of the British music weekly *Melody Maker* by O'Shea and Cork, looking for vocalists for the Garbage project; left: the band's first official photo session, which took place at the Comedy Store on Sunset Boulevard in Los Angeles.

"By the time Nirvana and the Pumpkins took off, we had done a thousand rock bands at Smart," says Vig. "I was tired of guitar, bass, drums. To me, Public Enemy were rock and roll." The 1992 "Butch Vig mix" of "Shamrocks and Shenanigans (Boom Shalock Lock Boom)" was, essentially, Garbage's first demo.

Vig got into remixing at the behest of Shannon O'Shea and Meredith Cork, whose company, SOS Management, specialized in producers and remixers. "Shannon called me out of the blue," says Vig, who—since *Nevermind*—had been turning down all kinds of management offers to represent him as a producer. "Everybody wanted to sign a one- or two-year deal, and they all promised, 'You'll be working with the biggest bands; you'll be working in the best studios.' I wasn't interested in that. Shannon was the one who said, 'Let's do some remixes.'"

O'Shea had read an interview with Vig where he had talked about his love of keyboards and pop music. "I thought, *Ooh, if you took grunge guitars and threw in keyboards and a pop beat, that'd be really unusual*," she says. She decided to contact Vig with her idea. Significantly, O'Shea did not ask for a contract. Each remix would be a one-off deal.

"So I got my bandmates—the guys I'd been working with in bands for years—and said, 'Let's go in and just fuck around,'" recalls Vig. He and Marker had already bought a couple of basic samplers for Smart Studios: an Akai S1000 and a Kurzweil K2500. Marker had become Smart's hip-hop guy after working with a local group called Fresh Force, which then attracted other clients. "It was this weird little thing that we did at the studio that nobody else wanted to do," Marker says. "Making up hip-hop beats and using samples, layering all that stuff. I learned how to use the sampler that way."

Marker also remembers driving down to Chicago in 1990 to see a Sonic Youth/Public Enemy double bill at the Aragon Ballroom, a show that ended in a riot. "Steve came up with the template for Garbage," says Vig. "He was the one who turned me on to Public Enemy, and that was why I started doing remixes. I remember listening to those records, trying to figure out how the fuck they did it: all the crazy loops and ambient noise and weird beats and cutting/dropout stuff."

The word *remix* understates the work that went into the House of Pain track. "We recorded all new music on it," Vig says. Marker came up with a fresh guitar part. Some cut-up vocals were pretty much the only thing retained from the original.

"Instead of creating some extended dance club track, we'd create a whole new song, with a completely different chord progression, beat, and arrangement," says Erikson. "We were already making Garbage music in a way."

"We'd just kind of do our own thing," says Vig. "You could erase everything on there and record all the music and just fuck around. Take a snippet from the song, load it into the sampler, and run it backward and chop it up and print it back and run it through some pedals and just do all sorts of crazy stuff. There was never any expectation that we had to get a club mix or something that would be on Top 40 radio."

Even so, the House of Pain remix took off. "All of a sudden, that's the version getting played on MTV," says Vig. Remixes for Nine Inch Nails, Depeche Mode, and U2 followed. And then O'Shea revealed her hole card.

VIG: After we'd done a bunch of remixes, Shannon said, "You've got to take that sensibility and see if you can get a band thing going."

MARKER: We never would have been a band without her. She really pushed us to do it.

VIG: She kept saying to me, "Butch, start a band with Duke and Steve. Take a break from producing other artists. Do it, do it!" I was like, "Okay, cool." But I wasn't really sure we could turn our remix approach into a band.

ERIKSON: The three of us were just trying to please ourselves, with no other agenda. Just create something really great and write good songs.

VIG: Shannon and Meredith were pushy, but that pushiness contributed to the experimental vibe of what became Garbage. They encouraged us to take chances. They would come to the studio and we would play them tracks. They would say, "The song is hooky—now fucking go crazy! Make it sound fucking insane, make it noisier!"

MARKER: "Push the boat out on this one!" They always had ridiculous sorts of phrases.

VIG: "Push the boat out! Just pull the butt plugs out and let it sink in the sea! Go crazy with it!"

MARKER: It was the perfect storm.

During a remix session for Nine Inch Nails, local percussionist Pauli Ryan stopped by Smart Studios while Vig was recording some distorted drum loops. "He said, 'This shit sounds like garbage,'" Vig remembers. "And I said, 'Yeah, well, we're going to turn this garbage into a song!'"

The throwaway line stuck. O'Shea remembers a cocktail-fueled fax from Erikson arriving. It outlined the game plan: *Butch and Steve and I are going to start a band. It's going to be a postmodern industrial outfit with the occasional violent outburst. We're only going to write happy songs. We're going to call it Garbage or Trash. What do you think?*

MARKER: It was sort of a joke with the name.

ERIKSON: The only reason it stuck was because of Shannon and Meredith.

VIG: "That's awesome. We're gonna push the boat out on that!"

MARKER: Didn't the fax say something like, *We'd like a record deal by morning?*

O'SHEA: *We haven't heard from you and we're reaching our prime, so we need to know if we're going to get a check or not.*

ERIKSON: The whole fax said, *Steve, Butch, and I are starting a band called Garbage. We need a record deal by morning. Thank you.* And then we laughed about it.

MARKER: They called our bluff and made us do it.

ERIKSON: The next morning, it was faxes, *boom, boom, boom.*

VIG: Overnight. Within, like, a week, label reps were flying in from London, New York, and Los Angeles.

<p style="text-align:center">X X X</p>

Truly, Garbage could have had a record deal within hours. "The fax comes in," remembers O'Shea, "I tell one A&R guy, 'I've got this postmodern industrial outfit with Butch Vig. They're only going to write happy songs. It's going to sound like the remixes, and it's going to be great.' And he's like, 'I'll give you an offer on it.'"

Moving at a more deliberate pace, the band signed with the UK arm of Australia's Mushroom Records by the end of 1993. The decision to go international initially, instead of with a US label, was partly due to the fact that SOS was then based in London. It proved crucial to the band's early success. "Shannon and Meredith knew it was important to focus on the rest of the world as much as America, maybe even more," says Vig. "It's a damn big world out there."

Gary Ashley, Mushroom's general manager at the time, remembers Vig telling him, "I spend my life taking people's songs and turning them into some form of a pop hit. My plan is to write a bunch of pure pop songs with verse-chorus simplicity and fuck them up."

"We'd hit a wall with guitar/bass/drum bands," says Erikson, "and there we were with this studio full of all these toys. It was pretty hard to resist camping out in the studio and playing with all that stuff. But what set us apart from other folks using loops and samples was our love of the three-to-four-minute pop song. We went back to being essentially a guitar/bass/drum band when we started to tour. Still are."

The three friends knew that Erikson, who'd fronted Spooner (and had cofronted another band, Fire Town, with Vig), was not going to be the singer. For one thing, they wanted to avoid comparisons to their previous bands. But they also wanted a woman's voice, at least for a few songs. "We liked the idea of a female voice over what we thought was going to be industrial, heavy music," says Erikson.

MIXED DRINKS, HIGH VOLUME
CAFÉ MONTMARTRE WAS A PLACE WHERE GARBAGE SPENT MANY (MANY) HAPPY HOURS

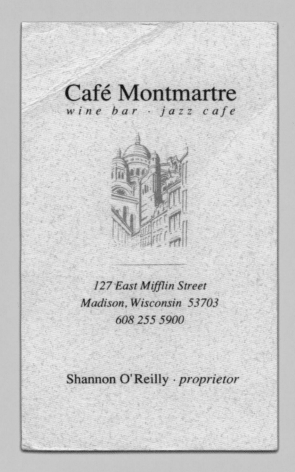

Café Montmartre
wine bar · jazz cafe

127 East Mifflin Street
Madison, Wisconsin 53703
608 255 5900

Shannon O'Reilly · *proprietor*

When Garbage was still in its formative stage, there was a place in Madison where the band would test out the music they were working on: Café Montmartre—a bar, restaurant, and music venue about five minutes away from Smart Studios. "We'd show up at two in the morning," says Vig. "'Hey, wanna hear this song we're working on? It's called "Stupid Girl."' Crank it on the speakers downstairs at stun volume, and there'd be a bunch of people drinking beer."

Run by a then-married couple, Craig Spaulding and Shannon O'Reilly, Café Montmartre opened in 1992. Vig remembers it as a different kind of place for Madison—a wine bar with an artisan approach to cocktails. "We poured classic cocktails with all fresh ingredients there—no soda guns or sour mix," says Jim Meehan, who tended bar at Café Montmartre in the midnineties and went on to become one of the leading mixologists in America. "It was a really progressive place food- and drink-wise."

Café Montmartre closed in 2009, but from 1994 to 2000 it was where Garbage went nearly every day to do their drinking and thinking. So much of both that the band developed their own signature cocktails, like the "champagne supernova" (see page 89), with help from the Montmartre crew.

"It was our clubhouse," says Erikson.

"Smart was our clubhouse," amends Vig. "Montmartre was like the social hour, the parlor. We would just all hop in a car and go up to the café, which was ten blocks away."

"We cabbed it back though," says Erikson.

"Well, we didn't go back," says Vig.

Manson remembers being shocked by the way the boys could put away their liquor: "They drank phenomenal amounts of alcohol. And I had come from a boozy band. But they were able to consume unbelievable amounts of alcohol and not seem drunk at all. The whole town was like that."

Manson is not exaggerating about the quantity of alcohol—Vig and Marker think the band might have spent as much as $150,000 at Montmartre over the year the band made *Version 2.0*.

"And then we went on tour and their number-one customer left town," says Vig.

"They were so generous in sharing this most exciting time with their friends and those around them," says O'Reilly. "Their enthusiasm, creativity, and graciousness brought so much to all of our lives—the café was just the place where this happened, the hangout. They let everyone be a part of these great celebrations. The more they shared, the more the incredible feelings of that great time spread."

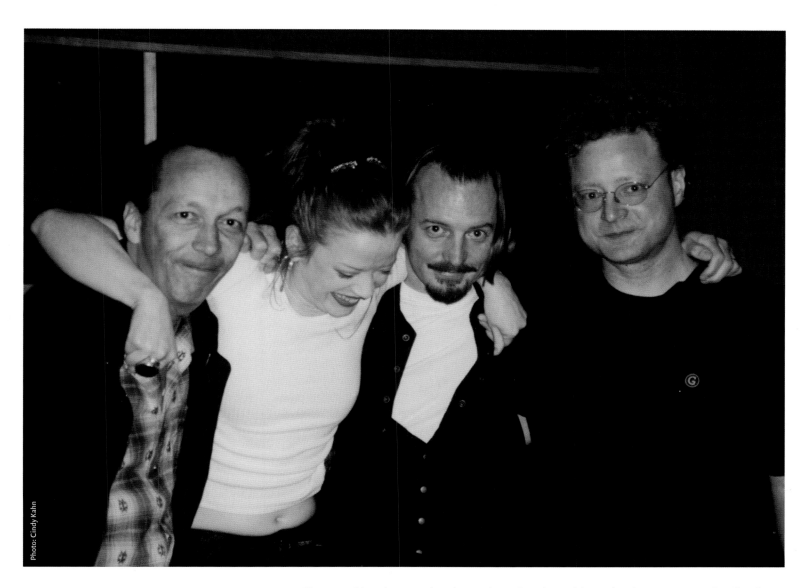

Photo: Cindy Kahn

Manson's first session with the boys didn't go so well, but on a second try her quiet vocal on "Queer" blew them away and she relocated from Scotland to Madison to work on the first album. Opposite, clockwise from top left: Manson attempts to give Marker a dead arm; Manson, Vig, and a microphone; Manson and Erikson; above: a full band huddle.

They considered patterning themselves after the Golden Palominos, a New York collective with a constantly changing cast of members. "We'll record each song with a different singer. It will be a studio thing; we're not going to tour," remembers Vig. He originally imagined Kim Gordon singing what ultimately became the single "Queer." Ethyl Meatplow's Carla Bozulich almost came to Smart for an audition, but instead decided her new band, the Geraldine Fibbers, needed her full attention. O'Shea suggested a singer called Gavin Rossdale, who later went on to form the band Bush. The trio held two auditions with female vocalists from the UK and Texas.

MANSON: You mean you weren't a virgin before you met me?

ERIKSON: We dated a lot of girls before we met you.

Manson heard from SOS as well. "I faxed SOS as soon as that episode of *120 Minutes* was over to have them find out who that singer was," says Marker. O'Shea remembers Marker telling her to find the singer from "Angel-something, out of Scotland."

"Turns out there was another Angel-something out of Scotland, which was a guy who wore cycling shorts," O'Shea says. "But we finally tracked down Shirley."

"I got a phone call from Phil Schuster, my A&R guy at Radioactive, saying that he had been contacted by Shannon O'Shea," says Manson. "She represented a producer in America called Butch Vig, who was interested in working with me. And I was like, 'Who's Butch Vig?' I thought the name was ridiculous. Phil proceeded to explain to me that Butch had produced the Smashing Pumpkins, Sonic Youth, and Nirvana."

FILL YOUR GLASS WITH GARBAGE

ROCK AND ROLL COCKTAIL RECIPES

VIG: As a band, we like to have a cocktail. A little sip of wine before we go onstage.

MANSON: Did he just say, "A *sip*"?

There's never been an official Garbage drink. At least not just one.

Like their music, the band's choice of tipple has changed across the years. In the early days, Smart Studios was filled with both magnetic tape and beer, a.k.a. "frosties." ("'Is it too early for a frosty?' was a regular query," says Manson.) By 2016, the locale had shifted to Billy Bush's Red Razor Sounds in Los Angeles, where the control room was dominated by digital gear and Duckhorn sauvignon blanc. In between, the band has drunk their share of sidecars, sea breezes ("too sweet," says Vig), dark and stormies, and MacRostie chardonnay.

The recipes here are some of the most memorable (or regrettable) libations from more than two decades of Garbage—consumed in the studio, at Madison's Café Montmartre, backstage, and in hotels and restaurants around the world.

THE LEMON DROP

Traditionally, this cocktail is made with vodka, triple sec, and lemon juice or lemon simple syrup. But "in the spirit of sharing," says Café Montmartre's Shannon O'Reilly, Garbage and the café turned the drink into a simple-flavored vodka shot, with both the band and the house covering many, many rounds.

"We'd order like forty of them," remembers Vig. "'Just bring lemon drops for everybody!'"

RECIPE
—*Absolut Citron vodka, shaken and poured into a sugar-rimmed shot glass.*
—*Accompany with sugared lemon, to suck on after finishing the shot. (This step was often skipped when ten-plus shots were poured.)*
—*Repeat several times if it's a typical Tuesday night. Or several thousand times if it's a Garbage record release party.*

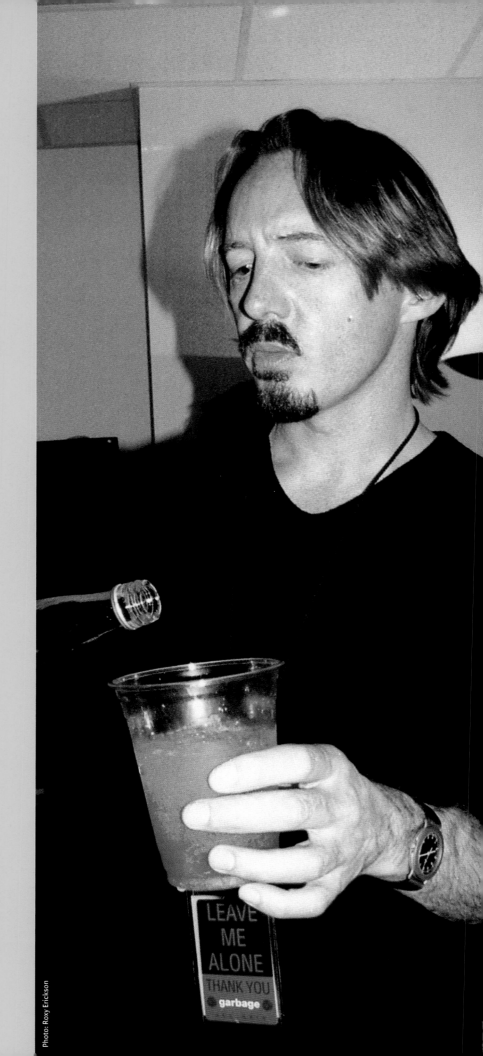

Above: Manson rehydrates; left: Vig demonstrates his cocktail poise. Believe it or not, he still owns the shirt he's wearing in this picture, though that drink has long since been metabolized.

Manson was impressed, even if she wasn't exactly clear as to why. "I was excited because they were all bands I listened to, but I barely knew what a producer did," she says. "I'm not being funny. I never looked at who produced records back then. Never."

Erikson, Marker, and Vig traveled to London in April of 1994 to meet her. Manson took the train down from her home in Edinburgh. "I met them in the Landmark Hotel, where I thought they were staying, but they absolutely were not," she says. "We met in the incredibly posh atrium at the back of the lobby. All glass ceilings. I was wearing a black fake-fur coat I had bought at the local charity shop opposite my house, so I walked in feeling horribly cheap."

The location was O'Shea's doing. "I thought, *Let's have them meet where we want to end up*," she says. In reality, the band was staying at an old-fashioned B&B, which may have ended up costing them more than the Landmark would have. Not for the room, for the drink. "They had this full bar that was help yourself," says Marker. "An honor bar. We didn't know what that meant." What that meant was you drink all you want, the staff replenishes the bottles every day, and, at the end of your stay, you settle up. "It was a big tab," says Vig.

The three Midwesterners were no less dazzled by the Landmark's poshness.

ERIKSON: I thought the lobby was beautiful, and was excited to be there. But when Shirl arrived, I realized that she must think we were three extremely wealthy assholes trying to impress or intimidate her. It was awkward at first. What broke the ice was just talking about music—everything from Sinatra to the Beatles to Siouxsie and the Banshees, Roxy Music, Public Enemy. And we laughed a lot. We laughed at the situation.

MANSON: It was one of those forced conversations that quickly became effortless. We talked about music and art and god only knows what. I'm not sure we talked much about the real reason we were all sitting there.

ERIKSON: I admired her for having the guts to even show up. Must not have been easy. Like a job interview. We tried hard to make it not feel that way because it wasn't a job interview, it was us looking for a mate: a bandmate. I've always believed that your bandmates should be your friends as well, otherwise it's just not a real band. I kinda felt like I knew Shirl already.

It was April 8, 1994, and it went well enough that Manson would make a trip to Madison a few weeks later. But twenty years after that day, that meeting is not what everyone most remembers. That was also the day Kurt Cobain's body was discovered at his home in Seattle.

"I got back to the house I was staying at and his suicide was all over the five o'clock news," Manson recalls.

Vig, meanwhile, was on his way to Soho to meet up with producers Alan Moulder and Flood for pints and gearhead talk. "I walked in, they all looked at me, and I was like, 'What's up?' And someone said, 'Have you heard the news? Kurt's dead; he committed suicide.' I didn't know what to do. I sat down for a minute, had a sip of a beer, then stood up and said, 'I've got to go.'" By the time Vig made it back to his hotel to book a return flight to Madison, there was a flurry of messages from the staff at Smart asking what to do. TV crews had already descended on the studio.

"I just wanted to disappear," says Vig. "People are kind of freaked out when I say it, but it's true: that moment was a dividing line in my life because I met Shirley the day I found out Kurt died. Before that was one chapter in my career, and Garbage is another chapter in my career."

X X X

Manson's first audition was at Marker's house. With no paying client, the band couldn't afford to tie up time at their own studio. "Smart was a thriving business then," says Erikson. "So many bands were coming in, it was too busy for us to actually go in there and work. So we set up a makeshift studio in Steve's basement."

Manson was stationed in a make-do isolation booth set up at the top of the basement stairs, with the door closed. It was just her, a microphone, Marker's cat, and a bleak view of the Madison winter. "I went up periodically between takes to see how she was doing, and she was sitting there, petting the cat and peering out the window, looking a bit lonely," says Erikson. "I'd always ask if I could get her anything, and she would always say no. I think she may have been thinking, *Yes, you can get me the fuck out of here!*"

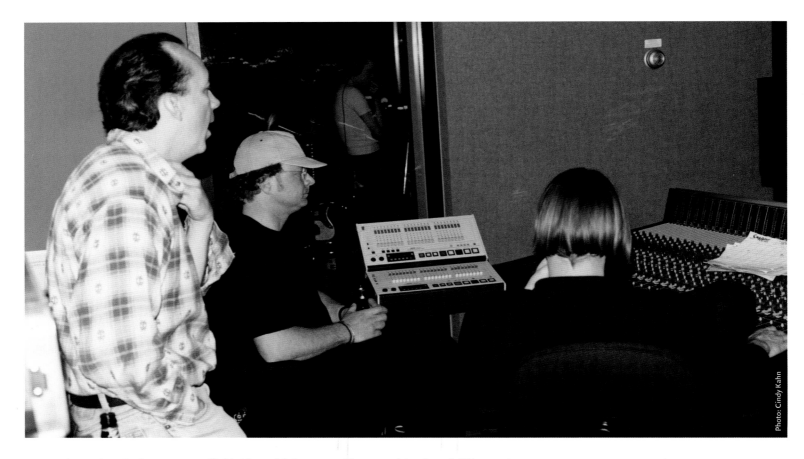

At that point, Garbage were still thinking of doing one-off songs with a lot of different singers. Which was probably just as well, since they barely even had one song. There were bits and pieces of what would become "Stupid Girl," "Queer," and "My Lover's Box," but not enough in terms of lyrics or complete melodies to give Manson anything to work with. "We were like, 'Just make something up and sing it,'" says Marker.

"Vow" was one of the few tracks with more structure, including the first couple of lines as scrawled by Vig in his old notebook: *I can't use what I can't abuse.* Manson says, "I can still remember looking at that line, looking up at the boys, and saying, 'Good words.'"

"I don't think the three of us really knew what we wanted," says Vig, "and we didn't really give her any direction." About a week later, Manson got a call from O'Shea, asking how things went.

"It was a disaster," Manson said.

O'Shea replied, "Yeah, well, the guys felt it was a little bit disappointing too."

But the underwhelming tryout didn't stop the boys from going to Chicago's Cabaret Metro a few weeks later, where Angelfish and the late Vic Chesnutt were opening up for Live, Radioactive's biggest band.

"An absolute fiasco of a show," Manson declares.

"Not true," Vig disputes.

"Seeing Shirley perform in Chicago was eye-opening," says Erikson. "She commanded the stage. It was a million miles away from the bored girl sitting there petting Steve's cat."

Afterward, the four of them spent a drunken night together at Raw Bar and Grill on Clark Street, punctuated by Manson—to her horror—dumping the wheelchair-bound Chesnutt onto the sidewalk in front of the bar. "He made a bit of a scene for dramatic purposes, waving his arms around like a little beetle and moaning a lot," says Manson, who grew close to Chesnutt on that tour. "Truly, we had consumed too much tequila for him to feel a thing. But Vic liked to play upon people's fears and prejudices about the disabled. He later confessed he was merely enjoying watching me freak out."

A few weeks later, Angelfish were still slogging their way through an itinerary that included performances such as playing outside of a Fashion Bug on the sidewalk of a strip mall, Manson's mic attached with gaffer tape to a clothing rail in lieu of a stand. Throughout, Manson and Erikson stayed in touch. "I'd call her up and we'd talk a bit about the tour," says Erikson. "She'd complain or say something funny about the hotel room. I sent her a Cormac McCarthy book

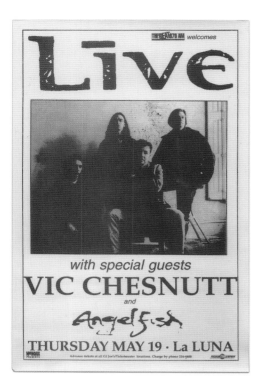

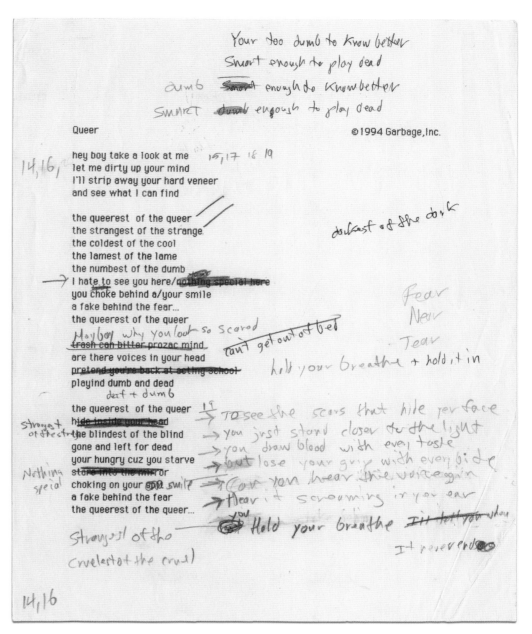

Right: the working lyric sheet for "Queer." The song was inspired by a scene in the Pete Dexter novel *Brotherly Love* in which a boy's uncle takes him to see a prostitute. Vig had ideas for lyrics that he gave to Manson — "who took them and totally changed it into the song that it is"; above: a poster for an Angelfish show opening for Live and Vic Chesnutt. The boys went to see Angelfish perform on this tour at the Metro in Chicago shortly after Manson's first audition; left: Erikson, Marker, and Vig in Smart's Studio B, with Manson in the booth doing vocals for the first album in 1995.

once." Manson was holed up in a hotel she describes as too scary to leave in the seaside town of Asbury Park, New Jersey, when Erikson asked if she would come back for a second session. She flew to Madison almost immediately.

This time, the boys set up at Smart Studios instead of Marker's basement. They were also more prepared. "Stupid Girl" had turned into a song, and "Queer" was more lyrically developed. "It had some lines like: *The pinkest of the pink, the reddest of the red,*" Manson remembers. The boys had also sent her a rough demo of it prior to her arrival, with Vig singing a completely aggro, rumbling guide vocal: "*THE QUEEREST OF THE QUEER!*"

"And then Shirley sang it the exact opposite," says Vig.

From Manson's perspective, she had no other choice. Though a fan of screaming vocalists like Courtney Love and Brody Dalle, she was not one herself. "I grew up wanting to be Patti Smith and Billie Holiday," Manson says. "I wanted to sing it harder but I couldn't. So I sang it all soft."

"None of the other singers we tried had that kind of dynamic ability in their vocal," says Erikson. "It was Shirl's vocal on 'Queer'—seriously, it sounds really corny, but we all just looked at each other. That was when we knew."

Not long afterward, Manson got a call from Erikson that would change her life. The boys had been talking, and they wanted to know if she'd come to Madison and set up residence there for a while. They thought they could make a great album—not just one song—with her. She would, and they did.

GET SMART!
THE STORY OF SMART STUDIOS

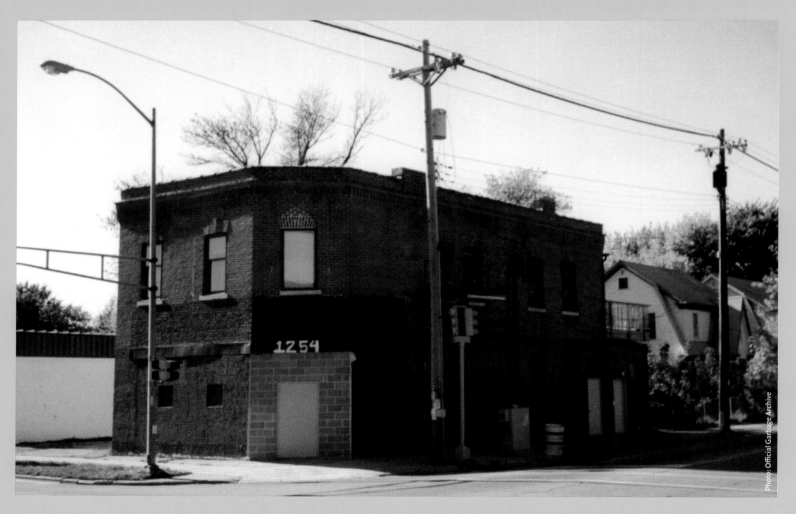

Here is how Smart Studios got its name: It was 1979. Butch Vig, having dropped out of the University of Wisconsin, was playing drums in Duke Erikson's band, Spooner. Spooner had recently recorded an EP of their taut garage-pop, *Cruel School*, and though they had a reel-to-reel tape of the mixes, they had no way to listen to it. So they turned to Steve Marker, who Vig had first met at UW, and who had been a combination roadie/soundman for Spooner. Marker had a four-track recorder they could use to make cassette dubs of the EP.

Clearly all this called for a celebratory beverage, or perhaps more than one. This cycle—music, four-track recording, beverages (though not necessarily in that order)—became known as "getting smart."

"There was a college bar called the Plaza Tavern right off State Street," says Vig. "It was like one-dollar pitchers—dirt cheap. Steve and I would go there with a bunch of other friends and play pool and pinball and drink a bunch of pitchers, and we'd say, 'Let's get smart!' Which meant get really stupid drunk and then go record on his four-track."

In 1982, Spooner cobbled together $15,000 from live gigs, family, and friends, and set off for Zion, Illinois, to record an album with Gary Klebe of the Shoes, who'd produced their EP. "We got the recording bug and realized for all the money we spent, we could have built a studio," says Erikson. So they did.

Smart Studios began as a small-scale operation, but in 1983—powered by a $20,000 loan from the Madison Development Corporation—it became a more professional endeavor, and moved to 1254 E. Washington Avenue. Soundproofing the space cost about fifty dollars. "We got a thousand egg cartons and glued them onto the wall," says Marker. "Apparently, when you're gluing a thousand egg cartons to the walls you're supposed to open the windows. We had this industrial glue. It was pretty fucked up."

It was a seat-of-the-pants operation in other ways as well. "We never really had a business plan," says Vig. "We had to draw one up when we got the loan, but it was all bullshit: *Fifty to seventy bands every couple of months, some radio jingles, thirty dollars an hour or . . .*"

At the start, Smart would record local bands for almost nothing. "We just wanted to get people to come in," says Vig. "Professional studios charged seventy-five or a hundred dollars an hour. The local bands were like, 'First, we don't want to record there, and second, we don't have a thousand dollars to go in for a day.' I think we charged five dollars an hour but we'd go, 'Okay, give us fifty to cover our electrical overhead, and bring in a reel of tape.' And then we got up to ten dollars an hour, and then twelve an hour. We didn't make any money. I was still driving a cab part-time." Marker saved money by living at Smart for a while until he got a new apartment.

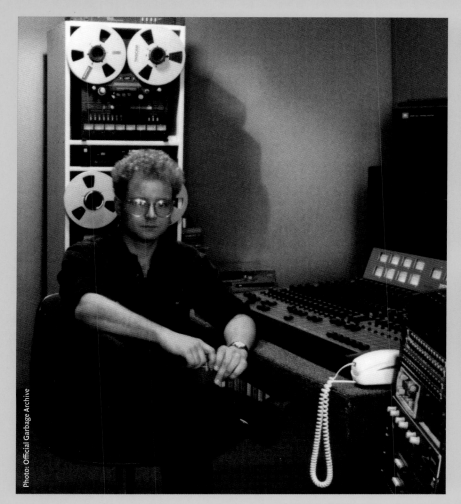

Photo: Official Garbage Archive

Photo: Cindy Kahn

Photo: Cindy Kahn

Madison bands like the Tar Babies and Killdozer recorded at Smart, and they were signed to two of the most important indie labels of the day: SST and Touch and Go, respectively. Word of mouth began to spread. "There was this market that existed that wasn't being served," says Marker. "There weren't many places bands could go for five hundred dollars and make a single. So we were lucky. People started coming from out of state even."

"Anytime we made fifty or a hundred dollars, once we'd paid our rent for the month and our electric bill, we would buy a compressor or a used microphone," says Vig. And gradually, Smart Studios became a Midwestern indie-rock brand name, capable of capturing the raw, distorted live sound of bands like the Laughing Hyenas, or adding dark, spacious atmosphere to albums like Killdozer's *Twelve Point Buck*.

That album marked a turning point. "Billy Corgan heard *Twelve Point Buck* and called me out of the blue," says Vig. And then Corgan brought the Smashing Pumpkins to Smart to record their debut album, *Gish*. "That was the first major budget we had. I think we said, 'We want $350 a day for studio time'—sort of sweating it—and they approved it. And I thought, *Shit, we should have asked for five hundred a day*. We had thirty days in the studio to record and mix. You could spend time getting guitar tones and really work on the performances."

They put the money they earned into their first sampler and a new microphone. "An SM7," says Vig, "because that's what Michael Jackson used on *Thriller*, and we heard it was a good workhorse—you could use it on guitars and vocals and you could drop it on the floor."

But some six months before the Pumpkins recorded *Gish*, another out-of-town band impressed by the heavy sound of *Twelve Point Buck*

came to Madison in search of the Smart touch: Nirvana. Dave Grohl had not yet joined the group, so Chad Channing was still in the drum seat when Nirvana spent five days at Smart Studios. "We didn't finish everything," says Vig. Kurt Cobain blew his voice out on an early version of "Lithium," but they did cut eight songs. "I did a couple rough mixes on what we got, and sent them to Sub Pop. And then I didn't hear anything. Turns out, when they got back to Seattle the band pressed a hundred cassettes and gave them out to all their friends, unbeknownst to Sub Pop. All of a sudden people were making copies: 'Hey, did you hear the Nirvana? It's the Smart sessions.' And those got around to A&R people and there was a bidding war and they signed with Geffen about six months later."

That signing led to *Nevermind*, which Vig ended up producing in Los Angeles. It was an album that altered the musical landscape.

In the wake of those changes, many bands made the pilgrimage to Smart Studios: L7, Soul Asylum, and Everclear, among others. Smart had helped create the breakthrough moment for grunge—or indie, or whatever you want to call it—but the genre had its limitations. "It could be really narrow-minded," says Marker. "You had to have the white Ford Econoline, and the two guitars and bass and drums, and that's it. Keyboards not allowed. Women rarely allowed. And to make any effort of an image or visual sense was not allowed."

Of course, Erikson, Marker, and Vig had a plan to change all that. It would require the old "Let's get smart!" formula: beverages, music, recording. Only this time, they'd call it Garbage.

"LET THEM GET A LITTLE SUCCESS, AND THEN WE'LL SEE WHAT THEY DO."

—JERRY MOSS, 1995

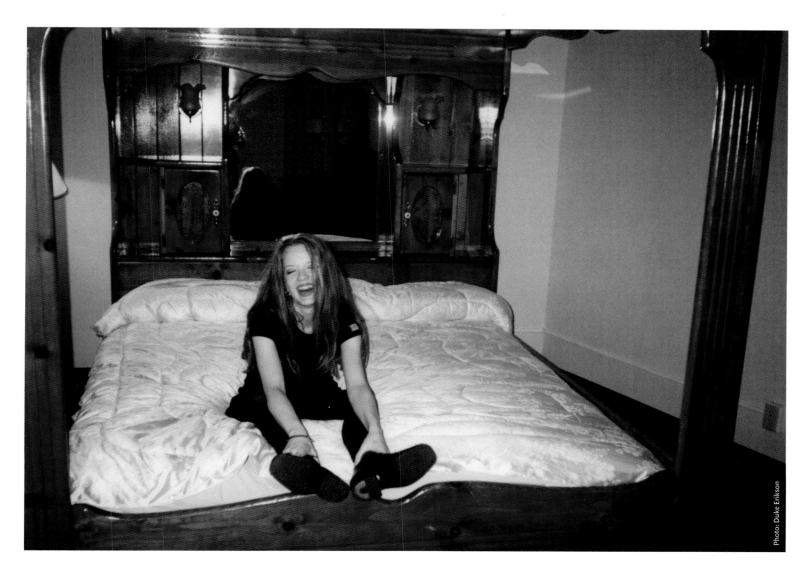

Photo: Duke Erikson

Captured for history: Duke photographed Manson on her arrival in Madison, Wisconsin (fresh off a plane from Edinburgh, Scotland), in her hotel room at the Inn on the Park—which included a waterbed and a mirror on the ceiling. The laughter you see here is more horrified than joyful, wondering what on earth she had gotten herself into. She stayed at the Inn on the Park through the summer of 1994, until she finally moved to the Edgewater, her Madison home base for the next few years. Previous pages: Smart Studios, at the corner of East Washington Avenue and Baldwin Street; Marker in 1985; Vig and Erikson in 1983; Marker and Vig at the Plaza Tavern in 1983, famed for its dollar pitchers.

When Shirley Manson arrived in Madison in the summer of 1994, there were problems. "I didn't drive," she says. "I had no money. I had no phone, no computer, no credit card. I mean, it was dismal." The weather, at least, was less dismal than back home in Edinburgh. But this, too, was a problem. The average daytime temperature in Edinburgh in July is fifty-nine degrees—sweater weather. In Madison, it's eighty-two. "Boiling-hot summertime, and I was in completely black clothing because I had no idea what it was like to live in a hot climate of any nature. So I was always uncomfortable. Whenever I'd arrive at the studio, I was soaked in sweat from top to bottom and bright red."

The night Manson touched down in Madison, Erikson picked her up at the airport and took her to the Inn on the Park, located right by the state capitol and in between two of the city's four lakes. They'd booked her the executive suite. Which sounded nice, but wasn't.

ERIKSON: We walk in and there's this ridiculous bed . . .

MANSON: A waterbed . . .

ERIKSON: With pillars. And she goes, "It smells like men's cum in here."

MANSON: Businessmen's cum. *Old* businessmen's cum.

ERIKSON: She lays down on the bed, looks up, and there's a mirror!

MANSON: On the ceiling! The whole thing was mirrored. I was putting on a good show, but in my head I was thinking, *Jesus fucking Christ, what am I doing here?*

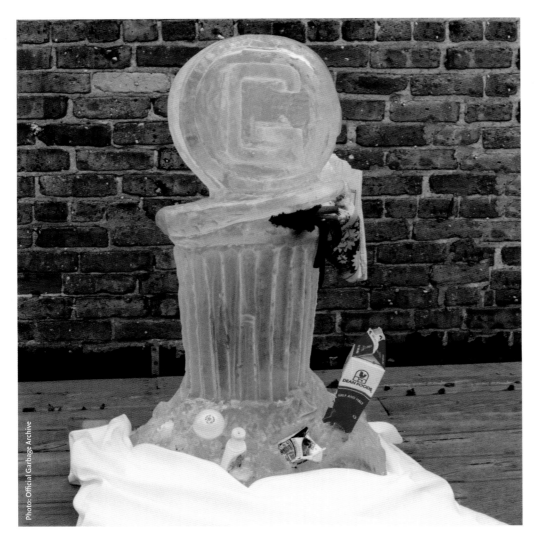

Photo: Official Garbage Archive

During the major-label wooing process, **SOS** Management asked record companies to demonstrate their commitment to the band. At left, one label's token of esteem: an ice sculpture of a garbage can. This unnamed label did not win the derby, but pictured right is the team from Almo Sounds that did. From left to right: Gary Ashley from Mushroom (who had signed Garbage outside the US), Erikson, Shannon O'Shea, Vig, person unidentified, Marker, Almo A&R men Howard Thompson and Bob Bortnick (back row).

This was Manson's home for the next few months—"until there was an incident where I was literally scared to go out of my room," she remembers. "One of the staff, who was mentally disabled, was having a fit outside my room, throwing himself from side to side in the corridor, going absolutely ballistic. I had to call reception, they called security, took him away, and when I eventually came out, he had clawed all the wallpaper on either side of the corridor. I told the boys, 'You need to get me out of there.'" They moved her to the Edgewater Hotel. "It was indeed a step up," she says. But by then, it had begun to get cold. "I was really shocked by the winter. I thought I was going to die."

By early 1995, Manson had been in Wisconsin off and on for months. "Word got out that we had something special, which we did," says Marker. The band was about to go through a true music business courtship.

In the 1990s, record companies in America were in a state of flux. Geffen, Columbia, MCA, and Warner Bros. all went through shifts in ownership, distribution, or leadership, while industry insiders both old and new were starting boutique operations, most with backing from existing major labels. Among them were former Talking Heads manager Gary Kurfirst, who founded Radioactive, Angelfish's label; producer Jimmy Iovine, who cofounded Interscope; and A&M Records cofounders Herb Alpert and Jerry Moss, who started a new label called Almo Sounds.

This music business churn was one of the reasons why O'Shea had shopped the band in Europe first. But now it was time to make a US deal. To add a little drama to the process, SOS asked executives from all the different labels to attract the band's attention with a grand symbolic gesture. "Some sort of surprise or gift to demonstrate the depths of their commitment," Marker remembers.

One company sent an elaborate ice sculpture: a giant garbage can with bits of trash encased inside. Interscope sent a faux platinum album, representing a vision of the future in which Garbage and Interscope would sell a million records together.

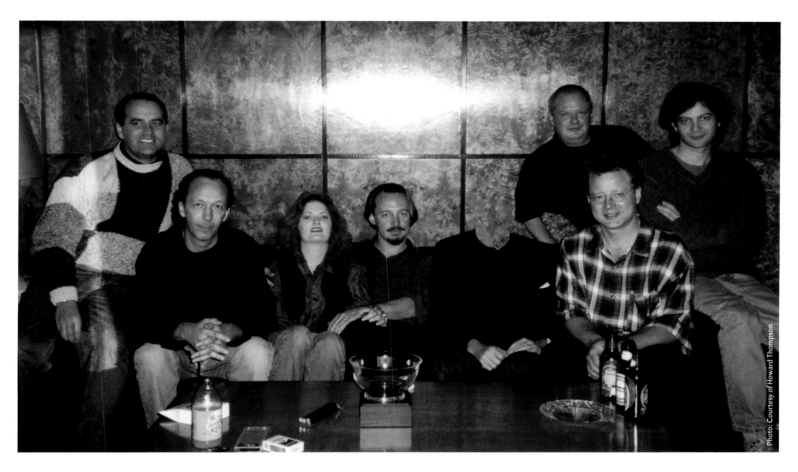

Photo: Courtesy of Howard Thompson

The contrived seduction was not necessarily a good fit for three low-key Wisconsin guys and a cynical Scotswoman, all of whom had been around the business for a decade (or two). "We were mortified," says Manson, "but you know, it worked, sadly. In retrospect it was the right approach because all these idiots love arrogance and all of that tacky, bullshit, larger-than-life promotion. We wouldn't have sold ourselves like that, but we also wouldn't have gotten the kind of deals that we got."

The pièce de résistance was not something any label did for Garbage, but something Garbage did to all the labels. Imagine: you're a record company president from London, New York, or Los Angeles. There's no direct flight to Madison. You land at Dane County Regional Airport, wait at baggage claim for longer than you're used to, and then—finally—are greeted curbside by the expected sight of someone holding up a card with your name on it.

Except you're not getting into a limo. The driver is in work clothes, and he's putting your bags into a garbage truck. "I have to say, we kind of collaborated with Shannon and Meredith on that," Erikson admits.

"We found the garbage truck by calling garbage-collection services in the local yellow pages," says O'Shea. "It was not that expensive—the company was small and they thought it would be fun."

Gary Ashley of Mushroom was the first to get this treatment. "The garbage truck was quite clean," says Cork. "The driver took Gary's bag and chucked it in the back. He didn't say a word to him. Just drove this garbage truck and then pulled up outside the Edgewater Hotel."

Not everybody dug the stunt. Late in the process, Almo's Jerry Moss came to town with A&R men Howard Thompson and Bob Bortnick.

MARKER: Jerry Moss is a classy guy . . .

VIG: A billionaire.

MARKER: When they got out of the garbage truck at Smart, Jerry got out first and he was laughing.

BORTNICK: The thing about Jerry is, I would sit at his house, and we'd be drinking cognac or

something, and—oh yeah, there's the Warhol of him and his wife! Right next to the Picasso. But you could put your feet up on the one-of-a-kind Stickley table. He was like, "Whatever." He thought it was kind of funny.

MANSON: He was used to doing the dog-and-pony show.

MARKER: But Howard got out red with rage. He was so pissed.

ERIKSON: I'll never forget Howard's face.

VIG: He was beet red, man.

Thompson was already nervous; he and Bortnick hadn't yet told Moss that Manson was still bound to Radioactive. Because she was not contractually a full member of Garbage, and because nobody knew if Garbage (and, specifically, Garbage with Manson) would be anything other than a one-off project, that was not a pressing problem from the band's perspective. But to a record company president, it meant extra paperwork and lawyers.

THOMPSON: If we had told Jerry that Shirley was under contract with Radioactive, the trip to Madison would never have happened. He learned about it on the plane, and I remember him being noticeably peeved. The garbage truck only made things worse—for me at least. In the end, it didn't matter, but it was an uncomfortable ride to the studio. And then we met them, and there was no looking back.

ERIKSON: Once we got to hang out, Howard was fine. He leaned over to me at dinner and said, "I love your music, but I have a problem with the name Garbage. I think you should really think about it." And I just said to him, "Hey, you know, Howard, you may be right, but think of all the stupid names that are out there." Once they become part of the lexicon, you don't even think about it. I mean, "the Beatles"? They're named after a bug.

X X X

One sticking point the band was sure to stress up front: there would be no live show. They regarded music videos as essential, and left open the possibility of performing on TV, but there were no plans to tour.

That was a deal-breaker for many, including Interscope, who cancelled their trip to Madison, as well as Michael Goldstone, the Epic A&R man who signed Pearl Jam. "I've known Goldie a long time," says Vig. "He told me, 'I love your music but if you're not going to tour I just can't sign you.'"

"And he was right," says Marker.

Bortnick remembers the band saying they weren't planning to do videos or press because it was just going to be a one-time thing. But Moss was unfazed. Bortnick says, "Very early on— maybe the first time we came back from Madison—Jerry said to me, 'I've had experiences like this before. Let them get a little success, and *then* we'll see what they do.'"

As with Mushroom, Garbage would be Almo's flagship band. "Both Almo and Mushroom were tiny, tiny companies with just a few people," says Erikson, "but with a big company to back them up. So that seemed like a smart way to go about it."

Thompson had a track record that the band respected—as Elektra's head of A&R he'd signed Björk and Happy Mondays. And Bortnick earned some serious goodwill with Manson. Because she was not yet contractually a member of the band, it was easy for the label people to exclude her from the process and essentially treat her like "the girl."

BORTNICK: I remember Shirley asking me if I wanted any tea or coffee, and I said, "Yeah, coffee would be great." I followed her into the kitchen and said, "You don't have to make me a coffee, I can do this myself." Years later on a bus one night, she said, "You know why I wanted to sign with Almo? You were the only one who followed me into the kitchen and said, 'You don't have to make this for me; you're the artist!' I always remembered that."

X X X

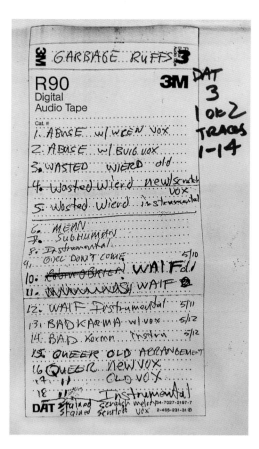

```
3M GARBAGE RUFFS 3
R90                    3M  DAT
Digital                     3
Audio Tape                  1 OR 2
Cat. #                      TRACKS
1. ABUSE w/WEEN VOX         1-14
2. ABUSE w/ BUG VOX
3. WASTED WIERD old
4. Wasted Wierd new/scratch
                       VOX
5. Wasted Wierd Instrumental

6. MEAN
7. SubHuman
8. Instrumental
9. GIRL DON'T COME          5/10
10. Crash/Bitch  WAIF 1
11. Dx-wxx/Wx-xx  WAIF 2
12. WAIF Instrumental       5/11
13. BAD KARMA w/ vox        5/12
14. BAD Karmn  Instru       5/12
15. QUEER OLD ARRANGEMENT
16. Queer NEW VOX
17.   "      OLD VOX
18.   "      Instrumental
DAT Stained Scratch Melo 94-7027-2197-7
    Stained Scratch Vox  2-465-231-31 Ⓡ
```

Photo: Cindy Kahn

As the band kept working, Manson became more comfortable and her role expanded, but there were still communication problems. When Manson sang, she had no accent, but "between takes we could barely understand what she was saying," says Erikson. "That went on for weeks or months. 'Could you repeat that please?' *'Sigh.'*"

MANSON: I don't think I was particularly assertive on the first record.

VIG: But you had opinions.

MANSON: I didn't say I didn't have opinions.

VIG: You were opinionated, but you were tactful.

MANSON: That's all gone down the toilet, unfortunately.

ERIKSON: We were all writing lyrics, us three, and Shirl was contributing a bit. But she never really came out and said, "I want to write lyrics."

MANSON: Well, I had never written any lyrics before. But when I met them they were like, "Do you write?" and I was like, "Yeah, I write." Right there and then I decided that I would have to

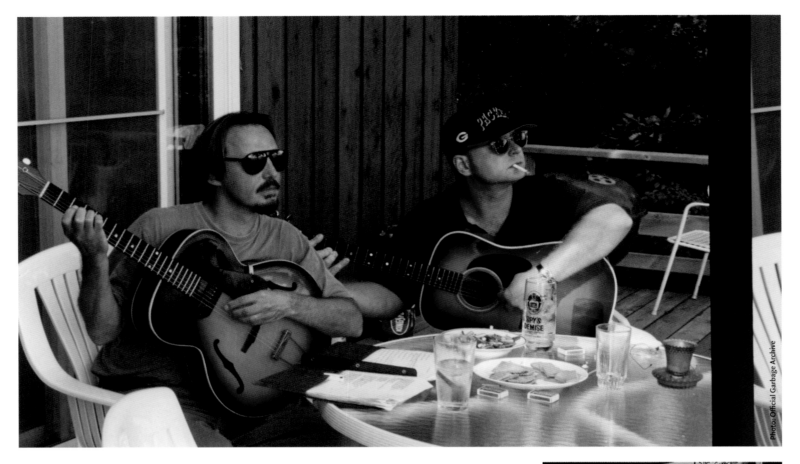

bullshit my way into this job. And when I came to Madison, I think it's fair to say they were struggling a little with lyrics.

VIG: A lot!

MANSON: They kept saying, "So what do you think?" And I'd be paralyzed with fear, sick to my gut. Never lie, people. It's such a bad idea.

ERIKSON: It was not easy for her being in the studio all the time. So we would go to James Madison Park and get on the swings and talk. Then one time we were working on "Not My Idea," and she said, "I have an idea for that." And she sang that whole lyric as she sat there swaying on the swing: *"You thought I was a little mouse."*

VIG: Those were the first lyrics she wrote. What's the next bit? *"Now I'm here burning down your house"*? That defines Shirley's personality. It was like, "Here I am!"

ERIKSON: You couldn't stop her after that.

<div align="center">x x x</div>

Late in the recording process, the band still didn't know exactly what they had. During one of Manson's trips back to Scotland, the boys decided they would go on a work retreat to Green Lake, Wisconsin—"a posh destination for Chicago golfers," says Erikson. The first stop was Four Star Video.

Vig says, "We rented a bunch of artsy-fartsy movies, took guitars, and we were going to watch movies and listen to the tracks—try to get some perspective on where we were at with the songs. We went to a liquor store and bought some great wine and cocktails and stuff . . ."

VIG: Basically all we did for three days was party.

MARKER: We played golf.

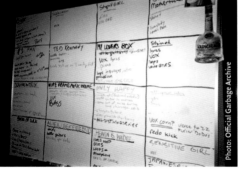

Left: Vig and Marker in Green Lake, Wisconsin, where the boys went on a work retreat toward the end of the recording of the first album in 1995. Note they are holding their guitars upside down, possibly an indication that cocktail hour had already begun. Or never stopped; above: a whiteboard at Smart's Studio B in 1995, with working notes on tracks from the debut album (with provisional titles); right: a 1995 publicity shot by Sednaoui in a diner, Times Square, NYC.

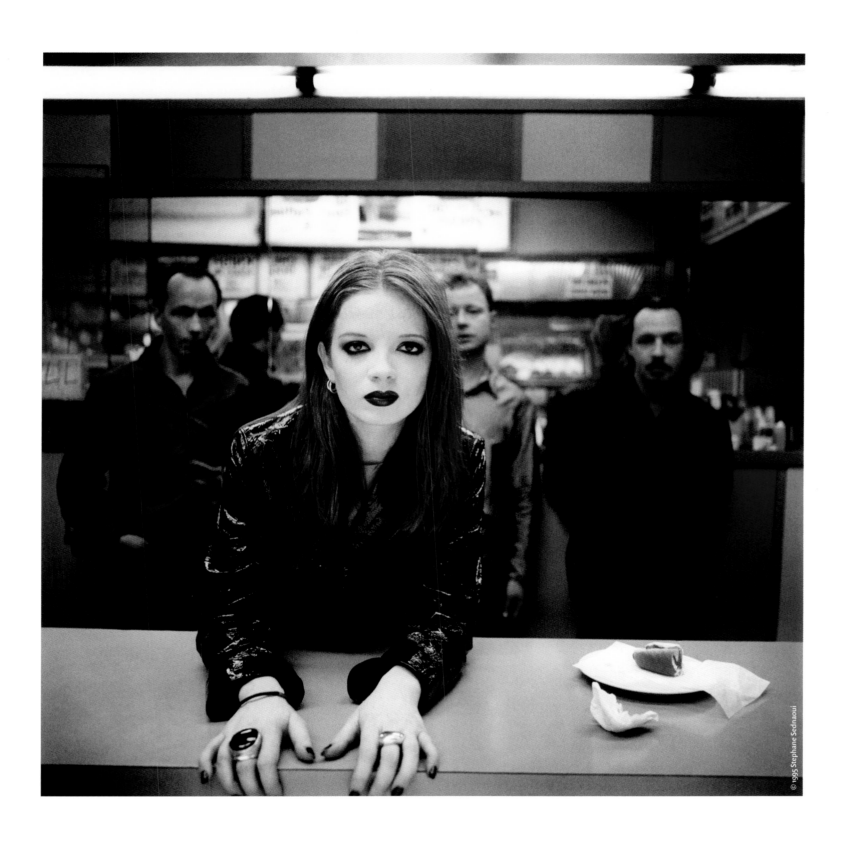

The photograph is credited in the right margin: © 1995 Stephane Sednaoui

THE EDGEWATER HOTEL

Madison's Edgewater Hotel opened in 1948 with plans as grand as the view it provides of Lake Mendota, which stretches out like an ocean for 9,781 acres to the hotel's north. The owners signaled their intentions right away by bringing in a manager from the well-known Drake Hotel in Chicago, who booked the Jimmy Dorsey band to play on the Edgewater's roof and broadcast the shows nationally. Over the years, guests have included everyone from Elvis Presley and Sammy Davis Jr. to Bob Marley and the Dalai Lama.

But by the nineties—when it became the hotel of choice for bands visiting Smart Studios—Elvis was long dead and the Edgewater's art deco glamour had faded. "Listen, I only stayed there a couple nights, and I have miserable memories of it, you know?" recalls Bob Bortnick. Eric Avery arrived there in 2004 to rehearse as Garbage's bass player before the *Bleed Like Me* tour, and likens the experience of staying just off a lake in the bitter cold to Jack Nicholson's isolation in *The Shining*: "It is so the Overlook Hotel."

The Edgewater is just about a mile and a half from Smart Studios—a five-minute drive. Nirvana, L7, and Paw (who destroyed the walls of their room in a BB gun–shooting contest) all called the place home while cutting albums with Vig. And for the better part of a decade, so did Manson.

At first, it was a matter of convenience. The band had begun as a one-off project, and Manson's home and future husband were in Edinburgh. But as Garbage made a second and third record (and even after Manson's first marriage ended), she continued to live there.

"I had to stay in a hotel, really, for a lot of different issues," Manson says. "*Issues* being the operative word." Moving out of the Edgewater would be admitting that she actually lived in Madison. Living in a hotel kept her connection to Madison transient. It also provided other advantages, like an extra layer of security to deter the occasional overly enthusiastic or scary fan.

But by then, the Edgewater had seen better days. It was more a form of self-flagellation than rock-star indulgence. A Baby Ruth bar from the vending machine in the basement counted as a treat. For entertainment, Manson remembers, "there was the amazing creaking, moaning, and cracking of the ice on the lake in the springtime." And then there was the time she found a cockroach in her pillowcase.

"I left a note for housekeeping," says Manson. "They left the following note in response: *Dear Miss, I got rid of the insect. From Bill in housekeeping.*"

Journalists—flown in from New York, London, or Texas to interview the band—would get stashed at the Edgewater. Same thing for record company executives as well as the band's road crew for pretour rehearsals. Vig lived at the Edgewater for a spell, in between his divorce and his relocation to Los Angeles. When Avery arrived to begin rehearsals, he remembers seeing a solitary ice fisherman outside his window, and something else: a room service menu that bore remnants of a previous guest's meal. *Oh, wow, look: there's already food on it for me to make a judgment*, he thought to himself.

There were certainly other hotels available, given the proximity of the state capitol and the University of Wisconsin. But now that he has known and played with Garbage for a decade, it doesn't surprise Avery that they never wavered from the place. "They're funny that way," he says. "Cutting-edge technology meets the craziest rut of well-worn, unexamined habit—the part of them that is the Midwest. Like, 'This hotel still gets it done, so we're using it.' Same thing with an old drum machine."

A newly renovated Edgewater reopened in 2014, full of boutique-hotel touches like bathroom mirrors that double as flat-screen TVs. There's also a 4,000-square-foot outdoor skating rink, several restaurants offering locavore cuisine, and an in-house spa. "The rooms are great, the new lobby and bars are super cool, and the service spot on," says Vig.

But the Edgewater has gone high-end just as the band returns to their lo-fi roots, with self-financed tours and records. "Now that our own label picks up the tab, it's too fancy for us!" Manson says.

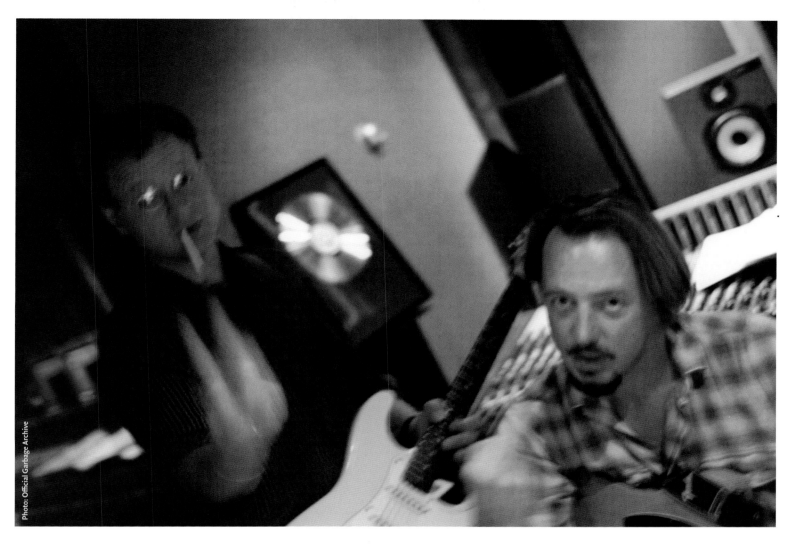

Above: Marker and Vig at work on the first album, taking a break from recording guitar overdubs to flip the bird (Marker — who still smoked at the time of this photo — is using the UK version of the hand gesture).

VIG: We played golf, we went swimming, we went to this place called Norton's of Green Lake—a super-cool fifties-style supper club. We would go and drink martinis. Steve lost his wallet there one night.

MARKER: It was a checkbook. My wife Cindy calls me at the rental house: "Are you missing your checkbook?" And I was like, "No, I've got my checkbook with me." "Because I just got a call from Norton's Steak House that you left it there when you paid your bar tab last night."

ERIKSON: Very productive.

But as the weekend wore down, a panic set in. The band still hadn't actually done any work. Vig says, "We finally put on all of the rough mixes, and we cranked it up and listened to it really loud. I think it was the first time we realized that we had a record. That it all felt good. Each song kind of had its own vibe and soundscape, and Shirley's singing was the glue that held the album together and gave it continuity."

Manson's vocal ad-libs, such as the *"doo-doo-doo-doo-doo-doo-doo"* on "Not My Idea" and the whispering on "Fix Me Now," came to define those songs. "We became aware of the possibilities of little inflections like that, where she didn't just have to sing all the time," says Erikson. "She could talk, she could whisper, she could make a noise, she could do whatever. And that became part of everything we've done since then. We've always looked for something like that from Shirl's vocals to make a song special. What might turn into a hook or give it a certain personality."

Manson also came up with the *"like Joan of Arc coming back for more"* rhyme in "Vow," and—though she barely remembers it—the opening lines to "Supervixen," which are also the first words you hear on *Garbage*, the band's debut album: *"Come down to my house / Stick a stone in your mouth / You can always pull out / If you like it too much."*

"I think 'Supervixen' was the last song that came together," says Vig. "We didn't have any lyrics for it, and no title. There was a point where all four of us were banging heads, like, 'What is this song about?'"

"Supervixen" got its title from a Russ Meyer movie, but was influenced by Pier Paolo Pasolini's *Salò, or The 120 Days of Sodom*, which had been playing on a monitor above the soundboard at Smart when they were working on it. "A lot of the musical ideas came from wanting to see something as well as hear it," says Erikson. "We wanted the music to sound cinematic. We didn't always know why a sound we'd added worked. It just did."

Inspiration for other tracks on the album came from various sources. "Queer" came to Vig while he was reading Pete Dexter's novel *Brotherly Love*. "It's about two boys caught up in Philadelphia mob life, and there's a scene where one of them who's emotionally stunted gets taken by his uncle to see a hooker, to 'make him a man,'" says Vig. "The boy realizes his uncle has also been with the same woman. So I wrote all these lyric ideas down about the woman observing this odd, emotionally scarred boy and gave them to Shirley, who took them and totally changed it into the song that it is. Then Steve came up with the sample from 'Man of Straw' by the Australian band Single Gun Theory, which we layered over a hip-hop beat in the verse. It gave the track a great groove."

"Stupid Girl" includes a drum sample from the Clash's "Train in Vain," but that wasn't the only inspiration.

ERIKSON: "Stupid Girl," we were trying to write like Creedence Clearwater Revival.

VIG: A riff like "Suzie Q."

MANSON: I don't even know what "Suzie Q" is!

X X X

Above: Manson practicing guitar in the top lounge at Smart; right: a photo shoot for British music magazine *Select* posed the band on Hollywood's Walk of Fame. A digital star was made for the occasion by photographer RIP.

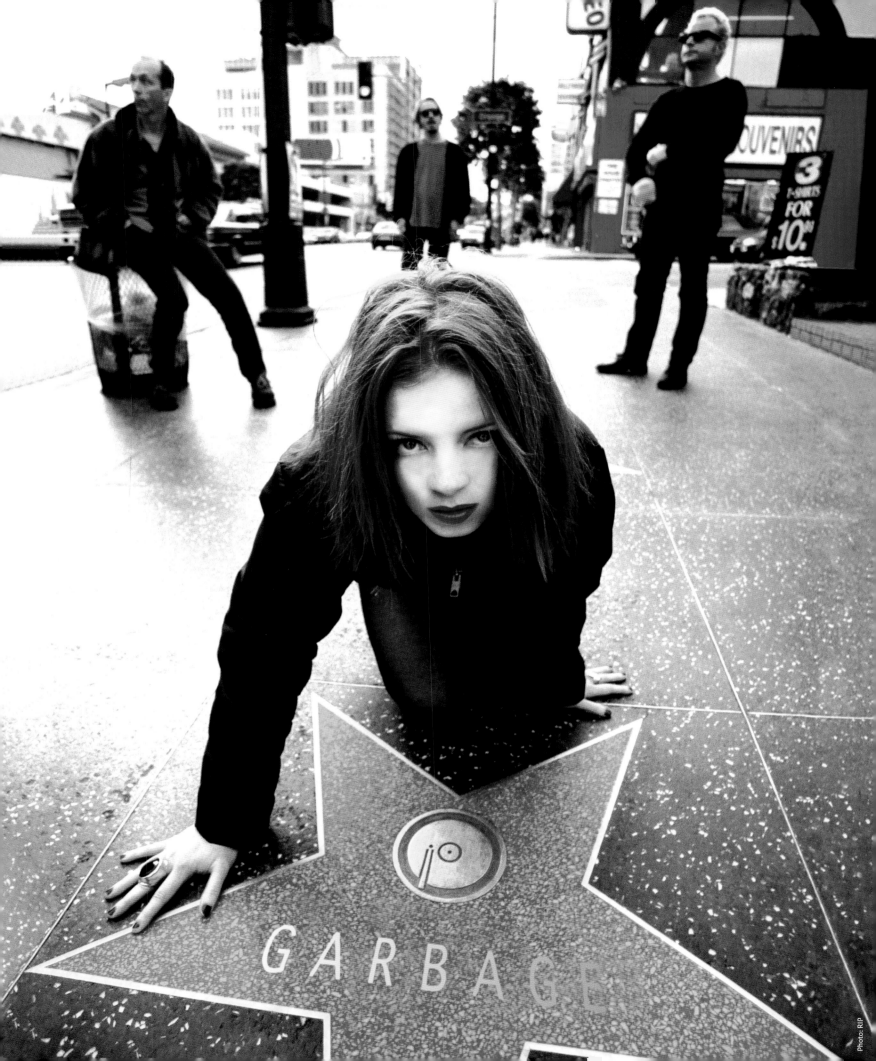

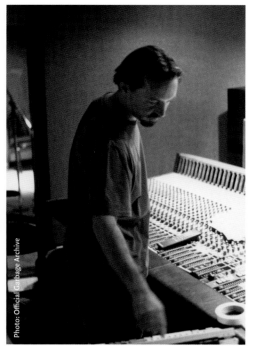

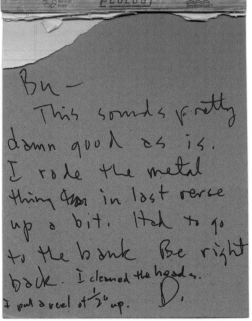

Garbage might still be in the studio working on the first record if not for "Vow." The song was quietly included on the British CD sampler and magazine *Volume* at the end of 1994. "*Volume* was an underground tastemaker minimagazine with a CD. Butch did not want the band to be introduced on the back of his name," says O'Shea. "He wanted people to respond to the music only. And the UK is a good market to introduce an artist somewhat gradually and still get attention because of its size and reputation for music worldwide. This way, Garbage would have fans discover them authentically. Those are the kinds of fans that stay for life."

The impact was felt well beyond the UK. "I used to buy *Volume* to find the next big thing," says Marco Collins, who in 1994 was the program director at KNDD/The End radio station in Seattle. He purchased the issue of *Volume* while record shopping with his friend Lisa Worden, who was then the music director at LA's KROQ. When "Vow" came on, Collins perused the tiny liner notes and was both shocked and delighted to see Butch Vig's name.

"This was something so different than what I expected out of the guy who produced *Nevermind*," Collins remembers. "Sweet, sultry, and beat-driven. I remember thinking, *He's gonna shock a lot of people with this project*. I couldn't wait till Monday to officially add it to the radio station's rotation. I loved adding records before my competition even knew what it was."

KROQ also got on board, as did John Peel and Steve Lamacq at Radio 1 in the UK. In March of 1995, "Vow" came out in the UK as a 7", backed by "Subhuman." The limited-edition metal package set the visual tone for Garbage: high-tech, tough, and sharp around the edges, both glamorous and dirty. The 7" was priced like a normal single, but the aluminum sleeve was so expensive to make that the label ended up taking a loss on every copy.

"The deal that we did with the record label, we told Gary, 'Listen, we won't advertise. These ads in *NME* are going to cost X. We're going to put that money back into the punters' hands with these metal discs,'" remembers Cork. "Of course, they got miles and miles of column mentions."

Mushroom wasn't a major music label. It was best known in the UK for *Neighbours* actors turned pop sensations Jason Donovan and Kylie Minogue. To distance themselves from such a

Clockwise from left: the limited-edition UK package of "Vow," encased in a metal sleeve—only a thousand were made; Vig at the mixing board at Smart; a studio note from Erikson to Vig (Midwestern thrift clearly dictates using every part of the legal pad).

MY FIRST TIME

SHIRLEY MANSON

FIRST SINGLE I BOUGHT: The theme song to *The White Horses*, the Yugoslavian TV show. I want it played at my funeral.

FIRST ALBUM I BOUGHT: David Bowie, *Ziggy Stardust.*

FIRST SHOW: Siouxsie and the Banshees, Edinburgh Playhouse, 1981. My lifetime hero. Few gigs have ever captured the magic and majesty of this show. I was mesmerized and obsessed. I still am.

MEMORABLE EARLY SHOW: David Bowie, June 28, 1983, Murrayfield Stadium, Edinburgh. Me and all my friends camped out overnight to get tickets. They sold out in minutes but we were at the front of the queue so we secured them. My friend Patrick Cox made bootleg cassettes of the entire show and gave them to me for my birthday the following August. I used to listen to them and cry, believing I would never get to meet him and he would never know I existed. I was wrong about that, as it turns out.

BUTCH VIG

FIRST SINGLE I BOUGHT: Creedence Clearwater Revival, "Bad Moon Rising."

FIRST ALBUM I STOLE: The Who, *Live at Leeds.*

FIRST SHOW: Went with parents to see Glen Campbell at the Dane County Coliseum (Madison, WI).

MEMORABLE EARLY SHOW: A couple weeks later I saw Steppenwolf at the DCC. Parents dropped us off. Steppenwolf were awesome! Singer John Kay whipped the stage with a metal chain. They played a smokin' ten-minute jam of "Magic Carpet Ride." First time I saw weed being smoked at a gig!

STEVE MARKER

FIRST SINGLE I BOUGHT: Smokey Robinson & the Miracles, "The Tears of a Clown."

FIRST ALBUM I BOUGHT: Joni Mitchell, *Blue.*

FIRST SHOW: Duke Ellington Orchestra, NYC, 1968.

MEMORABLE EARLY SHOW: Rolling Stones, Madison Square Garden, 1975. My mom wrote me a fake note so I could skip school and go into NYC to get tickets the day they went on sale. Fourth row center! Sixteen dollars! This was *Taxi Driver* New York back then—I still can't believe my parents would let me go to shows by myself. I'm glad they did, but what the hell were they thinking?

DUKE ERIKSON

FIRST SINGLE I BOUGHT: The Kinks, "You Really Got Me." The opening guitar riff hit so hard and the song never let up after that. It was thrilling every time it came on the radio. I had to have it.

FIRST ALBUM I BOUGHT: *Meet the Beatles!* I was walking down Main Street in Lyons, Nebraska, and as I passed Roby's Furniture and Appliance store, an album on display stopped me in my tracks. The cover was dark and shadowy: four guys with weird haircuts peering out of the darkness. I finally went in and asked about it. The woman who worked there, Irma, opened up the sealed record and played it for me. I was blown away. Hooked. We didn't own a phonograph then so I kept going back, asking Irma to please play that record. She finally said I had to buy it. So I did, and I would take it to friends' houses to play—really loud.

FIRST SHOW: In high school I had a little combo called the British. We played the KOIL Teen Fun Fair band competition in Omaha. We didn't win but we didn't place last either! But all that music going on—I was in heaven. It was there I saw the Shadows of Knight, a Chicago band. They had a hit covering Van Morrison's "Gloria," and they did a kind of psychedelic version that went on for fifteen minutes. I didn't really like it, but I was excited to see a band whose record I'd actually bought. After their set, I got the lead guitarist's autograph.

MEMORABLE EARLY SHOW: The Who. In 1970, my buddies Curt Going and Goober Peterson and I drove all night from my hometown in Nebraska to Colorado in Curt's Ford Mustang. We were gonna find work and live in Colorado for the summer. Our other mission was to see the Who at Mammoth Gardens, in Denver. The most powerful rock show I've ever seen. The sound was pummeling and the band so together, but not together. It was controlled chaos. We didn't get the jobs. Had to drive home a couple days later. But I didn't care.

mainstream association, Mushroom put out "Vow" on a subsidiary, Rob Jefferson's Discordant Records. "The effort and money spent on packaging and limiting the manufacturing run was all part of the strategy," says Ashley.

The band's first record company bio, penned in late February of 1995, gave birth to a Garbage urban legend that has never died. It read: *One of the tracks, "Subhuman," begins with the sound of Butch accidentally wiring the mixing desk into the studio air-conditioning system.*

MARKER: Totally not true. But we had to come up with quotes for a press kit, and so that still lives on.

VIG: I can't attribute a sound to the air-conditioning, but there were some bad patch-bay connections that occasionally we did.

MARKER: On "Vow."

VIG: The very first version we mixed and sent out, we later realized that one of the stereo channels was patched through a compressor that was not working. So if you put headphones on and listen to the stereo balance, it's definitely off. There's a weird, sort of out-of-phase left/right disconnect. There was a haphazard approach we took, and it sort of became a philosophy. At Smart, we'd drink some beer and go, "Okay, just patch this in, let's try this." And we'd be messing around with the stomp boxes and effects that we've always had in this band. As much as we could slave and obsess over the sound of something or a tiny part of the performance, there was also the other half of our mentality where we just didn't care. Our mantra was more, "It's fucking weird and loose, and that's why there's a vibe to it, so let's keep it."

"Vow" ended up as single of the week in both *Melody Maker* and *NME*. "Surreal pop heaven mixed with industrial nightmares," said *Melody Maker*, concluding that the song "has classic written all over it." Now, all of a sudden, the band's record companies on both sides of the Atlantic needed a mixed and mastered album. Collins remembers leaving Vig a message at Smart when The End started to play "Vow." "He called me back a few days later to say thank you," says Collins, "and in the same sentence, 'What the hell have you done?'"

What Collins and the other stations playing "Vow" had done was shift the whole idea of Garbage from an idea to a reality—they'd pushed the boat out, and the boys felt like they were suddenly at sea. "We were just sort of drinking beer, taking our time, thinking, *We'll get the record done whenever we fucking want*," says Vig. "Then all of a sudden we got these calls: 'You've got to finish the record now because these songs are blowing up on the radio! You've got to get it together!'"

ERIKSON: We imagined we wouldn't have to think about what we were doing too much. That we didn't have to live up to anything. We weren't thinking about the people who had given us this money.

VIG: I remember starting to feel this immense pressure. Like, *Oh shit, this record's going to come out, and if it flops it's going to be my name. No one's going to care about these three. It's my ass on the line here if this flops.*

MANSON: And it was your ass on the line, to be fair. You must have been under incredible stress.

VIG: I was panicking, like, *This isn't good enough!* I got obsessive about mixing. I would try to beat Steve and Duke in to the studio, because whoever got the board first kind of got control. We were arguing about the mixing, as we still do now because we record a lot of different parts and ideas for each song. It's like an abstract painting: you throw on a lot of colors of paint and you have to decide what to take off and what to leave in. We were arguing about the solo on "Queer," and I just remember it going on for like two days. And then I threw a chair off the porch of Smart, saying, "Just make a fucking decision! Goddamnit, this is stupid!" I never get that way, but we had been mixing for two days. I think we went back to the original thing we had done on the demo.

Above: Manson and Erikson at Smart Studios; right: hot dogs.

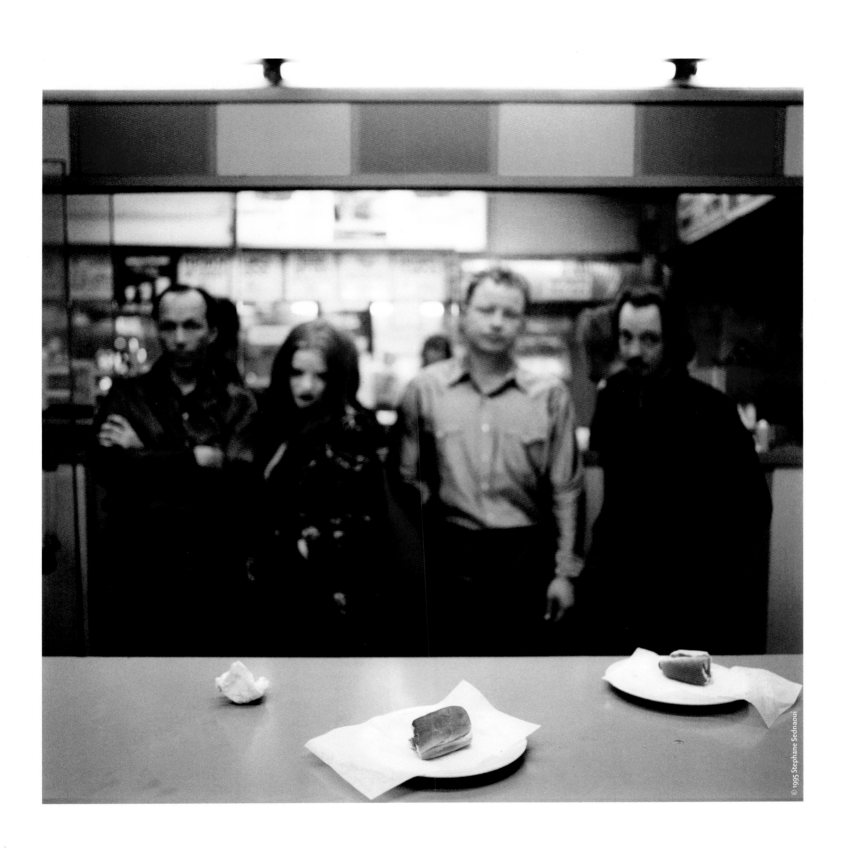

© 1995 Stephane Sednaoui

FILL YOUR GLASS WITH GARBAGE

ROCK AND ROLL COCKTAIL RECIPES

THE VODKA WITH ANYTHING

In the early days of Garbage, when things were wild, the band's backstage rider always included two liters of vodka. But after two decades, things have changed. "Now we only get one," says Marker. "Multiply that by the number of shows we've played and that makes, um, a lot of vodka." Thus the invention of the Vodka with Anything.

RECIPE

—*Fill plastic cup halfway with vodka*
—*Add ice (optional, and likely impossible in Europe)*
—*Top off with something to hide the taste of the vodka: sparkling water, apple juice, orange juice, cranberry juice, blueberry juice, grape juice, purple Gatorade, red Gatorade, Red Bull, Red Bull Sugarfree, Orange Fanta, or tonic water*
—*If you don't have any of the above, iced tea, Sprite, Coke, or Diet Coke will do. Really, anything will do.*
—*"If you want to show off you can put a slice of lime in there," says Marker. "But that's unnecessary and frankly just a bit pretentious."*

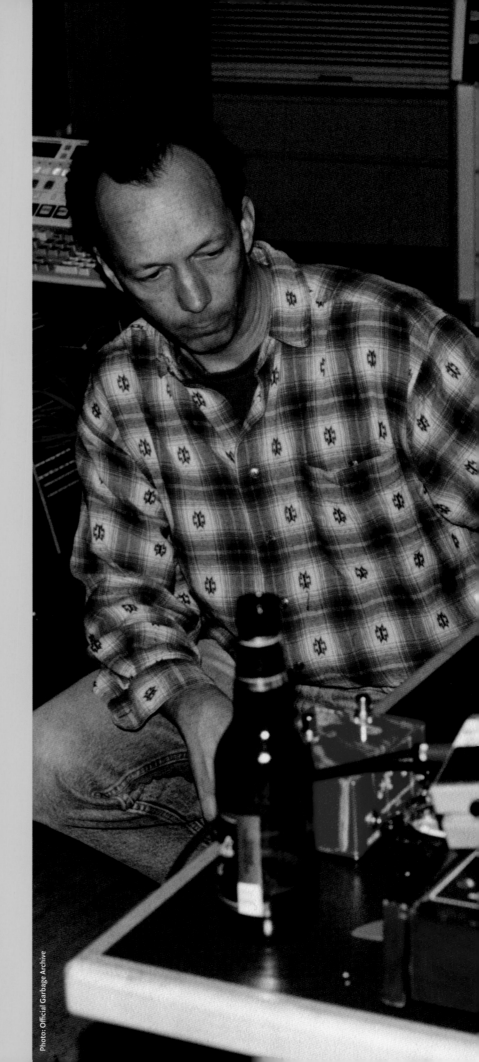

Photo: Official Garbage Archive

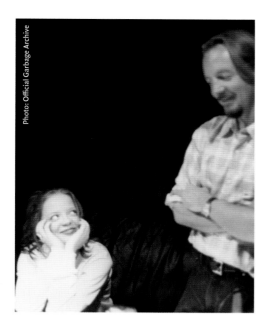

Above: Manson and Vig during the debut album sessions; left: Erikson tweaking effects upstairs at Smart Studios; following pages, clockwise: from their first days on the road, Garbage caught in a stairwell during a Bay Area tour stop; Vig, Manson, and Marker flaunt their manicures; Marker shows off the shiny shirt and eye makeup he sported in the video for "Only Happy When It Rains."

ERIKSON: But remember when we first heard "Vow" on the radio? We had pulled up to buy beer at PDQ. A Madison station had gotten the *Volume* thing, and we heard it on the radio, and it was like . . . it was incredible.

VIG: It was one of the coolest things in the world.

<div align="center">

X X X

</div>

Shirley Manson was puking in the bathroom. Director Samuel Bayer had been up all night throwing paint on the walls. A statuesque actor/model—shaved bald, kohl-eyed, and painted head to toe in yellow—was preparing to writhe on the floor. And Steve Marker was wondering what the heck he was even doing there.

This was the video shoot for "Vow," on a soundstage somewhere in LA. Garbage still weren't finished with their record, still weren't officially signed to Almo, and still weren't entirely at ease with each other. So to get in front of Bayer, who'd directed Nirvana's "Smells Like Teen Spirit" video, felt pretty odd. And sudden.

Vig and Erikson had made videos before—with Spooner and Fire Town—and had a coping strategy: drink a few beers, pick up your instrument, and have some fun. But for Marker, accustomed to life as the soundman/engineer/producer, it was unexpected and uncomfortable.

And so far as Manson went, well, the prospect made her sick. Literally. The band had never even practiced live before, and now she had to prove herself as a frontperson on screen.

"I think the three of us had blinders on, like, 'Hey, we're gonna shoot a video! Here we go!' But Shirley realized the importance of it," says Erikson.

The boys had rehearsed the day before, but without Manson. "Shirley came in and set up on the stage with us, and she was freaked out," says Vig. "'I have to get up and perform, and I have never performed with this band!'"

"She must have felt like that was the weirdest possible thing you could ever do," says Erikson. "To pretend to be in a band. To pretend to perform live. To pretend to perform live with a band she'd never played live with before."

It wasn't a comfortable experience. Manson threw up a few times on set and had to be dragged out to perform, where she found Bayer yelling at the band: "Play hard! Fucking play! Fucking pound the shit out of the drums! Play!"

"I like to believe I pushed them a little bit to be their best. Just like an asshole football coach," says Bayer.

"He also brought in this weird crawling guy, the yellow man," says Erikson. "Probably because of our lack of charisma."

But Manson pulled it off, and the process made them a band—before they'd ever even rehearsed. "Being thrown into this cauldron together made us all feel more comfortable, and that was the turning point," says Erikson. "That was when Shirley's mind changed."

Under the most contrived circumstances—on a video shoot with paint-splattered walls and a yellow man—the four of them realized that the project could work live. "We had never stood behind Shirley as her band, and she had never stood before us as our singer. The feeling that, when you're a band, we're supporting that person, and she's feeding off of us. That was the first time we felt that," says Erikson. "And I think she did too, even though she puked afterward."

"Puked *during* it!" adds Vig. "The last scene she was supposed to shoot she couldn't do because she had thrown up so many times. Sam was like, 'Okay, I think we got it.'"

"I don't remember too much other than I vomited in the toilet a couple of times between takes. I think it was nerves, but it might have been bad sushi the night before. Either way, I was struggling," says Manson.

When she stepped onto the set, though, Manson became a bandleader. The guys watched her commit to the band right in front of their eyes. "We saw her pouring her heart out into the song that we'd all written together. We felt like she was in it for the long run," says Erikson.

"It brought us together," says Marker.

"It was a moment when the three of us realized how fucking good Shirley was," says Erikson.

"She owned the stage that day on the set," says Bayer. "Certainly no one had told me when I did the video that they'd never played together. They played and performed like a band that had played tens of thousands of times."

It was the moment Garbage became more than just a concept. They weren't even finished with the album, but the shoot for "Vow" was their christening as a band.

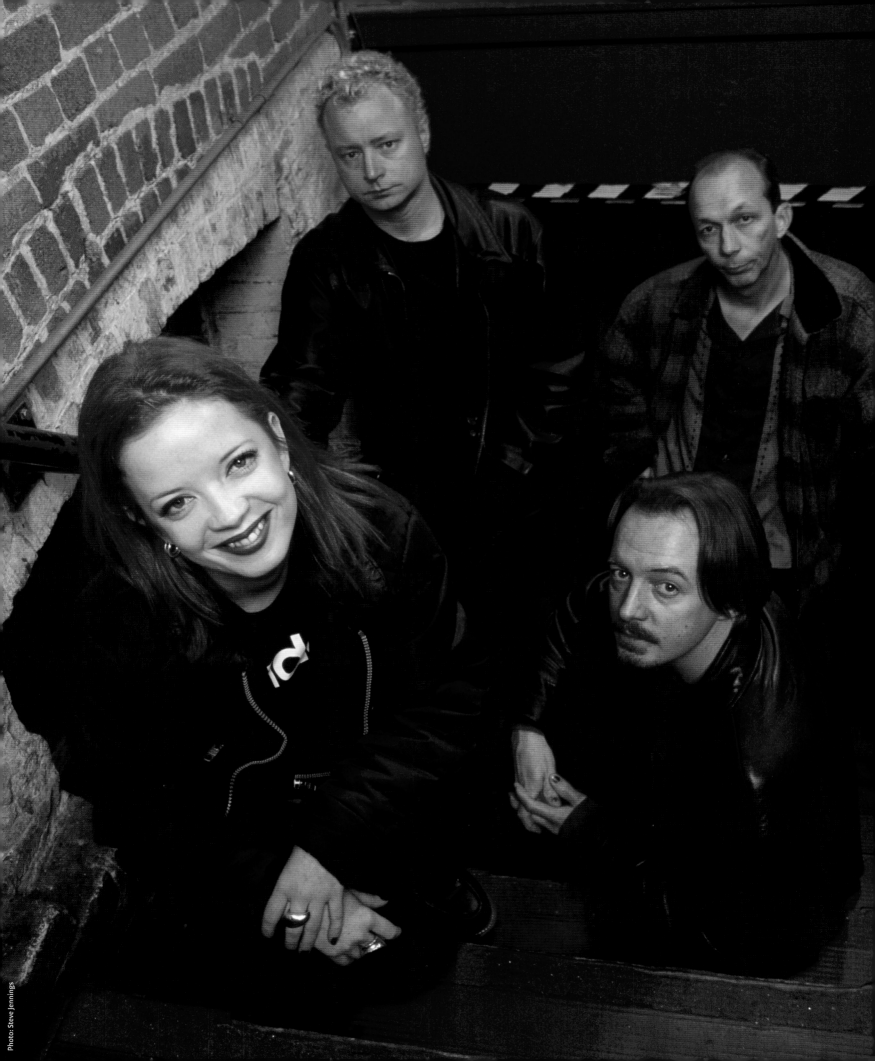

CHAPTER 3

"IF I WASN'T IN THIS BAND, I WOULD GO, 'YEAH, RIGHT, THREE PRODUCERS AND A GIRL.' BUT WE FOUND A CHEMISTRY THAT I DON'T THINK YOU CAN PREDETERMINE. IT WAS JUST ABSOLUTE LUCK."

—SHIRLEY MANSON, 1995

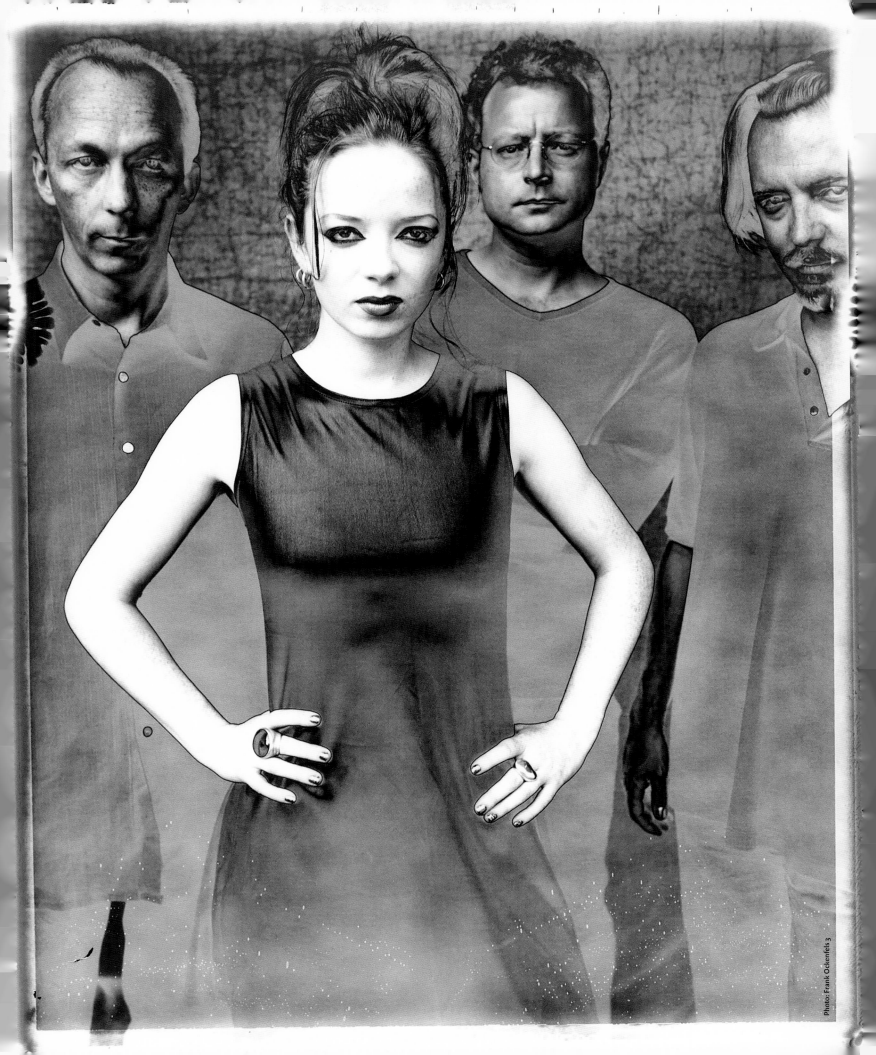

"No one will want to talk to you."

It was the band's first meeting with the publicity team at Geffen, the major-label handling marketing and distribution for Almo Sounds. After everything it took to get inside the room—the years hidden behind a keyboard in her first band, Goodbye Mr. Mackenzie; the false promise of Angelfish; the dodgy first Garbage audition; the shitty hotels and lonely months in Madison; the puking in between takes at the "Vow" shoot—Manson was invisible again.

Or at least that's how she felt. In Manson's mind, Jim Merlis, the Geffen PR man who'd previously worked with Nirvana and Sonic Youth, had basically said that when it came to selling Garbage, Butch Vig was the only member of the group that mattered.

"We were at Geffen and Jim Merlis sat me down and said, 'Now the press are not going to want to talk to you at all,'" says Manson. "'We'll try and get somebody to speak to you, but we can't guarantee it, so I just want you to be aware of that.' I said, 'Okay, okay.'"

Merlis, who would become an ally of the band for years, remembers the meeting differently. "There's two versions of the story," he says. "There's Shirley's version, which is they sat down, and I pointed to her and said, 'No one's going to care about you.' Then I pointed to Butch and said, 'We're gonna have to use Butch to sell this record.'

"That's not really what happened. What happened was, I said, 'Y'know, we've got this great asset in Butch; he will open up a lot of doors for us.' And it's so crazy because Shirley was really shy during the meeting. It was mostly a conversation between me and Butch, with the other guys nodding. The idea was always for Shirley to take the mantle eventually."

Merlis's postmeeting memo to the band and SOS summed up the label's strategy: *After meeting with the members of Garbage, I have a feel where the band wants the press campaign to go.*

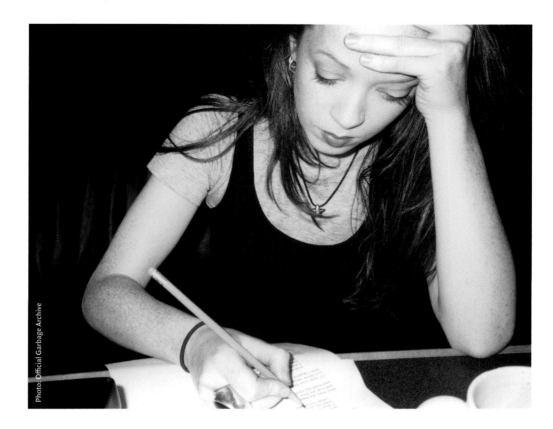

Photo: Official Garbage Archive

*Garbage wants to be perceived as a band, not as a Butch Vig side project. We all agreed that the press
without any direction would initially focus on Butch—but we will try to sway the press away from that
by having other band members (especially Shirley) do as many interviews and be the focus of as many
stories as possible.*

This wasn't an issue for long. When the record came out, every magazine in both the US
and the UK was interested. And Manson never failed to give them great material.

"This huge personality emerged," says Merlis. "She treats the interview as a performance,
and she knew how to do interviews better than anyone I've worked with. She's that good."

"I think I must have been putting on a bit of a show. I understood on a very base level that
being provocative did well," says Manson. One of her most famous interviews—given before
she even joined Garbage—involved her telling an anecdote about shitting in a bowl of her no-good
boyfriend's Corn Flakes.

ERIKSON: That was when I knew you were right for us.

MANSON: I always knew that would get a response one way or another. People would either
laugh or they'd be shocked.

The boys weren't actually excited to do press anyway. "They wanted to send out Chippendales
guys to take their place," says O'Shea.

X X X

As they prepared to first introduce the band to the world, Garbage and SOS exploited the con-
ceptual hook of "three producers and a girl." But the band also found itself pigeonholed by the
concept.

"The press never picked up on the fact that we were all musicians and had been playing in
other bands forever—that we had all been writing songs and making records," says Erikson.

"Three producers and a girl" also made it all sound manufactured, as if they were Svengalis
in a sound factory and Shirley was their latest sensation, a blank slate for their product. "People
thought that because we were producers we had masterminded this whole plan—plotted it all
out and then just got this chick to do what we told her," says Marker.

"If only," says Manson.

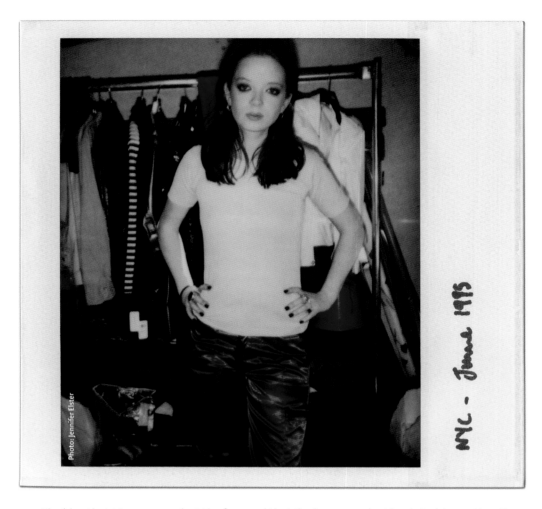

Photo: Jennifer Elster

NYC – January 1995

Left: a Polaroid captured by stylist Jennifer Elster during a fitting for the photo shoot for the debut album package; opposite: Vig behind the drum kit, sound-checking for one of 174 shows played in support of the first album; following page: this photo of the band against a deserted Wall Street streetscape was used as a gatefold image in the twentieth-anniversary reissue of the first album.

The idea that Manson was just the face and that the boys were just knob-twirlers rather than musicians was equally insulting to all of the band members. In truth, the way Garbage work together in the studio makes them an ideal band—it's not a Garbage song if all four members don't each leave some mark on it. Though Manson is the only singer and Vig the only live drummer, all of them produce, compose, and come up with musical ideas, with no strictly defined role or instrument.

But the marketing was also a backup plan. "SOS were just trying to get us work," Erikson says. "After the first record failed, we'd be producers again."

X X X

Although Manson initially deferred to the "three producers" when it came to shaping Garbage's sound, she put herself squarely in charge of the band's look. She began by selecting French photographer Stephane Sednaoui for the band's first photo session; the photos would be used for both album artwork and publicity stills.

"Shirley was the visual producer of Garbage," says Vig. "She had strong opinions about how we should look."

"Thank god for that!" says Marker.

The shoot with Sednaoui helped define that first record. "It's just a couple of photos, but you see a *band* because of the way it's shot and composed," says Vig. "Shirley's aesthetic—her sense of what Garbage could be like visually—was very important."

"Shirley made us dress the way our music sounded," adds Erikson. "She painted all of our fingernails black." They might have been midwesterners in jeans and flannel shirts, but they loved the same dark music Shirley loved, so dressing a little more the part was in order. Not that the Midwest was ready for it. "We would get shit. We would go into a gas station on tour and these rednecks would get on our case about it," says Vig.

X X X

FILL YOUR GLASS WITH GARBAGE
ROCK AND ROLL COCKTAIL RECIPES

MYERS AND TONIC

Along with the dark and stormy (dark rum, ginger beer, and lime), this was Manson's Wisconsin drink of choice, especially on the oppressive summer days Madison uses to balance out winter's bitter cold.

RECIPE
—*2 oz. dark rum*
—*Pour over ice*
—*Fill rest of glass with tonic*
—*Garnish with a lime*

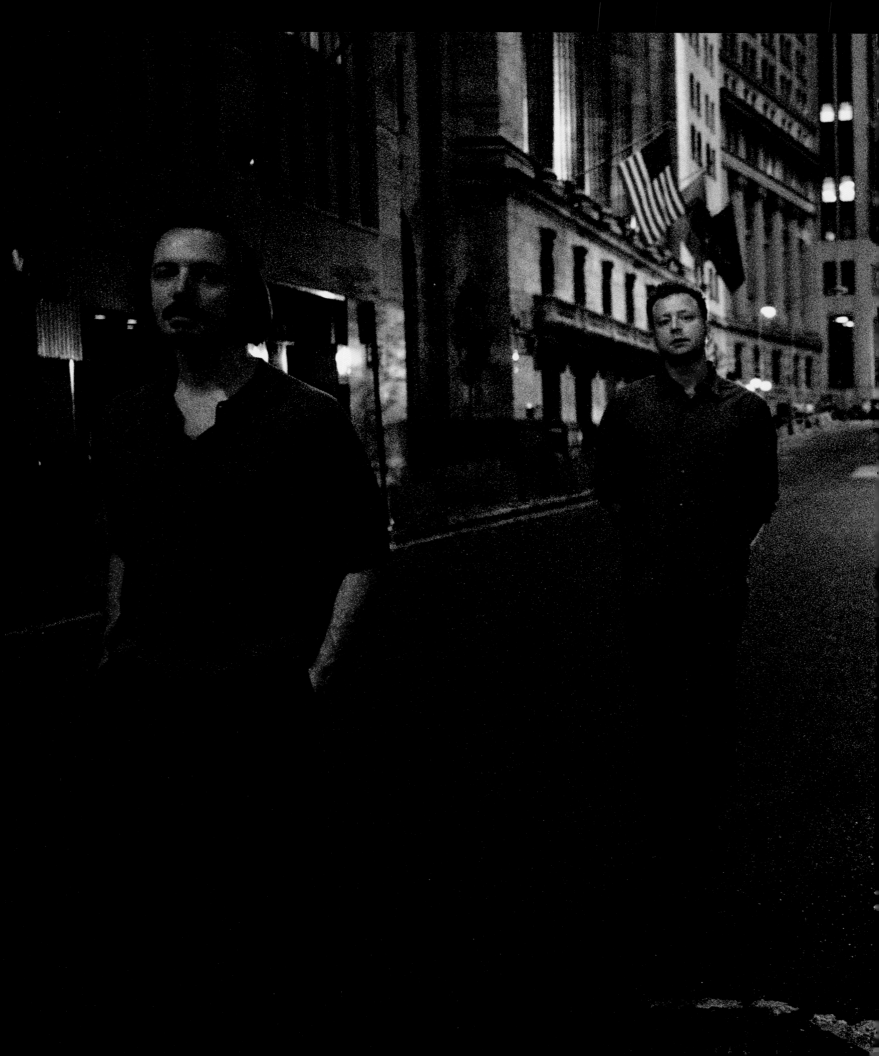

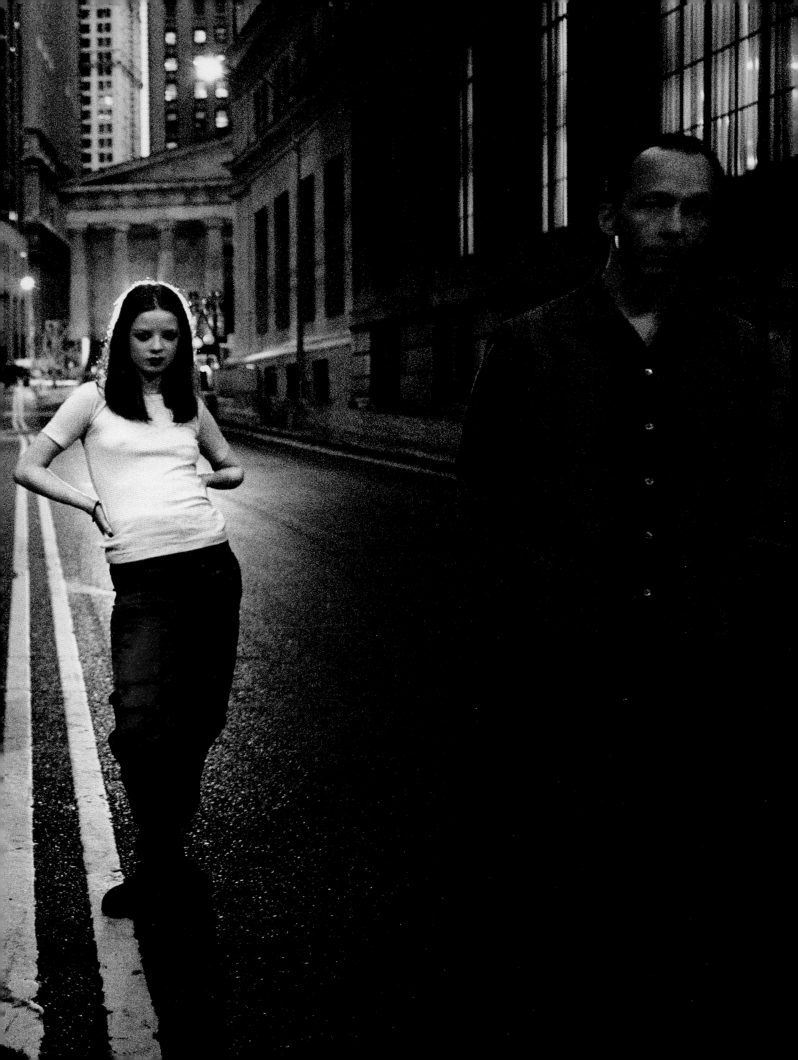

The debut album, *Garbage*, came out on August 15, 1995. The album was heralded with the single "Only Happy When It Rains" in the UK and "Vow" in the US, followed by "Queer." Critically acclaimed and beloved by radio, the album was still not an instant hit. It charted high in England (#12) and Australia (#5) the week of its release, but took four weeks to crack the US *Billboard* chart, debuting at an underwhelming #193.

Then, as now, bands have to tour to really make things happen. Making the "Vow" video revealed to the band the possibilities of performing live, but actually going on the road was still less than a sure thing. Even today, the band can't agree about who wanted to tour less.

ERIKSON: Shirley didn't want to tour.

MANSON: But neither did you lot!

VIG: It was going to be six weeks. I remember agreeing to six weeks.

MARKER: Shirley dreaded the idea of appearing onstage with these three total geeks who were ten, fifteen years her senior.

MANSON: That speaks to my own immaturity, but the age difference to me at that time was vast in my mind.

On November 6, 1995, the band made their public live debut at 7th St Entry in Minneapolis. Daniel Shulman, who'd been hired to play bass on the road, remembers looking outside from the tour bus to see a huge line.

"I was like, *Oh my god, how do this many people know about Garbage?* And they looked really tough, all wearing chains and leather and tattoos," says Shulman. "Then I looked up at the marquee and it said, *GWAR.*" The horror-rock band was headlining the adjacent (and much larger) First Avenue club.

Manson's role as frontperson wasn't one she took to immediately. "We weren't very good on the first tour, really," says Vig. "A lot of shows Shirley would get sort of freaked out and just stand at the mic."

Manson was still working toward owning her position. "On the first tour, I genuinely didn't believe I belonged there or that anyone would take me seriously as the frontperson of a band. I was just petrified. I didn't speak because I felt so self-conscious. I felt really aware that I was representing the boys, and I didn't want to piss them off or say anything that wasn't sanctioned by them. I felt so grateful to have been given the opportunity, I thought that I should just shut up."

But Garbage relied on technology as part of their sound, which meant the band was prone to technical glitches. When that happened, Manson had no choice but to start speaking. The boys were shy; when a show was interrupted by technical difficulties, they would smoke cigarettes on the side of the stage while waiting for it all to be fixed.

That left Manson as the ringmaster, the only one onstage with a microphone, and the one who had to entertain the crowd through the awkward silences. "So the beast that they have is the beast that they made," she says. "Looking at it now, I'm like, *Yeah, I was kind of cool.* Why was I so racked with self-doubt? I really don't feel inhibited when I'm onstage anymore. I feel more inhibited walking into a supermarket."

Playing live was complicated by the band's reliance on MIDI, sampling, and—now it can be told—backing tracks. Back then, that sort of thing was for disco and hip-hop, not rock and roll. "That's why I was so reluctant to go on tour with Garbage," says Vig. "All of the bands that I produced that were successful were rock bands."

"When we started, it was really weird what we were doing live," says Marker. "We worked like crazy to play everything, used MIDI guitars and regular guitars and keys and Butch's samplers, but there'd still be parts missing. Now it's standard to use sequenced tracks to play along with to fill in the gaps. We had to be so secretive about that because if anybody found out, we would have been exposed as charlatans."

ERIKSON: Butch and I were sitting in the Barrymore Theatre in Madison once, and a local journalist was interviewing us, and they were running the backing tapes on the stage and he goes, "What are those keyboards?" And I go, "Oh, they're just checking the MIDI for my pedals in the back, you know, and that's my MIDI guitar." We lied about that for, you know—

Photo: Official Garbage Archive

Above: Steve gets some couch time backstage; opposite: Daniel Shulman's resemblance to Adam Sandler was positively uncanny, as proved by a midnineties photo of him standing next to Sandler's dressing room—case closed.

MR. BASSMAN

HOW DANIEL SHULMAN BECAME THE GROOVE MAN—
AND CONFESSOR—FOR GARBAGE

Photo: Official Garbage Archive

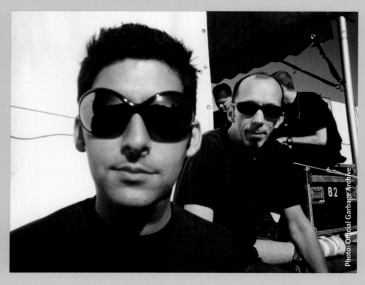

Photo: Official Garbage Archive

Photo: Official Garbage Archive

Before Garbage could tour, they needed to hire a bass player. The challenge wasn't finding someone who could play, it was finding someone who could hang.

"You're only onstage for an hour—maybe an hour and a half—every night," says Vig. "What are you going to do the other twenty-three hours of a day? You want someone who is easy to hang with."

Daniel Shulman became Garbage's bass player on that first tour, and then for the next seven years. Though nearly not—Manson rejected him on first sight.

"We were sitting there and Daniel comes ambling in," says Vig.

"I was like, 'Absolutely no way,'" says Manson. "He looked terribly serious in his long black winter coat, probably because he thought too much about his appearance."

"Shirley goes, 'I'm gonna leave right now. He can't be in the band!'" says Vig. "And then he sat down and we talked for, like, one minute."

"He went to the bathroom and then I was like, 'I was wrong. He's perfect,'" says Manson.

Having passed the personality test, Shulman crushed the musical-talent portion of his audition, including the groove of "Stupid Girl."

"All the other bass players struggled with that riff because it has an R&B feel to it. He nailed it immediately," says Erikson.

There was a good reason for that: Shulman was immersed in the hip-hop world through his half brother, Lyor Cohen, who was then Russell Simmons's partner in Def Jam. In 1986, while still a teenager, Shulman played on Run DMC's *Raising Hell*. He was also the bassist on Warren G's *Regulate . . . G Funk Era*.

Shulman gave Vig a cassette of some hip-hop recordings he'd been working on, unsure that his experience would be a plus. "I was like, 'I play rock music too,'" Shulman recalls. Of course, since Garbage had been inspired by hip-hop aesthetics, his background made him perfect. He signed on for six weeks of touring, which turned into a year and a half, which turned into seven years with the band.

"I seriously doubt we would have been able to tour for as long as we did without Daniel being part of the equation," says Manson. "He brought a much-needed sense of fun into our lives. He was goofy and laid-back but also well read and strikingly intelligent—a great tour bus conversationalist. He seemed to be able to run with the pack without causing any of us a minute of concern or heartache."

But running with the pack was an acquired skill for Shulman. They were drinkers, and he was basically a teetotaler—at first. "Slowly but surely my drinking increased," he says. "I have no idea how they did it, because I was ten years younger than them and it took an extreme toll on my body. I thought it was the lack of sleep and the travel, and then before *Version 2.0*, during rehearsal I was like, *Why does my body have that beat-up, on-tour feeling? Oh! I'm hungover. That's what this is*."

His one attempt to match the boys round for round, during a long afternoon in New Orleans, did not go well for anyone. "We had to keep going because he was keeping up with us," says Erikson. "We were like the old pros, y'know? We drank so much and so long that we were nearly late for the show. Then we showed up and played."

Manson disputes this last point: "Playing was not part of it! But there was a show, and there was something like music. "We were just plastered by the time we went onstage," says Shulman. "And the crew afterward was just like, 'Who are you guys and what did you do with the band?' We were just awful."

After the *Beautiful Garbage* tour finished in December 2002, Shulman transitioned to the other side of the music business, doing A&R for Island Def Jam. But it was a time of upheaval in the shrinking world of major labels. "You picked the worst time to get into this," his boss told him. "It used to be fun."

"Going to see bands, working with bands, that part was great," says Shulman. "All of the rest—the business side of it—wasn't my natural strength."

Now a therapist in the Los Angeles area, Shulman has occasionally reconnected with Garbage for recording and live shows. His current profession isn't surprising to Manson: "He's an incredible communicator, really gentle and empathetic. He just seemed to be able to cool our waters in some strange way. He was kind of like our priest."

MARKER: Years. We still catch ourselves lying about it.

ERIKSON: It was total bullshit. But he seemed to buy it so we just continued to go with that in every interview thereafter. You know, "Why am I hearing a keyboard when I don't see anybody playing keyboard?" "Well, that's Butch, he's up there triggering samples with his feet."

MANSON: Nobody gives a fuck anymore. We got so slagged off for it but it went on to become almost the template for how many bands approach playing live now.

ERIKSON: That first record, learning how to pull that off live was really fairly comical. We had numerous train wrecks. The technology then was so archaic.

SHULMAN: During "Milk," Shirley would often come in at the wrong place for the first verse. Because the tracks were set, we couldn't adjust. We would all try to stay with the track, but then it would be impossible to ignore what she was singing, so we would start again. Shirley made people feel good about it. She would go, "I apologize—that might not have been the best, but remember, you are always our first."

<p style="text-align:center">X X X</p>

The crowds quickly warmed up to the band's power and ramshackle charm, though they almost didn't get the chance. The fourth show of the tour was at Cabaret Metro in Chicago, the same venue where the boys had seen Manson play with Angelfish in the spring of 1994. Almo was not convinced by the band's performance. "Somebody at the label came up to me and said, 'We're going to pull the tour,'" O'Shea says. "I was like, 'Trust me, it's going to be fine.' And then after that, it kicked in. They started getting tremendous reviews."

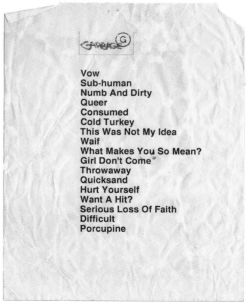

GARBAGE Ⓖ

Vow
Sub-human
Numb And Dirty
Queer
Consumed
Cold Turkey
This Was Not My Idea
Waif
What Makes You So Mean?
Girl Don't Come
Throwaway
Quicksand
Hurt Yourself
Want A Hit?
Serious Loss Of Faith
Difficult
Porcupine

Above (top): an empty stage post–sound check, preshow, in 1996; above (bottom): an early set list; opposite: a contact sheet of Manson onstage at Brixton Academy, March 24, 1996.

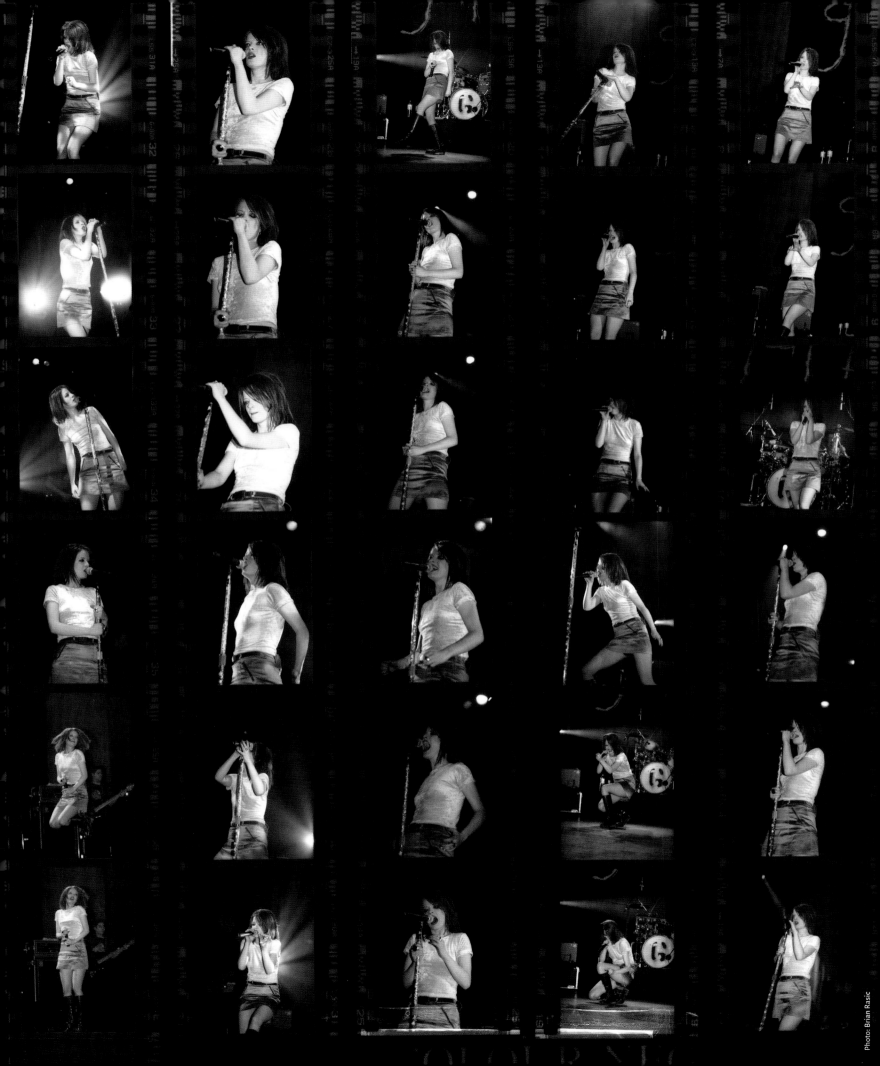

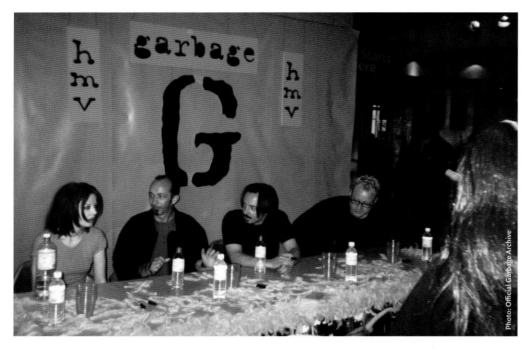

Photo: Official Garbage Archive

Indeed, the live shows went well enough that it quickly became clear that the first six weeks would turn into more dates. The band's original road manager, Bill Rahmy, couldn't stick around because he had already been booked to work a Smashing Pumpkins tour. His replacement was Harald Kohl, a veteran of tours with Queensrÿche and Metallica.

"First thing, I stick my foot in my mouth because I've never worked with a female artist," says Kohl. "I'm like, 'Oh, hi, Shirley Girly.' She instantly took offense, so *boom!* I start off perfectly."

At this point, the band was still trying to decide how large a part touring would play. "We didn't bring sound or lights or anything significant at all," says Kohl. "It was really just about taking it to the point and trying to see if this would fly."

Kohl also introduced a key member of the road crew in Billy Bush, who'd worked with him for Metallica (and also with Hole and Suicidal Tendencies). Initially just Erikson's guitar and keyboard tech, Bush eventually became a one-man technical support for the whole band—the rock and roll IT department, troubleshooting the electronics and figuring out how to better integrate the sampling and technology.

The band's first dates in the UK were also pivotal. The UK press in particular had a way of getting under Manson's skin, partly because that was her home territory. "My memory of the first record, strangely enough, is all we got was negative reviews. Looking back now, I realize that was not the case, but that's how it felt to me: whenever I was in the UK I felt beat at home," says Manson. "I came to every show with a bad attitude."

Her band members say that even to this day, Manson feels more pressure when performing in the UK. "I think every tour we went on—and I still notice it—Shirl gets a little uptight whenever we're in the UK," says Erikson. "She's quieter and more contemplative backstage."

It wasn't just returning to her homeland that made the UK shows more consequential for Manson; it was knowing that her family and friends were coming to see *her*. "It's always more nerve-racking doing shows like that, when you have people you know," says Vig.

"Some nights Shirley would go out and not move," says Marker. "She'd be blinded by the lights and not even look at other band members, let alone engage with the crowd."

"She sort of did this thing in the beginning where she would either stand there and sing or she would walk in a circle," says Shulman.

Until, that is, Manson found her inner lead singer. According to Bob Bortnick, it happened at a show in Nottingham. "I saw her backstage and she was visibly upset, and Shirley was always kind of bulletproof. There was some guy there who wrote for *NME* and *Melody Maker*, and this guy just wrote one scathing review after another. She was crying and I sat down next to her and said, 'What's the matter?'"

Manson showed Bortnick an article in which the writer compared her to the singer of the Red Hot Chili Peppers, referring to her as, *Anthony Kiedis with smaller tits*. She looked at Bortnick and said, "You know, I don't give a fuck what these people say, but my mom reads this, you

Above left: **Garbage at an HMV in-store appearance and signing session; above right: an early hospitality rider; opposite top: this group photo is enhanced by a banana, which Manson is holding; opposite bottom left: Erikson in recovery mode, aided by Manson's feather boa and a Corona; opposite bottom right: the band backstage during their first tour, with Erikson documenting the moment on video.**

Photo: Cindy Kahn

Photo: Official Garbage Archive

Photo: Official Garbage Archive

Photo: Cindy Kahn

know? My sister." Afterward, Manson went onstage and seemed subdued, but halfway through, something changed.

"Midset, Shirley changed from the queerest of the queer to Queen Helen," says Bortnick. "It was unbelievable. She started stalking the stage. And from that moment on, the bravado just became massive."

The tour eventually took the band to Manson's home country of Scotland. When they pulled into Glasgow, Manson lay awake on the bus, unable to sleep. "You've got to remember, I've played in bands for over a decade in somewhat miserable circumstances, sleeping in the back of a transit van," she says. "I was in a corporate bus for the first time, so to roll into town with a big touring bus—I remember just going, *Oh my god, I'm going home and I'm going home a victor. I'm not going home a loser.*"

The boys went all out for their singer's home-country crowd, changing into kilts for the encore. "We were like, 'Will they be insulted if we wear kilts?'" says Vig. "Shirley was quite confident that the crowd would love it."

"It was like taking your boyfriend back to meet your mum, you know? I was proud of them. I remember being really aware of our cultural differences, and it made me laugh."

She knew the local girl would be welcomed back warmly, and she wasn't disappointed.

"Scots have always been good about that," says Manson. "They'll be loyal to you. They were without a doubt the best crowd on that tour. I had high expectations, and they far exceeded my expectations. They went fucking mental."

<p style="text-align:center">X X X</p>

By the end of 1995, *Garbage* had gone gold in the UK. By the following April, "Only Happy When It Rains" was an American radio smash hit. The album went gold in the United States, and the band graduated from clubs to theaters. By July, thanks to the single "Stupid Girl," *Garbage* was platinum, hitting a *Billboard* peak of #20.

Above: the boys postshow, back-stage in Glasgow Barrowlands, Scotland, March 21, 1996; opposite right: Manson displays her pride in the Scottish dental care system.

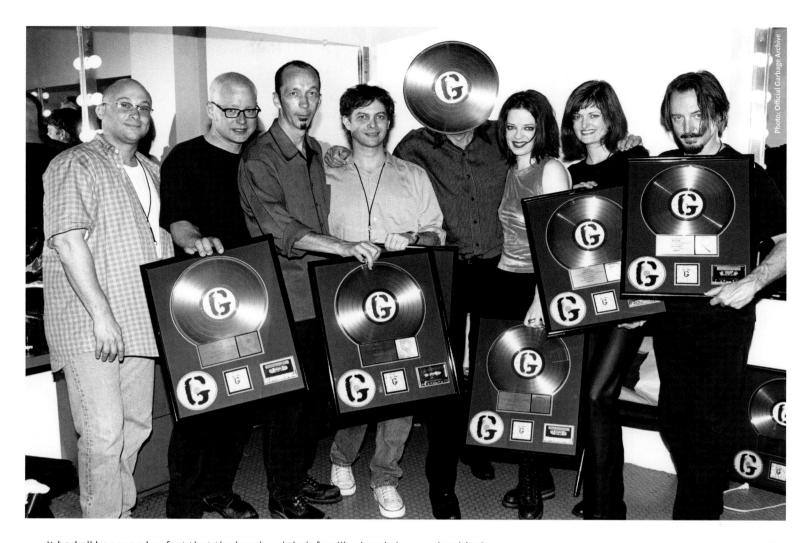

Above: the band receives their **US gold records for the debut album, Los Angeles, 1996.** Pictured from left: **Paul Kremen, Marker, Erikson, Bob Bortnick, unidentified person, Manson, Shannon O'Shea, Vig.** Opposite top: **Garbage onstage at RFK Stadium in Washington, DC, for the HFStival, June 1, 1996;** opposite bottom: **Garbage take a ride on a boat, Sweden, 1996.**

It had all happened so fast that the band and their families barely knew what hit them. Manson's relationship with her boyfriend, artist Eddie Farrell, had been long-distance since the project started, but the boys had not expected to spend so much time away from home. Marker's wife, Cindy Kahn, loved being part of the band's journey—when Garbage was actually home, she and Manson would sit around handmaking T-shirts and answering fan mail. But the band's rapid rise and the touring schedule were challenging. Kahn says, "I'd moved from Chicago [in 1993] to be with Steve and left all my friends and—*boom!*—he was gone."

It was the same for Vig's then-girlfriend, Beth Halper, who did A&R for DreamWorks Records and was expecting to see lots of her producer boyfriend in Los Angeles instead of Madison. "I thought, *Okay, I can live with seven shows where you're not around,*" says Halper, referring to Vig's first prediction of how many shows Garbage intended to play.

Instead, the band went on to play more than 170 shows, including several months of dates opening for the Smashing Pumpkins on the *Mellon Collie and the Infinite Sadness* tour. Early on, the tour was marred by tragedy when Pumpkins keyboardist Jonathan Melvoin fatally overdosed on July 12, 1996, just before a Garbage/Pumpkins show at Madison Square Garden. That show and several others in July were cancelled to give the Pumpkins time to regroup. The tour restarted in the fall.

"I think they were excited to have us on the bill, but they were so dysfunctional as a band that they didn't really come and hang," says Vig. "But the Frogs did." The Milwaukee duo, whose keyboardist, Dennis Flemion, had replaced Melvoin, was third on the bill, and the fellow Wisconsinites bonded. "Every night we'd come into our dressing room and the Frogs would be waiting for us. They'd be drinking our beer and eating our potato chips," says Vig.

"Every night," says Marker.

In between segments of the Pumpkins tour, the band played the *Late Show with David Letterman*, an event that was monumental for the three Midwesterners, not just because they were all huge Letterman fans but also because of the pressures of taping a television

Photo: Bill Rock

Photo: Official Garbage Archive

CRUSH GROOVE

HOW SHAKESPEARE CONTRIBUTED TO ONE OF GARBAGE'S BIGGEST HITS

The best-selling Garbage song of all time was never on a Garbage album. The band left "#1 Crush" off their debut. It had come out as a B-side (to "Vow" in most of the world, and to "Subhuman" in the UK) before director Baz Luhrmann tapped it for his 1996 movie *Romeo + Juliet*.

The soundtrack for the Claire Danes and Leonardo DiCaprio vehicle, with "#1 Crush" as the opening track, debuted at #2 on the *Billboard* album chart in late October 1996. By the spring of 1997, the album had gone triple-platinum in the US, ultimately selling ten million worldwide.

"One of our many brilliant career decisions," Erikson says about dropping the song from Garbage's debut album. Accounts of why that happened differ. As Manson remembers it, they just didn't think it was that strong of a track. "The lyrics were a bit over the top," Erikson adds.

The label agreed with this assessment. Bob Bortnick says the song was slated for the album at one point, but label cofounder Jerry Moss objected. "Jerry called me and said, 'You gotta take that song off the record,'" says Bortnick. "I asked why. I can't say it was an obvious single, but I knew it was a good song. And he said, 'I'm not going to have some fifteen-year-old girl jumping off a bridge and leaving that as her suicide note.'" Although that's more or less what made the song successful once it ended up on the soundtrack to the most romanticized suicide ever.

The hit version of "#1 Crush" from the *Romeo + Juliet* soundtrack was not actually the original. Given the band's roots in remix culture, Garbage had been happy to have their songs remixed—Todd Terry had done house versions of "Stupid Girl," Adrian Sherwood did a dub version of "Queer," and in this case Soul II Soul's producer Nellee Hooper gave "#1 Crush" his own spin. Hooper, who also worked on the score for *Romeo + Juliet*, moved the drums up and started the track with an erotic vocal sample. "Adding the moans at the top gave the song something that our original version maybe didn't have enough of," says Erikson, "sex appeal!"

Hooper's remix also played down the guitars. "I said, 'There's no way this will ever get any play on alternative radio,'" recalls Erikson. "Boy, was I wrong. It was massive at radio." The *Romeo + Juliet* soundtrack was on Capitol, and the promo guy working the album was desperate for Garbage to make a video for "#1 Crush." But Almo was concerned it would compete with the next single from Garbage's debut.

Video or not, this was correct. The band released "Milk" as the final single and video from *Garbage* in early October, about a month before *Romeo + Juliet* came out. The band's previous single, "Stupid Girl," had gone to #2 on the *Billboard* modern rock chart, and reached #24 on Hot 100. But it was "#1 Crush" that built on this momentum, spending four weeks atop the modern rock chart, while "Milk" never even charted.

"Turns out they didn't need a video," says Erikson.

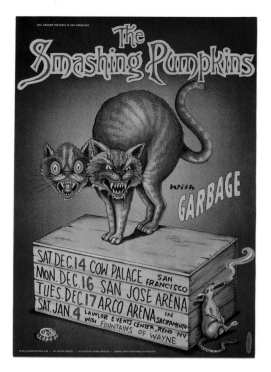

Above: a locally generated poster from the Smashing Pumpkins/Garbage tour; opposite: Marker on the set of the "Only Happy When It Rains" video.

performance. "That's probably about the most scared I've ever been," says Marker. "It's live to tape, so you don't get to do multiple takes. It's just nauseating."

"You have all day to think about how you cannot fuck up," says Erikson. Manson, though, being unfamiliar with the American television institution, was much less anxious.

The band then took off on their own to play the European festival circuit, including a triumphant main stage set at the Reading Festival in the UK. They were drawing bigger and bigger crowds. "When we went to Europe, it was really shocking—much larger venues, much larger crowds," says Kohl. "It was very exciting to work for a band that was on a rocket-up trajectory. I'd never experienced that, and maybe very few people ever do."

After the festival dates wrapped in August, there was a break of a few weeks. Manson and Farrell took advantage of the time off and got married in Scotland—then it was back to work for Manson. The touring moved on to headlining shows in Asia, starting with a gig at the end of September in Singapore. Given the rules provided by the venue—no cigarettes or chewing gum, don't swear onstage—the band was expecting a reserved crowd. "We were told that the crowds were just going to sit in their seats and not do anything, but they would applaud afterward," says Marker.

That turned out not to be the case. As the band drove up to the venue, fans lined the road, beating on the vehicle. "It was fucking crazy," says Vig. "It was Beatlemania—very weird for us to have that kind of frenzied attention. We didn't even know we were getting any airplay in Singapore."

It was a far cry from the polite applause they'd been told to expect. "They screamed the whole time," says Marker. "High-pitched, shrill screaming *the whole time*. One girl screaming made another girl scream. It was just that chain reaction."

The band picked back up with the Pumpkins in October, taking a night to headline the Beacon Theatre in New York. It was one of the few times that Manson, rather than the boys, fell victim to the party—and not in a fun way.

"That was a disaster show," says Marker.

"D'arcy [bassist for the Smashing Pumpkins] came and hung out with Shirley because they were trying to bond or whatever," says Erikson. "D'arcy gave Shirley a Valium and then they drank a bottle of champagne." Manson proceeded to break down during the performance. "There would be these long breaks where she would just stop and cry for like five minutes," Erikson adds.

It was one of the rare times when Manson wasn't the most sober person onstage. "I was so high," she says. "So wasted on Valium and vodka and god knows what else with my darling friend that I painted almost my entire face with silver glitter before the show, and I went onstage. It was one of those horrible situations where you're looking at the audience and I felt like the band were literally a mile behind me." But while the band considered the show a catastrophe, it was still well-reviewed.

Less than a week later, Garbage flew to London with the Pumpkins to play "Milk" at the 1996 MTV Europe Music Awards. Since they had a show scheduled in Tampa the night after the awards, the Pumpkins decided to charter the official Chicago Bulls jet, equipped with a bar and sleeping cabins.

"Billy Corgan's a huge Chicago sports fan," says Vig. "He goes, 'If we get the Bulls jet, I'll do it.' But we split the cost. We sort of got the bad end of that deal, because it was not cheap."

"But we had a lot more drinks than they did," adds Marker.

Manson, who usually didn't get to do the after-show partying because it would wear on her voice, remembers the night vividly: "We all hung out, took pictures, and it was a proper *Almost Famous* moment, you know? The plane literally had rooms in it and beds. Full beds— proper beds behind doors with windows, almost like real railway carriages. I mean it was un-fucking-believable."

So after finishing a show in Chapel Hill, North Carolina, both bands flew to London, played the awards, and flew back to play the Tampa show the following night. "That was about the tail end of the record industry where they would go, 'You know, this is worth about a hundred grand to send these guys over to play one song,'" says Marker.

"One song on MTV," says Vig. "Garbage played one song, the Pumpkins played one song, and we got on the plane and flew back."

The band won the award for Breakthrough Artist, beating out the Cardigans, the Fugees, Pulp, and Skunk Anansie. U2's Larry Mullen Jr. and Adam Clayton presented them with the award. When they went up to accept, Manson said, "Thanks very much. Thanks to our record company, and thanks to all our fans around the world. Cheers."

Photo: Official Garbage Archive

Later, Corgan would take her to task for her brevity. "Billy Corgan, on the way home, was giving me shit," explains Manson, "saying, 'This is your one moment—you've got to milk it, you know, everyone will forget you. You didn't use your time or your space.' And I remember thinking, *Oh my god, I've really fucked up here.*"

The band knew they'd really made it when, after the awards show, they were visiting the crosswalk immortalized by the Beatles on the cover of *Abbey Road* and suddenly heard someone yelling, "Garbage! Garbage!" They looked up to see designer Jean Paul Gaultier, who had been a presenter at the awards, leaning out of a car.

"Shirley goes, 'Look, it's Jean Paul Gaultier!'" says Erikson. "And we're like, 'What? Okay.'"

Garbage was officially hot. They finished out 1996 with the Pumpkins, as well as with appearances on a handful of radio shows and at concerts like KROQ's Jingle Ball. Six weeks had turned into more than a year. The band had played over 170 shows, and spent most of the days they weren't onstage shooting videos or doing press.

No one had time to reflect until the tour was over. "I remember getting dropped off at the hotel in Los Angeles," says Vig. "I put my suitcase in the cab and just sat there going, *What the fuck did we just do?* Because we had no intention of ever touring, much less doing 170 shows."

Above: Manson and Smashing Pumpkins's guitarist James Iha on tour, 1996; opposite: a Sednaoui photo from 1995 turns the boys into mysterious shadow figures looming behind Manson; following pages, left: let it be known through all the land that March 14, 1996, was officially Garbage Day in Madison, Wisconsin, as this mayoral proclamation attests; right: Garbage in 1995—note Vig's nail polish, which was part of Manson's push to have the band dress the way the music sounded.

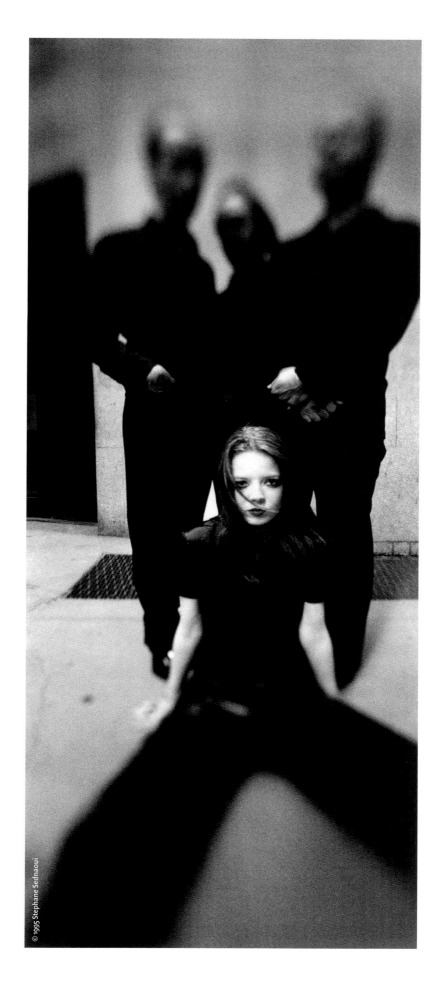

Mayoral Proclamation • City of Madison, Wisconsin

WHEREAS, Madisonians Butch Vig, Duke Erikson and Steve Marker joined with Scotland native Shirley Manson to form the band GARBAGE in 1994; and

WHEREAS, in the short time since then, GARBAGE has established an international reputation, with its debut album selling over half a million copies worldwide; and

WHEREAS, GARBAGE's concert tours have taken them to London, Brussels, Amsterdam, Berlin, Frankfurt, Hamburg and Paris, in addition to all of the major cities in the United States; and

WHEREAS, in 1995 they appeared on the BBC television show "Top of the Pops" as the hippest new act from the U.S.; and

WHEREAS, in their travels the band members are proud to advertise their Madison roots in all interviews; and

WHEREAS, following their homecoming show on March 14 at the Barrymore Theater in Madison, GARBAGE will embark on another European tour;

NOW, THEREFORE, BE IT RESOLVED, that the mayor of the city of Madison does hereby proclaim Thursday, March 14, 1996,

"GARBAGE DAY"

in Madison, Wisconsin.

Paul R. Soglin, Mayor

Signed and dated this 13th day of
March, 1996, at City Hall.

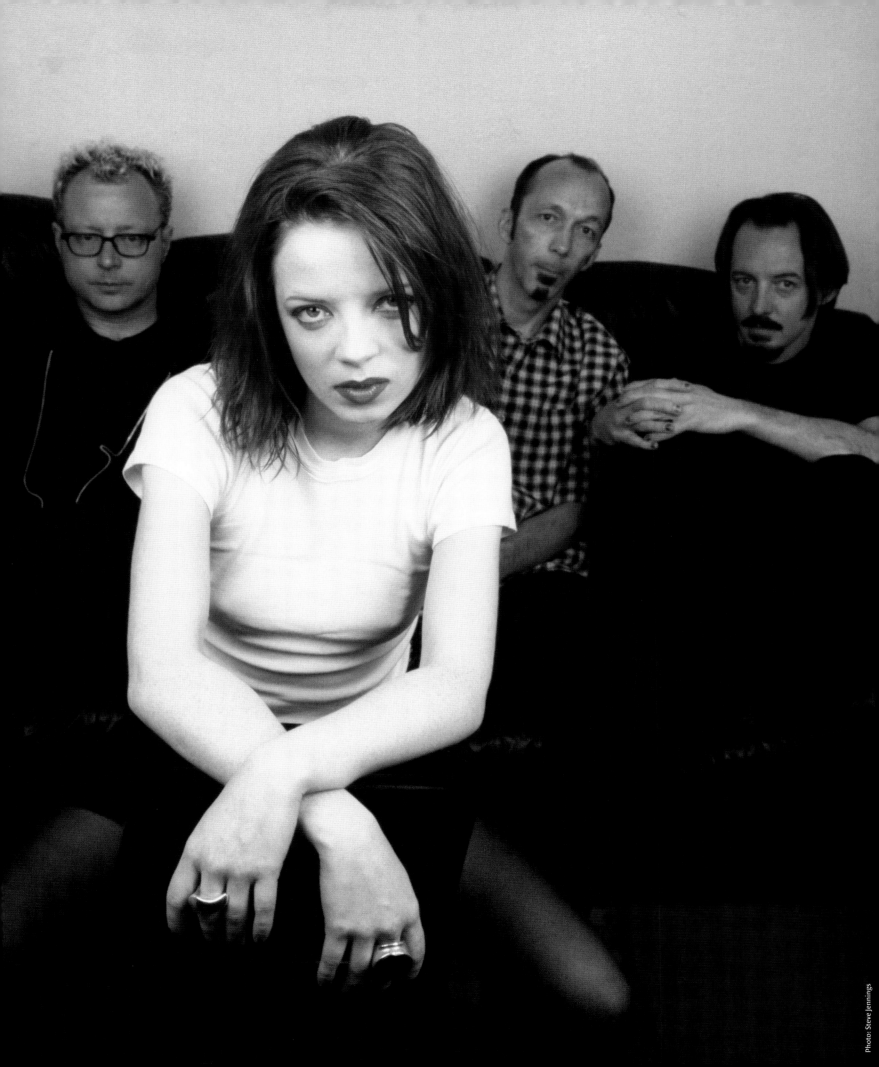

"THE SECOND ALBUM, WE WEREN'T JUST THIS IDEA. WE WERE ACTUALLY A BAND."

—STEVE MARKER

NATIONAL ACADEMY OF RECORDING ARTS & SCIENCES®

presents this certificate to

Garbage

in recognition of your Nomination for

Album Of The Year

"Version 2.0"

GRAMMY® Awards Year 1998

MICHAEL GREENE
National President/CEO

PHIL RAMONE
Chairman of the Board

Butch Vig was in the middle of the San Juan Island forest wearing nothing but a towel, steam wafting off his body, his skin as boiled and red as a Dungeness crab. The second Garbage album was now underway.

There had been no victory lap for Garbage after the first record—neither figuratively, as the band took next to no time off, nor literally, as they lost to fourteen-year-old LeAnn Rimes for Best New Artist at the 1997 Grammy Awards. "It wasn't something that was on our radar to even get nominated," Vig says.

"It was quite fun because we'd never been to the Grammys," says Manson, though she admits that losing stung a little bit. "I hate to say it, but every time you think, *Well, why not us?* There's always hope—until that moment when it's dashed. And then you sort of hate yourself, because you don't want to believe in all that nonsense in the first place."

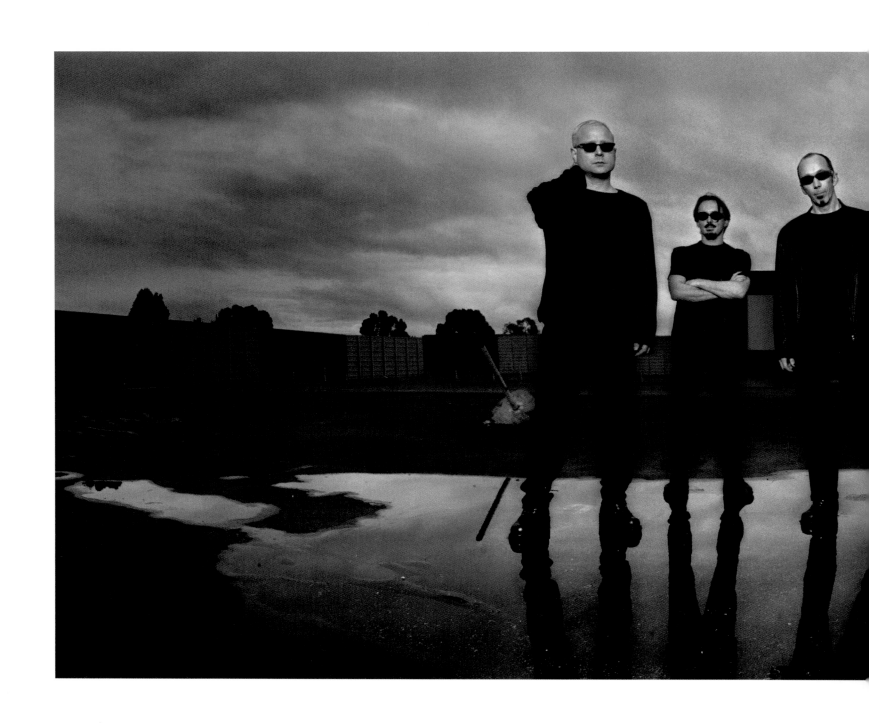

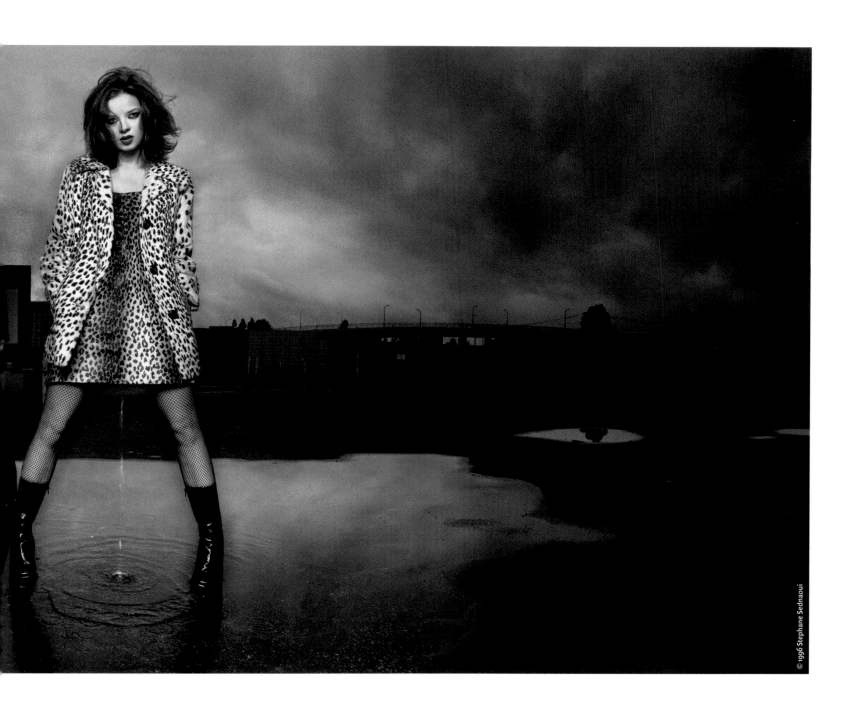

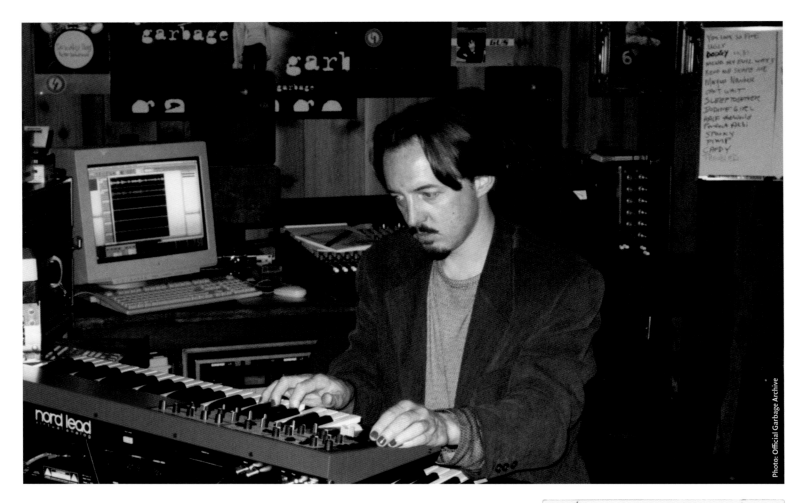

Even so, it actually *was* an honor just to be nominated—the perfect exclamation point on the first record, and a burst of motivation to begin work on the second. The band's visibility was higher than ever. They were invited to perform "Stupid Girl," which had been nominated for Best Rock Song and Best Performance by a Duo or Group, at the Grammys, which were held at Madison Square Garden.

"I would rather play on the Grammys than win anything," says O'Shea, who also notes that—befitting a band that's so particular about sound—Garbage brought their own crew to the Garden. "They sounded great, and everybody else sounded pretty crappy."

Manson wore Versace to the event, pairing her dress with sneakers for the after-parties. It was the beginning of a beautiful friendship between the singer and the fashion industry.

MANSON: Gianni Versace was the first premier designer to reach out and say, "We'd like to dress you." I got to go to their big flagship store in London and pick anything I wanted, which was really exciting and amazing.

VIG: We were lucky, because all the fashion people wanted Shirley. Honestly, at the start I didn't even know some of the designers. I was wearing red flannel shirts with a black vest and jeans.

O'SHEA: We did a deal with, I think, Tommy Hilfiger. They were going to give them suits. And then on the way to their fitting they passed Paul Smith and went in there.

VIG: I still have my Paul Smith suit. And a Calvin Klein one.

MANSON: There was a picture of me taken at the Grammys that came out in *Rolling Stone* a week later, and it was the first time that I realized I'd put on a lot of weight since the record took off. I always think of that as my fat period.

VOGUE

Dear Shirley,
 As you know, Vogue love you! We are looking forward to featuring you as one of the influential stylemakers of the 90s. We hope that you

will be able to give us dates in September for the shoot. If you have any questions about the shoot or anything we ca do for you while you're here in the city (restaurants, clubs, etc) please feel free to call
Best

X X X

Above: Manson in the Friday Harbor home of label boss Jerry Moss, on San Juan Island in the Pacific Northwest, where recording for the second album began; opposite, above: Butch on keyboards at Friday Harbor while working on *Version 2.0*; below: a note from American *Vogue* recognizing Manson as "one of the influential stylemakers of the '90s" (you're welcome, '90s); previous pages: a Sednaoui shot of the band for *Spin* magazine. That's not Photoshopped—Manson was really taking a pee in this photo, but when *Spin* ran the picture, the pee was retouched out.

"I ADMIT THAT I FINALLY FELT LIKE A ROCK STAR. I WAS LIKE, *OH, THIS ISN'T GOING TO GO AWAY OVERNIGHT AFTER ALL. I WAS ABSOLUTELY LIVING THE DREAM.*"
—SHIRLEY MANSON

There was little hesitation about starting on the follow-up to *Garbage*. Everyone wanted to build on the momentum. The grueling tour schedule for the first album had cemented the band's chemistry, and gave Manson confidence in both her performing skills and the band's future. "When we made the first record I couldn't imagine ever being onstage with those boys. I really couldn't," she says. "And then by the time we came to make *Version 2.0*, they felt like blood brothers."

Everyone in Garbage had seen enough band ups and downs to know that when things are up, you keep going. "It was like, 'Fuck, let's get back to work,'" says Vig. They had only just broken even on the tour from the first record but had made money from album sales—the opposite of how the music industry works for most artists. Making another record as soon as possible was also a pragmatic business move.

"We were old enough and experienced enough to know that this kind of success doesn't happen very often," says Marker. "We could have easily taken more time off, but we knew that we had to take advantage of where we were at that point."

"We had been in bands that had failed so miserably before. There was definitely an urgency—we wanted to get it done," says Manson. Garbage was not a miserable failure. In fact, the band was the jewel in the crown for both Mushroom and Almo, and there was pressure to deliver a big second record. "That gives you glorious confidence in some regards because you're not vying with other bands for attention from your label," Manson says. "But we were a little terrified of failure as well."

Billy Bush remembers hearing from Vig a mere two days after the band and crew came off the road from the first tour. "Butch called me and was like, 'Let's do this, let's do this, let's do this.'"

"This" was not just getting back to work, but making a big technological transition. Garbage had made use of Pro Tools software on the first record, but Moore's Law (which says that chip speed and computer power double every two years) also applies to digital recording: both the software and the hardware had evolved during the band's time on the road.

"Butch said, 'Go find what the best new recording technology is, buy it, learn how to use it, and then come to the studio for two weeks and show me,'" says Bush. "And I was like . . . *No expense spared, buy the coolest thing to work with, and then go spend two weeks in the studio working with them? Sold!*"

Before they headed back to Smart Studios, the band took Jerry Moss up on an offer to write, demo, and woodshed at Moss's vacation home in Friday Harbor on San Juan Island, off the Washington coast between Seattle and Vancouver, Canada. The sprawling and spectacular spot, nestled in an archipelago, was a bit of an upgrade from Green Lake.

VIG: We were in this unbelievably gorgeous house. We'd get together in the afternoons and drink wine and play music.

MARKER: We set up in the game room. I remember I spent a lot of time sitting on the pool table playing guitar.

ERIKSON: We had guitars and amps and all that stuff amid the video games and the pool table and the ping-pong table.

BUSH: I set up a whole portable studio. Everybody takes it for granted that they can record anywhere now, but in those days it was like, "You're doing *what*? Why?"

VIG: The idea of jamming a song out was just so foreign to everybody.

MANSON: I wanted to die. I had never ever jammed in my life, ever. I didn't know what to do. Do I wait for them or was I supposed to lead? Steve and I in particular were crippled with nerves and self-doubt.

But the jam sessions did produce the beginnings of what would become "Push It," "I Think I'm Paranoid," "Hammering in My Head," "When I Grow Up," and "Wicked Ways."

"'Wicked Ways,' I remember that beat," says Vig. "We set the drums up in Jerry's dining room. Playing that same groove over and over."

"There was a good feeling for all those songs, just from the four of us playing together," adds Erikson.

"We got tiny little kernels of arguably the best songs on the record from those jamming sessions," says Manson.

The house also came with its own "hippie caretaker," who went by the name of Thaddeus, still remembered by the band years later for his "incredible tuna melts." Thaddeus built a fire every night, and the band would hang out listening to music and watching movies. Moss also suggested they experience the local Native American tribe's sweat lodge ceremony, which took place in a forest near the house. Vig, Erikson, and Bush were takers.

VIG: One of the most terrifyingly claustrophobic things I've ever done.

BUSH: You're in a tiny teepee with twenty other people, stripped to the underwear.

VIG: Or naked. They give you a towel.

BUSH: It's pitch black. You can't see anything. There are a whole bunch of half-naked hippies.

ERIKSON: But they all knew each other.

BUSH: And all of a sudden they started moaning and growling and it's pitch-black and super hot and you can't breathe.

ERIKSON: I was bending down, getting close to the moist earth so I could get some oxygen.

VIG: Me too! I had my head in the dirt going, *Oh my god, oh my god, just get me out of here.*

ERIKSON: You're supposed to take turns giving some kind of gratitudinal speech. It gets to Butch and he goes, "I just wanna get the hell out of here!"

VIG: I crawled out. And it was in the woods, pitch-black and cold. I'm completely naked, steam coming off my body. Two seconds later, Billy and Duke came crawling out.

ERIKSON: I was determined to make it. But when those guys left I felt like, *I don't know any of these people.*

VIG: We walk through the woods and we come in and Steve and Shirley were watching movies, and Steve went, "Oh my god!" We were beet red. Like someone had sunburned us from top to bottom.

X X X

Above: a Mushroom Records promotional condom for "Paranoid"; opposite top: Erikson, Marker, and Vig back home at Smart, where recording of the second album continued; below: Duke, Shirley, and Steve in the studio at Smart toward the end of recording *Version 2.0.*

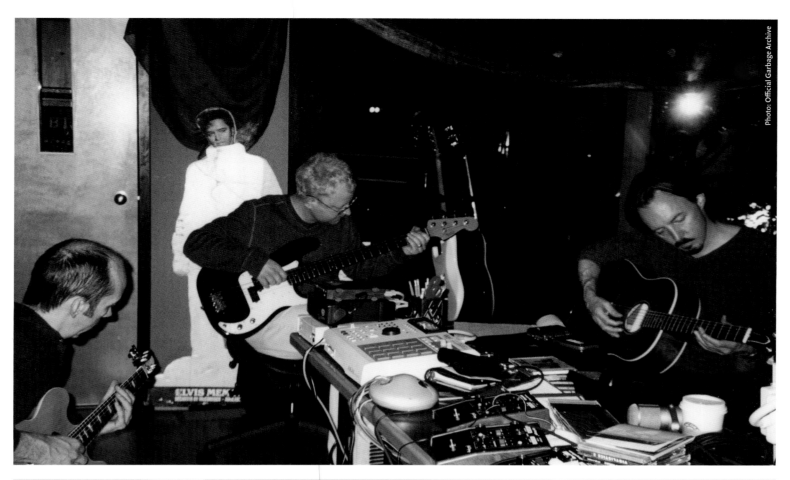

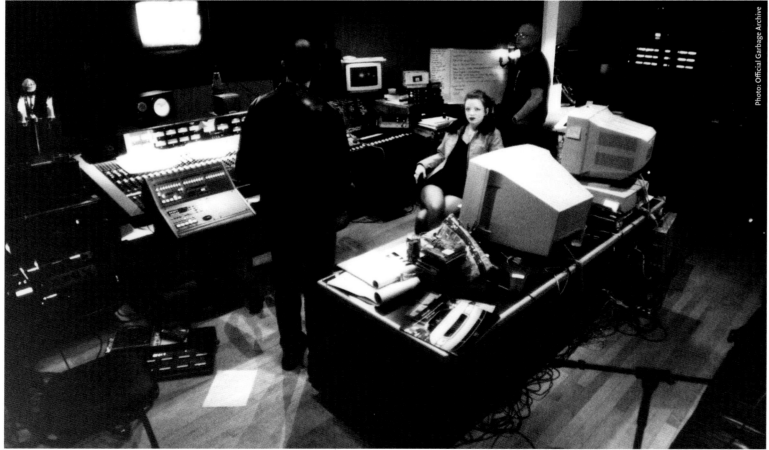

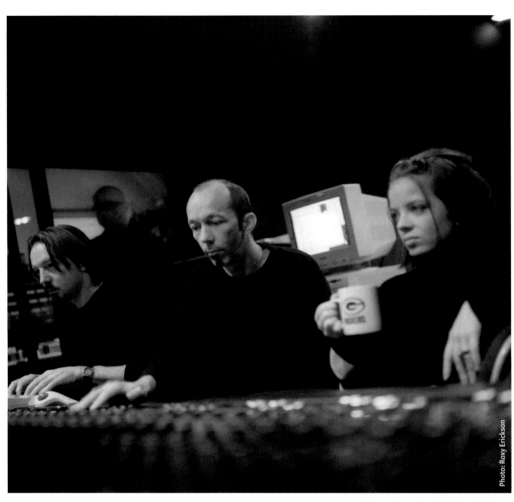

Photo: Roxy Erickson

Left: at the mixing board in Studio
B at Smart (note Manson's Packers
mug); above: a fax—signed by
Brian Wilson!—authorizing a sam-
ple of the Beach Boys's "Don't Worry
Baby" for "Push It"; opposite:
engineer Billy Bush upstairs at
Smart Studios.

Almo's Bob Bortnick, who'd played music himself in Dancing Hoods before transitioning to A&R, says he was hands-off with Garbage. With three producers and four strong opinions, they didn't need a fifth. "I remember at one point thinking that I wanted the second record to sound more different than it ultimately did."

The album's eventual name, *Version 2.0*, was not an accident. It symbolized refinement and advancement. *Garbage* depicted a band figuring out who they were and what they did. *Version 2.0* was the realization of that. "It's not like we made album one, part two," says Marker. "It was a different record. But we had learned a lot and there was new technology, and we didn't have to think about the funding this time."

By the time the band got back to Smart, Bush had a full-time job: two weeks was not nearly enough time for Vig, Erikson, and Marker—longtime analog veterans—to become Pro Tools experts. Plus, as with all hardware and software, things don't always work the way you want them to. Bush could offer tech support and more.

"Butch was like, 'You're going to engineer this record,'" Bush says. "'I'm going to teach you everything you need to know about recording, and you're going to teach us everything we need to know about working with this thing.' Pretty good deal."

According to Shulman, Vig was a slightly tougher negotiator than that: "He said, 'You're going to get credit for engineering this record. It's going to sound amazing, and you're going to get a lot of job offers after this. But you still have to go on the next tour with us as guitar tech.'"

The first record was recorded onto forty-eight-track analog tape. "But other than maybe some live tracking for drums, guitars, and Shirley's vocals, everything got sampled," says Vig. Every riff, beat, or loop would be manipulated, triggered, and then recorded back to tape. For *Version 2.0*, everything began in Pro Tools, which could be synced with forty-eight-track analog tape. And since it was all digital, they didn't have to stop at forty-eight.

"Some of the songs had so many tracks—over 125—but that's the record we wanted to make," says Vig. "We decided, 'Let's go crazy, let's try every idea. We can always pull it back a little bit if we think we've gone too far.' Steve and Duke would loop a four-bar section of the

THE FIFTH WHEEL

HOW BILLY BUSH WENT FROM GARBAGE ROADIE TO PRODUCER—AND FAMILY

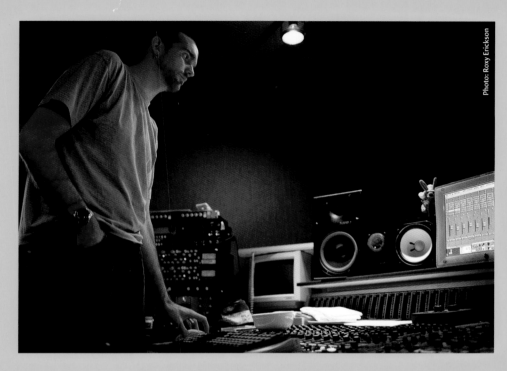

Photo: Roxy Erickson

In 1996, Billy Bush joined the second leg of Garbage's first tour as Duke Erikson's guitar tech. Since then, he's been in the studio as an engineer or producer for the making of five Garbage records, and at nearly every show the band has ever played. "Billy is really the fifth member of Garbage," says Vig.

Bush was a veteran of tours with Metallica and Suicidal Tendencies when he started working with Garbage, and his professionalism was something of an upgrade for the band as that first tour—which started with club shows and ended with arena dates supporting the Smashing Pumpkins—picked up speed. "I was not used to people treating me the way he was treating me," bassist Daniel Shulman says, referring simply to Bush's insistence on picking up Shulman's bass and handing it to him.

As the sessions for *Version 2.0* began, and the band dove into Pro Tools technology, Bush got an upgrade of his own—from guitar tech to engineer. What he brought to the control room was not just technical expertise, but the ability to translate ideas into sounds. "Everybody in the band hears things in their head, and there's no way to describe it exactly," Bush says. He remembers a moment during the recording of "Push It" when Vig said he thought the end of the song needed "to sound like a dump truck in a tornado." Bush put together a couple of approaches, one of which Vig loved. "I think my ability to translate what they're thinking into some sort of sonics is one of the things they liked about working with me," says Bush. "It allows them to play what they heard in their head."

Bush describes the Garbage working method as "a lot of construction, deconstruction, reconstruction. It's almost like every single time they go to write a song, they're writing a song for the first time, because there's no process." That said, there are roles within the band that have held true over time. "Duke and Butch are more of the traditional songwriter types. Writing a whole song is more natural for them. Steve will create more soundscapes." If a track is too much of a "meat and potatoes" sort of song, "then invariably Steve and Shirley will look at it and go, 'What can we do to fuck it up and make it weird?' And that's when Shirley will write a melody that isn't the melody you would immediately gravitate to for that song, or Steve will change the beat into something completely different. All the really great songs have got equal amounts of each of the four of them. When the balance is skewed one way or the other, it doesn't really sound like Garbage anymore."

Bush also unexpectedly became the "fifth member" of Garbage in another way, when he became Manson's significant other and, eventually, second husband. The relationship unfolded slowly. Manson, who didn't learn to drive until she moved to Los Angeles in 2006, began getting rides from Bush to and from Smart Studios.

"Duke got fed up picking me up and coming to get me because the novelty wears off pretty quick," she says. "And so when Billy did start picking me up, I resented it—I felt completely kicked to the curb. Pissed me off. And then because Billy is so mellow and so easy, I was just lulled into this super-mellow vibe every time I'd step into his car. And then I'd begin to miss it when it wasn't there. I noticed I would miss him when I was in Scotland and weird shit like that."

There was, Manson remembers, an awkward moment when Vig came upon the two of them in Bush's car, having an emotional discussion in the Edgewater Hotel parking lot. "From that moment on I just assumed that the band knew," she says. "It was never like, 'Hey, by the way, guys, me and Billy are going out on a date.' It was never talked about."

song and record over it. Sometimes there would be two hundred takes of a four-bar riff, with endless variations. It wasn't the most efficient way—we should have made decisions as we recorded—but it was the first time we used Pro Tools. So we recorded every idea."

"That was one of the first illustrations of how bad that technology can be because you can do it forever," says Marker. "All of a sudden it's like, *I don't really know what I want to do, but I can do five hundred ideas*. I'm sure it was a huge pain in the ass. Not good."

"Some songs, like 'Wicked Ways,' suffered because of that," says Erikson. "That should have been a more primitive, really simple track, but it turned into this huge production."

"We just wanted to cram as many riffs and sonic ideas into each song as we could," says Vig. "I guess that approach is our collective ADD as a band. 'Okay, something new needs to happen halfway through the second verse, we need another riff in the second chorus, we need a scene change in the bridge, and the last chorus has gotta get big and noisy.'"

The record has often been cited for its modern take on Phil Spector's "wall of sound" production style, but the recording process also reflected the band's love of movies: shoot everything, and then figure out what you actually have in editing (or in this case, mixing).

"It was a crazy process to weed through all the tracks, but that was also what was kind of fun about it," says Vig. "At the last minute you're making a decision that's taking the song either this way or that way."

"Now," says Erikson, "we always question whether something really has to be there or not. Back then we were pretty confident that it *did* have to be there!"

Bush believes *Version 2.0* was one of the first albums ever recorded completely in Pro Tools. "It's now taken totally for granted," he says. "I think it's a testament to their forward thinking, particularly Butch—but everybody in the band realized that it was sort of the magical key that allowed them to unlock their creative potential."

The technology was still so new that Bush and the band were constantly stressing its limits. Smart's PowerBook (an upgrade over the first record's Mac Plus) saw its share of sad Mac icons. "Every once in a while," says Bush, "we'd end up running into a situation where we would ask, 'Okay, why can't we do this?' and the Pro Tools folks would respond, 'Well, why would you want to do that?' Then a day or two later they'd send a new version of [the program]. They were actually rewriting code for us."

These days, when the band looks back on the first record, they get a little nostalgic. *Garbage* was high-tech but still handmade—literally, with razor blades and tape reels. Things weren't always 100 percent in sync. "I think all those little imperfections are what gives that record a certain charm and feel," says Erikson. "It was like combining different media onto a canvas."

VIG: The first album has kind of a lo-fi sound—a loose, handmade feel.

ERIKSON: It's the only record where the samples and the different textures actually give it a feel. The samples are laying back in the pocket, man!

MARKER: But back then it was two days of physical work to get the pocket to feel right.

VIG: Now, with Pro Tools, you can take a drum part, enter the command, "quantize" it, and it will sound perfect. But if you make the performances too perfect, it stops sounding like a band.

ERIKSON: That's a constant comment when we're working: "Make it sound like a band. Make it feel like a band." Sometimes we would have to work hard to get that feel. It's usually the tracks that we wrote during a jam—where we were all playing together—that feel the best, like "Push It" or "Paranoid." The feel's already there. We just had to make sure not to lose it!

X X X

After two years of fronting the band, Manson's role was much more definitive in the studio, including taking on most of the lyric writing. "Shirley was a lot more opinionated on the second record," says Erikson. "She was writing a lot more lyrics. She had learned from the first record that she was the one who had to sing these things. So she took charge of that part, as well as coming up with more melodies."

"The press takes the singer to task about the words," Manson adds. "I realized I had to own every word, so I guess I did feel like for the most part the words had to be mine."

Right: British makeup artist Mary Jane Frost adds some finishing touches to Manson on set for the filming of the music video for "Special"; bottom: a fax from Scottish novelist Janice Galloway giving permission to use the title of one of her books for "The Trick Is to Keep Breathing"; following pages: a Joseph Cultice band photo—Vig recalls being hungover in this picture, though this is not the only picture to document that condition; following pages: a publicity shot by fashion photographer Ellen von Unwerth, New York City, 1998.

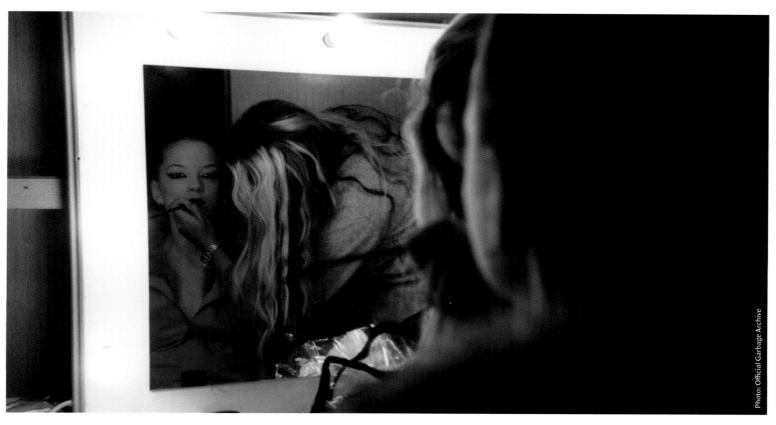

FAX NOTE VIA FAX MODEM

TO: *Shirley Manson*
FROM: *JANICE GALLOWAY* Phone/Fax 00 44 141 550 8726

9:33 pm; 10/10/97

Dear Shirley Manson

You aren't bothering me at all. I am delighted the track has been
recorded and look forward hugely to hearing it. Whether or not I dance
to it will have to remain to be seen.

Credits are welcome and should be straightforward. What you put is a
good basis. I suggest "Thanks to Janice Galloway for her use of her title
The Trick Is to Keep Breathing from her book of that name published by
Vintage/Dalkey Archive." If you felt moved to call it 'her great title', as
you did in one of your letters to me, I'd be even more able to show it off
I'd be able to go to clubs and everything and feel dead cool.

I will be thrilled to get a gift of concert tickets when you are next in
Glasgow – my signature is quote legible and won't spoil your book. I am
not writing just now, or not enough, but I've a couple of novels on the
boil about MOTHERHOOD and CLARA SCHUMANN (another musician). I
envy the fact you've an album coming out. I wish I had.

Best wishes –
 Janice
 (unsigned via the modem)

The inspiration for two of the album's most memorable songs came from two women Manson admired. The first was "The Trick Is to Keep Breathing," which Erikson calls "an amazing accomplishment."

"I love 'The Trick Is to Keep Breathing,'" Manson says. "We wrote it all together upstairs at Smart Studios from a jam session, if I remember correctly. The title comes straight from the brilliant book by Scottish author Janice Galloway. I stole that title like a dirty, brazen bandit, and then I wrote the rest of the song around it.

"Then I sent Galloway a copy of the song—how I got her e-mail, I can't rightly remember— and she very generously gave us permission to use the title because she loved the music and loved our band. We were thrilled by her generosity because obviously the magic of that song is in the title. She even came down to our show at the Barrowlands in Glasgow on the *Version 2.0* tour. I think she was really chuffed that the song turned out rather beautifully and was something she felt proud of."

Erikson also remembers being aware that Manson wrote the song with one of her close friends in mind. "It took on a very personal edge for all of us," he says. "There was always that kind of atmosphere in the room when we worked on that song. Like we were trying to help someone out."

While "Trick" got its title from the outside world of literature, "Special" evolved more from Manson's subconscious. She had just recently begun taking guitar lessons, and was practicing some chords while coming up with her own melody. Shulman happened to be in the room.

MANSON: Daniel was like, "That's a really good melody," so I felt confident about taking it to the rest of the band. By the end of recording, I realized that it had ended up sounding very much influenced by the Pretenders. Being that Chrissie Hynde is one of my biggest musical heroines, I thought it only right that we be sure to acknowledge the fact. You shouldn't take something and pretend it's solely yours without acknowledging the shoulders you are standing on. I thought it best that we ask her permission to use the line, I *thought you were special.*

We had her phone number from when we met her at *Top of the Pops,* and when she'd come to see us play live. We got in touch and said, "We've used this line. Do you give us your blessing?"

Hilariously, she sent a fax back to us at Smart Studios that said, *You can use my words, you can use my music, you can use my very ass.* —Chrissie.

X X X

HOW TO BREAK PRO TOOLS

WE HAD ONE SONG WHERE WE HAD REACHED THE NUMBER OF CROSS-FADES AND THE COMPUTER WAS CRASHING. THE LIMIT PRO TOOLS HAD AT THE TIME FOR CROSS-FADES WAS 65,536 (256 × 256).

I ASKED, "WHY DID YOU STOP AT 65,536 CROSS-FADES?" AND THEY RESPONDED, "WHY WOULD ANYBODY NEED ANY MORE THAN THAT?"

AND I HAD TO EXPLAIN, "WELL, YOU KNOW, IF THE SONG IS 140 BEATS PER MINUTE AND IT'S FIVE MINUTES LONG AND YOU'RE CUTTING THIRTY-TWO TRACKS OF DRUMS, BASS, AND GUITARS TO SIXTEENTH NOTES, THAT'S HOW MANY CROSS-FADES YOU NEED."

SO THEY SAID, "WOW, OKAY, WE GET IT, WE'VE TAKEN THAT LIMITATION OUT."

—BILLY BUSH

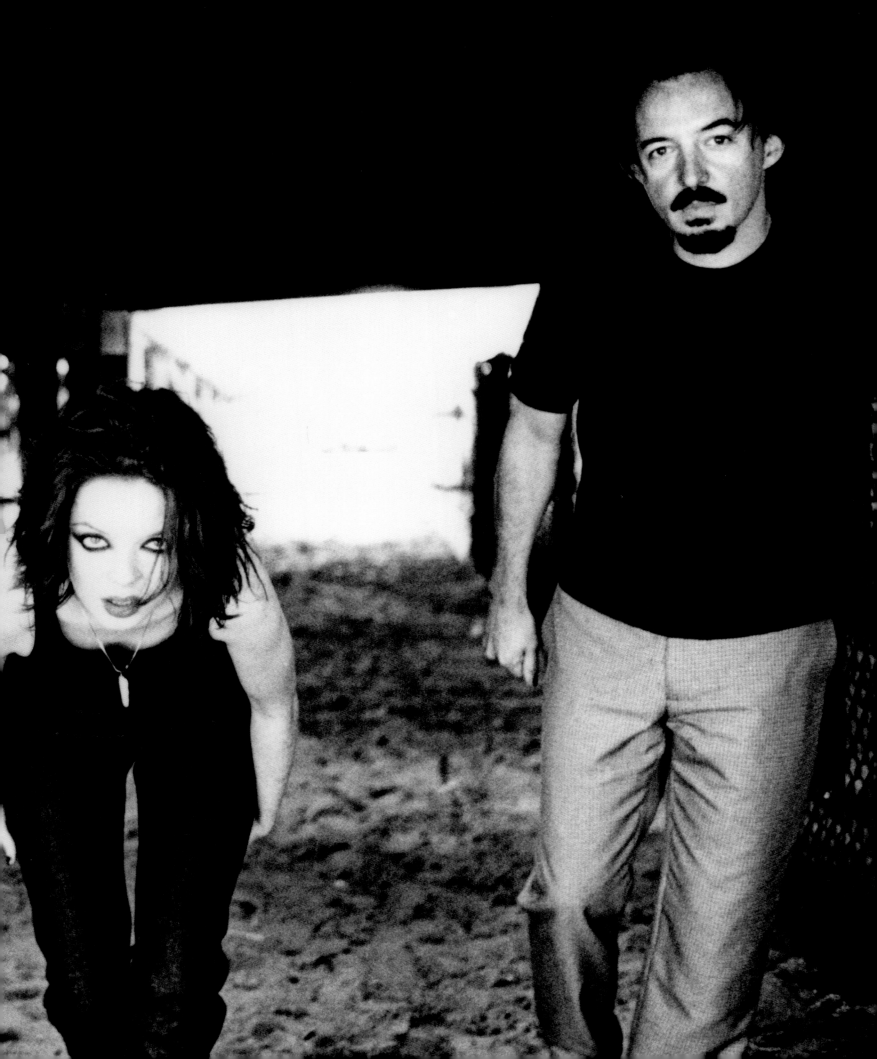

Anticipation for *Version 2.0* was high. The album's first single, "Push It," was released to radio in the UK and the rest of Europe on March 16, 1998. KROQ in Los Angeles immediately followed suit—two weeks before Almo Sounds actually serviced the song to US stations, much to the label's chagrin. Almo sent a cease-and-desist letter to the radio station. "Who tells radio not to play a record?" says KROQ music director Lisa Worden, though it was a common enough practice that she had a folder of such letters. "No one would ever do that now. They're like, 'Pleeeeaaassse . . . please play our record!'" But KROQ felt like Garbage was almost one of the station's house bands—they'd already played three KROQ charity concerts and would appear at another in December 1998. "So, yeah," says Worden, "when *Version 2.0* went out—another fantastic album—'Push It' went right on the air."

The Andrea Giacobbe–directed video debuted on MTV in April. Anticipation for the record grew so high that Garbage were asked to be the musical guest on *Saturday Night Live*—one of the last episodes of the season, airing even before the record's official release date of May 12.

Garbage said no.

"We weren't ready," says Erikson.

The band figured that a bad *SNL* performance would hurt them more than no performance at all, something Manson—who didn't even know or care about *SNL* back then—came to appreciate later. "I've seen many a band who arguably should have done the same thing but didn't, and then you're watching them fall flat on the national stage. It's toe-curlingly embarrassing," she says.

Jerry Moss was not amused. He'd just spent almost a million dollars on Giacobbe's outrageous vision, and now the band didn't want to build on the video's momentum via one of the world's most prestigious promotional opportunities? Well, yes.

Almo's general manager, Paul Kremen, warned Vig that the show would never ask again. But the band had not even begun rehearsing for the road yet. "I remember saying to Paul, 'Look, if we go on there we'll be so freaked out. We haven't even played the song,'" recalls Vig. "I think it was 'Push It'? We hadn't even played it in front of people before."

One year later, after a world tour and five more singles and videos, *Version 2.0* not only went platinum but also earned the biggest Grammy nomination of them all: Album of the Year (as well as Best Rock Album). The band played *Saturday Night Live* on March 20, 1999.

Above: a "Push It" poster; **opposite:** three Polaroids show the range of emotion, from smiles to grimaces, produced by the *Version 2.0* tour; **following pages, clockwise from left:** sketches for Vig's plane in the Dawn Shadforth–directed video for "Special"; in full wardrobe for the "Special" video shoot; the boys and performer Paula Weird (a.k.a. the naked woman) on the set of the "Push It" video; the band (and dog) on set for "Push It"; **following pages, clockwise from left:** Manson goofs for Joseph Cultice while the boys play it straight; Vig, Erikson, and Shulman go shirtless to promote the rarely seen (okay, never made) Garbage workout video; Marker wearing a shirt that reads, *If you don't like Garbage, go fuck yourself.*

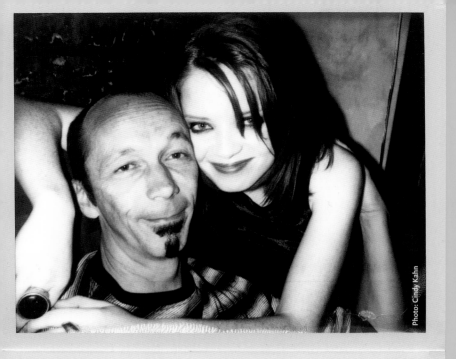

Photo: Cindy Kahn

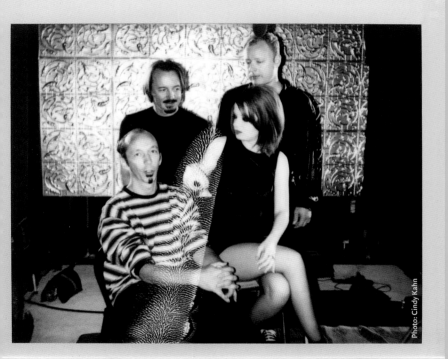

Photo: Cindy Kahn

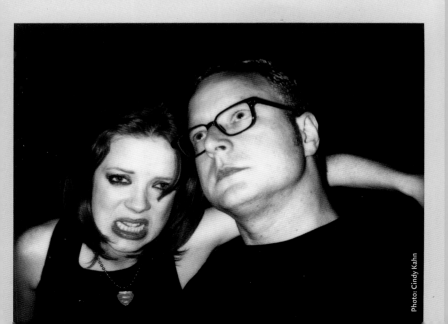

Photo: Cindy Kahn

FILL YOUR GLASS WITH GARBAGE

ROCK AND ROLL COCKTAIL RECIPES

THE CHAMPAGNE SUPERNOVA

As far as Café Montmartre's Craig Spaulding can remember, this drink was Vig's invention, named for the Oasis song, though Vig believes he first read about it in an *NME* interview with Oasis singer Liam Gallagher.

RECIPE
—*1½ oz. cognac*
—*Top with champagne or sparkling wine of choice*

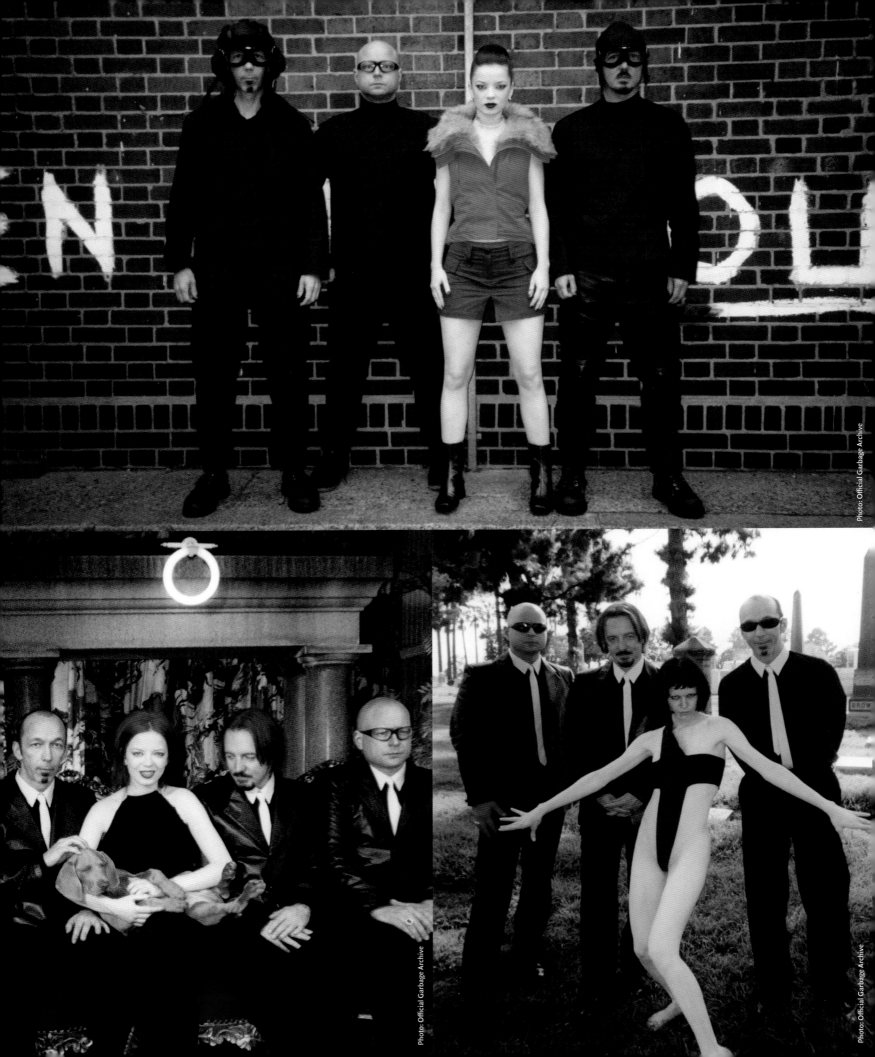

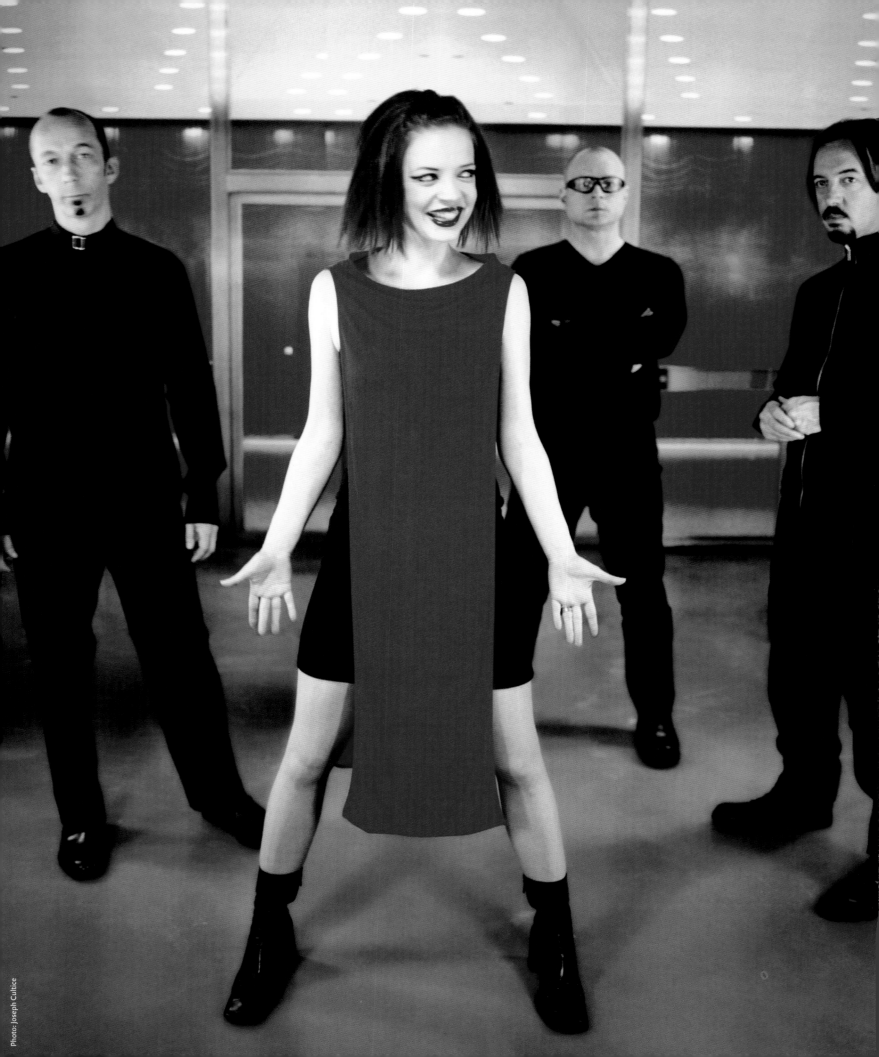

"EVERYONE THINKS OUR FIRST RECORD WAS THE DEFINITIVE GARBAGE RECORD. TO ME, *VERSION 2.0* WAS DEFINITIVE."

—SHIRLEY MANSON

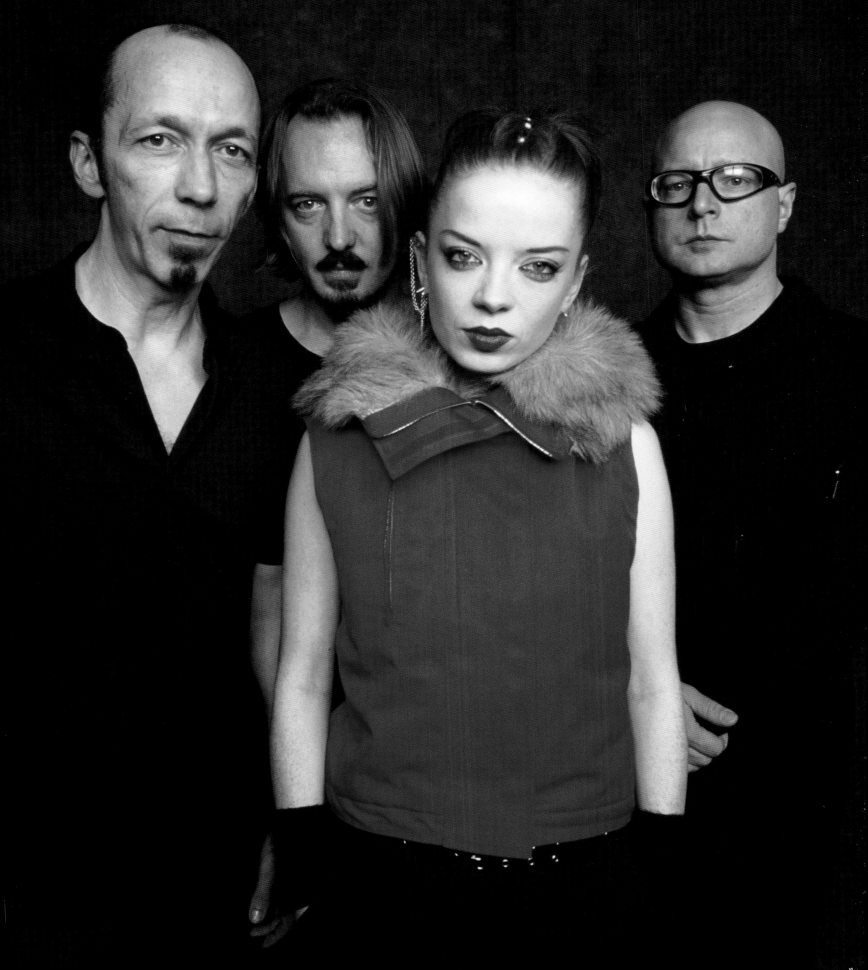

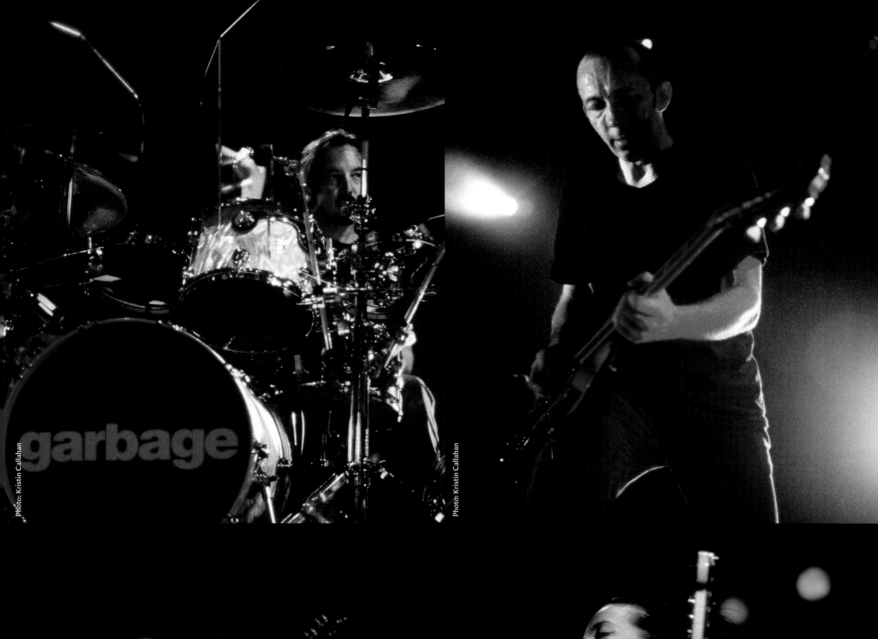

garbage

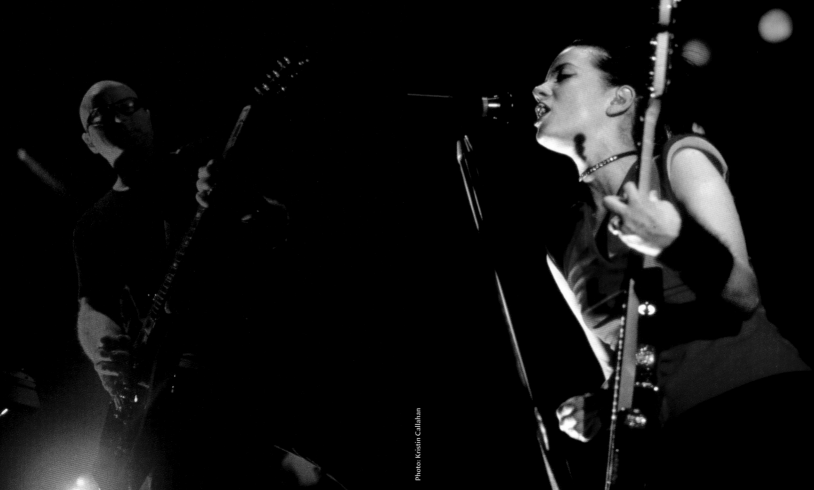

The band that hit the road for *Version 2.0* put in a lot of work to make sure their performances were just as much new-model as the album's sound. They had more rehearsal time, more experience, and a better handle on technology.

"I think we tried to make the first tour sound too much like the album," says Vig. "By *Version 2.0*, we realized a studio recording is one experience and playing live is a completely different experience. Let's let them be their own thing."

"They became a juggernaut," says road manager Harald Kohl.

The presentation was also very different, with Manson now completely comfortable as frontwoman and rock star. "A lot of times, when a band goes off to make a record, they come back and it takes them awhile to get as good as the last tour," says Billy Bush. "But with Garbage, the first show on *Version 2.0*, they just picked up where they left off and then got better. Shirley was completely different from the get-go. It was like, *Who are you?* She had a newfound confidence, a newfound persona. She was fierce. I also think the boys felt more comfortable in their abilities. They now had two records that were successful. It was like, *Okay, we're a band for real now.*"

"I tell people all the time Shirley is the MVP of Garbage," says Vig. "If she wasn't in this band we would not have had the success we had. On the first tour she was a little reticent, then all of a sudden she became a fucking tiger. She became much more uninhibited and realized, *I'm the leader of the band because people are watching me.*"

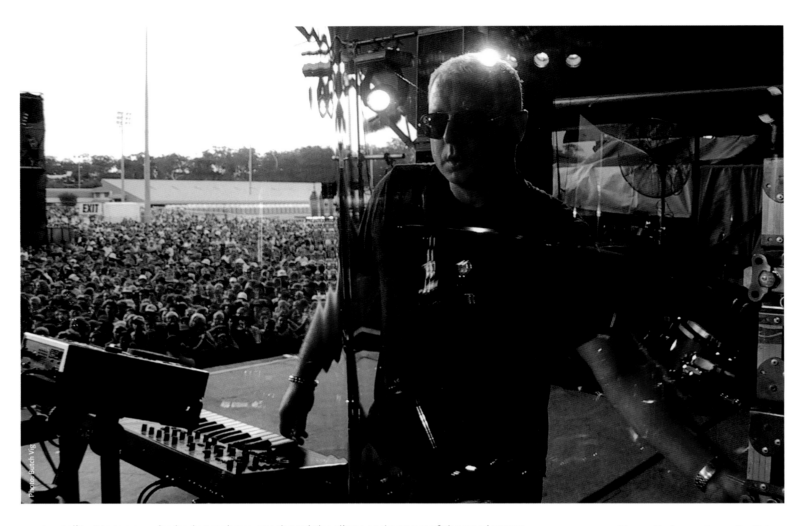

Photo: Butch Vig

In reality, Manson—who had somehow weathered the slings and arrows of the music press on the first tour—still struggled with day-to-day self-doubt, and the pressure only increased as she began to see her face on the cover of more and more magazines. Despite being hailed as a sex symbol and role model, she still suffered from lifelong body-dysmorphia issues.

"I felt ugly and I felt embarrassed," Manson says. "I can remember feeling really self-conscious about my physicality. That made it even tougher when negative reviewers chose to pile on the criticism . . . The press said some outrageous things. I was already really unsure of myself, that I wasn't as good as everyone else. Now I look back and I realize that I actually looked really cute. When I think back about what some people wrote in their reviews about me, I can see that there was a deliberate, very nasty agenda at play. But I didn't understand that at the time."

Onstage, though, there were no doubts, just complete confidence. "After a while I just snapped," says Manson. "I was like, *Fuck you—I'm up here doing this, and actually I'm pretty good at what I do, so you can fuck right off.*"

Mirroring the album title and the use of Pro Tools, the band's live set was itself a new "release" of software, hardware, and visual presentation. Most notably, they began to get rid of the amplifiers, running all the instruments straight to the mixing board and PA system. The idea started with Bush and the band's front-of-house engineer, Tom Abraham, who wanted the best possible sound. Doing away with the guitar and bass amps meant there was no bleed from the stage and no sonic distractions for the band members, who could then get their own digitally perfect, personally customized mix through their in-ear monitors. That's also why Vig always has his drum kit behind plexiglass—so that the sound coming off his cymbals can't be picked up by the vocal mics.

Then–production and lighting designer LeRoy Bennett (who went on to work with Lady Gaga and Beyoncé) ran with the concept, hiding the amps that were necessary in sci-fi looking towers. "A lot of people described the music as futuristic sounding, and I think that captured our imagination," says Manson. "So that idea became very much a focus for the second record—a kind of techy, futuristic, *Blade Runner*–esque sort of vibe."

Above: Marker onstage—the distortion you see is because the shot was taken from behind Vig's plexiglass drum shield; opposite, clockwise from top: Garbage sharing a red Solo cup moment backstage with Girls Against Boys, one of their favorite supporting acts on the *Version 2.0* tour; Beck with bassist, Garbage studio session player, and future record producer in his own right Justin Meldal-Johnson, and Vig, in the hotel bar post festival appearance, 1998; are we not men? We are the men of Garbage with lampshades on our heads!; following pages: a Joseph Cultice publicity shot, Madison, Wisconsin; a Garbage skateboard deck, a UK-specific piece of merchandise featuring icons generated of each band member by the art designer for the music video "Special."

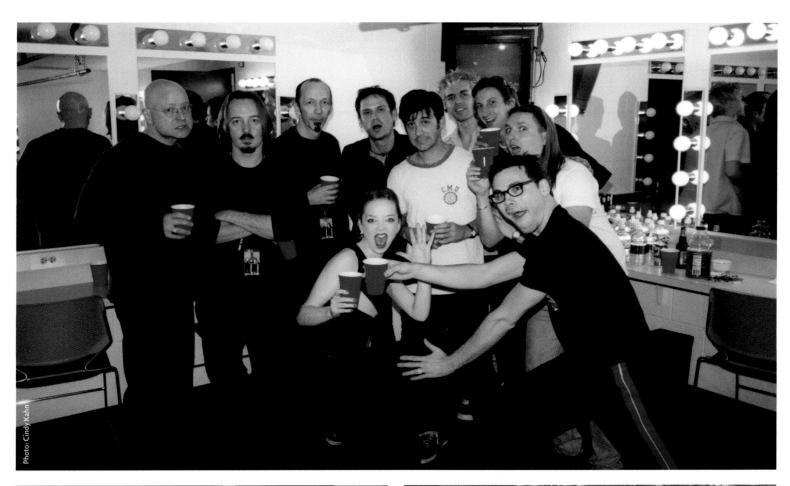

Photo: Cindy Kahn

Photo: Official Garbage Archive

Photo: Official Garbage Archive

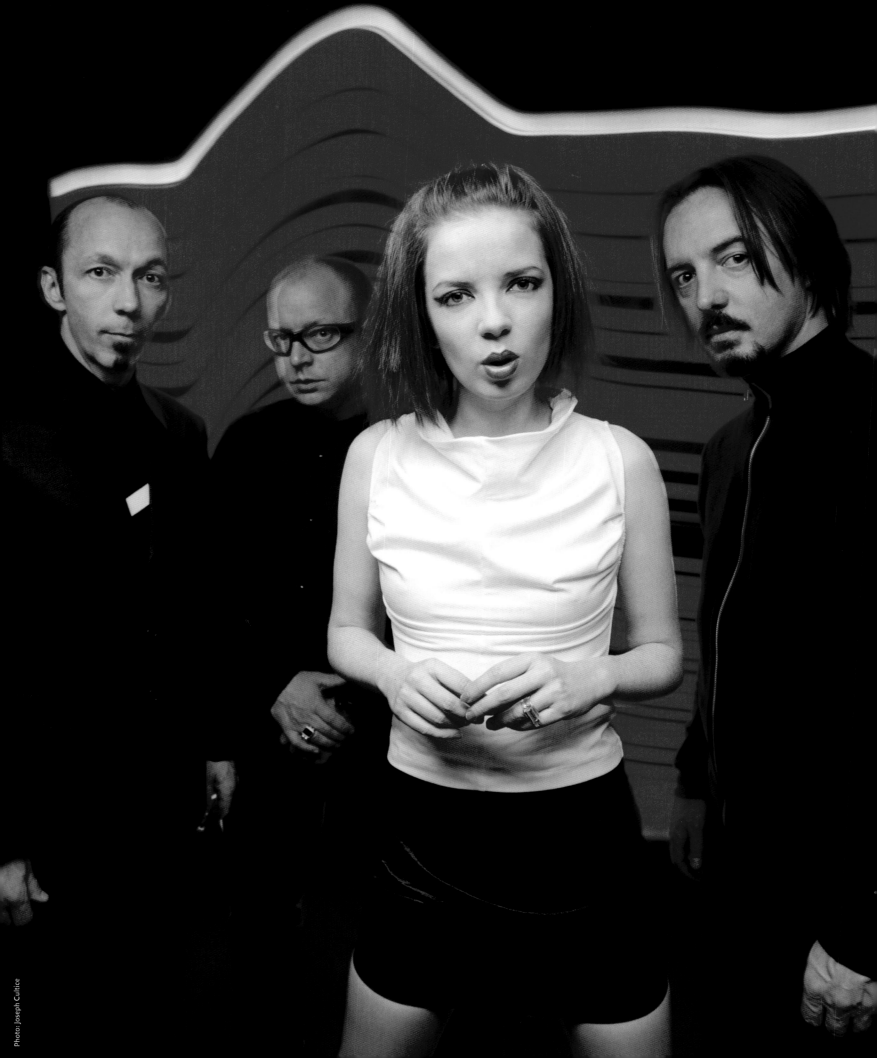

The setup is much more common today; back then, Metallica (who had previously employed Kohl, Bush, and Abraham) and Garbage were the pioneers.

The break with tradition did have its drawbacks, however, especially at radio station shows and music festivals, where there were lots of bands on the bill. "We were always kind of bummed out when we saw other bands watching us from the side of the stage because we knew it probably sounded pretty shitty and weird," says Shulman. "But obviously the goal is for the audience to hear it as good as possible."

Former Jane's Addiction bassist Eric Avery, who would eventually replace Shulman in Garbage's touring lineup, remains confounded by the fact that there is no bass amp physically moving the sound waves behind him. "It's weird to not feel any breeze," he says.

"Neither Steve nor I like it all that much," says Erikson. "But it makes so much sense. You just dial your sound in and it's there forever. You don't have to fuck with a pedal."

X X X

Version 2.0 debuted at #1 on the UK album charts; in the US it shipped gold, meaning Almo did a first pressing of 500,000 copies. The album debuted on the *Billboard* chart at #13.

In terms of the band's business affairs, getting to that point had not come without some bumps. Feeling that SOS had been a fantastic management team for a fledgling project but not necessarily for a thriving international band, Garbage—with the encouragement of Almo's Jerry Moss and Paul Kremen—hired a more experienced management team, choosing a small agency run by industry veterans Gary Borman and Steve Moir over former Nirvana manager John Silva at Gold Mountain and Cliff Burnstein and Peter Mensch at Q Prime.

The band also renegotiated their deal with Mushroom Records. The label's UK general manager, Gary Ashley—who'd signed them—had moved on, and the band's contract had a "key man" clause, meaning it could be terminated due to Ashley's departure. Mushroom owner Michael Gudinksi, who considered Garbage so important to the label that he called the band "my Beatles," fought off Virgin Records to keep them.

As Gudinski recalled it in a 2003 interview, "Garbage was one of the greatest bands that Mushroom has ever worked with, one of the bands that mostly saved Mushroom in England, and one of the bands that most probably were the most loyal acts I've ever worked with . . . Richard Branson had just offered them a three-million-pound check . . . I came up with enough money, nothing like Richard Branson could."

"We did indeed end up accepting a lot less money from Mushroom than we were being offered by Virgin at the time," says Manson. "I can't say there were not times I severely regretted our decision, but in the long term I am glad we did the honorable thing. I can sleep at night."

Korda Marshall, who ran the Mushroom imprint Infectious Records, succeeded Ashley in managing the day-to-day operations of Mushroom. "We were incredibly lucky with Korda Marshall. He inherited us and believed in us long past the rest of the company," Manson says. "He continues to have success in the music business as a bit of a renegade because he has taste and deep faith in the artists he signs."

While Manson's status had changed within Garbage, as far as the lawyers were concerned she was still bound to the deal Goodbye Mr. Mackenzie and Angelfish had signed with Gary Kurfirst. *Shirley Manson appears courtesy of Radioactive Records* appeared on every Garbage album up until 2012's *Not Your Kind of People*, with Kurfirst and various parent corporations getting a share of the band's royalties as well.

"It was a very smart deal and he's a very smart guy," says Kremen. "Jerry got played a little bit, but I think Jerry at the time wanted back in the game and there was heat on this act, so he was down for whatever."

SOS's Shannon O'Shea remembers trying to set up a meeting between Kurfirst, Moss, and Gudinski: "Gary was super excited about the potential of his being able to work with Jerry Moss. When that didn't really happen, he got upset, and I think that's why he made the second album difficult. He thought, *Well, they've upset me by not making me part of it, and I could make money so I'm going to.*"

X X X

Nothing demonstrated how big Garbage had become after the success of *Version 2.0* more than the European summer festival season. In 1998, the band headlined the Reading Festival, the

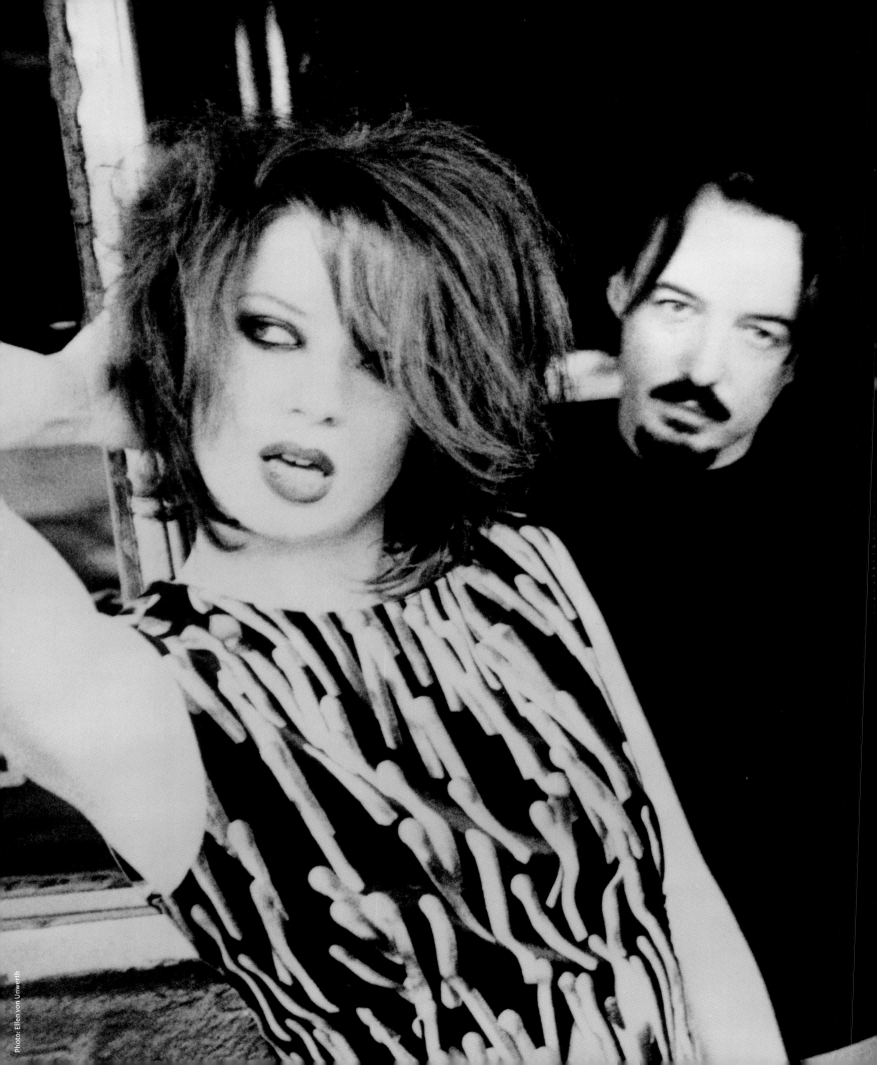

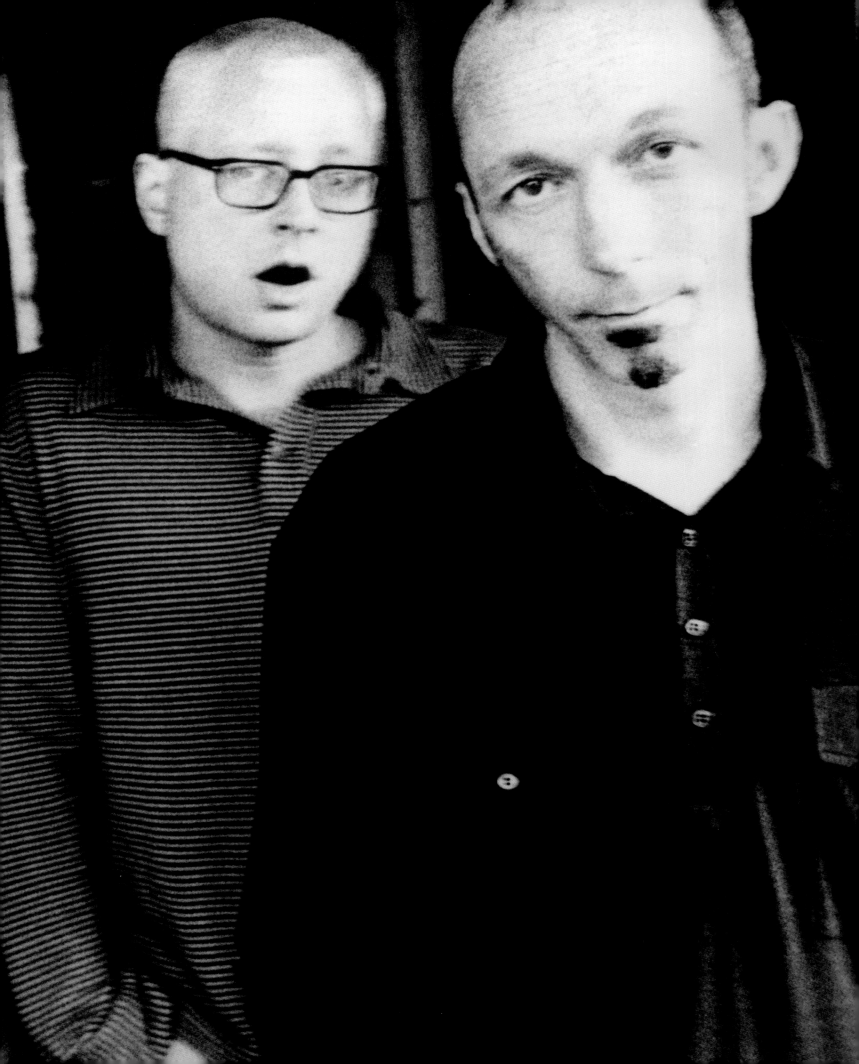

capstone of the English summer festival circuit. Just two years earlier they'd been second on the main stage, opening for Black Grape. Now the band was so big that they went on *after* New Order, who had returned for their first show in many years.

"New Order were a bit grumpy about it, but it was an amazing gig. Garbage were the headliners, and they should have been headliners," says Marshall. Infectious/Mushroom ponied up 20,000 quid for a festival-long party, hosting a tent in the VIP area, where Manson hung out at the bar with Kylie Minogue and Nick Cave, Vig shook hands with Gary Numan, and MTV taped all its interviews. "We spent a lot of money," says Marshall. "This was the nineties."

In truth, the band was a bit embarrassed to be following New Order. "We played in Greece and Patti Smith opened for us," says Manson. "I mean, come the fuck on. I was deeply, deeply ashamed."

Things were even stranger at the Danish festival Roskilde. "Bob Dylan went on before us," says Erikson. "I wanted to hide in the dressing room until we went on, then get in the bus and leave."

The biggest show of the tour was the Fuji Rock Festival in Tokyo Bay, Japan, where the band played to a crowd of 100,000 in the middle of a scorching day. "Garbage never thought of themselves as a daylight band," says Shulman.

MARKER: Seems like it was early, it was almost noon or something.

MANSON: We went on at noon.

The sun and the heat wilted everyone in the band almost immediately upon taking the stage. Manson had worked up a singular sartorial look for Japan, styling her hair into a complicated fifties roll and wearing elaborate stage makeup. "It was so hot my hair began to droop to one side and just sort of flopped in this really weird, unbecoming way. All my makeup melted off and ran down my face. I was mortified. We had to cut the set short because I was about to pass out. We flopped like a dead fish off the stage."

Meanwhile, Marker had decided that the perfect outfit to wear under the midday sun was a pair of thick technical-fabric snow pants, which he'd scored during a photo shoot for British style mag *The Face*. He made this decision from the chilly comfort of his air-conditioned hotel room, not the 110-degree stage.

MANSON: Steve looked so hot, like he was about to burst a blood vessel.

MARKER: It was so humid you couldn't even breathe, but as is often the case, we have it easier than the singer does. I think I just kind of stood back there and poured water on my head and I was okay. Who was it coming onstage after us?

MANSON: Sonic Youth. They said, "Shit. What happened? Is everything okay?"

VIG: All I did was tap the snare, hit the hi-hat. I didn't do any thrashing at all. We came offstage and they were like, "Oh my god, what is it like out there?"

MANSON: When we got offstage, Harald Kohl had iced towels and he pushed them over our heads. That's when Sonic Youth saw us. They said they thought we'd been hurt.

MARKER: We scared them.

MANSON: That was the first time I met Kim Gordon. The situation was far from ideal but I was still so thrilled.

Happier memories followed on that tour. While playing Wembley Arena, a huge milestone for the band, Garbage were joined onstage by none other than Chrissie Hynde, who performed "Only Happy When It Rains" with them.

"It was completely wonderful and utterly insane to be onstage with her. I still can hardly believe it really happened, to be honest," says Manson. "Afterward, there she was in my dressing room drinking champagne with my mum and dad. My mum kept looking over at me, grinning and winking, knowing full well—even though I was trying to act all cool and normal about the situation—exactly what it meant for me to have Chrissie there."

Top: Garbage onstage at an Australian festival in 1999; above: Vig protects his hearing in Japan, 1998; opposite: yes, definitely do meet your idols. Clockwise from top left: Vig with Gary Numan; Manson with Nick Cave (caught in an unusual smiling moment); Manson with Kim Gordon; previous pages: a publicity shot by fashion photographer and director Ellen von Unwerth, New York City, 1998.

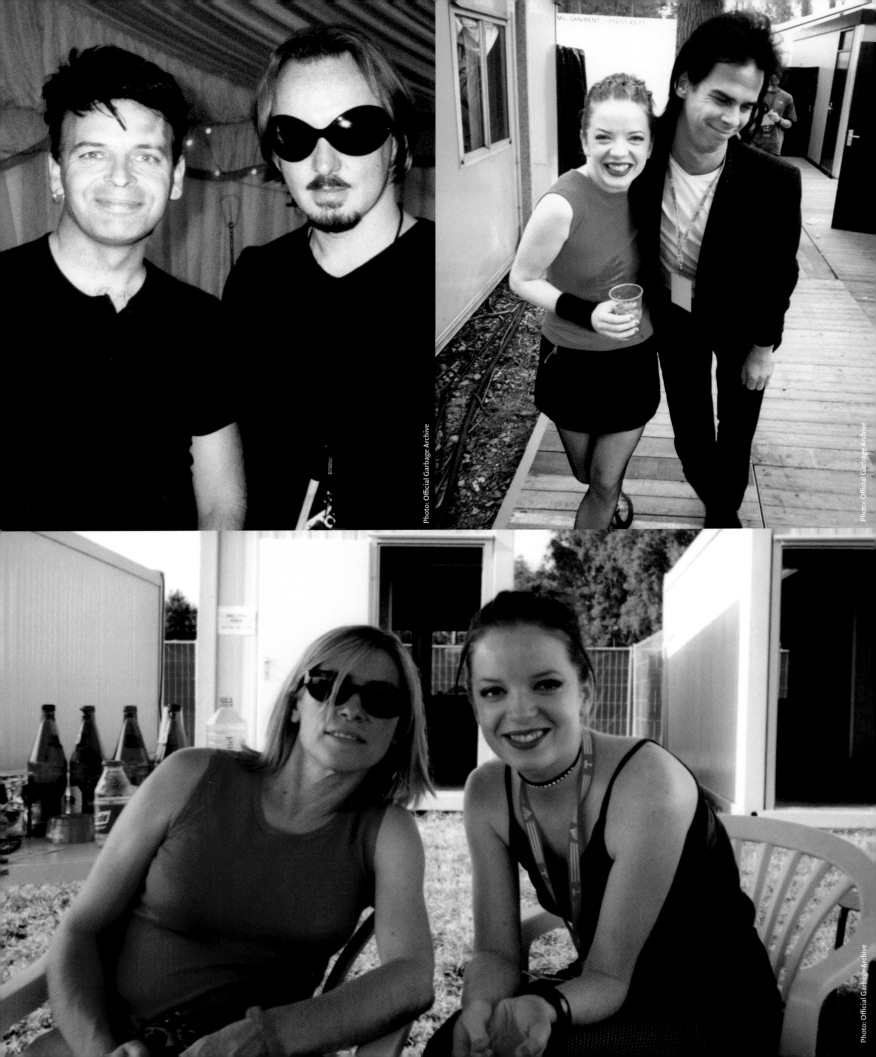

An even bigger moment for Manson came in 1999, when Garbage were invited to headline the official ceremonies celebrating the opening of the Scottish Parliament. It was the first time Scotland had its own parliament since 1707. For Manson, it was the greatest possible honor she could receive. "To be asked by my city and my *country* to represent them on such an occasion was fucking mind-blowing," she says. "My entire family was shrieking in excitement when I told them. It was *such* a big deal."

The rest of the band might not have grasped the seriousness of the honor. While Manson and her father had the occasion-appropriate bottle of Scotch on hand, the boys were busy throwing back charlotkas, a Polish cocktail made out of bison-grass vodka and apple juice. They'd been in a bit of a charlotka phase, and daily habit was trumping ceremony. "I remember being really offended when they all insisted on drinking charlotkas before we trooped onstage, even though my dad had brought a bottle of whiskey for us all to toast the future of Scotland," says Manson.

In preparation for the performance, Manson got the band to work up a cover of the Beatles's "Don't Let Me Down." "The new parliament was going to have their work cut out for them, and all our hopes and dreams as a nation were on fire back then," Manson recounts. "It was definitely a word of caution born out of my culturally typical Scottish pessimism."

Onstage, Garbage were introduced by Donald Dewar, the First Minister of Scotland, who has been called the "Father of the Nation" because of his advocacy for Scottish devolution. "It was a really beautiful evening," says Manson. "We were playing in the royal gardens beneath the castle and the whole crowd sang along at the very top of their voices to almost every song. It all felt incredibly optimistic and uplifting. When interviewed on the BBC's *Desert Island Discs* a few years later, much to my pride and joy I was informed that Dewar picked out 'Stupid Girl' as one of his favorite songs because it was the last song he heard on the happiest day of his political life."

<p style="text-align:center">X X X</p>

All things considered, the band coped remarkably well with the intensity of their first two tours. "We were fucking tough as nails. We were on the road for twenty-one or twenty-two months," says Erikson.

"We didn't miss a show," says Manson.

Except for one—in Tallinn, Estonia, where the band was scheduled to play on February 4, 1999, the day after a gig in St. Petersburg, Russia. Kohl had allowed for plenty of time getting *to* Russia, but it turned out that the hard part was getting *out*.

"We figured they'd give us far more trouble getting in," says Kohl. "But they held up our trucks for twenty-four hours at the border for whatever political bullshit, bribery reasons, and as a consequence we couldn't get our gear to Estonia in time to play the scheduled show. That was the first time the band ever had to miss out on doing something."

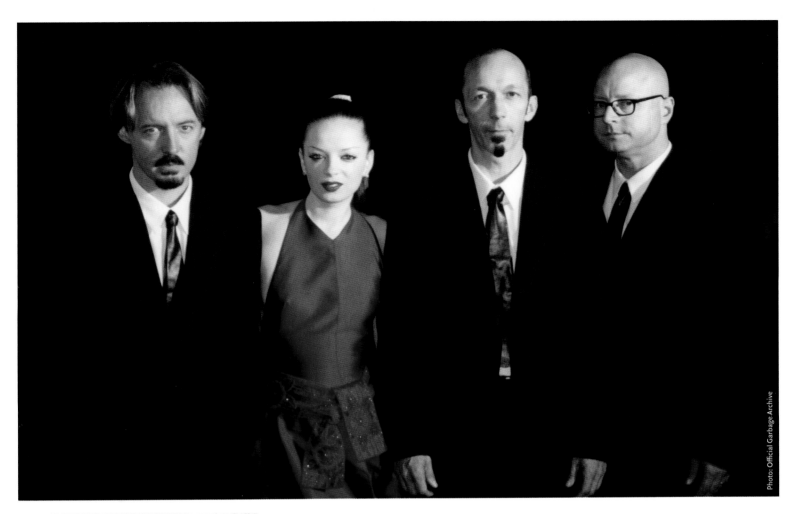

Opposite: Manson onstage, wrapped in the Scottish flag, celebrating the 1999 opening of Scotland's first parliament since 1707, and an invitation to the event; top: the band on set between shots filming the video to James Bond theme song "The World Is Not Enough"; above: astronaut and big Garbage fan Piers Sellers "spinning" "The World Is Not Enough" in weightless space. He flew three space shuttle missions for NASA.

The show promoter was in tears when he was first told of the problem. Out of concern for his money or his life or both, he begged the band to help him explain his situation on television. As a result, Garbage were paraded out on national television to apologize for not making the show.

"Everyone was so emotionally drained because it felt kind of like being held hostage," says Kohl. "It was a really high-tension international kind of a thing."

It was almost like something out of a spy novel, particularly fitting considering the other project Garbage were working on: the theme for the next James Bond movie, *The World Is Not Enough*. It all started when producer and composer David Arnold called Manson, asking to meet next time she was in London. When that time came around, the two got together at a Starbucks around the corner from Garbage's hotel, and Arnold told Manson he wanted her to sing the next Bond theme.

"I just about crapped myself. I remember electricity going up my legs and through my body. I was like, *I just can't believe this is happening; this is insane.*"

She told the boys that night. "We were like, 'What? Holy shit!'" says Vig, although it occurred to him that Arnold probably only wanted Manson, not all of Garbage. But Manson wasn't having that—something the boys have always been grateful for.

Film producer Barbara Broccoli—daughter of franchise pioneer Albert R. "Cubby" Broccoli—came to the recording sessions in London, and the band worked to create something that sounded like themselves while still honoring Arnold's vision for the song. "We slaved over that Bond thing," says Erikson. "I thought we did a really amazing job at the end of it, and Shirl's vocal on it is incredible. The Broccolis were in there and she had to sing the lead vocal for the new Bond theme in front of all these people."

Manson had had no sleep; the band had flown in overnight after a show in Portugal. "We were all dead tired," Erikson recalls. "I had to play the guitar part with a bunch of strangers—movie producers—standing there looking on. Not your ultimate creative atmosphere. I finally came up with this kind of Bond guitar part that worked pretty well."

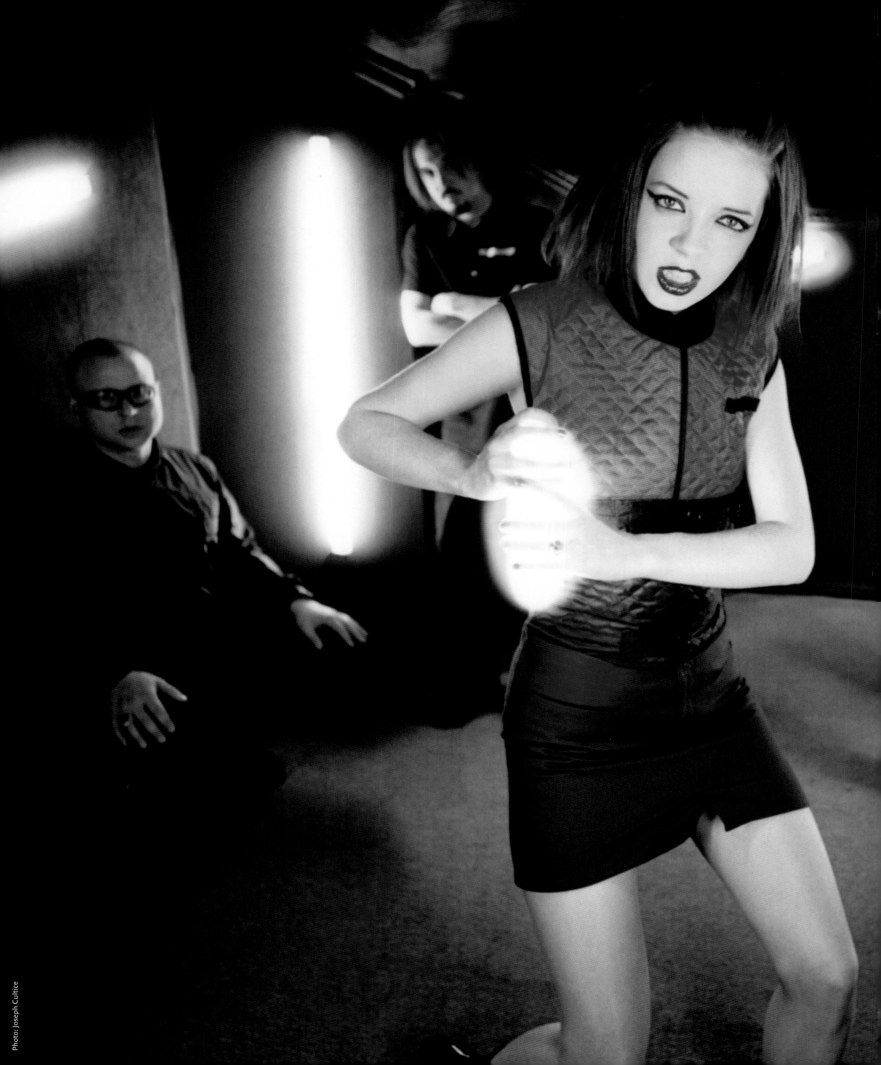

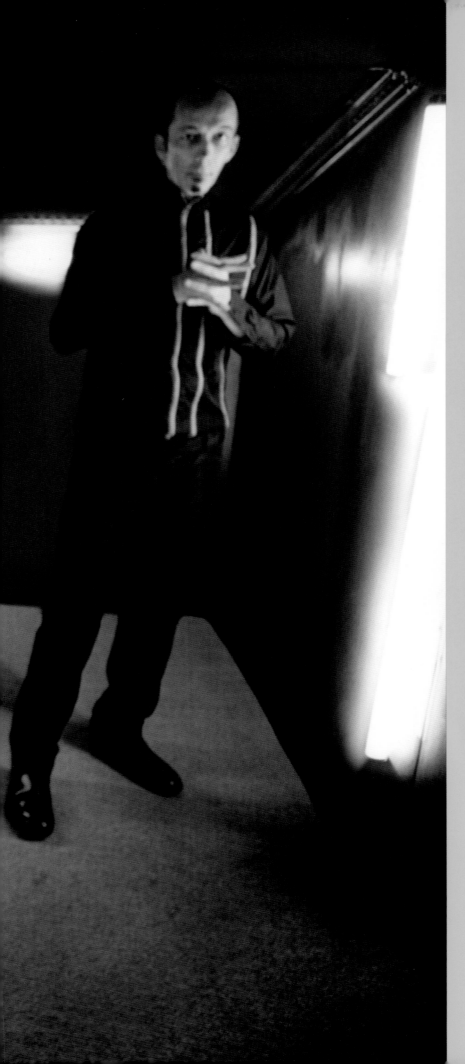

FILL YOUR GLASS WITH GARBAGE

ROCK AND ROLL COCKTAIL RECIPES

THE BEERGARITA

Butch Vig liked to make this hybrid at Smart Studios. "It's really good," he says. "It has a mellow fizz and smooths out the tang of the lime. It's really delicious, a bit fussy, but worth the effort! Use Don Julio tequila, or better. Seriously—drink good tequila!"

RECIPE
—*½ can of limeade frozen concentrate*
—*½ bottle light lager*
—*Put 2 ice cubes in a blender*
—*Add 8 oz. of tequila, 2 oz. of triple sec (or Cointreau), and the juice of 1 lemon*
—*Add half the limeade concentrate (you add more for flavor later)*
—*Top with beer*
—*Blend 20–30 seconds*
—*Pour over four ice cubes in a salt-rimmed glass*
—*Lime garnish optional*
—*Serves four*

"You can't actually—legally—play the Bond riff," adds Bush.

"I think the track sounds cool," says Vig. "We were able to make it sound like a James Bond theme and also like quintessential Garbage."

But it was not as great of an experience as it could have been. Broccoli nixed the initial video treatment by director Philipp Stölzl as "too violent." Stölzl rewrote his treatment, but Manson and Broccoli butted heads to the point where Broccoli actually uttered the dreaded Hollywood curse: "You will never work in this business again!"

"I wasn't even in her business!" says Manson.

A compromise was eventually reached. As Vig describes it: "Shirley Manson will be a robot with a bomb inside her and she'll blow everybody up in the end."

Much to the band's surprise, when they finally saw the film months later, the version of the song used was basically Manson's vocal mixed with snare drum and strings, with the rest of the band wiped out.

"We had accomplished all this, and then—weeks, months later—we finally see it, and almost every sonic detail was gone," says Erikson. "They remixed it for the movie, and not well."

"The theme song comes on, and I was like, 'Fuck!' I wanted to just leave," adds Vig.

Fortunately, the band was still able to release their own version of "The World Is Not Enough" as a single. "They fucked up," says Erikson, "because ours was so much cooler, and it would have made much more of an impact on the audience had they used it instead of this fucking bullshit stringy thing. Shirl's voice was amazing, but with the band behind her and all the stuff that we did, it would have made that shitty movie start out to at least feel like maybe it was going to be good."

"For four minutes," says Vig.

Regardless of what wound up in the movie, it was still an amazing honor and accomplishment. "The older I get, the more I realize how insane it was that we got that opportunity," says Manson. "Because when you get it, I mean, it's thrilling and kind of nuts, but you're so in the swing of your career taking off that it just feels like another thing you got. That might sound terrible, but you don't have perspective yet."

"For me, it was a whole new level of being respectable in the eyes of the in-laws or just people in general who never really understood what I did or what we did," says Marker. "But then when we did that, it's like, 'Ooohhh!'"

Another Hollywood encounter came with the "You Look So Fine" video, which was originally supposed to feature Brad Pitt. The actor was a friend of a friend of Paul Kremen. Pitt and the band hung out one night in Los Angeles, right before *Version 2.0* came out. "I remember him coming over and sitting beside me," says Manson. "I had this massive coffee-table book on my thighs at the time, which is just as well because at the proximity of Brad Pitt my thighs were shaking."

"I was sitting next to him," Erikson says. "I barely knew who he was. He said, 'So, Duke, Paltrow's a big fan.' And I said, 'Who's Paltrow?'"

MANSON: We nearly got him for "You Look So Fine," and then the day before the video shoot he crapped out of it and called me up at my hotel and said, "I'm really sorry to do this to you but I can't do the video tomorrow." "No problem, no problem at all," and then I put the phone down. Then, "Holy crap, what are we going to do?" Paul said, "I'll find you somebody." They got Kelly Slater.

VIG: The number one surfer in the world.

MANSON: Pamela Anderson came to the video shoot.

MARKER: That was pretty exciting.

But the video itself, directed by Stephane Sednaoui, was not. Essentially, Manson is the only band member featured in it. Between that and "The World Is Not Enough," the boys had begun disappearing from the screen in favor of Manson. This was not entirely unexpected. Meredith Cork remembers when Sednaoui made "Milk," the final video from the first record. "None of the guys were in focus, it was all about Shirley. And I was like, 'Stéphane, people need to see the guys. They need to be sharper.' He looked at me and he said, 'Meredith, you're asking me to turn an orange into a peach.'"

X X X

Opposite top: Manson and eleven-time World Surf League champion Kelly Slater on the set of the video for "You Look So Fine," directed by Stephane Sednaoui; opposite bottom: Garbage backstage at the *Late Night with David Letterman* show, November 1, 1991, where they performed the James Bond theme "The World Is Not Enough"; previous pages: a Joseph Cultice publicity shot to promote *Version 2.0*.

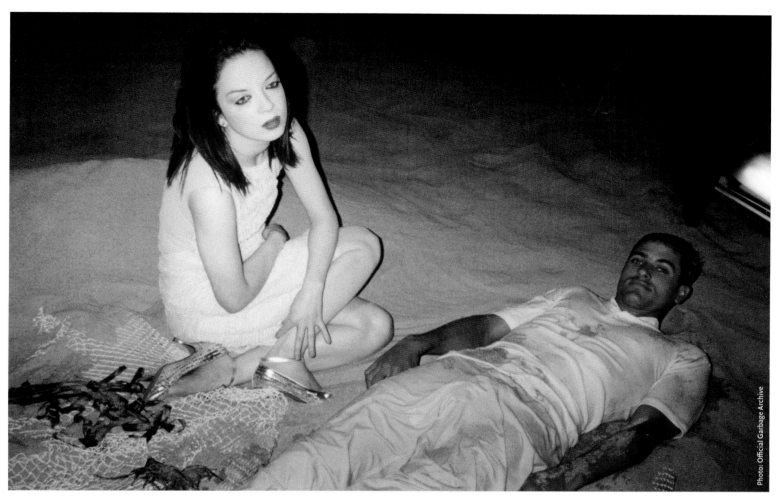

Photo: Official Garbage Archive

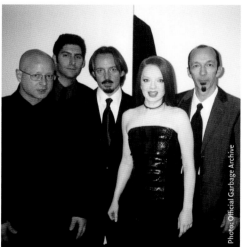

Photo: Official Garbage Archive

Despite the success of *Version 2.0*, the change of management hadn't gone well. "Borman couldn't handle business discussions with me," says Manson. "He was a white-gloved kind of manager—very timid, a real gentleman. And of course, I'm really aggressive and in your face." So, Manson says, Borman proposed that Moir "deal with the girl" while Borman dealt with the boys.

"It was pretty interesting to see how, as strong as she is, still the record company people would come in and talk to us before they'd talk to her about something important a lot of the time, and managers treated her like shit," says Marker. "They assumed we were the geniuses and she had nothing to do with it."

Management and press continued to see Vig as the band's mastermind, which wore on him and offended everyone else. "Gary would kind of direct stuff—'Should we do this?'—at me, even though we're all sitting there," says Vig. "It pissed Shirley off. It also really pissed Duke and Steve off."

Vig developed a tactic for handling such moments: "I learned if you ask me a question and I'm looking at Shirley or Duke, you're actually gonna turn and look at that person. I've done the same in interviews, when early on some guy would be asking me, 'So, Butch, what do you think about . . .' and I'd look at Shirley or Duke or Steve until the person asking the question would direct it over there."

Eventually, of course, it was Manson everybody wanted—especially for magazine covers and videos. That was fine when it was for a women's magazine or fashion photo shoot, but less than ideal when it was a music publication.

MANSON: I definitely carried a lot of the weight on that. Looking at the press, I'm shocked at how many cover shoots I did. Whenever possible we wanted to be shot together, but you know how it goes.

ERIKSON: We thought it was important to maintain that "we're a fucking band." It's for everybody's good in the end to keep it that way. But every now and then they'd pluck her out for a cover.

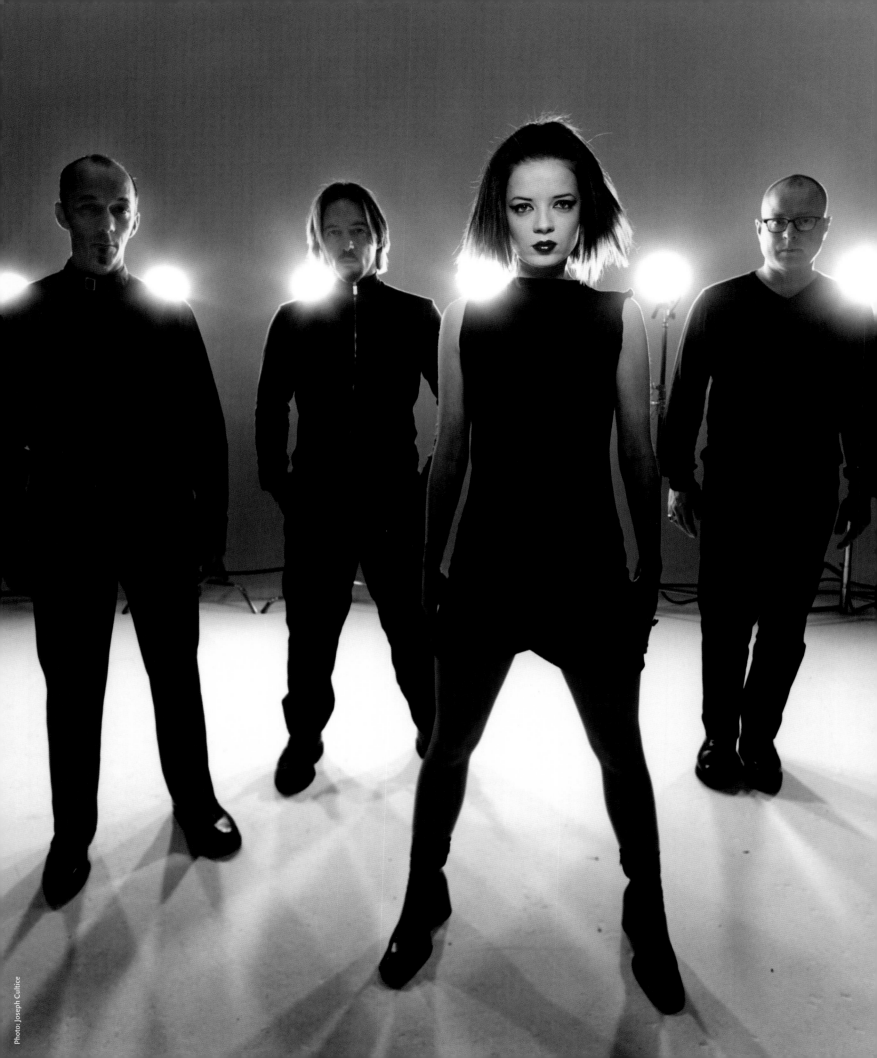

VIG: I remember the first week we were doing press in Paris for *Version 2.0*. We were staying at the Hôtel Costes, and we came down, all four of us, and they said, "Okay, you guys can go." We looked at the schedule and it was all Shirley. She had ten things in a row and we had one thing to do at five p.m. We went across the street, ordered a bottle of wine, and went, "How come we have to sit around just to come back and do this one thing?"

ERIKSON: We spent a good amount of time sitting around drinking, waiting, eating, sleeping, waiting, watching TV, waiting. And the reason we were waiting was because Shirley was either doing an interview or Shirley was getting makeup or Shirley was shooting her scenes for the video. But Shirley was working her ass off while we were waiting. When we were first doing videos, Shirley would have a six thirty a.m. lobby call, and the rest of us would be at ten, eleven. I used to get up early to go with her to show her some support, and she appreciated that, but after a while she said, "Duke, you don't need to do this anymore." I said, "Okay, good."

From the trenches of the road, Kohl had a much better sense of how the band worked, and ran interference. He'd come a long way from his "girly" days. It caused some conflict with management, who resented the fact that the band always listened to his opinion.

"They would give us their advice and then we'd go and ask Harald what he thought," says Manson. "We invariably took Harald's advice. They even tried to get rid of Harald, and we were like, 'We're not getting rid of him. End of story.'"

In fact, the band told Kohl they didn't feel supported by management and asked him to watch their backs. "We didn't trust them," Manson says.

Unfortunately, *Version 2.0* would be Kohl's final tour. (He is now a financial manager in Seattle.) The band owed him a lot and were sad to see him go. "I don't think crew ever really think that they have that much effect on the bands," says Manson, "but in Garbage we were very close with our crew, and we loved them. I was devastated when Harald left."

For his part, Kohl found working with Garbage—especially with Manson—transformative. "I learned a lot from Shirley," he says. "It was an educational experience for me as a human being as to what life is like for women in a man's world. In general, I would not give it a second thought to just go out somewhere, day or night, all alone. And I never would have realized that had I not been in the position where I needed to. I learned how different the world is for women. So I grew as a human being."

With Kohl departing and management relations souring, the sense that it could all disappear at any second hung heavy. "There was quite a dangerous amount of self-doubt and negativity brewing," says Manson.

In part, this was due to tensions in the music industry itself. As the nineties were ending, the industry was shifting its focus to pop stars like *NSYNC and Britney Spears, who were cooperative with marketing and less concerned with having things their own way. "We sold millions of records and toured all over the world," says Erikson, "but at the time the industry was so negative. Even if you sold ten million records, they always said you could have done better."

"We'd play a show in, say, Amsterdam and then the record company rep would go, 'Well, we could have got the single in the Top 10 if you had actually come here before now, but you said you couldn't,'" says Vig. "'We wanted you to do this TV show and your manager said you didn't have time.' It was always this negativity."

"Anything we did just wasn't good enough for the record companies," says Erikson. "So at the time, we never felt like, *This is amazing!*"

But the band tried not to take anything for granted. "Duke once said to me, 'You know, the best thing about this is we're old enough to appreciate it all.' And they really do," says Bortnick. "They're really appreciative and they really love their fans and they're great, great people."

"I think if we had been young we probably would have perceived it as, *It's going to go on forever,*" says Vig.

"We probably would have partied way more than we actually did," adds Erikson. "Therefore we would all be dead."

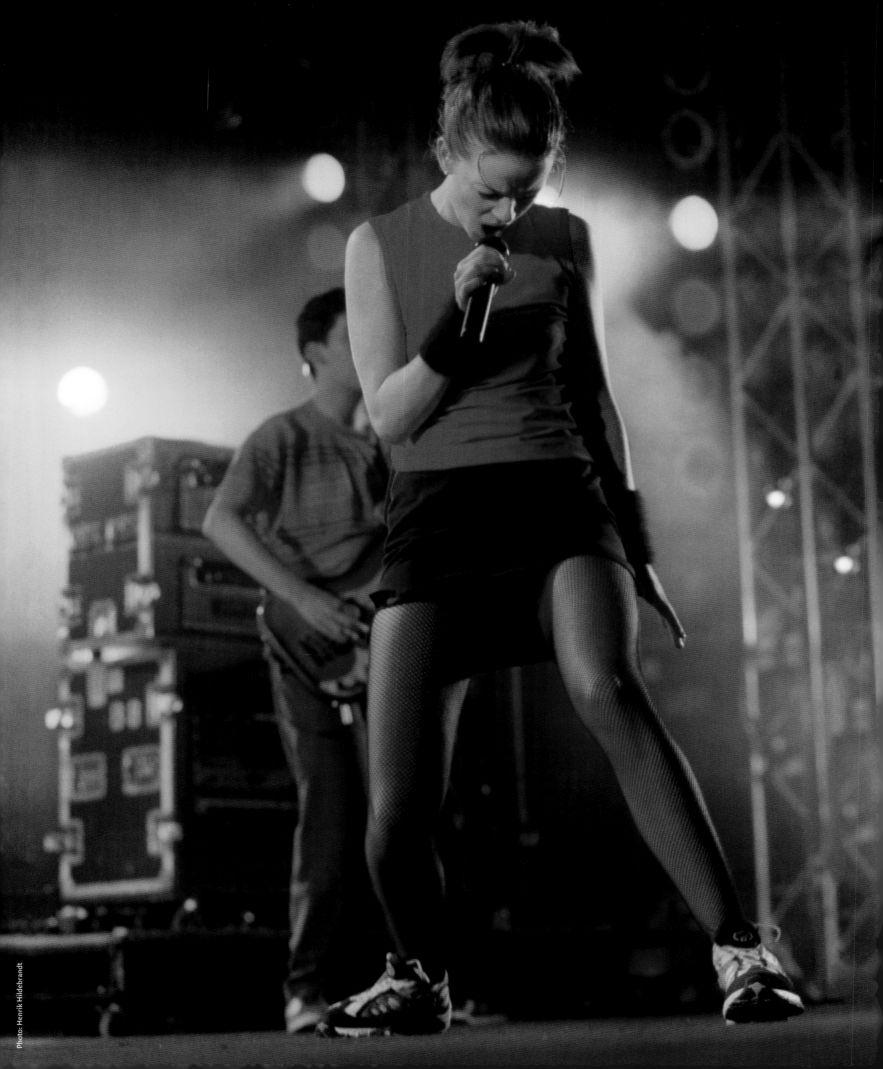

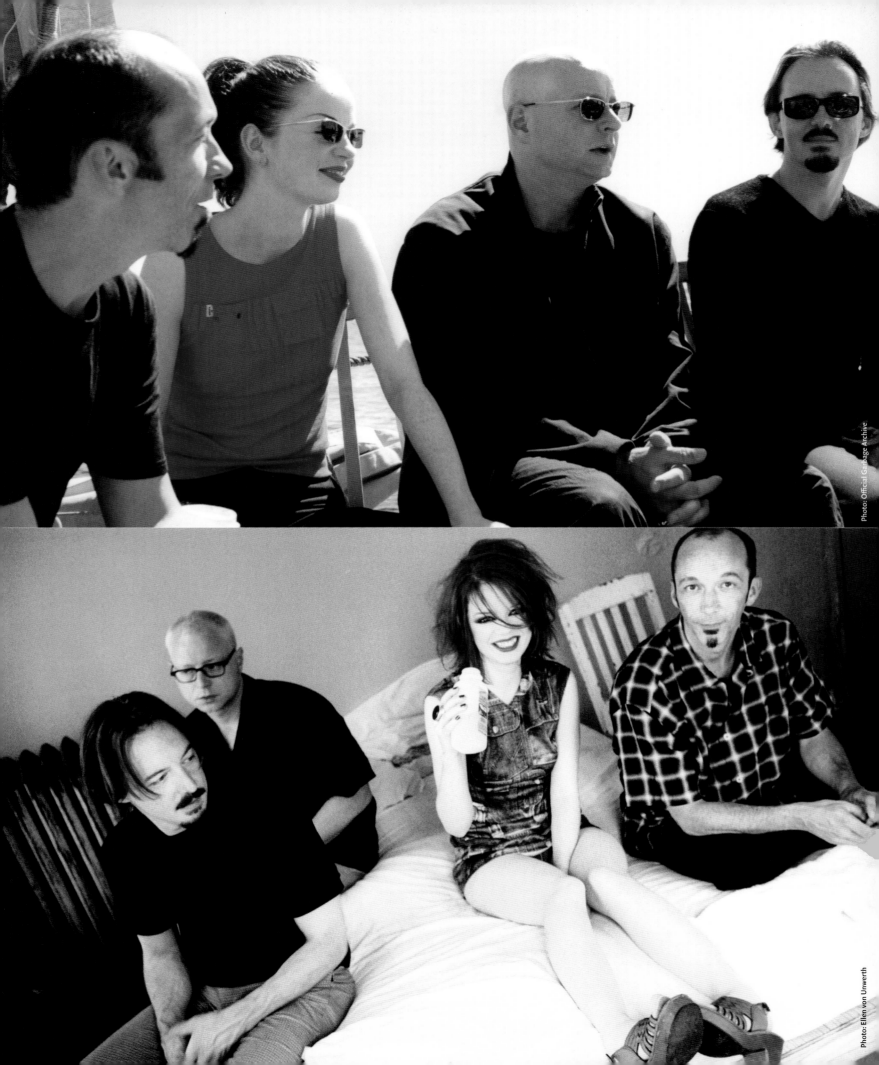

TUMMY TROUBLE

To be in a band is to experience food-borne illness. Often. And still not miss a show. The four members of Garbage could fill an entire book with tales of stomach woe. Consider these tales a very different version of Garbage's greatest hits.

There was the Falafel Incident in Jerusalem, during an otherwise fantastic (and rare) day of sightseeing. There was the Lentils Situation in Philadelphia en route to Washington, DC (though some accounts have it as DC en route to Philadelphia), in which tainted lentil soup served at preshow catering was consumed by everybody in the band (including band guests and family members) except for Manson. The ensuing gastric problems resulted in sealed baggies being tossed out of the tour bus window, in obedience to one of the most sacred rock and roll commandments: "No Number 2 on the Bus."

"When we pulled up to our hotel, there was a rush to see who could get out of the bus and into the lobby restrooms first," says Manson. "Good times."

More good times: In 1999, on the *Version 2.0* tour, food poisoning very nearly derailed the band's gig at the Big Day Out festival in Castlegar, Ireland. The day before, a show in the Spanish Pyrenees was preceded by a head-bumping, stomach-churning six-hour van ride, which the band had chosen over a helicopter. "The whole time, the kid driving is like, 'Hey, man, I love you guys,' while going eighty miles an hour on these five-mile-an-hour hairpin curves," Vig remembers. "It was fucking boiling hot, and I had the runs, gagging, throwing up. I had a shot of vodka to numb myself out a little bit, and made it through the show."

But then the journey from Spain to Ireland for the Big Day Out show included a bus ride *out* of the Pyrenees to Paris, a cancelled flight, four hours of sleep, an eight-hour delay on the rescheduled flight, and another couple of hours on the bus to County Galway. The entire time Vig was making twice-hourly trips to the bathroom. It took so long to finally get to Big Day Out that the Beastie Boys had to graciously agree to swap positions on the bill and play in Garbage's slot. Even so, there was still only enough time for Garbage to play seven songs, which at least meant Vig could quickly get back to the porcelain throne.

Yet this was not the most epically awful case of gastrointestinal distress in Garbage history. That honor goes to a raging case of Montezuma's revenge that visited Manson during the band's first year of touring, in the summer of 1996.

MANSON: It started out in Mexico City. They threw a party for us when we first got there, in this really cool club, and they had beautiful girls handing out beautiful little tidbits. Everyone had said, "When you go to Mexico, don't drink the water. Make sure you drink bottled water. Brush your teeth with bottled water. And don't eat anything that hasn't been cooked."

ERIKSON: "Don't have the salad."

MANSON: "Do *not* eat salad." So anyway, I can remember like it was yesterday: The girl came up with these little taco things, tiny little puffed tostadas, and on top of them was refried beans, guacamole, and some salad. I remember just going, "Oh, fuck it." Cut to the following day, we play a show. Beforehand, I'm feeling dreadful. Really dreadful. I'm going to the toilet a lot. I go onstage, I start singing, and we're having a great gig, and then all of a sudden I feel . . . *the shift*. Not only am I going to vomit, but I'm going to fart and/or poo. So I had to run offstage. Next day, we're back in Los Angeles for the KROQ Weenie Roast, when KISS reunited after twenty years or whatever.

ERIKSON: Which is enough to make your tummy go . . .

MANSON: My tummy is going crazy. As is my bottom. If I put anything into my body, it comes out five minutes later. And it's a KROQ show, and they want photographs of me with Gwen Stefani and No Doubt. Everybody's like, "Come over here and get your photograph taken!" And I'm feeling like shit. I am shitting. So I take photos with Gwen. I'm trying to look happy but you can see in the photos—she's all blond and happy and "YES!" and I'm barely holding on. I get back to the dressing room, and I'm sitting with Steve, and all of a sudden I go, "Steve, I'm gonna have to go to the Portaloo!" The artist toilets, for whatever reason, are too far away—so we go to the punter toilets.

MARKER: Yeah. There's a whole line.

MANSON: A massive queue. Massive. And I say, "Steve, I'm not fucking kidding, I need to go to the toilet right now!" And Steve, who's the quietest, sweetest man around—

MARKER: "OUT OF MY WAY. SHE NEEDS TO GO. SHE'S GOTTA GO NOW!"

MANSON: He's pushing people out of the way—

MARKER: And they're all like—

VIG: "Wait, that's the singer in Garbage. Shirley Manson."

MARKER: "SHE'S GOTTA GO REALLY BAD!"

MANSON: When you have a parasite, it's like coming out 360 degrees. I kept wondering who the person was who got in there after me. Oh, it was so bad.

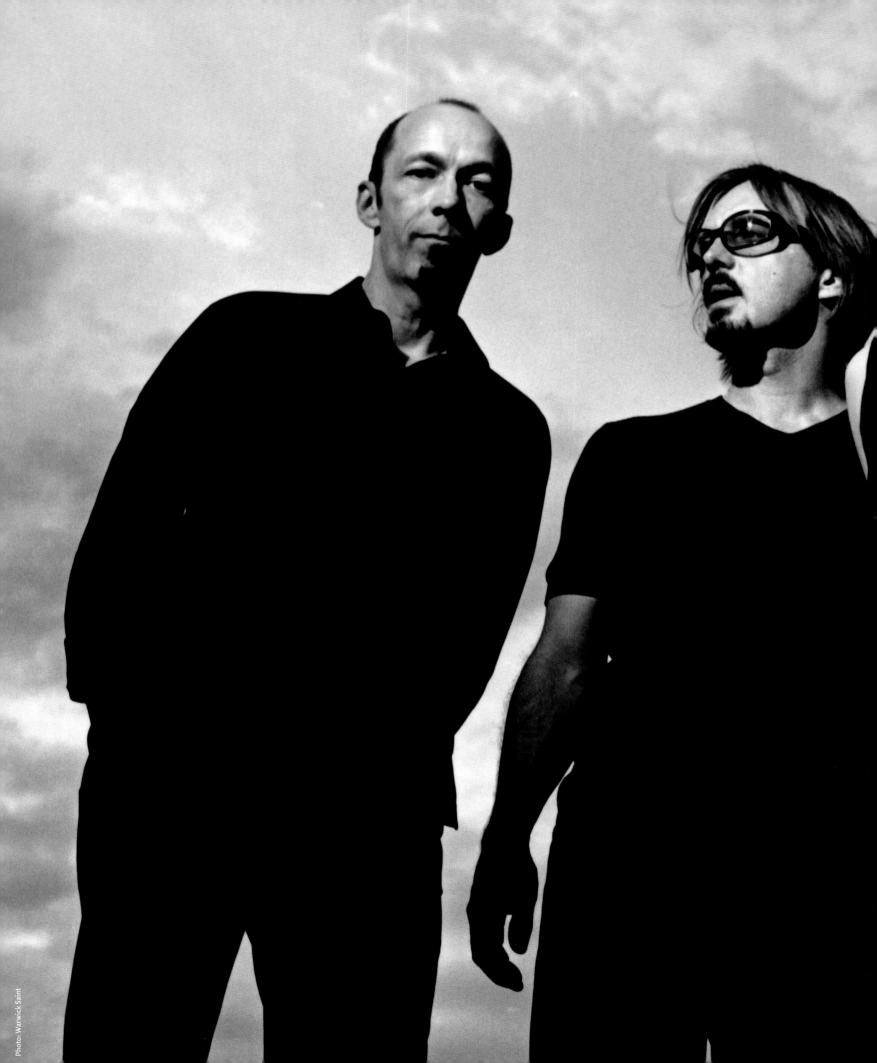

CHAPTER 6

21ST OF OCTOBER, 2001. NEW YORK— LOOKS LIKE BUTCH HAS HEPATITIS A. AND OH MY GOD......HE LOOKS SO ILL, IT MAKES ME WANT TO CRY. HE'S COMPLETELY JAUNDICED. EVEN HIS EYEBALLS ARE YELLOW. OF COURSE TRUE TO FORM, LIKE THE TROUPER HE IS, HE'S DECIDED THAT HE WILL INDEED BE ABLE TO MANAGE IT INTO THE VIDEO SHOOT TOMORROW FOR CHERRY LIPS BUT HE DOESN'T THINK HE'LL BE ABLE TO LAST THE ENTIRE DAY. WE'RE GOING TO HAVE TO SHOOT ALL HIS STUFF FIRST AND THEN SHOOT AROUND HIM. LUCKILY THE CONCEPT FOR THE VIDEO DOES NOT REQUIRE HIM TO BE PRESENT 100% OF THE TIME SO ON THAT SCORE AT LEAST, WE GOT LUCKY. OH BY THE WAY........I'VE DYED MY HAIR THIS AFTERNOON. I'M NOW A BLONDE!!!!

—SHIRLEY MANSON'S WEB DIARY

In the fall of 2001, Shirley Manson went from redhead to blonde, and a gravely ill Butch Vig turned yellow. But the color the band most associates with their third album, *Beautiful Garbage*, is black—as in the American Express Black Card belonging to Cliff Burnstein of Q Prime management.

For the third time in as many records, Garbage had changed representation. In the summer of 2001, Burnstein and his partner, Peter Mensch—the duo best known for handling Metallica, Hole, and the Smashing Pumpkins—came to Madison to hear the tracks for what everyone involved imagined would be the biggest Garbage record yet. The playback had gotten no further than the third song, "Can't Cry These Tears"—a towering girl-group confectionary with an electronica breakdown—when Burnstein reached into his pocket. "He said, 'Here's my credit card,'" Vig remembers. "'It's gonna be a massive single.'"

Mensch and Burnstein's optimism, as well as Q Prime's big-gun status in the industry, was crucial because the success of *Version 2.0* did not shelter the band from yet another round of music business machinations. In Australia, Michael Gudinski had sold his Mushroom label to Rupert Murdoch's News Corp, while in the United States, Almo Sounds had simply ceased to exist. Jerry Moss shut down the operation and sold both Almo and his Rondor music publishing company to the Universal Music Group. In the process, Garbage was absorbed by Interscope Records when the growing megalabel swallowed up Almo's manufacturing and distribution partner, Geffen.

And so a band that had chosen all of its record deals because the companies were small and independent now found itself on a major label, with a company president, Jimmy Iovine, who had declined to sign them the first time around. Being on Interscope was not what the band wanted, and it wasn't clear that Interscope necessarily wanted them either. Regardless, while many Almo bands were simply cut from the roster, Garbage was too valuable for the Universal Music Group to just let go.

Still, Interscope had clout. With Garbage coming off a very successful record in *Version 2.0*, both Interscope and Mushroom were willing to spend money on the follow-up. *Beautiful Garbage*'s cover design and artwork alone cost $75,000—a far cry from the first two record covers, which the band had largely hand-assembled. The labels paid the same amount to the Neptunes for a remix of the album's first single, "Androgyny," which hit radio in August 2001. A UK promo tour was booked, and the video premiered on MTV in the UK and VH1 in the US.

That was on Monday, September 10, 2001.

The next morning, unable to get anyone to answer their calls, the band got up and—as previously arranged—reported to the studio of Madison's public radio station, WHA-AM, for an

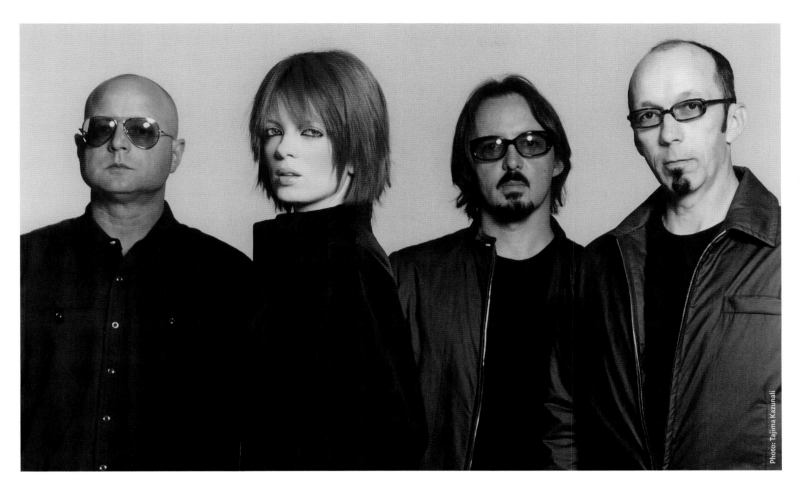

Left: Manson in front of famed rock-and-roll haunt the Chelsea Hotel in Manhattan; above: the band at the start of the *Beautiful Garbage* era, which found them with new management and a new label.

interview with national NPR. "To promote our stupid pop song," says Marker. "Everybody's just staring at the TV, and we're like, 'Hi! We're here for our interview.' And they were like, 'Uh, I don't think you're doing an interview.'"

The band were also slated to fly to London on September 12, but all flights were grounded. They had an extra week to consider just how to move forward. "We made the decision we had to carry on like everybody else in the country did," says Marker. "But it felt fucking weird."

"It was hard to talk about a rock record when all anybody wanted to talk about was, 'What's it like for Americans to finally feel terrorism on your own soil, on your own shores?'" Erikson says. "And rightfully so. We didn't know really how to respond."

"Androgyny" proved to be the wrong song for the moment. In the weeks following 9/11, no one knew exactly what to do with a playful song about gender confusion that merged R&B hooks with rock guitar. "Radio banished all sorts of songs, anything weird at all," remembers Erikson. "And this was a song about cross-dressers and transgender people or whatever. That wasn't going to fly for a second."

One night, as the band was waiting to perform "Androgyny" for an October 5 broadcast of *Top of the Pops* (a rare lip-synched version, due to not being able to get all of the equipment to the UK), Mushroom's Korda Marshall and his top radio promoter stopped in for a visit.

"They both looked devastated," Manson says. "They were like, 'We need to talk to you right now. Your record's fucked. *You're* fucked. We cannot get it played on any radio station and we have no plan B.'" The record had only been out two days at this point. "We had never had a problem getting played in the UK before, and coming off of a record as successful as *Version 2.0*, we had no reason to believe that we would meet with such sudden resistance. We were all caught completely by surprise."

Lost in all this was the fact that Garbage had gone out on a limb and made their most adventurous and ambitious record thus far. *Beautiful Garbage*—"our most unloved child," says Manson—was a swing for left field when many bands in Garbage's position would have continued to mine the formula that had brought them success.

"It's kind of a punk rock record," Manson says, "because we went absolutely against the grain of what was expected from us. We could have turned out another *Version 2.0*, and we

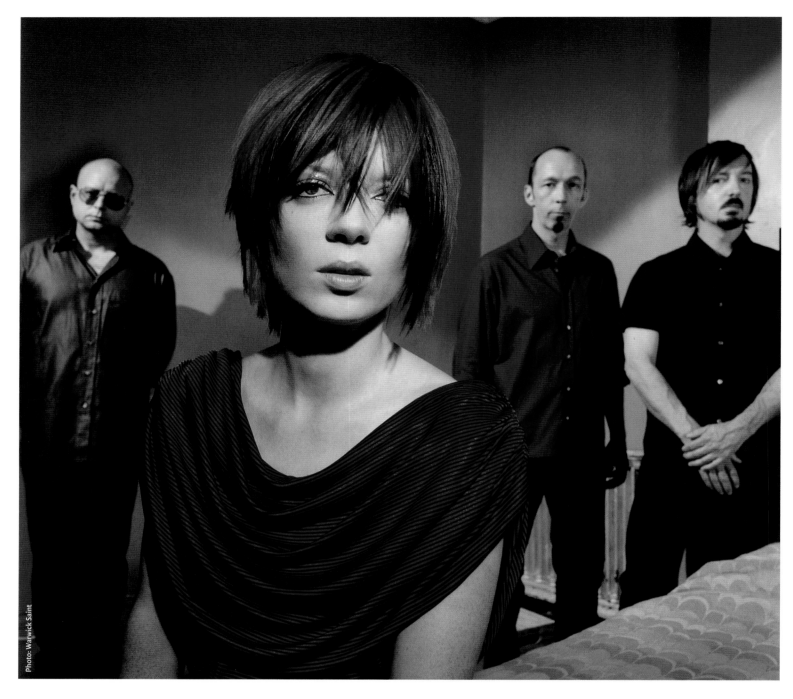

decided not to. We wanted to completely flip the playing board, and we did. We took a lot of chances. And then it just tanked."

"Tanked" may be an overstatement. Released October 1, 2001, *Beautiful Garbage* debuted at #13 on the *Billboard* album chart as well as at #1 on *Billboard's* Top Electronic Albums, where it remained for seven consecutive weeks. In addition, the album peaked within the Top 10 in the UK and multiple other European countries, coming in as the week's highest new entry at #2 on the European Top 100 Albums, besting new releases from superstars like Elton John and Kylie Minogue.

"*Beautiful Garbage* got amazing reviews, that's the irony of it all," says Manson. In fact, the album ultimately placed at #6 on *Rolling Stone's* year-end top albums list, with writer Rob Sheffield declaring Manson to be "one of the great Bowie girls of our time."

Vig describes it as the band's most eclectic record. "We jumped all over the place," he says. "We tried doing weird experimental pop stuff and some really heavy rock stuff." The diversity was partly due to creative ambition and partly to happy accident. In hindsight, however, the making of the album was by no means a cheerful experience. The band had gone into *Version 2.0* feeling unified, but that feeling had dissipated. Worse, they no longer wanted to work side

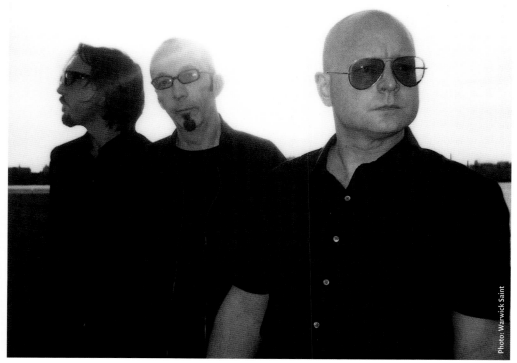

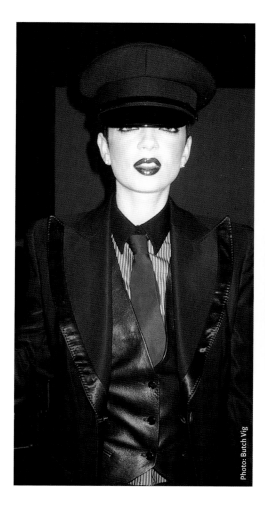

Above: Manson dressed as a chauffeur on the set of the "Androgyny" video; right: the Boys in Black; opposite: a photo by fashion photographer Warwick Saint from the *Beautiful Garbage* album package shoot.

by side, or necessarily even be in the same room together. The technology they'd exploited in the past meant they didn't have to be. Pro Tools made it easier for each member to work on his or her own, especially now that they didn't need an engineer to learn the basics.

"It became less of a group recording process and more of a fragmented process," says Billy Bush. "Duke would work on a guitar part and I wouldn't have to be in the room. Or Steve would be in there doing something for days and we'd just check in on him. 'Is everything cool?' 'Yeah, I have something I'm working on.'"

"We were so scattered," Erikson says. "We were all just searching for the right direction, for *any* direction. Everybody was bringing in disparate ideas. I remember Shirl wanting to bring in an arranger for the strings on 'Cup of Coffee,' which no doubt would have brought something interesting to the equation. But I was adamant that we could find our way ourselves, and in the end I was glad I stuck to my guns because that turned out to be one of our best moments. But disagreements like that didn't do much for band morale."

The difficult process resulted in an interesting album. "I think they were trying to figure out what the 2000 version of the band was going to be," says Bush. "Missy Elliott was doing amazing music. Timbaland was doing amazing shit. Prodigy was doing cool shit. Being a band that was built on taking an influence and mutating it into an unrecognizable form—they loved all that stuff, and ended up making a record which was really forward-thinking. It showed how many different directions the band could go sonically and it still works as the band."

But where Garbage was futuristic and eclectic, the rock zeitgeist was once again turning to less polished, more riff-driven sounds. The press and the indie audience were giddily enraptured by the Strokes and the White Stripes. Manson remembers reading about the White Stripes in *NME* and quickly purchasing their album after listening to a few thirty-second samples. "As I hit *BUY* I remember thinking, *We're fucked*," she says. "Because I knew that music had changed and that this music coming out of Detroit and New York was the new sound. We had been a counter point of view, and then all of a sudden here was the counterpoint to us. It happens to every artist, always. But it was weird to be aware of it."

That wasn't the only problem. "By that time," Korda Marshall says, "three albums, four or five years in, the people who loved them when they were thirteen, fourteen, fifteen years old were now eighteen, nineteen, and twenty, and no longer Radio 1's core audience."

"We had sixteen consecutive Radio 1 A-list tracks," Manson says, "and then along came *Beautiful Garbage*, and that was it. We were dropped from playlists, more or less never to be played again because we were seen as this band that had fallen from great heights."

Except where they hadn't. Half a world away, in Australia, *Beautiful Garbage* turned out to be a chart-topping smash, buoyed by the massive radio success of "Cherry Lips (Go Baby Go!)."

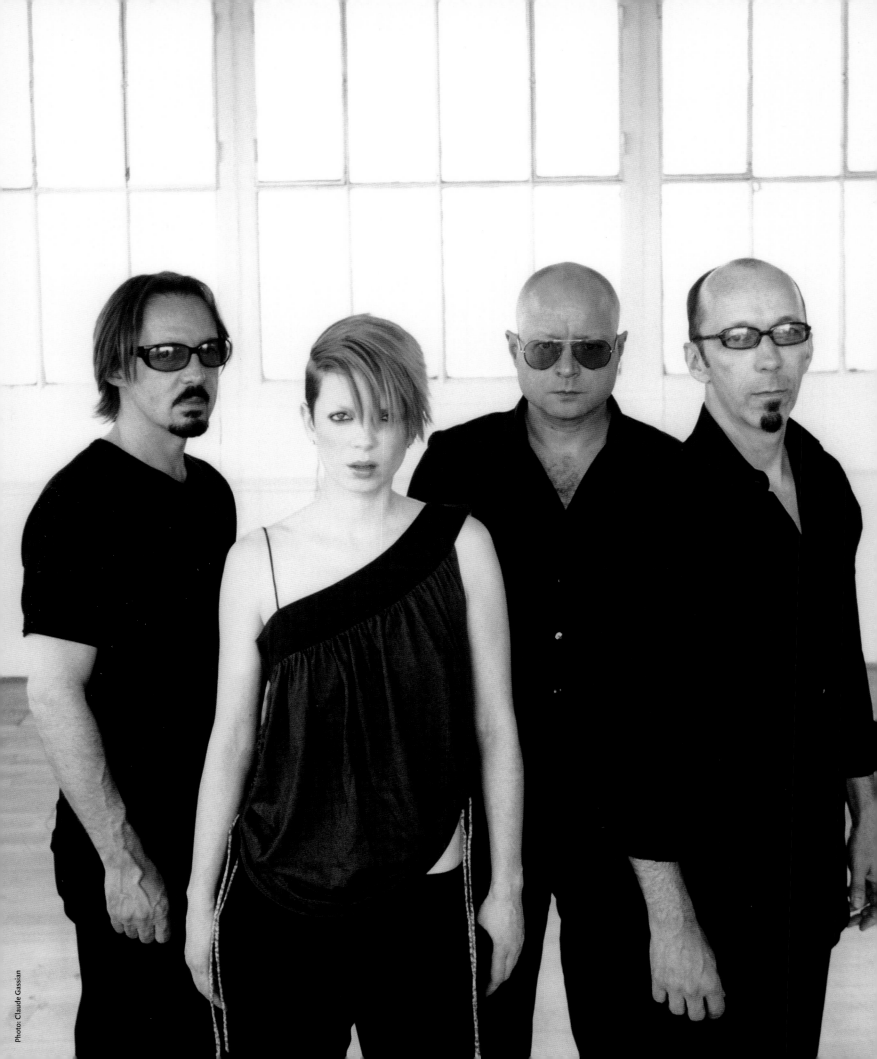

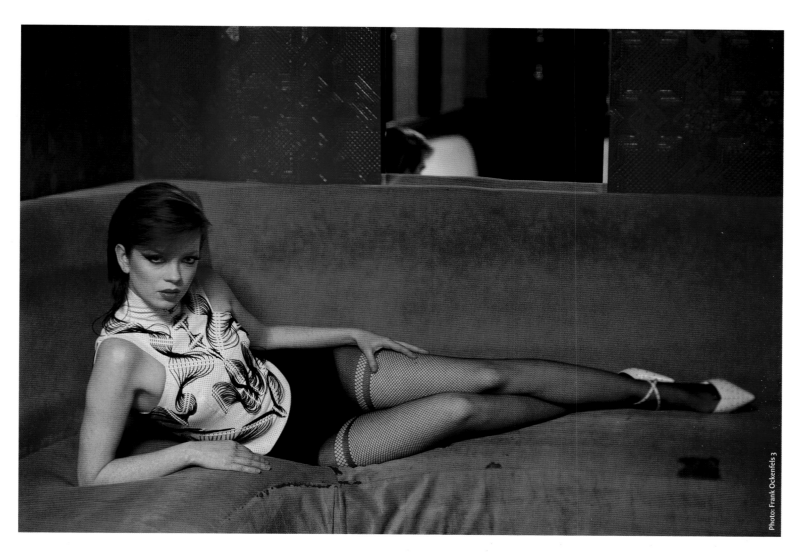

Photo: Frank Ockenfels 3

Above: Manson shot by Frank Ockenfels 3 in Santa Monica; left: the band shot in Paris by legendary French photographer Claude Gassian while on a promotional tour for *Beautiful Garbage*.

"Cherry Lips" is one of the many Garbage songs that resonates with the band's LGBTQ fans. Starting with "Queer" and continuing all the way to "Not Your Kind of People," the eponymous track off the fifth album, there has always been at least one such song on every Garbage album. "I've got some weird gender issues myself, and I always have," says Manson. "I've always felt aggrieved in some ways about being born female—it's curious. The four of us are intrigued by gender, or whatever that is."

Vig remembers the music he and Erikson played in Spooner being dismissed as "fag music." Marker says, "We always felt like outsiders as a band. We were weird-looking and too old and from Madison, Wisconsin. And that translates to wanting to support other groups of people who find themselves battling the system."

Manson's lyrics for "Cherry Lips" were inspired by the writing of JT LeRoy, the author of *The Heart Is Deceitful Above All Things* and *Sarah*. Like the rest of the world, Manson understood LeRoy to be a former teenage truck-stop hustler who'd escaped the streets to become a writer. "I had been embroiled in an e-mail dialogue with JT LeRoy for a few months by the time Butch brought in a surprisingly poppy instrumental that inspired 'Cherry Lips,'" says Manson. "I wanted to write an ode to the transgender spirit, inspired by my interactions with this peculiar but emotionally generous creature I knew online as *JT*." Years later, the LeRoy persona was revealed to be a hoax, the invention of writer Laura Albert. "I know lots of people felt conned in the end," says Manson. "I didn't. I just felt sad that a woman felt she would stand a better chance in the world if she was a man, that JT was 'dead' and wouldn't be part of my life anymore."

"Cherry Lips" became a huge hit in France and Italy as well as Australia, where it spent five nonconsecutive weeks in the Top 10. "We ended up having our biggest hit in some countries with that song," Vig says.

"And we were basically forced into spending a million dollars on a video," adds Marker.

Marker exaggerates slightly. But with little idea how to promote *Beautiful Garbage*, Interscope

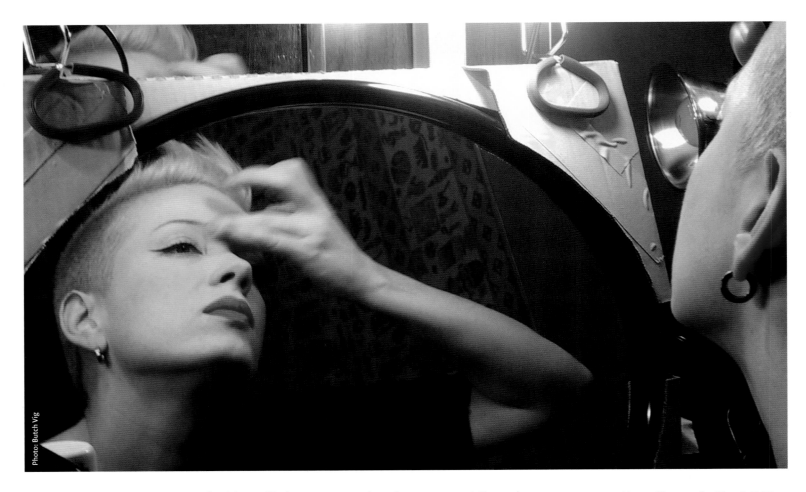

Photo: Butch Vig

did what many labels did in those final days of industry power—they threw money at the problem. Rather, they threw money at video director Joseph Kahn, an MTV Video Music Award winner known for his work with Snoop Dogg, Destiny's Child, and Britney Spears.

"We got bullied into making that video," Manson says. "Everybody from management to the video commissioner at Interscope basically said, 'You have to. You need to. You don't want to alienate the record company or then you are really all out there on your own.' They wanted us to go with Joseph Kahn because he had an 'in' with MTV. Turns out MTV never played the video. Joseph Kahn has made some amazing videos in his time, but this unfortunately wasn't one of them."

The "Cherry Lips" video production was beset by difficulty from the start, with Manson arriving on the Brooklyn set with a bright-white peroxide buzz cut.

"She looked great," Vig says, "but it was a shock. 'Holy cow, Shirley chopped her hair off.' The record company freaked about it, like now she didn't fit the image from the previous records."

"It was an odd marketing strategy, from their perspective," Erikson says.

"Exactly," Vig says. "You're messing with the brand."

"I just remember being impressed with the move," Erikson says. "It reminded me of Bowie. I didn't realize she was freaking out or anything."

In fact, Manson's hairstyle change was an outward sign of significant inner turmoil. She'd just begun what would prove to be the long, drawn-out process of divorcing husband Eddie Farrell. The fragmentation and ultimate breakdown of that relationship had also been an understandable distraction during the *Beautiful Garbage* sessions.

"Shirley was not paying a lot of attention," Erikson says.

"I was so isolated, angry, upset, and vulnerable," Manson explains. "I really had a hard time on that record. I was not myself. I was miserable." And touring again was no help. "There was no real support structure in place. You're just sort of getting on a smelly bus and going to the next smelly gig. I couldn't go outside because I was highly recognizable. So I was just cooped up in my hotel room *all day long.*"

Months later, troubled by the public and industry response to the album and her own stardom, Manson had had enough. "In some ways, it was a reaction to how omnipresent we'd

Above: Manson, the Blonde Edition, as photographed by Butch Vig; opposite: on set of the video shoot for "Cherry Lips," shot by Erikson's daughter, Roxy.

THE GREAT LOST "CHERRY LIPS" VIDEO

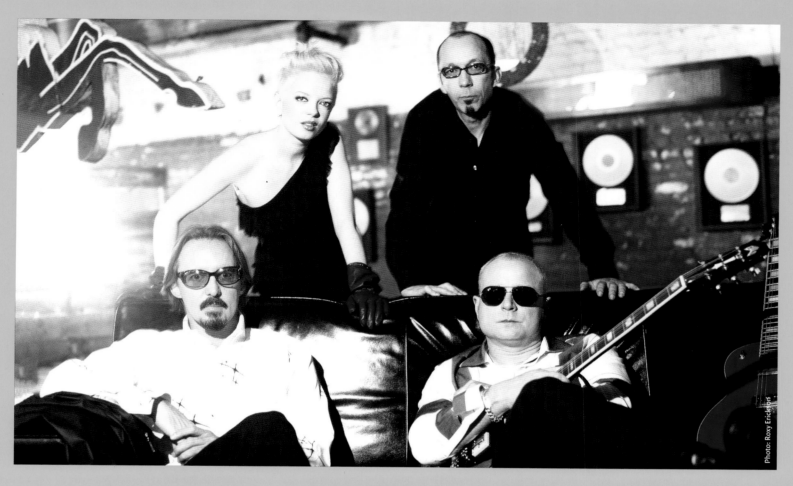

Photo: Roxy Erickson

The video for "Cherry Lips" was not the band's first choice.

"We got bullied into making it," says Manson. "Interscope basically said, 'You have to go with Joseph Kahn. Then you'll get on MTV.'"

Kahn was then hot off his work with Destiny's Child ("Say My Name"), Britney Spears ("Stronger"), and U2 ("Elevation"). But Manson had her heart set on Dawn Shadforth, who'd collaborated with Garbage on "Special," and whose star was rising further on the strength of the vintage sci-fi-styled video she'd directed for Kylie Minogue's "Can't Get You Out of My Head."

Knowing that "Cherry Lips" paid tribute to the writing of JT LeRoy, Shadforth put together a video treatment inspired by the twisted fairy-tale quality of LeRoy's writing. She wanted to combine that with the sleaze of sixties biker movies and the futuristic energy of Japanese manga comics to make a video full of "super-real hot-rod racing, cartoon energy blasts, and fireworks, lizard people, and twisted candy-pop gloss," as she put it in her treatment.

Shadforth saw the video as "a celebration of extraordinariness and difference" populated by "rare, weird, and wonderful creatures—alien beings," and set in an alternate universe truck stop. The lizard people were her take on the lot lizards (or truck-stop prostitutes) that LeRoy wrote about in the novel *Sarah*, but pushed that concept "into the surreal, so we are not being literal to the book—the people are literally lizards under the skin."

Garbage would be the house band at the truck stop, with manga animation sequences cued to the guitar parts. The truck-stop denizens appear normal at first, but the music transforms them. "When the people start to dance, a hint of 'lizardiness' appears, a tail creeps, and a tongue licks. Blink and you might miss it, it's subtle and a tease, not full-blown prosthetics. It's done in a really beautiful way, like a high-concept fashion still."

The video ends with a hot-rod race and a flying saucer: "Shirley climbs aboard the top or side of one of the cars; the ride is for the sheer thrill of it. Again the shots are stylized—the colorful cars, clothes, and people against the starry night sky. It's rock and roll but at the same time magical looking. The wind and slow motion add to the slick beauty of the performance shots. Meanwhile, inside the cars, the lot lizards are at the wheels, releasing their true 'lizardiness,' chasing the flying saucer, their faces flashing from human to lizard in between the strobe flashes of static electricity."

Shadforth's concept felt more connected to the song, which was an especially personal one for Manson, but Interscope's marketing desires prevailed and, ultimately, failed. Kahn's creation—full of television sets playing grainy video footage, and highlighted by a special effect where the band becomes invisible but their clothes don't, so it looks like cutout doll clothing is playing the music—got little MTV play.

"I still to this day remember Dawn Shadforth's video treatment," says Manson. "I feel brokenhearted that we never made it."

become," Manson says. "During *Version 2.0* I was walking through an airport terminal and I saw my face looking back at me from every newsstand. I was on the front cover of something like six magazines that month, and I was just so embarrassed to walk through that airport. I was angry and pissed off and I didn't want to be the pretty pinup girl of the nineties. I didn't know that at the time, I just knew that I was angry and fed up with reviewers talking about my mini-skirts and whether I was more fuckable or less fuckable than one of the girls in Steps."

Looking back, Manson sees herself as thumbing her nose at expectations. But she also sees something more than a rock star playing with her image—she was in crisis. "I was on the edge of a breakdown. I showed all the classic signs—I mean, *I chopped my fucking hair off*. And nobody said anything. How can you see someone you see every single day who has long red hair, then see them the next morning and they have short peroxide hair, and not say anything? It made me even more angry. The environment I found myself in felt so unhealthy that even when I changed my hairstyle in such an extreme way on the day of a video shoot, everyone just pretended it didn't happen. I started to wonder if I stood there and stabbed myself or immolated myself, would they ever say anything?"

"I think we were just shocked," says Marker. "As she describes it now, it's like, *My god, why didn't anybody take care of her?*"

Manson's reimaging was equally shocking to Garbage's audience. "The fans went mental," she says. "The music press went mental. I was no longer, in their eyes, a sexually attractive woman. Of course, I *loved* it."

Despite the disappointment of "Cherry Lips" failing to gain traction at MTV, the network requested the *Beautiful Garbage* track "Breaking Up the Girl" for their hit animated series *Daria*. The promise: it would be on the show, and MTV would play it twenty-four times a week.

"So we went and made a video for 'Breaking Up the Girl,' and they did *not* end up playing it twenty-four times a week," says Vig. "It fell by the wayside; it had no traction at radio. The whole cycle of that record was really fractured."

Adding to that fractured feeling was the band's attempt to dissolve their forced union with Interscope. Their contract had a "key man" clause for Jerry Moss, just as it had had with Gary Ashley and Mushroom. Moss, though, claimed to still be in Universal's employ, and there was some question as to whether this even mattered, as Manson also remained bound to Radioactive, a Universal company. The band sued to void both contracts, but lost.

"Jerry kind of fucked us in the end, because he flopped us over to a label that didn't really want us," says Manson. "We originally signed to two indie labels and then ended up being engulfed by two major labels." And engulfed at just the moment that Garbage singles stopped getting radio play. "For a major label, that's a disaster," Manson continues. "After two weeks, they're over it."

Years later, Manson found herself on a long international flight, in conversation with "a very, very famous rock star who I cannot name. He sat next to me and told me that he had witnessed a discussion—this is a true story—at Interscope about whether they were going to 'plow their money into Garbage' or whether they were going to 'plow their money into No Doubt.' Well, we all know where they put the money in the end."

To make matters worse, once Garbage lost their suit to sever ties with Interscope and Universal, they were—as Marker puts it—"even more fucked." They were still tied contractually not just to Interscope, but to Moss and Radioactive as well, meaning any profits had to be shared. "Basically, it took away any incentive," says Marker. Their biggest ally at Interscope was Tom Whalley, who was enthusiastic about Garbage. Whalley hired Almo's general manager, Paul Kremen, as Interscope's head of marketing. But then Whalley left to become the president of Warner Bros. before *Beautiful Garbage* even came out.

None of this would have been a problem if *Beautiful Garbage* had connected with the public the way the first two albums did. But the era of alt-rock had, effectively, ended. "The first two albums were so massive, and the singles kind of all fell in line," says Lisa Worden. That wasn't the case for *Beautiful Garbage*. "The band evolved, as they should—no one needs to keep making the same record over and over again. But the climate at radio had changed. In 2001, KROQ was playing Linkin Park and a lot more harder music."

"You want to know what the death of Garbage was? Limp Bizkit," says Peter Mensch. "It was getting tougher and tougher to get women on the radio. Interscope was not the best label for Garbage during that time. It never has been for rock bands." Mensch had an adversarial relationship with Interscope's Jimmy Iovine, but Q Prime had its own promotion department, and they were having no more luck getting Garbage on the air than the label was. "Bottom line,"

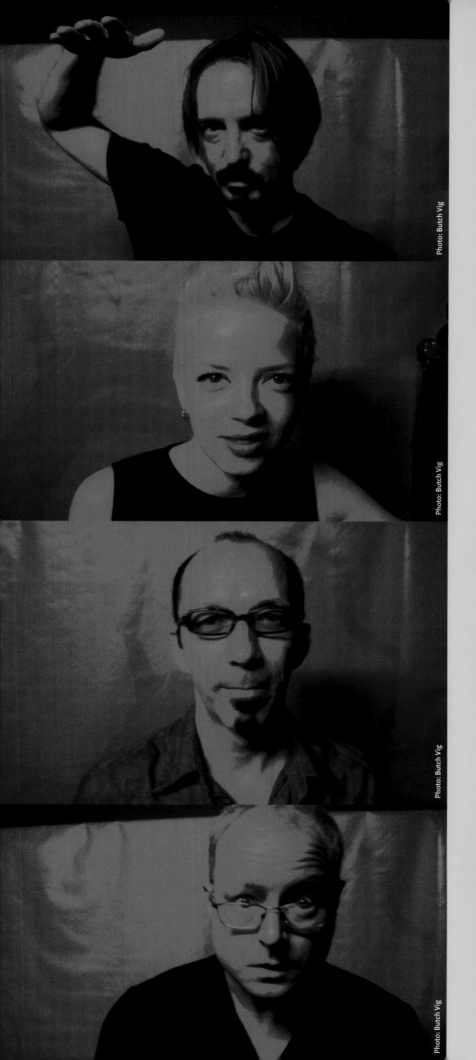

Photo: Butch Vig
Photo: Butch Vig
Photo: Butch Vig
Photo: Butch Vig

FILL YOUR GLASS WITH GARBAGE

ROCK AND ROLL COCKTAIL RECIPES

THE BLACK VELVET

It was during Garbage's tour with U2 that this bubbly thirst quencher entered the band's orbit. "U2 never sign autographs," explains Steve Marker. "But when we first went on tour with them, they left the following handwritten and signed recipe, along with the ingredients, in our dressing room. I know it well because it's up on my wall at home."

RECIPE
—*Fill tall glass halfway with champagne*
—*Top with Guinness. Pro tip: pour gently over an upside-down spoon held above the top of the glass*

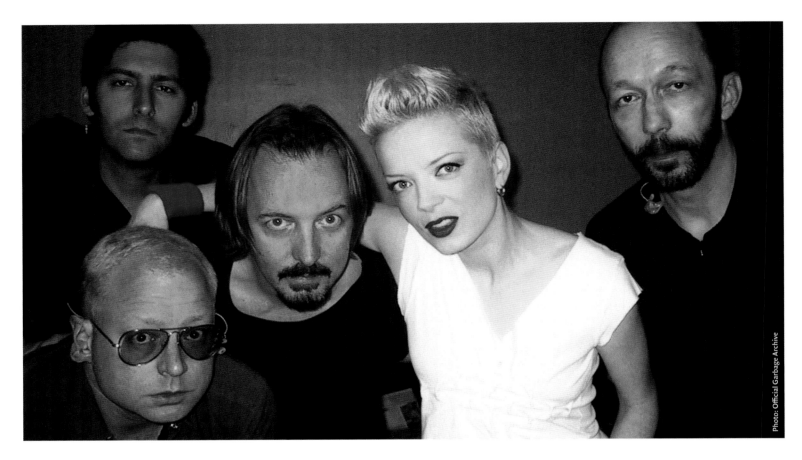

Mensch adds, "if your songs don't connect, you can love your record label or hate it, it doesn't make a difference. If you run it up the flagpole and no one salutes it, then you've got a problem."

X X X

Manson's cropped blond locks were not the biggest issue facing the band during the "Cherry Lips" video shoot.

"We got into an elevator the day of the video shoot," Manson says, "and everyone was looking at me because I had shaved blond hair. But I was shocked because I saw Butch and thought, *Oh my god, your eyes are yellow!*"

Garbage were just launching the *Beautiful Garbage* tour with a string of dates opening for U2. "Peter Mensch came backstage and said, 'Your skin looks really yellow,'" Vig says. "The next day I passed out on the plane to Baltimore and our tour manager, Diane, took me to an emergency room." Baltimore is known for its world-class hospital and medical school attached to Johns Hopkins University. But that's not the ER that Vig was taken to.

"It was fucking hard core," says Vig. "I was in a room with four guys. One had a gunshot wound, shouting, 'This guy shot me in the leg!' The second I got there, the nurse looked at my eyes and said, 'You've got hepatitis A.'"

When Garbage had toured with the Smashing Pumpkins, their Madison Square Garden date had been cancelled. Now, with the U2 tour headed to MSG, Vig wasn't going to lose out a second time. "Basically, if you can walk, you can play a show. And we've all done shows where we've been sick as dogs," says Vig. "I was like, 'I want to play Madison Square Garden.'" So Q Prime sent a car to Baltimore to pick up Vig and his then-girlfriend, now wife, Beth Halper. Vig made the trip in a stretcher. "I was laid out in this thing with shock absorbers so it wouldn't bounce, and I was driven from Baltimore up to New York. And my head was sort of stabilized that day to do the Madison Square Garden show. We changed the set. I said, 'I can't play anything rowdy.' We played all mellow songs."

Because hepatitis A, which Vig likely picked up from bad food, is contagious, the whole band and everyone on the tour had to get shots—including Bono. That wasn't the only way U2 pitched in. Drummer Larry Mullen Jr. had Vig's back. "He said, 'Butch, if you can't play, I'll just take over,'" remembers Vig. "And he sat five feet behind me the whole set. We only played a

Above: the band backstage during the *Beautiful Garbage* tour. Both the *Beautiful Garbage* album and tour fared better abroad than in the US, where the album's October 2001 release came just weeks after 9/11.

ON DRUMS: TWO MATTS AND A LARRY

When Butch Vig fell ill at two different times during the *Beautiful Garbage* touring cycle, Garbage avoided canceling shows by tapping the talents of not one but two drummers named Matt.

First up—when hepatitis A eventually sidelined Vig from the band's stint opening for U2—was Matt Chamberlain, who'd played on a few *Beautiful Garbage* tracks. "From what I remember, Shirley was a fan of my drumming on Fiona Apple's second record," says Chamberlain, whose varied experience includes everything from touring with Pearl Jam to a short gig with the *Saturday Night Live* house band, as well as studio credits with David Bowie and Bruce Springsteen. "I think they just wanted to see if I might be able to come up with something different than what they were doing."

To join Garbage live, however, meant just the opposite. Chamberlain describes himself as something akin to a character actor. "You study as much as you can about every part, and then try to be *that guy*," he says. "My job in those situations is to make the band sound exactly like the band."

One great challenge was adjusting to the unique setup Vig used for Garbage. "The drums were filled with packing peanuts," says Chamberlain. "Basically, I was playing a totally electronic kit. The drums were triggering sounds, and the only mics on the kit were the two cymbal mics and hi-hat. So my in-ear monitors were my lifeline to hearing what I was playing. It was odd at first, but I got the hang of it after a few shows. It's actually a genius setup."

Vig rejoined the band only to be struck down again, now with Bell's palsy, in the middle of Garbage's 2002 European stretch. This time the band turned to Matt Walker, who Garbage already knew well from when they played with the Smashing Pumpkins on the *Mellon Collie and the Infinite Sadness* tour; Walker had joined the Pumpkins after they fired their drummer Jimmy Chamberlin midtour. Walker remembers being "deep in the Pumpkin pressure cooker." He was always asking Garbage if he could steal a few minutes of their sound-check time in order to practice. "They were very understanding. I think they felt sorry for me."

Not only was Walker not the first Matt to play in Garbage, he was also not the first Walker to play with the band: his brother Saul was one of the bass players Garbage had tried out before settling on Daniel Shulman. Turns out Manson found Saul to be too handsome.

"My brother has had to suffer the fate of the too-good-looking bass player his whole career," says Walker. "Who knew he'd lose a gig because of it?" Walker remembers being envious of his brother's shot. "I was very jealous. I had just heard 'Queer' for the first time on the radio. I can remember exactly where I was—driving down the Edens Expressway north of Chicago. And I thought, *This would be the perfect band for me!*"

Walker felt pretty comfortable with Garbage's setup, although—like nearly everyone outside the band—he still found the lack of amplifiers and monitors to be odd. "If I took my headphones off, the stage was shockingly quiet."

As far as integrating himself into the band, Walker strove for a deep understanding of the musical and personal interaction: "The obvious necessity is knowing the drum parts and song arrangements. Beyond that, there is understanding the band dynamic. Every band has its own playbook, and I find that paying close attention to who calls the plays and how the band executes the plays is the key to not only fitting in, but figuring out how to complement the band with your own style. I did start out being very faithful to the recordings. I actually had the opportunity to watch Matt [Chamberlain] play a show before I took over the reins. I thought he was fantastic. But once I was behind the kit, I took some chances, introducing alternate fills and dynamics. The band seemed to like it, so I just kept going with it."

There was one other percussion pinch hitter on the *Beautiful Garbage* tour—for one night and one song. U2 drummer Larry Mullen Jr. took over the kit for "Only Happy When It Rains" on the last night U2 and Garbage were on tour together.

"Right before we went on, we decided that Shirley would make a scene and we'd get into a fake argument onstage," says Chamberlain. "I pretended to quit and threw my sticks down and I walked off the stage and Larry popped up to save the day." The playacting was a little too realistic: after Chamberlain "stormed" offstage, security guards tried to throw him out of the venue before a crew member stepped in.

It was Mullen's only performance with any band besides U2—ever—and Vig's setup made it even more difficult for him to just sit down and pound away. "Larry is one of my favorite drummers," says Vig. "If he had had a proper sound check, he would have figured out the headphone mix."

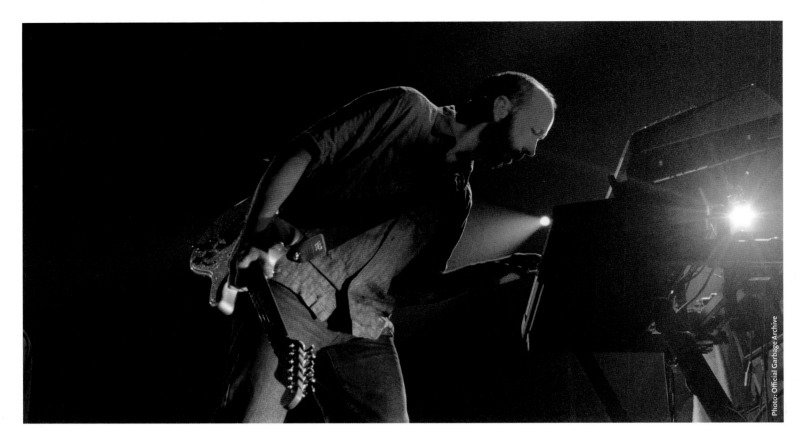

thirty-five to forty-minute set, but god bless him, man. If I couldn't do it, he would have tried to. That was pretty magnificent."

"His face was completely yellow," says Halper. "Totally, including the whites of his eyes, and the doctor is saying, 'You were about a smidge away from liver failure.' Like super close. He sweated for days. I think they threw that mattress away, he smelled so bad. It was just all the toxins and stuff. I remember talking to Shirley: 'How could you guys not know? His face is completely green! Fuck.' And I remember her saying, 'I don't know, you know, we just . . .' I was like, 'You play together every night.' I think that was the first clue to how detached they were becoming from each other."

Above: Duke, live onstage during the *Beautiful Garbage* tour; opposite: a magazine shoot during a visit to Japan in 2001, taken at a time when two members of Garbage (Manson and Marker) were blonds.

<div align="center">X X X</div>

TUESDAY, OCTOBER 16TH. 2ND NIGHT IN CHICAGO AND OH LORD......... YET ANOTHER MELTDOWN. THIS TIME WE ENDURED THE SELF-IMMOLATION OF DUKE'S GUITAR RIG. SMOKE BEGAN TO SPEW FORTH, ROADIES SWARMED OVER THE STAGE IN FRANTIC DAMAGE-CONTROL MODE AND AN ENORMOUS BUZZING SOUND COULD BE HEARD THROUGHOUT THE ENTIRE DURATION OF "SHUT YOUR MOUTH." AS MUCH AS OUR CREW STRUGGLED TO FIX THE PROBLEM, WE WERE UNABLE TO CONTINUE WITH OUR SET. IT WAS A VERY HUMBLED AND GRUMPY GARBAGE THAT LEFT THE STAGE TONIGHT. ZERO FOR TWO IN CHICAGO, ILLINOIS. HAVE I MENTIONED ALREADY HOW INCREDIBLE THE U2 SHOW IS? IT'S WEIRD.........DON'T KNOW IF IT'S THE WAY EVERYONE IS FEELING FOLLOWING THE WORLD TRADE CENTRE DISASTER OR WHAT BUT THE ATMOSPHERE AT THESE SHOWS HAVE BEEN INSANELY INTENSE. BONO JUST HAS SUCH AN INCREDIBLE ABILITY TO HARNESS THE CROWD'S ENERGY AND FEED IT STRAIGHT BACK TO THEM, RESULTING IN WHAT SEEMS LIKE COMMUNAL ECSTASY. I'VE NEVER SEEN ANYTHING QUITE LIKE IT. OUR BONO IS INDEED A MIGHTY FORCE. HE WALKS INTO A ROOM AND ALL THE AIR GETS SUCKED RIGHT OUT. HE IS COMPLETELY MAGNETIC.

—SHIRLEY MANSON'S WEB DIARY

If you were about to embark on a fourteen-month world tour in the unsettled times of October 2001, there would be far worse ways to do it than to start by opening for U2. This was the leg

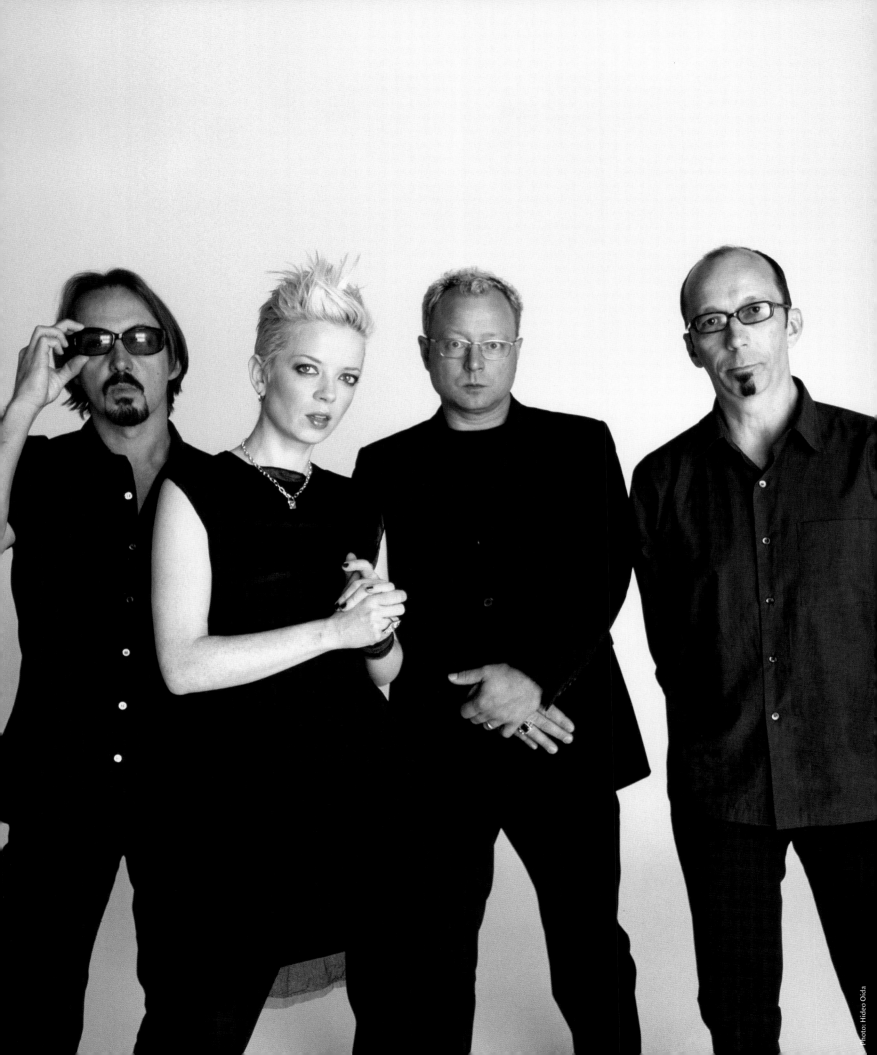

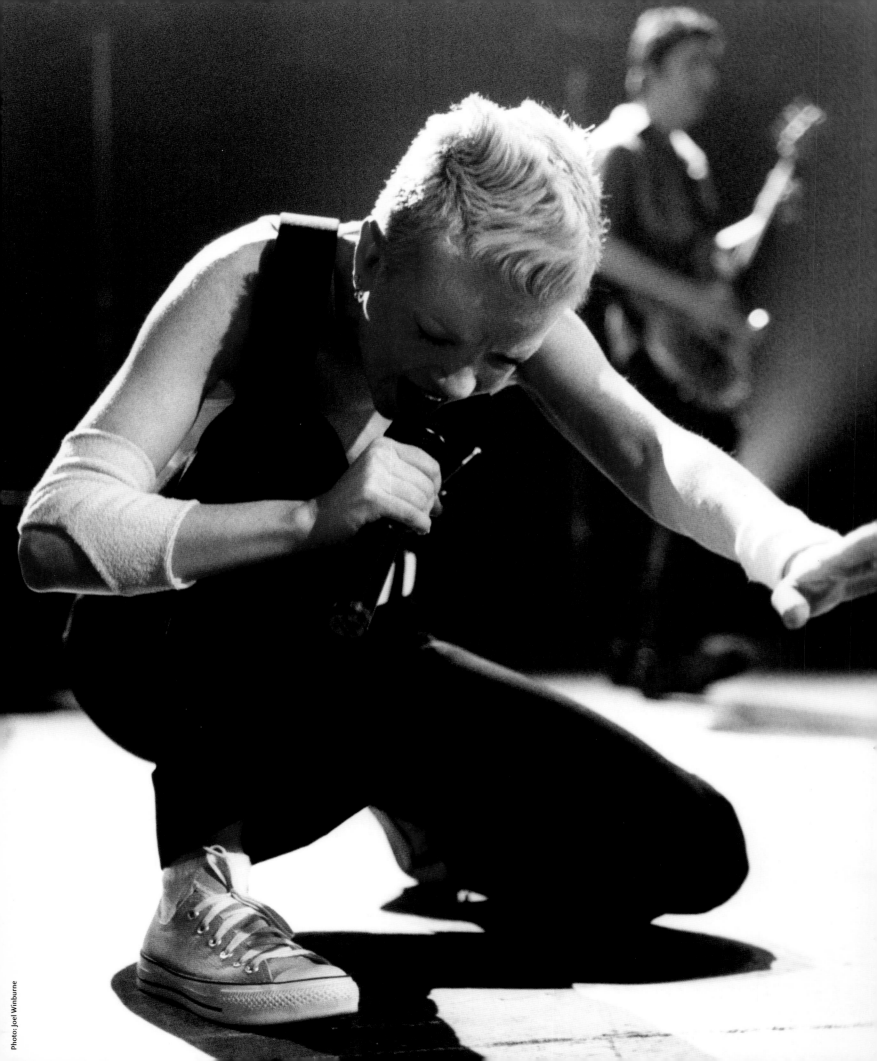

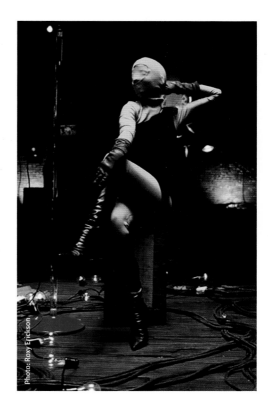

Above: Manson in a green bodysuit
for the "Cherry Lips" video; right:
Marker and Vig on set for the
"Breaking Up the Girl" video; left:
Manson drops to her knees during
the *Beautiful Garbage* tour which
included eleven shows opening for
U2 on their massively successful
"Elevation" tour.

of U2's "Elevation" tour when Bono would pull open his jacket to reveal an American flag lining, a healing gesture received by grateful crowds. "As fucked up as that time was," says Marker, "to open for them then, when people were just shattered, it was like going to church."

Despite all the difficulties, the band remembers these dates fondly. In Chicago, when Erikson's rig melted down, U2 offered one of the Edge's amps. "Nobody fucking does that," says Erikson. "They were true gentlemen the whole time, all of them."

ERIKSON: We only flew on U2's plane once because we had a long drive between one of our last shows. They offered us a ride and Bono hung out with us on the flight. Bono actually sat in my lap on the takeoff.

MARKER: He did. "Oh, Duke, sorry, we're taking off. Do you mind?"

ERIKSON: I minded a little. I couldn't fasten my seat belt.

But it was the aftermath of that plane ride that truly shook Bono. "We hit the hotel bar after we landed," says Erikson. At the show the following night, Bono's assistant approached Garbage's road manager and asked, "What the hell did you do to Bono last night?"

"I think he must have been a little slow getting out of bed that day," adds Erikson. Garbage and Bono had a hangover history—Vig credits one of his worst hangovers ever to a night of heavy drinking with Bono in Dublin during the *Version 2.0* tour.

But now, two years later, Vig was laid low under much more serious circumstances. He hadn't missed his chance to play Madison Square Garden, but he missed what followed, including U2's private plane. "I was like, *Goddamnit, I just want to fly on a jet with Bono*," he says. But after his initial hospital visit, Vig could barely move for a week. It was at this point that Matt Chamberlain filled in.

"I think he had one day to rehearse with us," says bassist Daniel Shulman. "He just sat down, played a song, wrote out some notes, and from that moment on it was unbelievable. He could play almost exactly like Butch, which was mind-boggling. Every fill exactly the same, every cymbal hit exactly the same. He had every beat."

Just how remarkable this was became even clearer later, during the European leg of the tour, when Vig was stricken with Bell's palsy and Matt Walker of Filter filled in. "Matt Walker was the exact opposite," says Shulman. "He made no attempt to play it the same way as Butch. He played it differently every night, just kind of freestyled, but he did have a really good memory for the arrangements—a sort of an internal sense of how the songs went."

Vig was not the only one plagued by physical afflictions. When the band returned to the Roskilde Festival in Denmark in the summer of 2002, Manson says she "walked onstage, opened up my mouth, and literally little to no sound came out. I didn't understand what was happening, whether it was fatigue or stress or whatnot. And let's face it, no one wants to talk to a singer about 'vocal problems.' It's tiresome for everyone involved because we are all so neurotic about our voices." Manson simply soldiered on until the band was out on a coheadlining tour with No Doubt, and Gwen Stefani pointed her toward a vocal specialist. "I had a large-sized cyst on one of my vocal cords, which was also causing considerable damage to the vocal cord opposite."

While *Beautiful Garbage* was beset by all sorts of problems, the touring cycle did end on a couple of positive notes. The Distillers opened the Garbage/No Doubt tour, kicking off a long friendship between Manson and the Distillers's Brody Dalle, as well as a professional relationship between Dalle and Butch Vig. "Going on tour with No Doubt and the Distillers was a lifesaving experience," says Manson. "I was a tad unhinged during the entire *Beautiful Garbage* cycle due to my marriage imploding the previous year. This tour pulled me out of the dark, and I have those two formidable women to thank for that. We'd spend hours together, cuddled up on dressing-room couches, shooting the shit and painting each other's nails. It was a real power coven."

The other highlight: Garbage were invited to be one of the performers at the tribute dinner that honored Bono as the MusiCares Person of the Year at the pre-Grammy fundraiser, on February 21, 2003. Kremen made sure that Garbage were on the bill, which included B.B. King, No Doubt, and Mary J. Blige performing U2 songs. "I wanted Garbage there to show Jimmy Iovine how good they were because he was going to be there front and center," says Kremen. "And they brought the house down."

The packed ballroom at the Marriott Marquis Hotel in New York City's Times Square included Robert De Niro, Salman Rushdie, and David Bowie. Also on hand was Bill Clinton, who presented Bono with the award.

MARKER: Playing for Bill Clinton . . .

MANSON: That was the best night of my life.

BUSH: That was probably the most amazing I've ever seen you guys play.

VIG: We rehearsed in Madison. We worked up "Pride (In the Name of Love)" there. Shirley was like, "We can't play 'Pride'!"

MANSON: "This is just so arrogant! So typically American arrogant!" Butch was like, "You're being Scottish and defeatist." And he was right.

VIG: Nobody chose it. We were like, "Let's play it." And the only proper rehearsal was the sound check. We played it maybe three times through. We were woefully underrehearsed, and had no idea what to expect. We came out onstage and—holy shit—there's like two thousand people there, and right in front of us is Bill Clinton at a table with Bono.

MANSON: And Robert De Niro.

VIG: We started the song, and Shirley fucking walks off the stage, right on top of their table, and sang right in their face.

MARKER: It was awesome.

MANSON: I remember looking down and it was like seeing my heart physically leap out of my chest because I was so pumped.

ERIKSON: We fucking nailed it.

Everyone agreed on this. "I got a phone call from Jimmy Iovine the day after, going, 'Your band smoked everybody last night,'" remembers Manson. "And Bono said the most incredible things to me after the show too."

"There was a huge after-party at the Hudson Hotel," remembers Joe Levy, then the music editor of *Rolling Stone* and a friend of Manson's. "I was sitting talking with Shirley when Bono came in, and he came right over to her. What he said was something along the lines of, 'There are only a few performers who can do what you did tonight: Bruce Springsteen, David Bowie . . .' I leaned over to Shirley and said, 'Bono just compared you to David Bowie.' And she elbowed me in the ribs. Hard."

"I thought I'd died and gone to heaven," says Manson. "It was a rock-and-roll fantasy."

The celebration went on until dawn. Kremen can still remember walking home that night with Iovine, who said, "They were fucking awesome. Get them in the office."

The stage was set for better things. But as it turns out, that's not the way it went.

Above: a pass to the 2003 MusiCares gala honoring **Bono**, where **Garbage** brought the house down playing U2's "Pride" in front of former president **Bill Clinton**.

THE TERRIBLE TRUE STORY OF BUFUNGO JOOCE

If you can remember where you first had "bufungo jooce," you probably didn't have bufungo jooce.

The most monstrous cocktail concoction in the history of Garbage was the brainchild of the band's longtime front-of-house sound engineer Tom Abraham.

Legend has it that the drink was first consumed by the band in South Africa. Or possibly the Cayman Islands. Or possibly it all started with the road crew and a few members of the band at the Edgewater Hotel. Memories are hazy here—a sure sign that bufungo jooce is involved. This recipe comes straight from the originator, Abraham.

BUFUNGO JOOCE

Serves ten to fifteen people "intent on bringing it." Adjust the quantity based on the number of drinkers. Adds Abraham: "This is the more high-end version, so it's better tasting." You may not want to try the lo-fi version.

BOOZE

—1 bottle of Stoli vodka
—1 bottle of Tanqueray gin
—1 bottle of white rum (Abraham prefers Havana Club)
—1 bottle of dark rum (see above)
—1 bottle of tequila blanco

FRUIT

Abraham insists on fresh fruit: "Don't buy canned fruit. It's already saturated and can't absorb any more liquid."

—2 large pineapples
—12 Red Delicious apples
—12 pears
—12 peaches
—1 seedless watermelon
—1 cantaloupe

MIXERS

—2 two-liter bottles of ginger ale
—2 large containers of fruit sherbet (any tropical fruit flavor)
—1 gallon of lemon-lime sherbet
—Several bags of ice (you'll need one more bag than you think)

PREPARATION

—Clean a big plastic bin. Abraham says a kitchen trash can works well (extra cleaning will be needed) or "the translucent Rubbermaid clothing storage bins at Target."
—Peel all the fruit and cut into one-inch squares. Advises Abraham, "Find a friend who is fun to talk to and can be suckered into helping. This part takes forever and is pretty arduous. Your peeling and cutting needs to be well executed for a smooth drinking experience."
—Place peeled and cut fruit in clean plastic bin. Pour all of the clear liquor over it (i.e., all the booze except the dark rum). Stir until well mixed. Put bin on ice—this will require a bathtub or a larger bin—and cover with two bath towels for four to six hours. "It needs to breathe," says Abraham, "hence the towels. It ferments fast and furious, so completely covering it with a plastic lid will blow the lid off in a very messy way. I find breathable wet towels work." He also recommends keeping the bin in a ventilated area.
—After four to six hours, uncover bin. ("If your eyes water, that means it's working.") Dump in ginger ale, dark rum, all the sherbet, and one bag of ice.
—"Stir like a muthafuka. When the sherbet has been stirred into a liquid, it's ready to drink!"

Final note from Abraham: "Eat fruit, make bad life choices. Next day, maintain plausible deniability, leave town."

"THAT'S WHEN I THINK IT STARTED GETTING BAD FOR THE BOYS."

—SHIRLEY MANSON

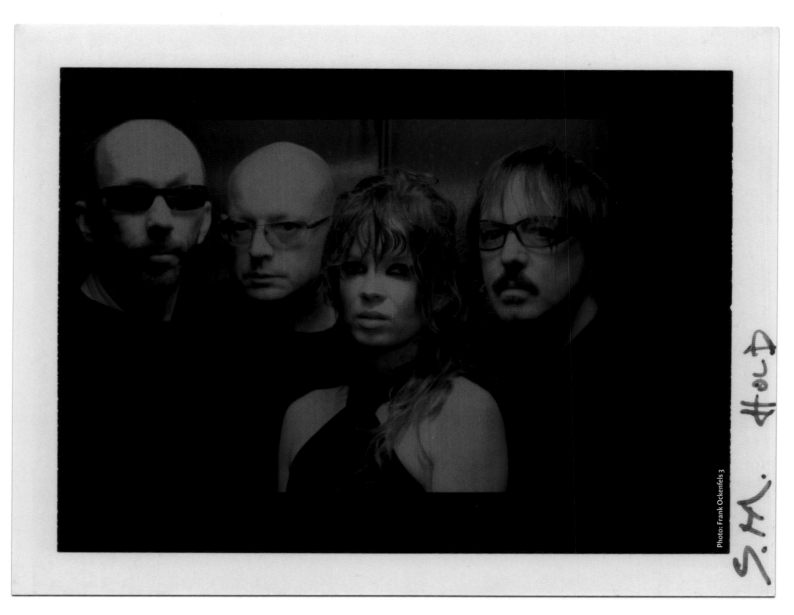

Photo: Frank Ockenfels 3

Above: a 2005 Polaroid test shot from the Ockenfels session for the *Bleed Like Me* album package.

More than ten years later, Garbage still can't reach a consensus: did the band come to an end— if only briefly—during the making of their fourth record? It depends who you ask.

"We broke up. Are we gonna say that?" Steve Marker asked Shirley Manson in 2005 as the band prepared to release the album. Manson thought so, but Duke Erikson did not. "That was never my understanding," he said.

Everyone agrees on this much: there was a moment in the recording sessions for *Bleed Like Me*—which began early in 2003 and didn't finish until the end of 2004—when things became so dark that Manson simply couldn't bring herself to come into the studio. And then Butch Vig felt the same, getting on a plane from Madison to Los Angeles without letting anybody know. In some recountings, including at least one interview with *Rolling Stone*, Vig has said he eventually declared, "I quit." In other tellings, he never used those words.

Whatever the case, things ground to a halt for several months. And yet somehow Garbage still made a very good record, then dragged themselves back out for what would end up being the only Garbage tour cycle to last less than a year. "We soldiered on," says Erikson. "We soldiered on with the record, we soldiered on with the tour, and then we broke up again."

Erikson, always the drollest member of Garbage, means that as a joke. But by the end of promoting *Bleed Like Me*, the band was indeed ready for some more substantial time off—from the band, from each other, from the music business. What had started out as fun was now a job. And what had started out as a project over which the band had complete creative control was now a product in the hands of a major label that perhaps didn't even want them. Technically,

Garbage had even changed labels again, moving from Interscope to Geffen, though it was still all the same company—Geffen was a sublabel inside the Interscope offices.

The perceived failure of *Beautiful Garbage* was traumatizing. Garbage had come into the world with low or no expectations, then enjoyed two albums of considerable success. But the minute they allowed themselves to have expectations, or had them imposed by a more demanding record company, the success began to evaporate—at least by label standards.

"*Beautiful Garbage* still sold a million copies, but the record labels—particularly overseas—were despondent because we'd been their jewel," says Manson. "We were their moneymaker. They ran their entire businesses off us. They were like, 'You need to go to the studio. You need to get [another record] going quick.'"

"All the confidence [the band] gained the previous four or five years went out the window very quickly," says Billy Bush. "It disheartened them and freaked everybody out. The fourth record is really a result of their fear. It feels like a band that's desperate, and everybody is thinking they need to be the one to fix it."

In the US, Garbage found themselves dealing with more outside input from management and A&R than they ever had. "When we made the first record, we just did it," says Vig. "By *Beautiful Garbage*, there were a lot of people giving us opinions."

Interscope's Jimmy Iovine was one of them. He suggested bringing in an outside producer, maybe even someone like Pharrell Williams or Timbaland. "The Interscope mentality is to always put you with producers and writers who have a hit," says Vig.

"We just knew that wasn't for us," says Manson. "But we knew we couldn't say no without the record company coming back with, 'Well, how about this?' All the joy had been sucked out of the room. Everyone was demoralized and paralyzed."

Manson was also still recovering from the vocal-cord surgery she'd had to remove the cyst once the *Beautiful Garbage* tour ended. But the sessions couldn't wait. As Bush remembers it, the band's managers at Q Prime pointed out that, once upon a time, Garbage was able to lay the foundation for some of its biggest hits and most enduring songs before they even had a singer.

"'Why don't you guys go back to where you were before 'the girl' got involved?'" is how Bush characterizes Q Prime's take. "They started to write songs without her, and she didn't feel like there was any place for her to be creative."

In fact, the whole group had become fractured, something that had started during the making of *Beautiful Garbage*. During those sessions, Vig remembers going in on Sundays instead of taking the day off, just so he could get some time alone. He was reluctant to present ideas to the band because everyone had grown so frosty. "I was afraid no one would respond," says Vig. "I came in and started recording, and I kind of felt free. Then I remembered, *Okay, that's what I like to do. Why is it a bummer when I come in with my band?*"

Erikson, who has always been an early riser, was equally unhappy with the studio environment: "I got frustrated because everybody would come in at one and then just sit and do e-mails for an hour. I had my little studio at home working pretty well by then, so instead of going into Smart I'd start working at nine a.m. at home and go in with lots of ideas by two or three in the afternoon. That was not exactly being a team player, but it felt better than spending half my time sitting around. But I think that wasn't good for the band. Then I think we all started behaving that way."

The "anything goes" ethos the band had started with—where they'd try whatever they could think of musically and follow any idea through—was now crippling their writing process. To be a Garbage song, all four members need to put their stamp on it, regardless of who first conceived the track. But that sort of collaboration wasn't happening anymore.

"Each of us would get an idea for something and really try to push it through," says Marker. "And very likely the rest of us weren't feeling it, so that one person just sort of ended up working on their own in the studio and the rest of us would be sitting out in the lounge watching TV for two weeks or just going to the bars or whatever. End result: nobody was really happy."

"We'd argue about everything," says Erikson. "Forget about the music: we'd argue about what we were going to eat. All the time."

Historically, Marker and Vig were more easygoing (or at least quieter) than everyone else, whereas Manson and Erikson used to go at it like siblings. In the band's first years, that was just part of their friendship and the band's creative tension. "She and I went at loggerheads more than any of us," says Erikson. "Neither one of us was afraid to call each other out about whatever." But by *Bleed Like Me*, there was no fighting—just the silent treatment.

There had also been a big change in Manson's personal life: she and Billy Bush were now a couple. All of the emotional tumult Manson experienced during *Beautiful Garbage* was now

Above: a helpful instructional note; opposite top: a typical Erikson and Manson face-off in the studio; opposite bottom: Vig at the controls, Studio B, Smart Studios.

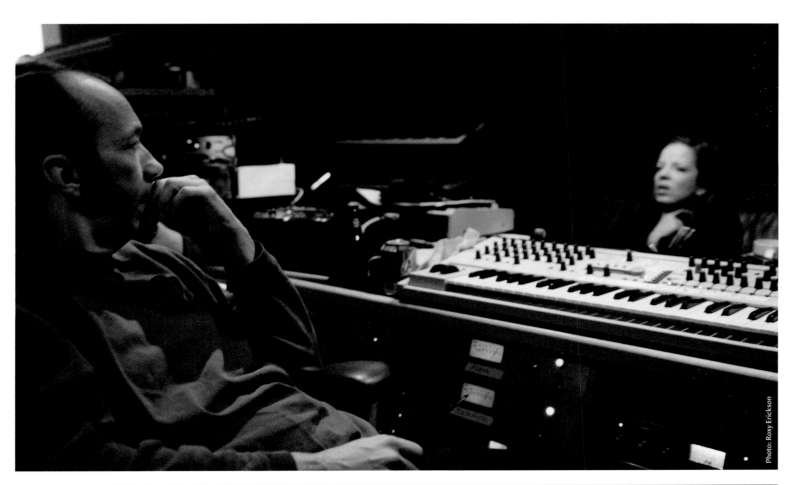

Photo: Roxy Erickson

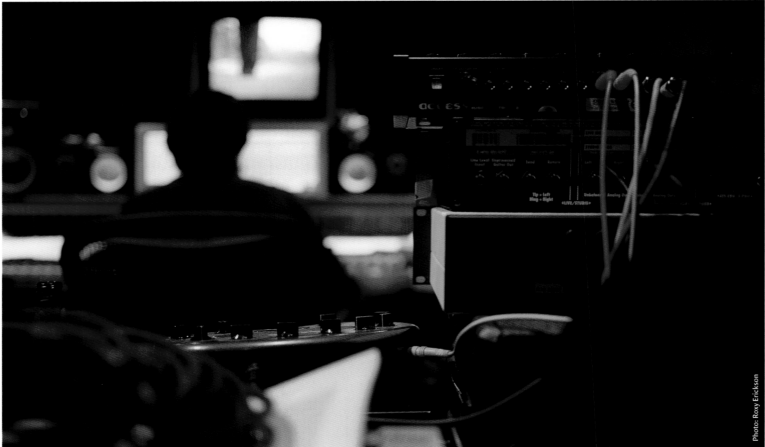

Photo: Roxy Erickson

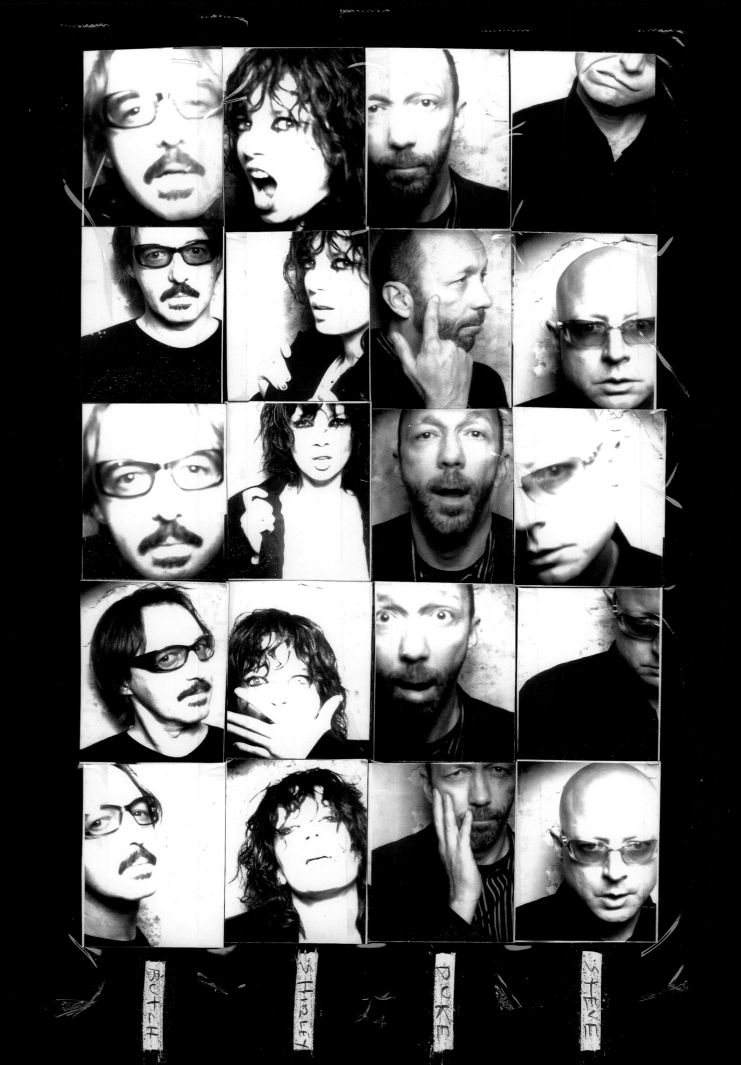

Photo: Roxy Erickson

Left: a Frank Ockenfels 3 collage which was used as a promotional poster for *Bleed Like Me*; right: Billy Bush changing a bass string at Smart, with Manson in the background.

behind her, and she had ended her long residence at the Edgewater Hotel to boot, having moved into Bush's Madison apartment before they relocated to Los Angeles in 2006.

The singer and the engineer had been good friends since *Version 2.0*—they were the two Madison outsiders, while Marker, Vig, and Erikson went about their normal hometown lives when away from Smart Studios.

"I always used to pick her up to go to the studio," remembers Erikson. "One day I was busy recording something, and I guess I'd gotten a bit tired of picking her up every day. It was toward the end of that record. And all of a sudden Billy goes, 'I'll pick her up!'"

Which is not to say Erikson saw it coming. "You walk into a dressing room and they're sitting there and it enters your mind but, it's like, *Nah, that's not going on.*"

That this had an impact on the band dynamic almost goes without saying—not that anybody talked about it at the time. Bush was Erikson's guitar tech and Vig's right-hand man at the recording console. He'd always "belonged" to them. Now he was Shirley's boyfriend.

"I can't imagine how weird it must have been for the boys," says Manson, "to have me fall in love with our engineer who worked with us in the studio, is a very close part of our unit, and then all of a sudden there's this weird shift. That may have been a contributing factor to the fractures in our communication, because up until that point we were pretty tight."

The relationship gave Bush a status that not even touring bassist Daniel Shulman had and, because he worked with the band, a presence none of the other Garbage spouses or family members had. "It was a four-against-the-world kind of thing," says Marker, "and then it was the five of us. And it was different."

Add in the normal exhaustion and attrition of a band that has worked and toured together for ten years, and you get Garbage circa *Bleed Like Me*. Things had become so fraught that there was even talk of bringing in Phil Towle, the "performance-enhancement coach" used by Q Prime's flagship band, Metallica (as seen in the documentary *Some Kind of Monster*). "I asked them to send that guy over, and they said we couldn't afford it," Marker jokes. (Towle cost Metallica $40,000 a month.) "So we had to do it ourselves."

MANSON: We were all miserable.

VIG: It was just a really strained time for the band in terms of our personal relationships, and

FILL YOUR GLASS WITH GARBAGE

ROCK AND ROLL COCKTAIL RECIPES

CHARLOTKAS

Erikson has the most detailed memory of how this Polish cocktail (sometimes spelled *sharlotka* or *szarlotka*) came into the Garbage world during the *Version 2.0* tour: "We were all in a van on our way from the airport into Katowice, Poland. I was asking the driver about the city and Poland in general. I asked him what the Poles liked to drink, and he said, 'Charlotka is the national drink.' He said it was made with Żubrówka vodka, which came with a blade of bison grass in every bottle, giving it a kind of golden-greenish hue. He said, 'Bison grass makes a man strong,' which I of course took to mean it was an aphrodisiac or something.

"We had the night off, and the band and the whole crew went immediately to the hotel bar and ordered the Polish national drink. We drank charlotkas for hours, until the bartender announced he was out of vodka and out of apple juice. At least that's what he *said*." For the rest of the tour, the band made sure their supply of bison grass vodka and charlotkas did not run out. Charlotkas were ladled out of a giant bowl during a particularly insane tour-ending night of partying (mostly for the crew) in South Africa.

RECIPE (BY BUTCH VIG)

—*2 shots of bison grass vodka (Żubrówka)*
—*3 drops almond syrup*
—*4 oz. apple juice*
—*Serve over ice*

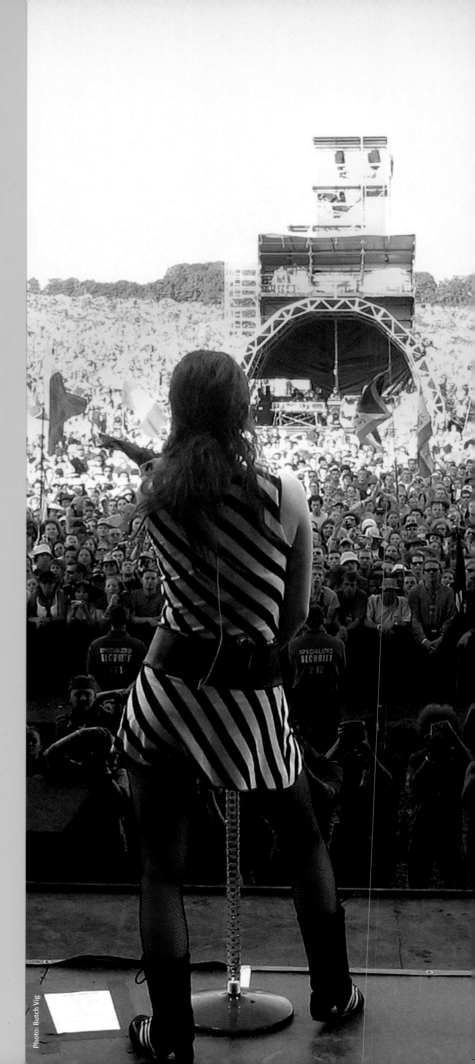

Photo: Butch Vig

Opposite: Manson (in a shot taken by Vig) on Glastonbury Festival's Pyramid Stage, 2005, before a crowd of 153,000; right: four on a couch that comfortably seats three.

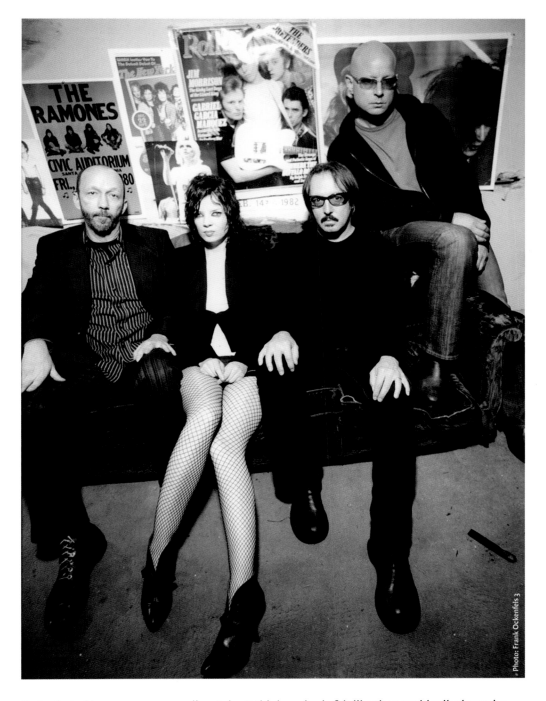

Photo: Frank Ockenfels 3

that affected how we were recording. I don't think anybody felt like they could talk about the music. People would get defensive. We'd always argue about stuff, but this wasn't functional. It was freaking me out. One day, I hadn't slept for a week, and I just said, "I quit!"

ERIKSON: I was oblivious to how upset people were. I thought we were having a tough time but we'd get through it. I really didn't think it was necessary for us to all go home.

VIG: Shirley and Duke were not even speaking. I felt like we needed to do something drastic, not, "Let's take a week off." So I was like, "Fuck it, I'm out of here. I quit." I'm not sure if I said, "I quit." I may have said, "I'm out of here."

MANSON: How I remember it is, I was freaking out and I had a big meltdown and I wouldn't come into the studio. Days went by, and eventually you were like, "What's going on? You need to come in." I came in and I was crying, and you were like, "You just have to calm down." You remember this?

VIG: Yup.

MANSON: And eventually you kind of calmed me down. And then the very next day—

VIG: I quit. But I never said, "I quit." I remember telling Duke; he started laughing. But I needed to go away. Everybody needed to go away and clear their heads.

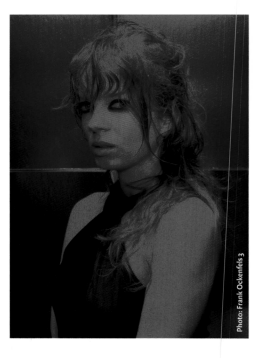

As Manson's roommate, Bush saw it from both sides on the day it all went down. "I go home, and she's been in the bathtub all day. She's like, 'This is it. I'm done. I can't go in. You need to get Butch to come over. I need to talk to Butch.' So I go back to the studio and I say, 'Shirley's not feeling well, and she wants you to come by, Butch.' So he goes over. And basically she tells him, 'I can't do this anymore.'"

Vig was able to talk Manson off the ledge, telling her to take a few more days and that they'd put things back together the next Monday. "And Butch is great in that situation because he can calm it and soothe it and make it be cool," says Bush. "So she's like, 'Okay, great.'"

Over that weekend, Manson and Bush went to see Marilyn Manson (her "father," Manson has occasionally joked) in Milwaukee, and the energy of Marilyn and his fans rejuvenated her. "She's like, 'You know what? I can fucking do this. We can fucking do this. I'm not giving up on any of this stuff. I'm gonna fight,'" Bush remembers.

But in the meantime, Vig was stewing over the whole situation and decided Manson was right. He got on a plane to Los Angeles, where he and his wife had been living since 2002. When Bush came into the studio to set up drums on Monday, Erikson, Manson, and Marker were there, but Vig was nowhere to be found.

"We're like, 'Where's Butch? Call Butch,'" says Bush. "No answer at his Madison apartment. 'Call Butch's cell.' No answer. About two hours later he called the studio and asked to talk to Duke."

Vig had been convincing when he told Manson that everything would work out, but he hadn't convinced himself. "I couldn't stand the tension between Shirley and Duke," says Vig. "It made me sick to my stomach. To be in the studio and feel this black cloud hanging over, this heaviness. I was just like, *I gotta get out of here.*"

"I think that took a huge toll on Butch because his natural inclination is to be the producer," says Manson. In other settings—in the studio with Nirvana or the Smashing Pumpkins, for example—it was Vig's job to solve all the problems, keep it all together. But here that wasn't possible—for the band or for him. "We all felt we needed to do our own thing. He was trying to pull something together out of that and it wasn't working."

<div align="center">X X X</div>

The breakup-that-wasn't lasted several months. When Garbage reconvened, it was in Los Angeles, and they'd finally accepted the label's suggestion that they use an outside producer. Manson was especially in favor of this drastic action, thinking that perhaps a producer who wasn't also in the band could be a more effective manager and take the pressure off Vig. The job went to John King, one half of the Dust Brothers—the team that had produced the Beastie Boys's *Paul's Boutique* and Beck's *Odelay*.

It didn't take.

"We worked with John King for three weeks at the most, and then we realized that it sucked," says Manson.

This wasn't King's fault. "We were looking in the wrong place for a solution to a problem that only had to do with us as a band," says Erikson. "We couldn't face the real inner problems, so we looked outside. It wouldn't have mattered who the producer was, it was doomed to fail. Adding one more opinion to all the other opinions in the room just complicated things instead of solving anything."

Faced for the first time with the prospect of being told what to do by somebody who wasn't one of them, Garbage opted to go back to being Garbage. "A producer is really someone with opinions, and there's four people in this band who are overopinionated," says Vig. "When we went in with John, we realized we needed to get back to being the four of us."

"I'm glad we did it because it really focused us as a band," says Manson. "But it was an expensive experiment. Sometimes I'm not sure the band has ever forgiven me."

The sense of togetherness wasn't total. The band did not return to Smart full time, with Manson, Bush, and Vig largely remaining in LA, and Erikson and Marker doing a lot of the work in their home studios. But the record still got made.

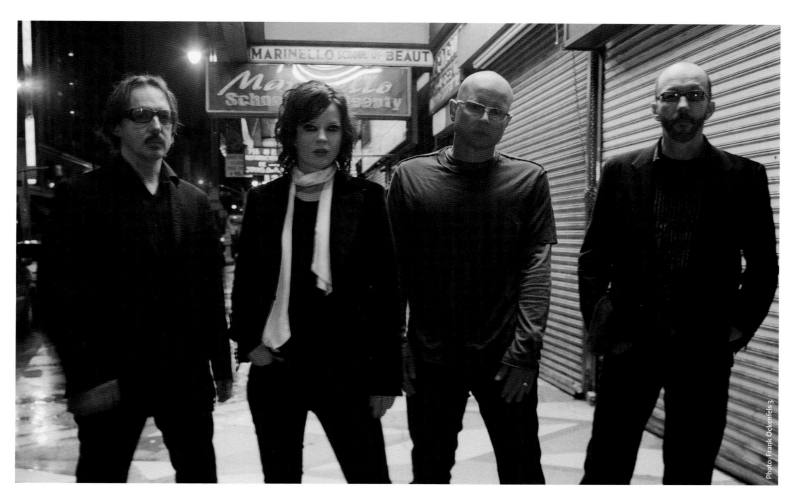

Photo: Frank Ockenfels 3

Above: Garbage in the street, downtown Los Angeles, 2005; opposite: Manson in a black dress under a red light.

One way Vig found to redefine his role as a musician and producer was to turn the drum kit over to other players for several songs—most frequently Matt Walker, but also an old friend who took time off from his day job fronting the Foo Fighters: Dave Grohl, who appears on the album's opener, "Bad Boyfriend."

Vig says, "I ran into him at a party, had a few beers, and said, 'Dave, you gotta play drums on the Garbage record!' And he's like, 'Cool, that'd be great! Just call me!'" After reaching out to Grohl's manager, John Silva, Vig didn't hear anything for some time. Then one day, the phone at the studio rang. "The kid can come in on Tuesday," Vig remembers being told. "All right," Vig said, "we'll have a drum kit set up."

VIG: It was great. We stuck DG up behind the drums, he heard "Bad Boyfriend," and he played it down a couple of times. I think we recorded three takes. Before the last take, he looked at Duke and asked, "What should I do in the solo, should I go for it?"

ERIKSON: I said, "Yeah, go wild!"

VIG: Dave played a wild drum break all the way through Duke's solo. It's a pretty chaotic moment, but it's friggin' awesome! He had a shit-eating grin the whole time. It was cool for me to have him play on our song, to come full circle. It was the first time I'd been in the studio with DG since *Nevermind*.

"That record brought out the fact that we were, more than anything else, a loud guitar rock band," says Marker. *Bleed Like Me* is the record that sounds most like a Garbage live show. Its rawness was also a response to the more electronic direction of *Beautiful Garbage*, as well as to the sound of bands like the Strokes and the White Stripes. "I think they did their best attempt to go back to being a rock band," says Bush. "Like, 'We can do this. We're a garage band at heart.'"

X X X

Another big change for the group was losing Shulman, who had left the touring lineup at the end of the *Beautiful Garbage* run to take a shot at the other side of the record business, doing A&R for Island Def Jam (also under the Universal Music Group umbrella). Manson saw it as a bad sign. "I remember that vividly, feeling like, *This is the end. We won't recover from this.* It felt like everything decent had kind of fallen by the wayside. It added to my despondency going into *Bleed Like Me.*"

Justin Meldal-Johnsen, who'd played with Beck, filled in on the bass for the album (with the exception of Vig's four-string debut on the album's title track), but when it came time for the tour, Shulman was replaced by Eric Avery.

As with Shulman, the congeniality portion of the audition counted most to the members of Garbage. "They had a really wise take on it all," says Avery. "They just assumed, *He'll be able to play the notes, but do we like him? Do we get a feeling like we'll be able to be stuck in a van with him in the middle of a snowstorm?*"

They did indeed, though Avery says it was hard for him to fit in musically. "A lot of their stuff is much more technical sounding," he says. "I know that they were initially like, *'Stupid Girl' sounds really weird when Eric plays it.* There was an adjustment period. Thankfully, they were fond enough of me as a person to be like, 'Ah, well, we'll get used to it.'"

Bleed Like Me came out on April 11, 2005, and—particularly in the context of the ever-shrinking music business—the record was a success. It just wasn't a blockbuster. The album debuted at #4 on the charts in both the US and the UK. (Garbage's first Top 10 debut on the *Billboard* chart.) The first single, "Why Do You Love Me," returned the band to both American "modern rock" radio and the British charts, where it hit #7, making it their most successful track in the UK since "Stupid Girl."

Garbage also maintained their reputation for cutting-edge music videos, even though the days of big budgets were gone. Enter Sophie Muller, who had directed a couple of the *Version 2.0* videos, and then became one of Manson's closest friends during the No Doubt/Garbage/Distillers tour (which she was filming for No Doubt). "Because *Beautiful Garbage* had failed so miserably, Interscope started pulling financial help out of the equation, and reduced our video budget to an embarrassing degree," says Manson. "I remember talking to Sophie about it, and she was like, 'I'll work with whatever you've got. Don't worry about it.'"

As Muller notes, what was embarrassing in 2005 would actually be comparatively healthy today. She directed videos for four songs on *Bleed Like Me*, including the title track and "Run Baby Run," which she and Manson filmed in four locations, guerrilla-style.

Muller's video for "Sex Is Not the Enemy" also led to one of the most inadvertently memorable moments on the *Bleed Like Me* tour. The video cuts between Manson, playing some kind of prophet/activist/street person character, and live footage of the band captured at the 9:30 Club in Washington, DC. The concept of the video is loosely inspired by Jim Morrison's famous Miami arrest for exposing himself, though it was also just a few months after Janet Jackson's Super Bowl "wardrobe malfunction."

The plan, says Erikson, was that during the 9:30 performance Manson would "flash the crowd and then the police were gonna come onstage, arrest us, and shut it down." And that's exactly what happened. But to make the moment really pop for the video, the crowd wasn't made aware of it. "It was our encore and we just stopped halfway through a song and left," says Marker. "It was really weird."

VIG: Shirley flashed her tits, the "police" came onstage, the whole crowd fucking went, "BOO!" They got really pissed.

MANSON: We just left, and then they went mental. *Mental.* Some of them were worried that I'd been arrested and put in jail.

ERIKSON: It was bad judgment.

MANSON: It wasn't bad judgment because it made for a good video.

VIG: Art for art's sake.

This was before smartphones and social media, or the outrage—at either the band or the fictional DC police—might have played much worse. There wouldn't have been any seminude

THE VIBES MAN: ERIC AVERY

Eric Avery describes his approach to the bass as being more about feel than technique. "I definitely have a vibe," he says. "If you want the thing that I do, then it's good to hire me."

Avery was a founding member of Jane's Addiction, and vibe is a big part of the reason he became Garbage's second touring bassist after Daniel Shulman left in 2003 to take an A&R job at Island Def Jam. "We looked around at a bunch of different characters, but when we met Eric we fell in love with him," says Manson. "Butch offered him the job right there."

Avery remembers that when his name was first suggested to the band by Maverick Records head Guy Oseary, the reaction was, "Oh, he'll never play with us." But Oseary pointed out that Avery's most recent job had been as a hired gun for Alanis Morissette, and he'd also toured with Peter Murphy. Avery joined Garbage for the *Bleed Like Me* tour and has been their man on the four-string ever since.

Though he passed the personality test instantly, Avery's musical style was harder to incorporate, causing him frustration when he first was learning the songs. "My struggle has been: *How do I not sound so much like me?*—because it doesn't fit as well with Garbage," he says. For counsel on how to make it work, he turned to bass guru Flea of the Red Hot Chili Peppers. Flea's advice? Learn the bass parts from Marvin Gaye's "What's Going On," as a sort of four-string mantra.

As Shulman had before him, Avery became more than a musical bedrock for Garbage. "They're both very psychologically intelligent and they have been our shrinks for sure," says Manson. "Eric's a gorgeous man—intelligent, sensitive."

"I do feel like I have been an emissary of sorts," Avery says. Part of his role has been simply to step back and make sure each band member's voice is heard clearly: "'I think what you're saying is *this*, and what they're saying is *that*.'" Initially, Avery imagined that Garbage would function as "a collection of producers who had a great frontperson"—more or less the same thing a lot of people thought when the band first started. But what he found was a true group. "It was much more organic," he says. "Everybody was really an equal voice. More so than just about any band I've dealt with."

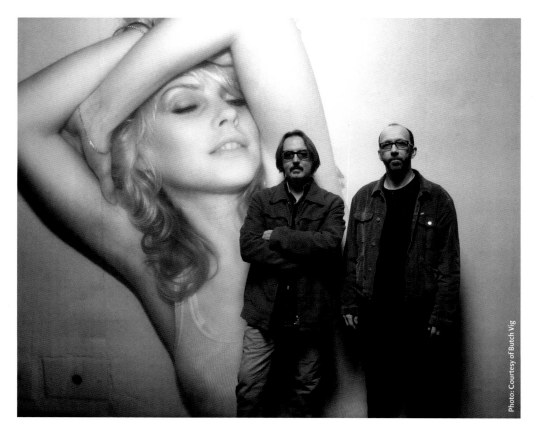

Photo: Courtesy of Butch Vig

Photo: Courtesy of Butch Vig

pictures of Manson, however, since she had a flesh-toned bandage wrapped around her chest. "Though I don't know why she didn't actually show her tits," jokes Muller. "She would do it practically everywhere else given the opportunity."

<center>X X X</center>

The most interesting of Muller's four videos from *Bleed Like Me* is "Why Do You Love Me," especially in retrospect. The video is like a snapshot of where the band was at the time. "Sophie wanted the video to be about our relationships," says Manson. "She wanted to depict the communication breakdown in the band."

Muller, however, is quick to note that she got most of the ideas from Manson, the two of them e-mailing back and forth while Muller pitched her treatment.

The video starts with Manson reluctantly getting out of bed (the word *LIAR* written on the wall above her headboard) and includes reenactments of nonverbal ill communication with both Marker and Erikson. In the kitchen, Manson retreats into a book and a cup of tea while Marker kicks and smashes things, then Erikson appears as a painter, receiving commanding directions from Vig and Marker. Then, in spite of it all, the band straps on their instruments and rocks out—angrily—before fighting again. It even includes a scene of Manson in the bathtub, just like that day in Madison. "*I get back up and I do it again,*" she sings. "*Why do you love me? It's driving me crazy!*"

"It ended up being a surreal documentary of the band," says Muller, "the whole dynamic in the band—but totally objectified out of that into some sort of Warholian kind of weirdness."

ERIKSON: When I showed up at that shoot and heard that Shirl and Sophie had devised this thing to express . . . whatever it was that was going on, I was like, "Okay," but I didn't know exactly what to make of it. What was I irritated with you about, Shirl? That you'd burned the toast?

MANSON: You're not irritated. She does that scene where you're looking at me when I walk in and I'm not looking at you, and you think I'm ignoring you. But when I look at you, you've already looked away and have walked out the door so I think you're ignoring me. It's more about that dynamic of wanting to communicate but we're all at cross-purposes. I think it's a beautiful way of describing exactly what happened. In a funny way.

LIAR

Above: an image from the music video "Why Do You Love Me," directed by Sophie Muller; opposite right: Garbage on set for the "Bleed Like Me" video, also directed by Muller. Both the "Why Do You Love Me" and "Bleed Like Me" videos had scenes that tapped into escalating band tensions. Opposite left: Vig and Erikson on the set of the "Why Do You Love Me" video, which featured an oversize portrait of Deborah Harry taken by Chris Stein and given as a gift to Manson shortly before she inducted Blondie into the Rock and Roll Hall of Fame in Cleveland, Ohio.

MARKER: I kick over a whole bar, and that could have some basis in real life. I actually came up with that. I was just pissed off. I wasn't drinking at the time, and those guys were—a lot. It was really tough. So there was something there.

VIG: And I'm not doing anything. I'm just fucking drinking and smoking, completely removed from everything. Seriously. And Shirley looks frustrated the whole time, just looking around like, *What the fuck?* She's not just singing "Why Do You Love Me?" to her family, her friends, or her fans. It also could be us: Steve and Duke and myself.

MARKER: That feels almost creepy to me.

MANSON: That *is* creepy! I like that it's creepy.

MARKER: I wasn't happy.

MANSON: None of us were. But we all still tried really hard.

VIG: Sophie got, in a subtle way or not-so-subtle way, what was going on with that record. She could see the cracks in our psyche, and they show up in that video. She wanted to make the problems into art. And make them beautiful instead of something that made us unhappy.

ERIKSON: Psychic almost. Just very perceptive.

X X X

"THIS IS OUR TENTH ANNIVERSARY, AND EVERYONE NEEDS A BREAK FROM ONE ANOTHER. I DON'T KNOW WHAT I'M GOING TO DO, TO BE HONEST. THE HIATUS MAY LAST TWO WEEKS, IT MAY LAST TWO YEARS. WE REALLY DON'T KNOW. WE'VE COME TO A POINT WHERE WE FEEL REALLY GOOD ABOUT WHERE WE'RE AT. WE'VE HAD AN AMAZING RUN WITH THIS RECORD, AND WE FEEL THAT IT'S A GOOD TIME TO TAKE SOME TIME APART."

—SHIRLEY MANSON TO MTV, 2005

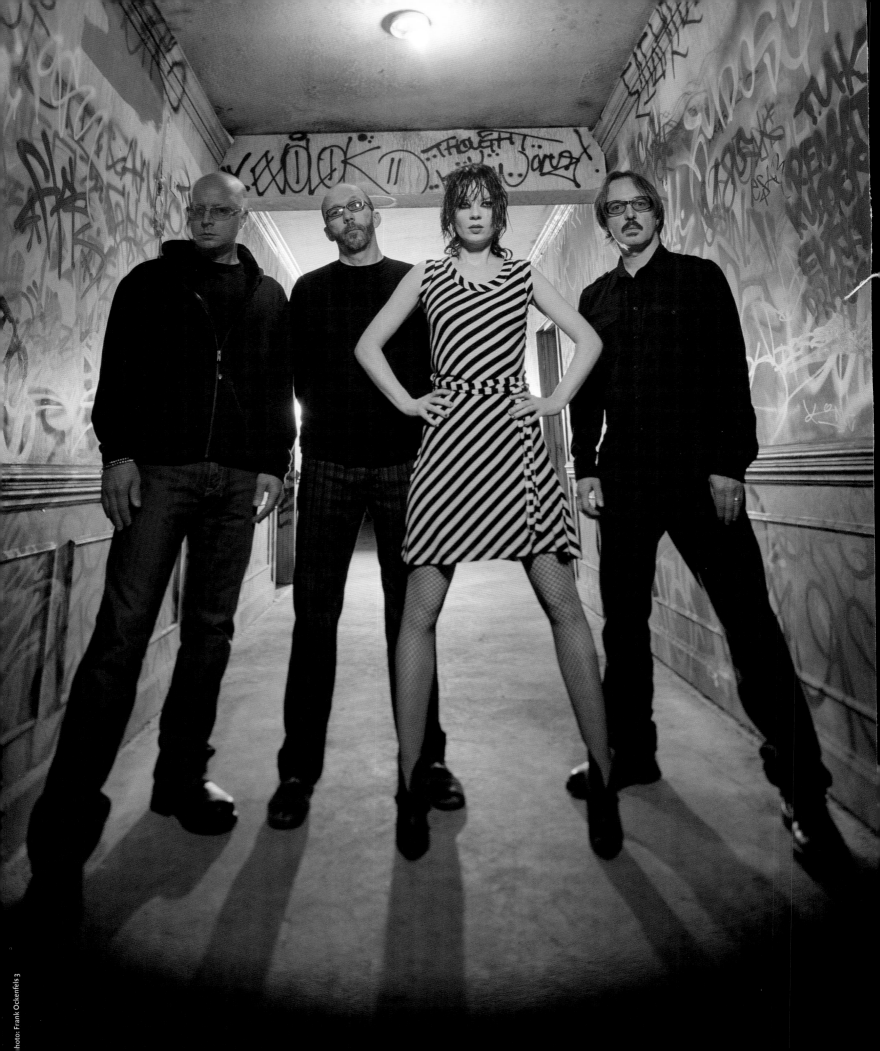

Photo: Official Garbage Archive

Photo: Butch Vig

Top: Marker at sound check at the Bullring in Murcia, Spain; above: bassist Eric Avery marvels at the luxurious amenities backstage at a music festival on the *Bleed Like Me* tour, somewhere in Eastern Europe, 2005; left: Garbage stand in the haunted halls of the since-demolished Ambassador Hotel, Los Angeles, famously the site of presidential candidate Bobby Kennedy's assassination in 1968.

In spite of everything, the band enjoyed being back on the road for *Bleed Like Me*. Avery fit in nicely (he would become close friends with Manson), the album was selling decently, and the shows were going well. But emotionally, it still felt like a slog, even though they'd only been out on the road from April through August of 2005. Then a grim economic reality set in, delivering a killing blow to Garbage.

MARKER: We were touring. It actually did well and we had fun.

MANSON: We sold a million copies. That's a shitload of records, especially at that time.

MARKER: We had some good shows. But then we had another big leg to go back to Europe, to play bigger places that were all booked, and our management was like, "Those shows are not selling very well." They brought us a number and said, "This is how much you're going to lose."

MANSON: It was in the UK—my home turf. And they told me, "This could be a situation you would not feel good about." And I said, "I don't want to do it."

VIG: Alternative music was falling off the face of the earth. Everybody had to grapple with a rapidly declining market value for what we were doing. Q Prime had a very sharp tour team. They said, "Okay, if you guys go play this last leg, you're going to lose $150,000. We recommend you pull the plug." We responded, "Let's pull the plug."

ERIKSON: That was crushing. Just depressing. We were playing really well. We were having fun. Then they call up and say this is all for naught.

MARKER: Within a year of us coming off the road, record companies were seeing their returns *really* diminishing. They would have killed to have a band like us sell a million records. But by then they'd already kind of washed their hands of us. And we had lost faith in ourselves.

Photo: Roxy Erickson

With the tour prematurely ended, Garbage went back to Madison to talk about what they should do next. For ten years, they'd been on the album-tour-album cycle, but this time they weren't ready to just rinse and repeat.

"We went to the studio and were talking about, 'Well, what are we going to do next? I guess we should make another record,'" says Manson. "And I just thought to myself, *What's the point? Whatever this is will be destroyed. I don't want to make another record.* I was miserable making *Bleed Like Me* for so many different reasons."

Erikson was the only band member who wanted to go back and record. "Duke said, 'Well, I want to make another record,'" explains Manson. "And I said, 'Well, I don't.' And he said, 'How does everyone else feel?' Steve said, 'I don't really feel like doing another either.' And Butch was like, 'Yeah, I kind of feel the same way.'"

Manson thought that no matter what they did, immediately making another album would kill the band. They risked releasing it to an apathetic public and destroying their reputation if it flopped, regardless of its artistic merit. "We could have made *Sgt. Pepper's Lonely Hearts Club Band* and it would have been ignored," says Manson. "I just thought, *This is the kiss of death to the band if we go in and make another record just for the hell of it because we don't know what else to do.*"

This time, everyone agreed. It was not a breakup. Nobody expected it would last for years.

Above: Erikson onstage during the *Bleed Like Me* tour; following page (left), clockwise from top: Manson onstage; Vig's perspective of Manson onstage—note the custom Shirley shorts by Kate Roos; Manson flips the bird with a smile; backstage vibes; Marker naps in a road case; following page (right): the final day sheet from the last of seventy-eight shows supporting *Bleed Like Me.* The band would not play together again until 2012.

MUSIC VIDEOS

VOW
Director: Samuel Bayer
Year: June 1995
Location: Los Angeles, CA

QUEER
Director: Stephane Sednaoui
Year: August 1995
Location: Los Angeles, CA

ONLY HAPPY WHEN IT RAINS
Director: Samuel Bayer
Year: February 1996
Location: Los Angeles, CA

STUPID GIRL
Director: Samuel Bayer
Year: February 1996
Location: Los Angeles, CA

MILK
Director: Stephane Sednaoui
Year: August 1996
Location: London, UK

SLEEP
Director: Karen Lamond
Shot by: Garbage
Year: November 1996
Location: Smart Studios, Madison, WI

PUSH IT
Director: Andrea Giacobbe
Year: April 1998
Location: Los Angeles, CA

I THINK I'M PARANOID
Director: Matthew Rolston
Year: July 1998
Location: Los Angeles, CA

SPECIAL
Director: Dawn Shadforth
Year: September 1998
Location: London, UK

WHEN I GROW UP
Director: Sophie Muller
Year: December 1998
Locations:
Egyptian Theatre, Indianapolis, IN—November 17, 1998
Dane County Expo Center, Madison, WI—November 18, 1998
Memorial Hall, Kansas City, KS—November 20, 1998
American Theatre, St. Louis, MO—November 21, 1998

THE TRICK IS TO KEEP BREATHING
Director: Sophie Muller
Year: December 1998
Locations:
Egyptian Theatre, Indianapolis, IN—November 17, 1998
Dane County Expo Center, Madison, WI—November 18, 1998
Memorial Hall, Kansas City, KS—November 20, 1998

YOU LOOK SO FINE
Director: Stephane Sednaoui
Year: March 1999
Location: Los Angeles, CA

WHEN I GROW UP (*BIG DADDY* VERSION)
Director: Sophie Muller
Year: June 1999
Location: London, UK

THE WORLD IS NOT ENOUGH
Director: Philipp Stölzl
Year: October 1999
Location: London, UK

ANDROGYNY
Director: Don Cameron
Year: September 2001
Location: London, UK

CHERRY LIPS
Director: Joseph Kahn
Year: December 2001
Location: Brooklyn, NY

BREAKING UP THE GIRL
Director: Francis Lawrence
Year: January 2002
Location: Los Angeles, CA
Note: a second version of this video exists featuring the MTV series *Daria*

SHUT YOUR MOUTH (ANIMATED)
Director: Henry Moore Selder
Year: July 2002

SHUT YOUR MOUTH (UK RELEASE)
Director: Elliot Chaffer
Year: September 2002
Locations: MTV *Five Night Stand* in London, UK—April 8, 2002
Cologne Palladium, Cologne, Germany—April 10, 2002

WHY DO YOU LOVE ME
Director: Sophie Muller
Year: March 2005
Location: Los Angeles, CA

BLEED LIKE ME
Director: Sophie Muller
Year: May 2005
Location: Linda Vista Community Hospital, Boyle Heights, Los Angeles, CA

SEX IS NOT THE ENEMY
Director: Sophie Muller
Year: May 2005
Locations: New York, NY
9:30 Club, Washington, DC—April 21, 2005

RUN BABY RUN
Director: Sophie Muller
Year: June 2005
Locations:
London, UK
Charles de Gaulle Airport, Paris, France
Paris Metro, Paris, France
Olympiastadion, Berlin, Germany
Mohrenstraße (U-Bahn Station), Berlin, Germany
Neu-Westend (U-Bahn Station), Berlin, Germany
Bosphorus Strait, Turkey
Pera Palace Hotel, Istanbul, Turkey
Istanbul Haydarpaşa Terminal, Istanbul, Turkey

TELL ME WHERE IT HURTS
Director: Sophie Muller
Year: May 2007
Location: Los Angeles, CA

BLOOD FOR POPPIES
Director: Matt Irwin
Year: April 2012
Location: Los Angeles, CA

BIG BRIGHT WORLD
Director: Julie Orser
Year: August 2012
Location: Thousand Oaks, CA

BECAUSE THE NIGHT, FEATURING SCREAMING FEMALES
Director: Sophie Muller
Year: April 2013
Location: EastWest Studios, Los Angeles, CA

GIRLS TALK, FEATURING BRODY DALLE
Director: Sophie Muller
Shot by: Butch Vig
Year: May 2014
Location: Los Angeles, CA

THE CHEMICALS, FEATURING BRIAN AUBERT
Director: Sophie Muller
Year: April 2015
Location: London, UK

EMPTY
Director: Samuel Bayer
Year: May 2016
Location: Los Angeles, CA

MAGNETIZED
Director: Scott Stuckey
Year: October 2016
Location: Los Angeles, CA

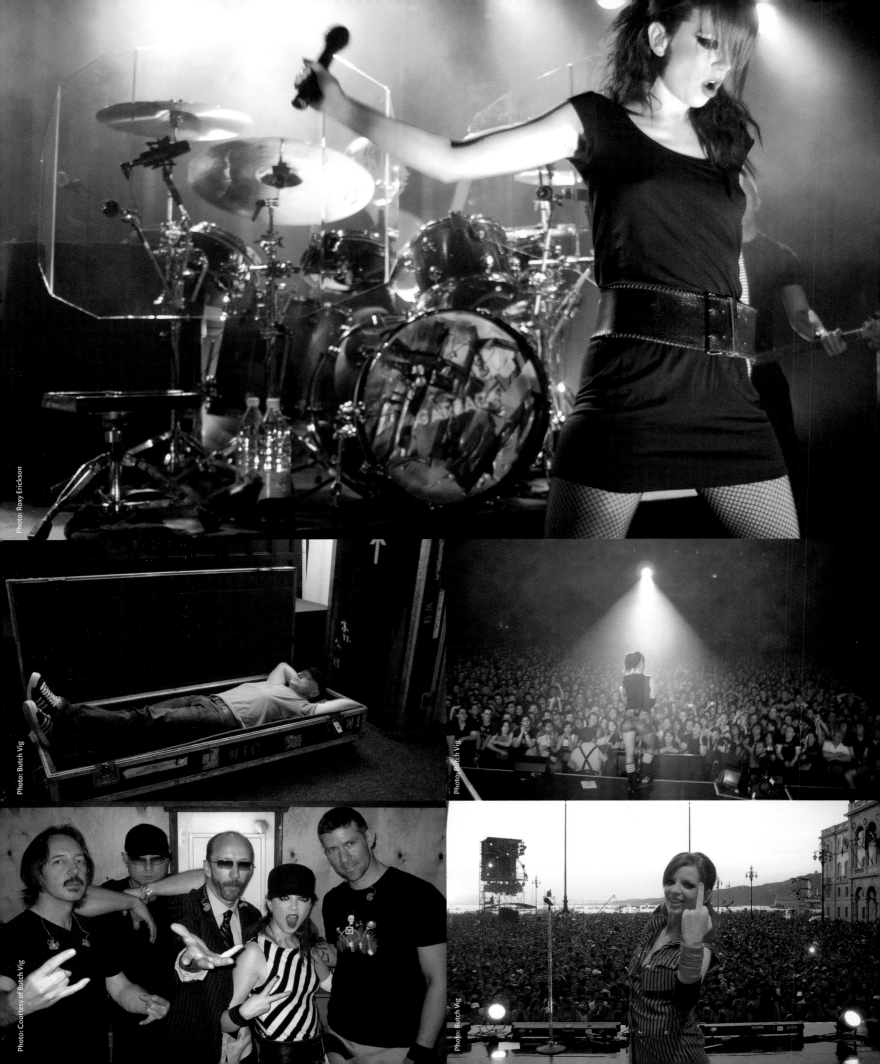

LAST SHOW!!

GARBAGE

TODAY IS:-	**Saturday Oct 1**
WE ARE IN:-	**Perth, Australia**
PRODUCTION LOAD IN:-	**10:00am**
BACKLINE LOAD IN:-	**2:00pm**
DINNER:-	**6:00pm**
DOORS:-	**7:15pm**
RED JEZEBEL:-	**8:00pm**
SET CHANGE:-	**8:30pm**
GARBAGE:-	**9:00-10:30pm**
AFTERSHOW:-	**Band & Crew return to hotel**
TONIGHT:-	**3:30am – LOBBY CALL** **Except Graeme & Duke**
	5:50am – FLIGHT DEPARTURE

Ramp it up !!!

This sucks !

Week at a Glance...

Saturday	Sunday	Monday	Tuesday	Wednesday	Thursday	Friday
Oct 1, 2005	Oct 2, 2005	Oct 3, 2005	Oct 4, 2005	Oct 5, 2005	Oct 6, 2005	Oct 7, 2005
SHOW DAY Perth, Australia	**TRAVEL DAY / DAY OFF AKA "YOU'RE FIRED"** HOME	**HOME**	**HOME**	**HOME**	**HOME**	**HOME**

HOME SWEET HOME

"WE ALL KNEW WE HAD TO HAVE A BREAK. BUT WE WERE THINKING IN TERMS OF SEVEN MONTHS, NOT SEVEN YEARS."

—STEVE MARKER

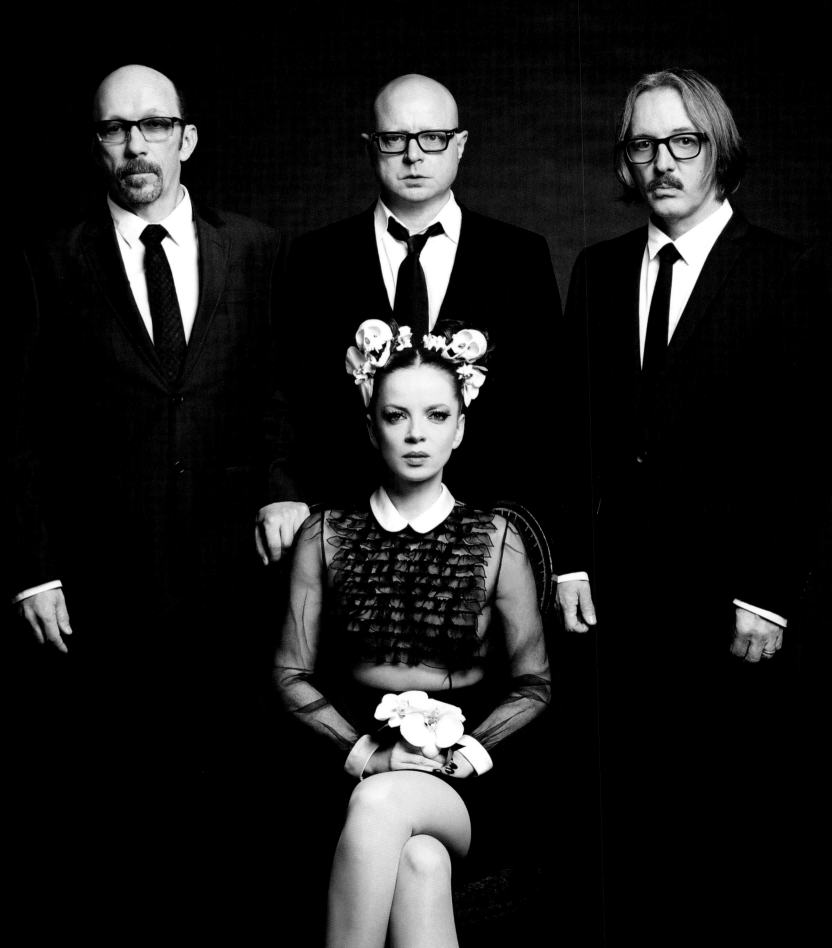

Seven years. That's how much time passed between the release of *Bleed Like Me* and 2012's *Not Your Kind of People*. When the band went on hiatus in 2005, Taylor Swift had yet to make a record. There was no such thing as an iPhone. And Barack Obama was just starting his first term—as a US Senator from Illinois.

VIG: In the back of my head, I thought we'd take a year off, then get back together and try to write some songs.

ERIKSON: It takes you a year just to acclimate to being a normal human being. And then another two or three to get to know your life again and enjoy it.

MANSON: It didn't feel like a long time at all.

VIG: It was necessary. All of us needed time away from each other.

Life itself was definitely taking precedence. Vig and Beth Halper had gotten married in 2003, and in 2006 Halper gave birth to a daughter, Bo Violet. Marker and Cindy Kahn had also become parents, in 2000. After the *Bleed Like Me* tour, Marker, Kahn, and their daughter Ruby left Madison for Colorado. Around that same time, Manson and Billy Bush settled in Hollywood. That left Erikson as the band's sole Wisconsin resident.

Contact was intermittent. Vig and Marker were still bound by Smart Studios, but now that anyone could record an album on their laptop, Smart—like many studios—was struggling. It ultimately closed in April 2010. Manson is Ruby Marker's godmother; she and Kahn remained close friends, albeit long-distance. Vig and Manson would cross paths in LA, while Vig and Erikson would convene several times a year, usually at Lambeau Field for a Green Bay Packers game or for the occasional gig (birthday, wedding, or benefit) with their cover band, the Know-It-All Boyfriends.

But collectively the four of them were rarely in touch. The band had never broken up—on this all four members of Garbage are in agreement—but rather was in suspended animation.

VIG: When I ran into my bandmates, there was no tension. But we never talked about Garbage.

Photo: Roxy Erickson

ERIKSON: I never worried about it. Those years went by so quick. I knew that if any one of us didn't want to get back together, it wasn't going to happen.

MANSON: We were all annoyed with one another for a billion million reasons—some warranted, some unwarranted. But nothing ever got said that was damaging or hurtful.

MARKER: I think we were all comfortable not talking about it, really.

According to his wife, Marker may have been the person who most wanted the band to resume. "I've never seen him so shattered," says Kahn about the aftermath of *Bleed Like Me*. "Garbage is his most favorite thing to do in the world. I think for every minute they weren't together, it was what he was hoping for."

<p style="text-align:center">X X X</p>

<p style="text-align:center">"I LIKE BEING IN A BAND. THERE'S A ROMANCE FOR ME IN A BAND."
—SHIRLEY MANSON</p>

But if it was seven years between albums, that doesn't mean there wasn't work to be done as a band—that's one reason the hiatus felt so different inside the band than outside of it. The four members of Garbage were in the same room pretty often in the first half of 2007. In January they played a benefit concert, Beat It Wally!, for Madison-bred drummer Wally Ingram. Between February and April, they also recorded several songs and shot a video to round out the DVD and double-CD compilation *Absolute Garbage*.

The best-of was more a matter of contractual obligation than creative choice, and those sessions only furthered everyone's estrangement. The band did not consider touring to promote it, and while being together provoked nostalgic moments—Daniel Shulman played bass on "Tell Me Where It Hurts," and his wife Lisa was one of the redheads in Sophie Muller's *Belle de Jour*–inspired video—nobody was saying, "Let's do this again soon!"

Absolute Garbage finally freed the band of their record deals, both with the Almo/Geffen/Interscope/Universal conglomeration in the United States and with Warner Bros.' A&E Records (which had absorbed Infectious/Mushroom) in the UK and Australia. Manson, though, remained bound to Interscope and Universal via her Angelfish/Radioactive contract. She began work on a solo record, collaborating with people of her own choosing as well as Interscope-approved hit makers. Nothing really took, not even a few sessions with Vig.

As had been the case with Garbage, the label's expectations weren't in sync with Manson's creative goals. "Jimmy [Iovine] liked to pull people out of bands and make them stars," says Peter Mensch. It was a strategy that had certainly worked with Manson's former tourmate Gwen Stefani. "He might have wanted to do that with Shirley," Mensch adds, "but she wasn't having any of it." Vig has said the label imagined Manson being as mainstream as Katy Perry, while one label executive told her she could be "the Annie Lennox of my generation." One track Manson and Vig worked on for the project, "Blood for Poppies," would resurface on *Not Your Kind of People*. The rest of Manson's solo tracks remain lost forever.

But Manson's struggles as a solo artist did help crack the door back open for Garbage.

MANSON: The only reason I ever went down that path was because things had gotten so fraught in the band, and I wanted to continue to make music. But my heart wasn't in it. I would come home from the studio and say, "Why am I doing this to myself? I should be doing this with the boys. I'd still be butting heads, but at least it would be with people I really love and adore."

In fact, Garbage released another song in late 2008. Living in Los Angeles, Vig and Manson had become part of the Silver Lake music community, which had rallied around Dangerbird Records owner Jeff Castelaz and his wife Jo Ann Thrailkill when their son Pablo was diagnosed with cancer. It was a time of loss for Manson too. Her mother, Muriel, was battling Pick's disease, an extremely rare form of dementia that would ultimately take her, at the age of seventy-two, in November. And earlier that year, in April, one of Manson's closest friends in Scotland, Morag Williamson, unexpectedly lost her husband David.

After an emotional memorial for David Williamson in Scotland, Manson began writing the lyrics to what became "Witness to Your Love," the opening cut on *Give Listen Help*, a benefit CD for Pablo's Pablove Foundation and Children's Hospital Los Angeles. The song was based on tracks from the 2007 Garbage session. Working on a tight deadline, Vig and Manson finished it themselves in California, with Erikson and Marker adding guitar long-distance.

When Pablo died in June 2009, his parents asked Manson if she would sing the six-year-old's favorite song, David Bowie's "Life on Mars," at the memorial. "It was heartwrenching," says Vig. After the funeral, he, Manson, and other mourners wound up at Silver Lake's Barbrix, across the street from the Dust Brothers's longtime studio, The Boat. Just fifty yards away from where the band had tried and failed to overcome their differences by working with John King on *Bleed Like Me*, Vig and Manson, in their grief, also remembered what was good.

MANSON: Butch said, "You sounded so beautiful. I've missed your voice." And I said to him point-blank, "I want to make another record."

VIG: I remember thinking, *Yeah, let's get back into the studio. Life is so short, we need to make music again. Now!*

MANSON: It was a moment of hopelessness and heartbreak, and music being there in great service to everyone. If I had not sung that day, I don't know whether we would have ever been in the same place to really go.

Some ground had already been laid, however. Garbage's longtime booking agent had pitched the band for a one-off concert at the Hollywood Bowl. It didn't happen but, says Marker, "That was the first time that we all got on the phone together." Manson had recently seen Marker in Palm Springs, where he was on vacation with his family, and she and Billy Bush were nearby to attend Coachella. Seeing all those other bands, who hadn't even existed during Garbage's commercial peak, made her think, *Why the fuck aren't we up there?* Manson made a side trip to the Westfield Palm Desert mall with Marker, Cindy Kahn, and Ruby, and a chance encounter there with some fans felt like a sign.

MANSON: These two kids came running out of Hot Topic—amazing-looking, little goth kids, screaming and shaking. They were like, "We love you!" One of them was crying. "When are you putting out a new record?" And as we walked away I said to Steve, "Why *aren't* we making a new record?"

X X X

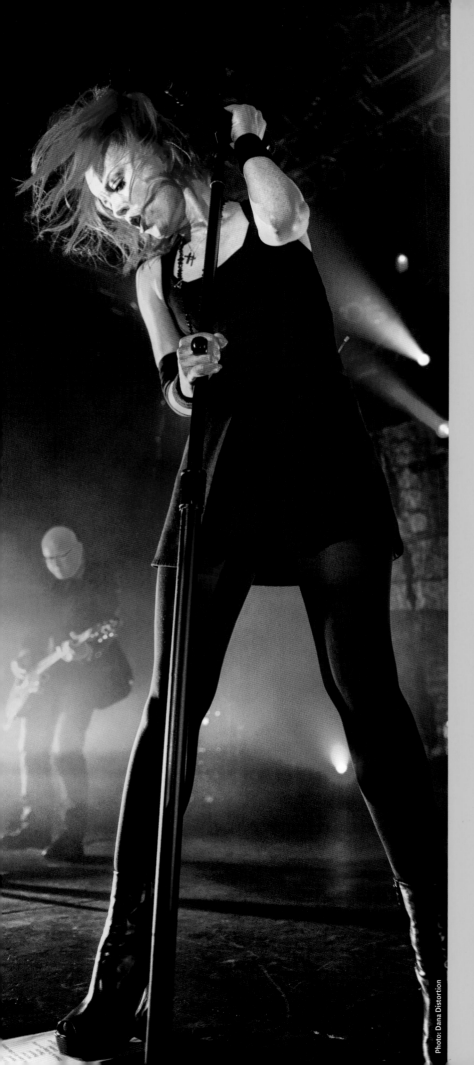

FILL YOUR GLASS WITH GARBAGE

ROCK AND ROLL COCKTAIL RECIPES

BAD BOYFRIEND SAUVIGNON BLANC

By 2012, Butch Vig had his own wine—not a wine he preferred (though there are many of those), one that he bottled.

"Sometime around recording *Beautiful Garbage*, our friend Robert Whitlock, a wine importer in Madison, turned me on to white wines," Vig says. "I was first seduced by Montrachet. It's a French chardonnay with complex minerals, fruit, and earthy tones. It's quite amazing. Then I discovered Napa's Duckhorn sauvignon blanc, and went quite mad for it. *Mad for it*. It became our house white, served on all occasions."

But Duckhorn became increasingly popular and expensive. "Obama served it at his inaugural dinner," says Vig. "That didn't help. So my wife Beth challenged me: 'Make your own version of Duckhorn!'"

As it happened, Pete Anderson, an old Wisconsin friend and on-and-off member of Vig's Emperors of Wyoming, was a wine-maker in Napa. Anderson created a wine that took its name from the Garbage song "Bad Boyfriend." Limited to fewer than fifty cases, the wine won a double gold medal at the California State Fair. And Vig hasn't run out yet. "I am quite pleased to say it has become one of our house wines here in Silver Lake!"

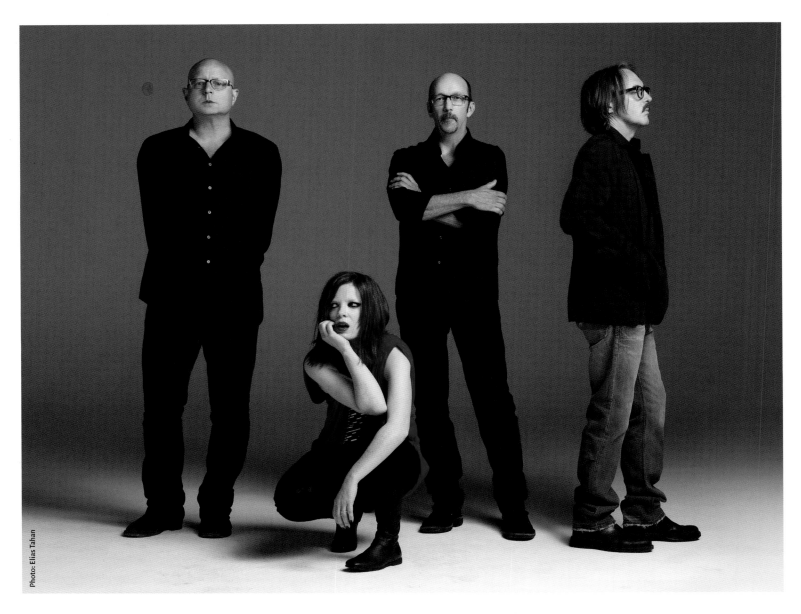

Photo: Elias Tahan

By January of 2010, they were. The band gathered at LA studio The Pass. "We all said, 'Let's go in for a week and see what happens,'" says Erikson.

Marker remembers there being a clear mission: "We set out to make a record. We all knew we were there by choice, not out of obligation."

To keep things fresh, and break the habits they had gotten into on the last few records, nobody was allowed to bring in old ideas or demos. "We were just going to start from scratch," says Erikson.

Manson showed up nervous, mostly about seeing Erikson. Aside from the work in 2007, "I really did not speak to Duke, I don't think," she says. "Physically—I'm not talking about e-mails and stuff." She, Bush, Marker, and Vig were already at the studio, well into a first bottle of wine.

"This was at one in the afternoon or so," says Vig. "And then a couple of hours later, Duke walked into the lounge and with a sly smile asked, 'Did ya miss me?'"

The tension immediately disappeared. "I have close friends that I don't speak to for years," says Erikson, "and the minute you talk to them, it's like you spoke to them yesterday."

Manson and Bush also had a big surprise—they'd gotten married a few days before. "And god bless him," Manson says, "Duke said, 'You got married? Without me? You didn't invite me?'"

VIG: We drank wine all afternoon. Around seven p.m. we started jamming. At one point Shirley was playing drums and we were just messing around, but then we started working on "Battle in Me."

MANSON: That was a victorious beginning.

Above: a posthiatus publicity shot from the band's first photo session in six years—note **Vig**'s subtle variation on the usual **Boys in Black** dress code; opposite: a publicity shot for the **"20 Years Queer"** tour, marking the twentieth anniversary of the debut record; following pages: striking a pose onstage, with **Erikson** leading the rocking and rolling.

HER LIFE AS A ROBOT

WHAT SHIRLEY MANSON LEARNED FROM PLAYING A TERMINATOR ON TV

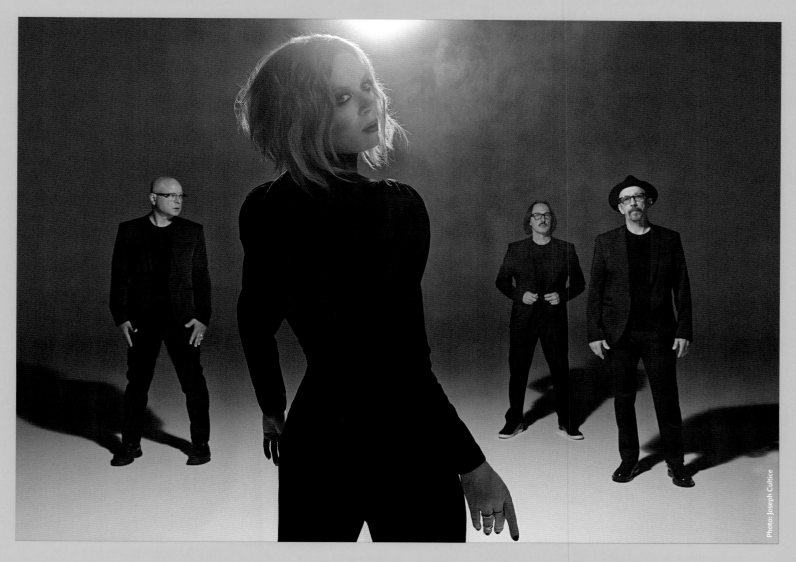

Photo: Joseph Cultice

In 2008 and 2009, Shirley Manson appeared in the Fox series *Terminator: The Sarah Connor Chronicles*, playing a technology company CEO who turns out to be a liquid metal Terminator robot. Manson filmed seventeen episodes in the show's two seasons.

She met the show's executive producer, Josh Friedman, at Gwen Stefani's baby shower, and they bonded over noir novelist James Ellroy. "We were talking about *The Black Dahlia* and a whole bunch of Ellroy books," says Manson, "and he said to me, 'Would you ever consider acting?'" Manson, in fact, had been serious about acting when she was growing up. "I was very involved with dramatics at home. And I told the truth, which was, 'Well, that's what I wanted to be until I stumbled into music. I was going to be an actor.'"

Friedman had a part for her: he thought she'd make an amazing robot in the show he was about to do, though Manson didn't take much notice of this. "Because Hollywood is like that all the time," she says. "You meet people and they're like, 'I'm going to do this for you, I'm going to do that. Will you do this for me?' There's so much bullshit. It never ever crossed my mind that he would call back."

Yet he did, and though the audition process wasn't simple, she got the gig. After her run on the show, while Garbage was still on hiatus, Manson spent two years taking acting lessons at the suggestion of her agent, and what she learned from her teacher, Sharon Chatten, has become part of the creative process in the band.

"She completely changed my attitude to being an artist and my approach to making music," says Manson. "She taught me how not to focus on results but instead to focus on ideas and taking creative detours and risks; how to cut the strings of who I thought I was and instead be in the moment, completely free of external appraisal."

Manson hasn't done much acting since, but she values her experience on *The Sarah Connor Chronicles*, both for what it gave her and what it clarified: "I loved it, but it also made me painfully aware that I loved making music, and that was the best job I could ever want for myself. I love being in a band. I love musicians. I've come to realize that they're my favorite characters in the world. Not the famous ones, necessarily. A working musician is a hero to me. I like being around them, and I love the whole idea of them. It's just a glorious endeavor."

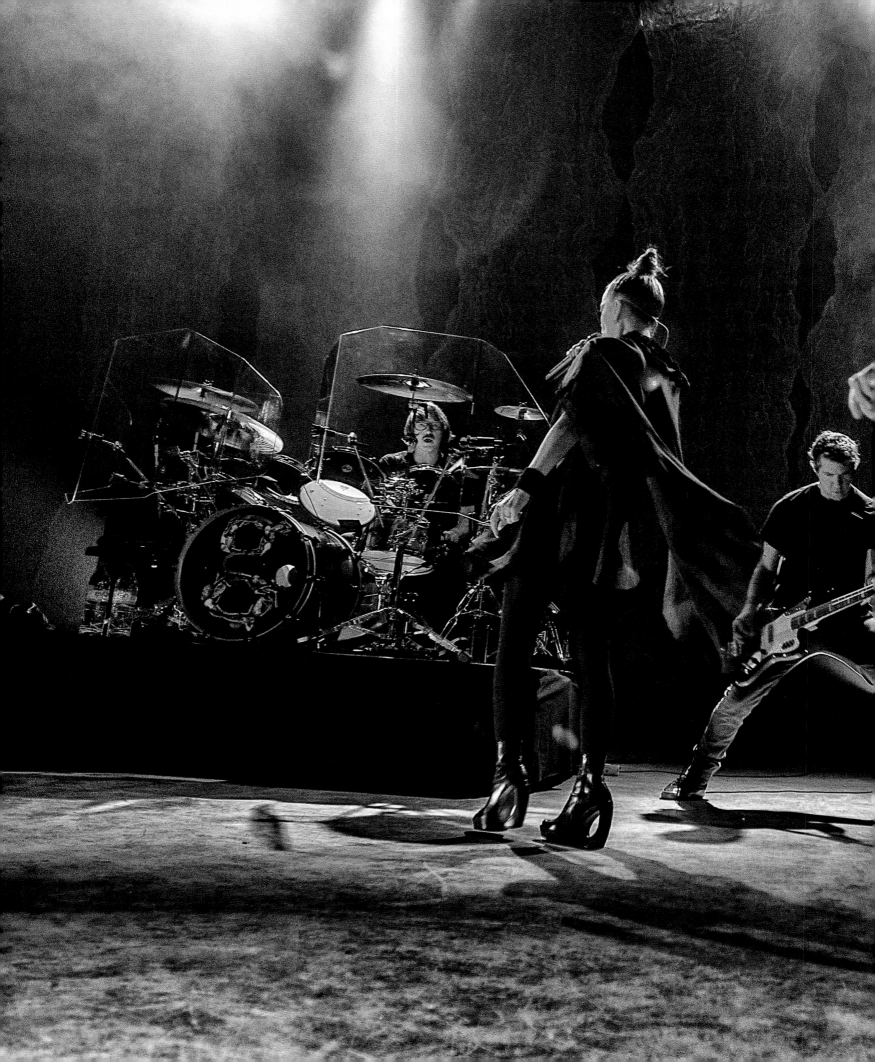

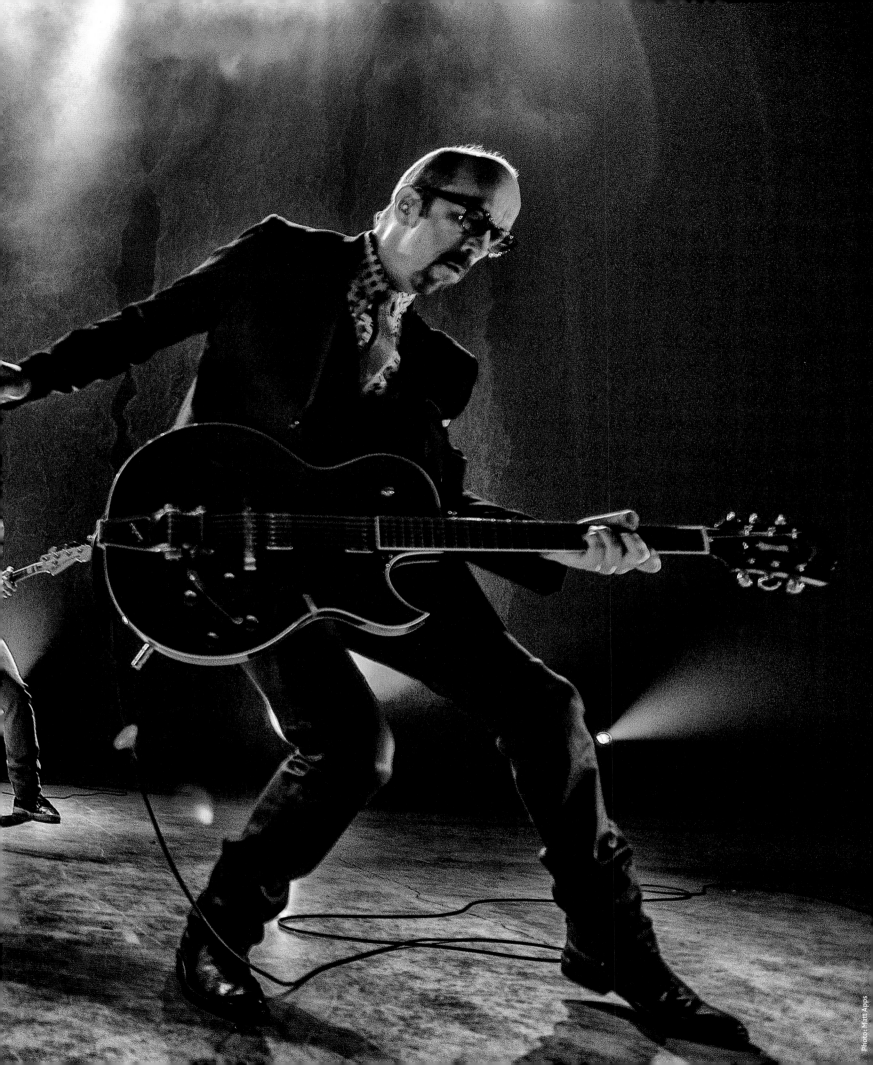

VIG: Steve came up with a bass line, and we started improvising on top of it.

ERIKSON: Weren't you trying to do a Michael Jackson bass line?

MARKER: I had just seen It Might Get Loud, and Jimmy Page is teaching Jack White how to play that riff from "Kashmir." That's what I remember.

ERIKSON: I think we used the bass line from "Beat It" as a reference.

VIG: And then that track sat around for like . . .

ERIKSON: Two years?

VIG: At least.

MARKER: It was probably a fifteen-minute jam at one point.

VIG: We took the best bits of everything, and then Shirley went and resang, and we added more guitars and a bunch of fucking chaos.

ERIKSON: That first night that we did it, that was the moment. That was very heartening to us. We felt like we still had it.

They recorded at The Pass for as long as they could afford to—a week or two—before moving to Bush's studio, the more affordable (though not free) option. There was no record company to pay for everything, but as a band they still had money, in part because they hadn't lost it all by finishing the *Bleed Like Me* tour in 2005. At that point, the band's business managers suggested they just leave it in the bank, rather than everybody cashing out.

"I think we were all smart enough to know that we weren't done," says Manson. "Everyone was like, 'Keep it in there.'"

"I was happy to do that because otherwise I would have just spent it," quips Erikson.

In 2010 the band was still managed by Q Prime. "At the end of that session I think we had four songs," says Vig. "We sent them to Q Prime, and they said, 'Hmm, you should go back, keep writing.' They were not optimistic."

"Very unoptimistic," adds Manson.

Despite Q Prime's lack of enthusiasm, the band was in an unexpected sweet spot. Everything that held them back on their third and fourth records was gone. They were in the same state that not-yet-existing Garbage had been in before their first album: doing everything for themselves. There was no label they had to please, and since Q Prime wasn't enthusiastic about what they were doing, they felt they were on their own. "We didn't even tell anybody we were doing it. No outside opinion at all," says Marker.

"Ultimately, if you are a band who wants to survive, you have to learn to do it all yourself," says Manson. "If you're lucky, people will step in and help."

Garbage were close to the end of recording when they decided to change management, and they knew exactly who they wanted—the only other person besides themselves who'd lived nearly every minute of Garbage: Paul Kremen. The former Almo general manager and Interscope head of marketing had remained close friends with Manson, and had done everything he could to end the hiatus.

"Paul was the only one who was like, 'This is something you love. This is something that has great value. You need to safeguard that,'" says Manson. "He said, 'You need to call the boys. This is ridiculous. This is what you all were born to do.' And that has stuck with me. I really trust him."

"When Paul was working with Almo, he was the voice that we trusted every step of the way," says Erikson. "It just felt like he was looking out for us, and always giving us the whole picture."

Kremen had worked closely with U2, both during his time at Interscope and independently, and been a marketing consultant for the Rolling Stones on their 2010 *Exile on Main St.* reissue. Kremen says that his journey with Garbage was "my graduate education in the record business. Garbage started it, and U2 furthered it dramatically."

At Q Prime, Garbage vied for attention with established mega-acts like Metallica and the Red Hot Chili Peppers, as well as developing bands like the Black Keys and Silversun Pickups.

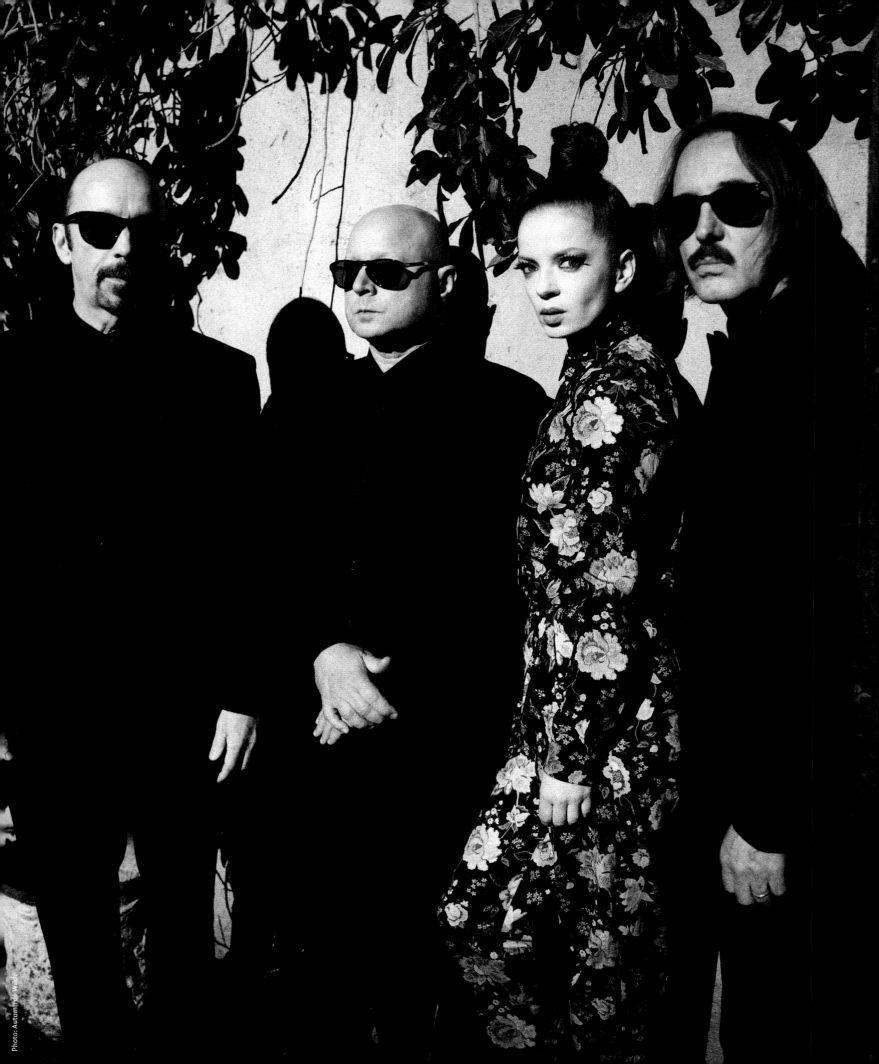

G IS FOR GARBAGE—ALSO, GREEN BAY
HOW GARBAGE HELPED THE GREEN BAY PACKERS WIN THE SUPER BOWL

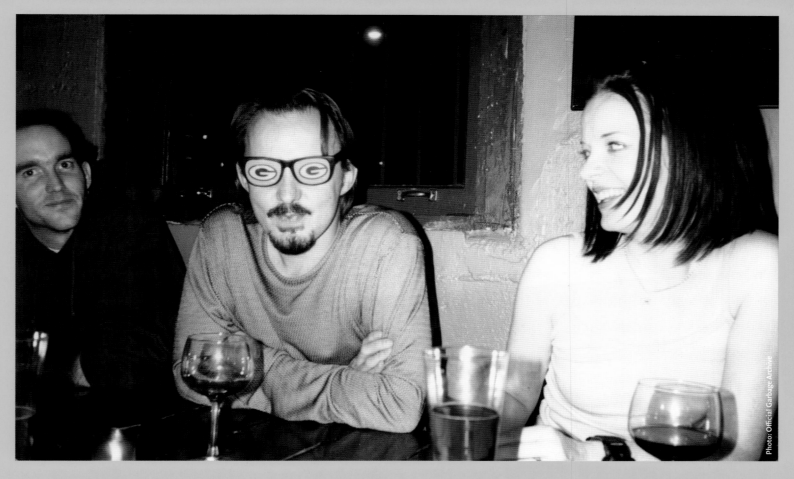

Photo: Official Garbage Archive

Butch Vig is a fan of the Green Bay Packers. A big fan. How big? If you get an e-mail from Vig, no matter where he is, it will be tagged with the signature line, *Sent from Lambeau Field*. In his heart, Vig is always at Lambeau Field.

For Vig, the affinity between Garbage and the Green Bay Packers runs deep: "There's a G logo in Garbage and a G logo for the Packers." What's more, the team's first Super Bowl with Brett Favre, in 1997, coincided with the band's big breakout year. Before that, the Pack hadn't had a championship year since it won the first two Super Bowls, in 1966 and 1967. And it goes deeper: just as Garbage began to struggle in the '00s, the Favre dynasty ended, and the Packers settled into another championship-free (though somewhat respectable) period. And then: Garbage gathered in the studio to begin work on *Not Your Kind of People* in 2010, and the Packers had another championship season.

"We took a break, the Packers sucked. We got back together, and the Packers won the Super Bowl," Vig says.

All this is why one of the biggest highlights of Vig's career was forming a makeshift band called the 6 Packers to record "Go Pack Go!," an updated version of the NFL team's fight song, "Go! You Packers Go!" which dates back to 1931.

The 6 Packers featured Vig, Erikson, and longtime Garbage guitar tech Chad Zaemisch. "Go Pack Go!" dates back to 2002, to a bus ride during the tour for *Beautiful Garbage*. Vig and Zaemisch were in the front top—the bunks high up at the front of the bus—watching the road rushing at them. "Chad and I were hammered at about four in the morning," says Vig. "We're talking about the Packers. We're like, 'We need to write a new Packers song.'" To capture the energy of a football game itself, Zaemisch cranked his guitar riff into a computer during sound check, and then Vig gathered various members of the No Doubt/Garbage/Distillers tour (including, as far as Vig remembers, one or two members of No Doubt) to shout some vocals.

That original recording included references to Brett Favre, but Vig redid it during the 2010 season, when Aaron Rodgers led the Pack to Super Bowl XLV. "Go Pack Go!" has been played numerous times at Lambeau Field—that's because there's one last connection between Garbage and the Green Bay Packers: DJ Malcolm Michiles. Michiles manned the turntables for the band Citizen King, who recorded at Smart Studios, and he also contributed samples to "I Think I'm Paranoid." Every game at Lambeau Field, he sets up his gear on the sideline and pumps out tunes to help the players get psyched up, including "Go Pack Go!"

"I've done Green Day and the Pumpkins and Garbage and whatever, but now I can die a happy man," Vig told MTV in 2011. "I've had a song played at Lambeau."

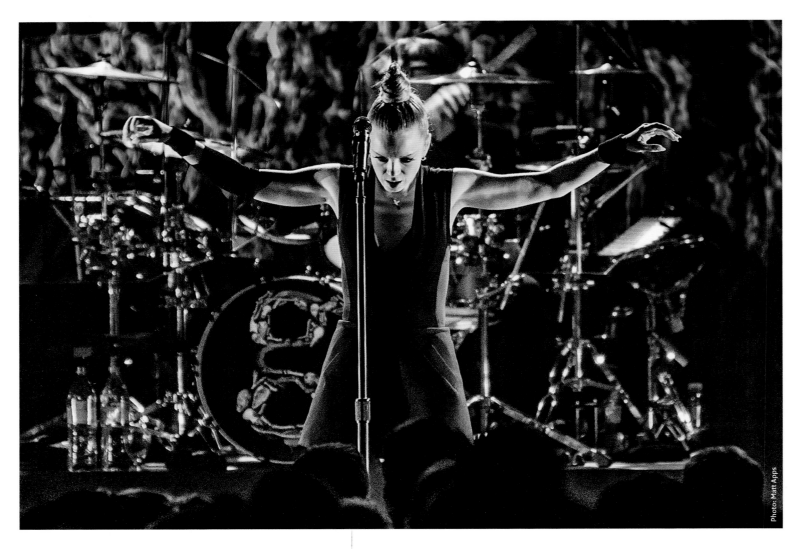

But Kremen offered something that a company the size of Q Prime simply couldn't: near-total devotion. And having exited the major-label system himself, he had a different perspective. To his way of thinking, it wasn't about getting rich; it was about keeping the band alive and thriving. He saw that the decline of the music business, so brutal for Garbage in 2001, could be the best thing to happen to them by 2011. They were not only out of their Almo deal, but the primary rights to their master recordings had reverted back to the band. (Manson, finally, was also free of Universal, having been dropped once her solo album didn't happen.) As smaller indie bands and labels have known for years, it's sometimes better to take home up to 70 percent of 100,000 records sold than to get 10 percent of a million records sold by a corporation (which, after the deduction of recoupable expenses, can amount to nothing). Garbage could put out their own record, and also make plans to reissue the entire catalog.

"Paul just practically creamed himself," says Manson. "He's like, 'You're not going to believe this, but you guys are in an amazing spot!'"

"And we had never heard those words before," Erikson deadpans.

The new reality was both exciting and a little scary. "We were the masters of our own destiny, which means we have final say in everything, but also we have to finance everything," says Vig. "And then we asked ourselves, 'Whoa, where's the money going to come from?'"

Kremen knew how to put together a patchwork of deals: iTunes, licensing agreements with foreign labels, a distribution deal in the United States. Publishing was also crucial, and that took the band back to their roots as well. Bob Bortnick, the A&R man who'd signed Garbage to Almo, now worked for Kobalt Publishing, which represents heavyweights like Paul McCartney. Bortnick had stayed in touch with the band via the occasional dinner or round of golf, and wanted back into the Garbage business. He offered an advance against future publishing royalties that preempted any need for record company lucre. "Basically, he financed the distribution and release of our record," says Manson. "So that's pretty fucking amazing on Bob's part."

Left: photographer Matt Apps captures a spooky moment during the *Not Your Kind of People* tour; above: a live shot taken from behind Vig's back.

"Garbage is the most important band in my career and in my life," says Bortnick. "*Garbage* was my first hit, and we have run the gamut of every emotion and type of relationship we could have together." Bortnick's years in the business had also taught him that there weren't many artists like Garbage.

"The others weren't awesome bands and weren't awesome people," Manson jokes.

<p style="text-align:center;">X X X</p>

The making of the album stretched well into 2011. Recording was piecemeal, with Marker and Erikson coming to LA for a week or two at a time, and Vig had to put things on hold for a while because he'd committed to producing the Foo Fighters's *Wasting Light*.

Eric Avery played bass on a few tracks, as did Justin Meldal-Johnsen. Guest drummers Matt Chamberlain and Matt Walker also returned. The record would end up being called *Not Your Kind of People*: a statement of solidarity between Garbage and their fan base.

MARKER: There was always this little buzz coming from the really interested fans who had stuck with us, even though we weren't up to much—letters sent to Smart from all over the world, incredibly detailed websites talking about how a certain song had made a difference. I felt like we should be writing for them.

VIG: "Not Your Kind of People" was a title I came up with while driving on the Ventura Freeway. There was no music, just that phrase. Then the four of us hunkered down, sat in a circle, and wrote the song in forty-five minutes.

ERIKSON: We sat down with a couple of acoustic guitars and bashed out the rest in an afternoon. The guitar figure at the top came out of Steve being funny, playing a kind of heavy metal goth riff. We were all laughing, but then it seemed to make more and more sense the more he played it, and it morphed into the signature riff of the song.

MANSON: The interlude in the middle of the song was something the guys sent to me via e-mail while I was recovering from some minor surgery. I was still pretty high from the anesthetic, and I opened the e-mail. The melody for the interlude and the lyrics came out of me all at once in a rush. I was crying as I was writing. Partly because I was still so high, but also because I had just woken up from a dream about my dead mother. If ever there was someone who was my kind of person and vice versa, it was my mum. The song turned into an anthem about the band, our tribe, about nursing beliefs that are hard to hold onto in the midst of the madness that surrounds us all.

"Not Your Kind of People" features the recording debuts of Ruby Winslow Marker and Bo Violet Vig, then ages eleven and five, respectively.

ERIKSON: The end bit was crying out for a children's choir, and we just happened to have a couple of children around.

VIG: When I asked Bo if she wanted to sing, she was super excited, and a little bit nervous. I made a rough mix and played it in the car over and over again, maybe twenty times, until she had the arrangement down. I recorded her at my home studio.

MANSON: I suggested we have Ruby and Bo sing on it because there is a weird kind of power that children possess that adults lose somewhere along the line. Kids are so pure. They meet people very instinctively, openly, and without prejudice. I thought it would be cool to capture that attitude on a song about battling prejudice.

Not Your Kind of People came out on May 11, 2012. It was available only on iTunes in its first week of release in the United States, debuting at #17 on the *Billboard* chart just from digital sales, then reaching #13 the second week, when physical copies shipped. It also gave Garbage their fifth straight Top 10 record in the UK, coming in at #10.

Touring was a different experience this time around. They'd had time away from ten years of grinding and were ready to get back on the road, taking nothing for granted. There was no

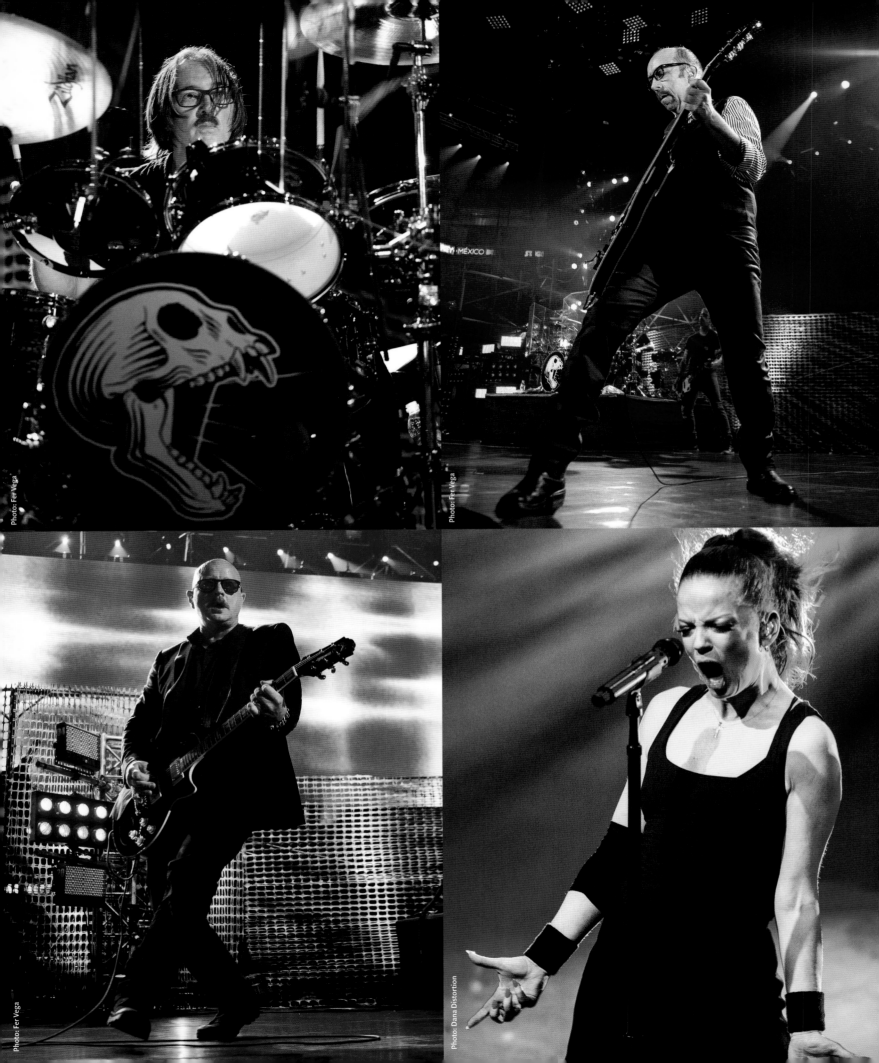

sense of been-there-done-that, no entitlement. "It's much more powerful to assume nobody knows who the fuck we are," says Manson. *"Let's just go at this fresh*. That was very helpful to us."

"Our comeback tour, so to speak, was maybe the best tour we'd ever done because we were all in a place to appreciate it," says Erikson. "And I suppose it's—in my mind—the best tour because it's the one I can remember the most."

Garbage's long track record on the road also meant there were still devoted fans eager to see them—a core international fan base. "The sense I got from them was, 'This is unbelievable— there's a half a million people across the world who actually care about what we do, and we can continue to do it for as long as it feels good with us,'" says Bortnick. "And that's an amazing position to be in."

New fans had also come to Garbage in the intervening years: young faces like the kids Manson had run into at Hot Topic, who weren't old enough to have seen the band prebreak. "It felt like it validated the whole twenty years," says Erikson. "It didn't feel like a reunion tour. It felt like we were continuing where we left off, but a whole new crowd had discovered us."

The best part was that Garbage didn't have to do any of this. They weren't hitting the festi- val circuit out of necessity, playing their old material and barely tolerating each other. "Some bands go out and they're miserable," says Vig. "They do it because they'd rather do that than get a job at Starbucks." But for Garbage, once they began making *Not Your Kind of People*, it was about the love of making and playing music together, and nothing else mattered.

"We didn't give a fuck about what anybody thought," says Erikson. "We didn't give a FUCK."

"About chart positions . . ." says Marker.

"About label people saying do this or do that," says Vig. "We were focused, but at the same time just fucking having fun."

Vig had his doubts at the beginning of the tour, though, wondering if he could handle it again, particularly after settling into family life. "It's kind of like going to war with your mates. You've got to leave home and you just have to go on the road and do this."

The first show of the tour was a warm-up at LA's Bootleg Theater, a tiny performance space near Echo Park. And it certainly felt like a warm-up when the power for the entire backline went dead in the middle of the show, killing all the sound. "Unbeknownst to us, all the power came from one socket in the wall behind Eric [Avery]," remembers Billy Bush. "He inadvertently kicked it loose. The lights and PA still had power, so it took a second to realize the simplicity of the failure."

There were other, more substantial problems. Tragedy intervened almost as soon as the band got on the road. In late April, when the band had just seven shows under their belt, Erikson's mother Carrie suffered a heart attack. Several shows were cancelled.

"The band understood I had to go," says Erikson. "She had moved into a nursing home after my dad died, so I went and stayed a few days with her." Even after all the band's success, Carrie had never accepted the name Garbage. "She was telling folks there that we were changing our name to Fantasia," Erikson explains. "I never corrected her on that, so I guess everyone in the nursing home thought I was in the band Fantasia."

Erikson had just rejoined the tour when Vig also received some devastating news: Beth Halper's brother Jim, a chef who had expatriated to Brazil a few years before, was murdered. "It was like, 'We just want to go and play shows, but life is happening,'" says Vig.

The band got back out on the road a few weeks later, returning to the KROQ Weenie Roast for the first time in sixteen years. "They were great, and they got a great response," says KROQ music director Lisa Worden. "The older KROQ listeners that grew up during that heyday of Garbage, they still love the band and are big fans."

The tour had finally picked up steam, with dates in both the US and Europe, when Erikson's mother had another, more serious heart attack. By then the band was about as far away from home as they could be, with a show in Warsaw, Poland, followed by a massive, remote festival gig in Samara, Russia, some 650 miles east of Moscow. Erikson caught a one a.m. flight from Russia, and was able to see Carrie before she died. "Once again, the band—bless them—understood I had to go," says Erikson.

The Russian festival gig was an odd one, paid for by the state and corporate sponsors, with Garbage as the second headliner, before Limp Bizkit. "It was by far the biggest audience we've ever seen from a stage," says Vig. But one thing about playing for 300,000 people in the middle of nowhere: hardly anyone was going to notice that Garbage was down a member. "It's chaos," says Vig. "There's a bunch of bands. It's not just Garbage fans going, 'Hey, where's Duke?' They're just looking at Shirley anyway."

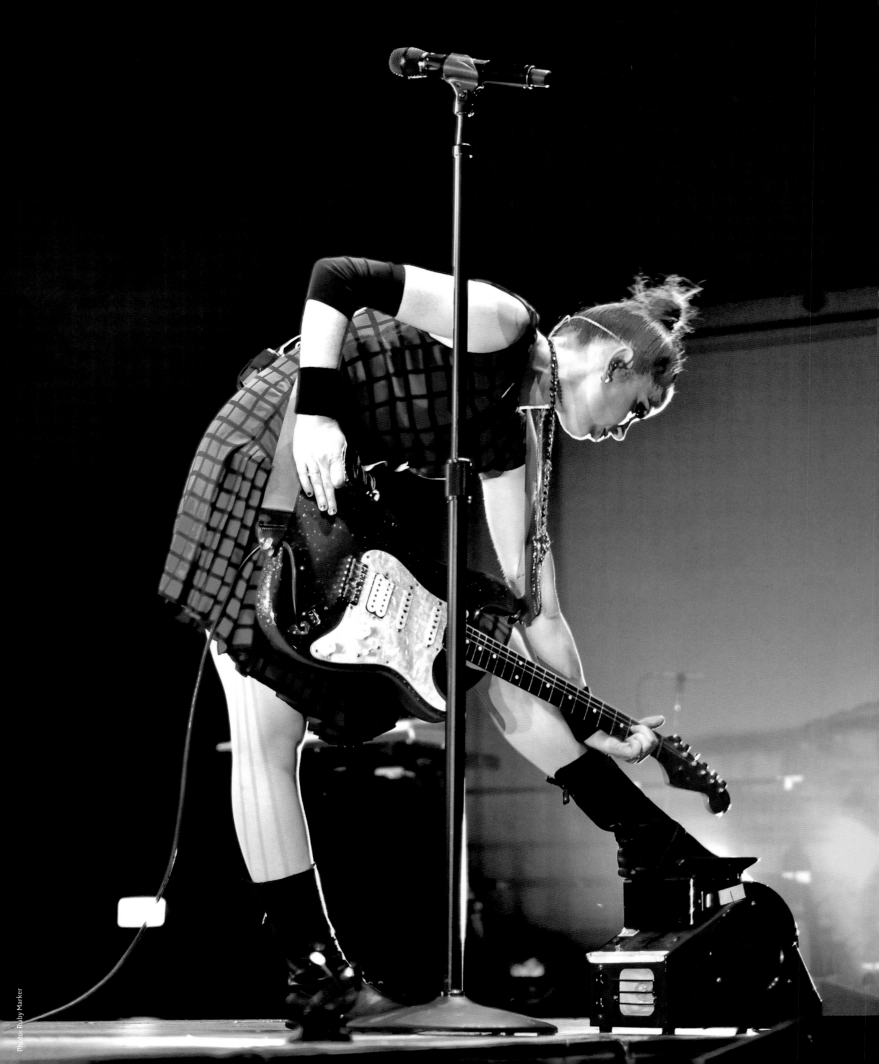

Left: Manson photographed from the "pit" by Marker's daughter Ruby, who provided the backing vocals on "Not Your Kind of People," the title track of the band's fifth studio album. Ruby joined the band onstage during a performance of the song during the tour's final stop in Berlin.

"We could have all gone home," Marker jokes.

The grind of touring combined with all the loss had Manson wondering if the band had made the right decision. "I remember telling Billy at the time, 'This is not what we're meant to be doing with our life. This is too difficult.'"

But alongside the difficulty there were rewards. Garbage had gotten each of its members through a lot of hard times. Erikson remembers how his bandmates had his back when his father died during the making of *Beautiful Garbage*. The loss of Pablo Thrailkill Castelaz was part of what made Manson and Vig reevaluate the band's importance in 2009. And the band was still a comfort in 2012 for everyone. "I was a bit down, but I must say I felt a huge sense of relief to get back on the road again with the band," says Erikson.

"The music kind of freed us, freed me," says Vig. "I felt like all of a sudden we got up and we were in the sky and you get above the clouds and it's like, *Okay, this is what we do and we're going to go and do it*. And then we had a fucking great tour."

"We were lucky that we always had something to escape to, and just lose ourselves in," says Manson.

<p style="text-align:center">X X X</p>

"POSSIBLY THE STRANGEST THING THAT I'VE EVER SEEN IS WATCHING MY DAD GO UP ONSTAGE AND COMPLETELY TRANSFORM. IT'S LIKE WATCHING ONE SUPERHERO DO A TOTAL 180 AND TURN INTO ANOTHER SUPERHERO. PEOPLE ASK ME A LOT WHAT IT'S LIKE TO HAVE A DAD LIKE MINE, AND I ALWAYS STRUGGLE TO FIND AN ANSWER. ONE OF THE WEIRDEST THINGS I'VE EVER EXPERIENCED IN MY LIFE IS SEEING THE BAND PERFORM IN FRONT OF FANS; I DON'T REALLY RECOGNIZE MY PART-TIME FAMILY AS 'ROCK STARS,' BUT WHEN THEY GO ONSTAGE THAT'S EXACTLY WHAT THEY ARE. WHEN I WATCH THE BAND PLAY ONSTAGE I SEE FOUR OF MY FAVORITE PEOPLE IN THE WORLD, WHO JUST HAPPEN TO BE IN FRONT OF TONS OF SCREAMING PEOPLE. SO WHEN I'M ASKED WHAT IT'S LIKE TO BE AROUND THOSE GUYS AND TO HAVE A 'FAMOUS' DAD, I CAN'T REALLY GIVE AN ANSWER. THE TRUTH IS, I WASN'T AROUND FOR THE BEGINNING SO I DON'T KNOW THE DIFFERENCE. MY DAD HAS ALWAYS BEEN WHO HE IS AND HE'S JUST DOING WHAT HE LOVES TO DO AND SHARING HIS ART. THAT'S IT. THE BIGGEST IMPACT ANY OF THIS HAS ON ME IS THAT WHEN THEY GO ONSTAGE AND PERFORM, I GET TO WATCH EACH OF THEM SHARE WHAT THEY LOVE TO DO. BEING ABLE TO BE AROUND PEOPLE FOLLOWING THEIR PASSIONS HAS TAUGHT ME THAT I CAN DO THE SAME. SO IF I HAD TO ANSWER THE QUESTION OF HOW MY DAD'S JOB HAS AFFECTED ME, THAT'S WHAT I WOULD SAY. NOTHING SUPER ECCENTRIC, BUT SOMETHING INCREDIBLY POWERFUL."

—RUBY MARKER

Garbage finished up 2012 with early-December appearances on the *Tonight Show with Jay Leno* and at the KROQ Almost Acoustic Christmas. But they spent Thanksgiving in Europe, with Berlin as the final tour stop. Marker's family came over for the holiday, and before the second encore of a lengthy twenty-four-song set at the 1,600-capacity Huxleys Neue Welt, Manson beckoned to her goddaughter, Ruby, who was squatting at the very back of the stage, a few feet from her father and Vig's drum kit.

"It's maybe one of the greatest love affairs of my life," Manson told the crowd. "Ruby kept me sane in the middle of a close-to-a-nervous-breakdown. She was just a little girl, and I used to come over to Steve's house, and she'd be so excited to see me. All my troubles went out the door."

The next song on the set list was "Not Your Kind of People," and one of its backing vocalists was *right there* . . .

"Ohhh, Ruby . . . you're gonna sing with us tonight," Manson said with a cackle. Ruby, in a red-and-black-checkered flannel shirt that practically matched Manson's techno-future tartan dress, responded with a thumbs-up. "Yeah, good girl!" continued Manson. "I love your courage and your guts, Ruby Marker." A roadie brought out a second, shorter mic ("Ruby-sized and Auntie Shirl–sized," Manson noted) and Manson filled in the audience: "We're gonna sing, and this is the first time ever Ruby has sung in public."

What followed was a giggling, adoring, hug-filled, and emotional version of "Not Your Kind of People," with a quietly delighted Steve Marker stepping closer to the front to be near his

THE FUTURE IS LOUD

HOW GARBAGE'S OWN LABEL, STUNVOLUME, CAME TO BE

Garbage had of course put out albums before, but in January 2012 the band released its first manifesto. "Today we announced the launch of our record label, Stunvolume," they declared in a press release. "We have had our fill of greedy corporate interest. We don't like how they do business. This time we are going to do it our way."

The first Garbage album in seven years, *Not Your Kind of People*, would be the first on the band's own label. Garbage's relationship with Interscope—which had released 2001's *Beautiful Garbage* and 2005's *Bleed Like Me*—had unfolded during a time of major-label consolidation and digital disintegration. It had seen more bad times than good, so while other labels expressed interest as Garbage began to wrap up the recording sessions for *Not Your Kind of People*, the band ultimately preferred to retain control of their own destiny. "They said, 'Why go back to the drama we just left?'" says manager Paul Kremen. "And it was unanimous: 'Fuck that. We want to run our own label.'"

At home and worldwide, Kremen was able to strike new distribution and publishing deals that easily funded what the band needed—independent publicity, digital marketing, and radio promotion—to release their own music. "We made all our rights deals around the world," he says, "and all of a sudden the band were their own label owner. There's no doubt that in every way—financially, spiritually, creatively—they're in a far better place than they were when they were signed to a major."

It was Steve Marker who came up with the name Stunvolume, which was a term favored by Butch Vig. "We wanted something that would have some relevance to our shared history, and after much head scratching, the name kind of jumped out at me," says Marker. "Butch has used that term as long as I've known him. He'd say, 'That guitar amp sounds best when it's at stun volume.' 'That My Bloody Valentine concert was at stun volume.' When we had to play finished Garbage tracks for visiting journalists and record company folks, we would turn the mixes all the way up and leave people alone in the room to listen at 'stun volume' as a subtle form of torture."

The Stunvolume logo is a screaming monkey skull designed by Ryan Corey that Marker calls "the icing on the cake—it looks excellent on things like kick-drum heads and stickers and shirts." The logo was inspired by a Garbage photo session with Autumn de Wilde for *Not Your Kind of People* (see page 161). In the photos the band looks sinister and sleek, dressed completely in black, with Shirley Manson wearing her hair up in a style that pays homage to a famous self-portrait of Frida Kahlo—except instead of roses in her hair, Manson has monkey skulls. "It was a deliberate nod to Day of the Dead rituals, in which we remember what has been lost with an eye to the future," says Manson. "I love the photo of us all that Autumn captured. We were like a family in mourning, dressed in black and in need of rebuilding. A family out looking for revenge."

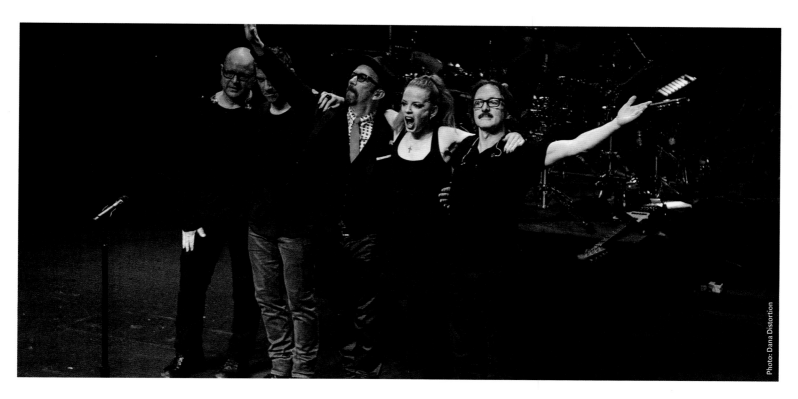

Photo: Dana Distortion

Above: the band takes a bow on the *Not Your Kind of People* tour; following pages, left: Shirley caught in midjump by photographer Dana Distortion; right: Marker onstage in Mexico City wearing a wrestling mask honoring the great Mexican tradition of *lucha libre*.

daughter. "It must have been terrifying for her, or at least extremely surreal," Marker says. "It sounded perfect to me." At the end, the German fans all chanted "RUBY! RUBY!," and Steve gave her a little kiss on the back of her head.

MANSON: It wasn't planned. I just saw her little face in the wings watching her dad play and taking photographs. She was mildly mortified, but like the trouper she is, she didn't let us down. To sing with her was heavenly and joyful. I will never forget it.

MARKER: From my perspective, she was a big part of the reason we were there at all. Some of us had stayed in touch through the bad years because of her, and on my end I had wanted to get it going again for her sake, mostly because it was such crazy, great fun to be a part of.

Bands that endure—the ones that last longer than the moment when lightning strikes (if it ever does)—can be many things: an artistic pursuit, a job, a family. Garbage had been all these things, each with its own ups and downs—but when Ruby Marker stepped up to the mic that night in Berlin, it brought the family aspect into clear relief.

ERIKSON: We all said "I do" twenty years ago. We had a long honeymoon, a trial separation, and now we're back together again—for better or worse! I have to say, it's a little better the second time around.

MANSON: It's totally my other marriage—or the brothers that I often longed for. To this day they amuse me, which is an incredible achievement: to still find people a little like catnip when you're around them. I enjoy their company immensely. I love seeing them laugh. They give me joy. They also infuriate me, as I infuriate them. But they do give me joy.

VIG: Garbage was sort of my family when we started out. Now I have a proper family. And I still have my family in Garbage too. We have had that emotional connection. Sometimes siblings and families can be very dysfunctional. We had to soldier through it, in the words of a Garbage B-side.

MARKER: That night in Berlin with Ruby singing stands out to me, but there were hundreds—thousands—of others where family and our family of friends were there alongside us. Maybe that's the mostly unacknowledged thing that kept us moving forward: there have always been significant others and significant friends behind us, filling in the background vocals and supporting us no matter what.

SHIRLEY MANSON'S BASKETBALL DIARIES
HOW A SCOT CAME TO ROOT FOR SAN ANTONIO

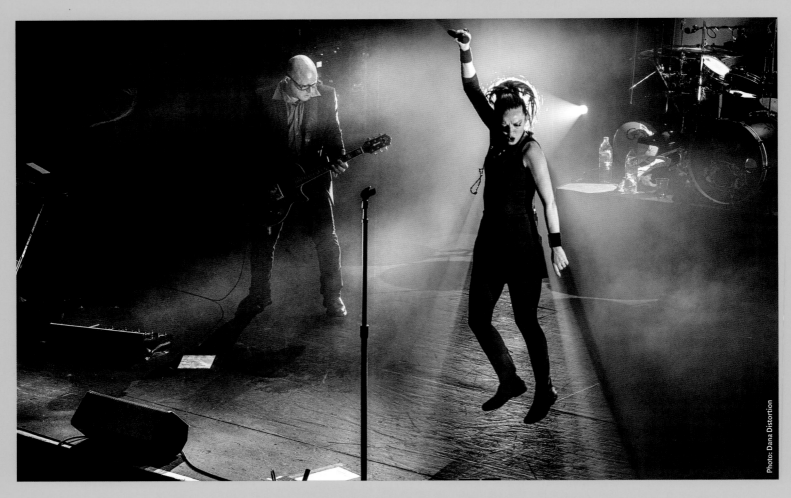

While the boys have their love of Packers and all that is green and gold, Shirley Manson's sports passion is something else entirely. Not, as you might expect of someone from the UK, soccer. Rather, she is a devoted acolyte of Tim Duncan, coach Gregg Popovich, and the San Antonio Spurs.

"I first fell in love with basketball when I started working with the band in Madison," says Manson. "I had nothing better to do half the time than watch TV. I remember seeing Timmy take a free throw one day and just falling in love with the serenity in his face. I decided then and there that the Spurs were my team, and Timmy D. was my kind of athlete, my kind of man."

Manson's timing was right. Duncan was a first-round draft pick for the Spurs in 1997—right when Manson was stranded in Madison working on *Version 2.0*—and he helped the Spurs make it to the NBA playoffs in his first year with the team. "I had absolutely no idea I had stumbled upon one of the great teams in the history of the sport, and Timmy, the greatest power forward the game has ever seen." As time went on, Manson moved from TV spectator to occasionally seeing her beloved Spurs in person. "I nearly passed out the first time I saw them play," she says. "It was in Milwaukee, of all places, and I kept turning beet-red for no reason at all other than I felt overwhelmed by being in the same arena at the same time as they were."

Popovich is famous for his ability to create a team mentality with the Spurs, and to maintain a consistent culture. Part of that, he's explained, comes from cultivating in his players an appreciation for the opportunity of playing in the NBA, rather than a feeling of entitlement. "We talk about those things all the time," he once said. "You have no excuse not to work your best. You have no reason not to be thankful every day that you have the opportunity to come back from a defeat, because some people never even have the opportunity." He has also talked about learning to value defeat as much as victory: "The measure of who we are is how we react to something that doesn't go our way."

During the troubled period making *Bleed Like Me*, Manson found herself wishing they could have some of that coaching: "The romance of the Spurs's team concept is delicious to witness and learn from. When we were making *Bleed Like Me* and were flailing around and there was no leadership, I used to say to Billy—and I wasn't kidding—'I wish we had Pop. We need Pop right now.' Because he never thinks short term. You know, you see it in sports all the time—the minute a player has a bad season, they're undermined, undervalued, sold, and shifted off somewhere. But Pop has that long-term view. 'We've got everything we need, everything we need. We just keep going.' It's powerful. And romantic. I love that."

TWENTIETH ANNIVERSARY PRESHOW PLAYLIST

Mazzy Star—Fade into You
L7—Wargasm
Cocteau Twins—Bluebeard
Beastie Boys—Sabotage
Dinosaur Jr.—Feel the Pain
Fun Lovin' Criminals—Scooby Snacks
The Jesus and Mary Chain—Reverence
The Prodigy—Breathe
Luscious Jackson—Naked Eye
Sleater-Kinney—I Wanna Be Your Joey Ramone
Massive Attack—Teardrop
The Verve—The Drugs Don't Work
Smashing Pumpkins—I Am One
Veruca Salt—Volcano Girls
The Breeders—Cannonball
Moodswings ft. Chrissie Hynde—Spiritual High
The Chemical Brothers—Block Rockin' Beats
PJ Harvey—Down by the Water
Nick Cave and the Bad Seeds/Kylie Minogue—
 Where the Wild Roses Grow
Pet Shop Boys—Go West
Placebo—Pure Morning
Edwyn Collins—A Girl Like You
Pulp—Common People
Cornershop—Brimful of Asha
Iggy Pop—Candy
Mercury Rev—Goddess on a Hiway
Liz Phair—Fuck and Run
Bikini Kill—Rebel Girl
Teenage Fanclub—What You Do to Me
Portishead—Wandering Star
Stereo MC's—Connected
dEUS—Instant Street
Jacky—White Horses
Supergrass—Caught by the Fuzz
Hum—Stars
Missy Elliott—The Rain (Supa Dupa Fly)
Ash—Girl from Mars
Tricky—Black Steel
Bettie Serveert—Tom Boy
Lush—Ladykillers
Fatboy Slim—The Rockafeller Skank
Patti Smith—Waiting Underground
Belly—Feed the Tree
Cypress Hill—Insane in the Brain
Björk—Human Behavior
Hole—Doll Parts
My Bloody Valentine—When You Sleep

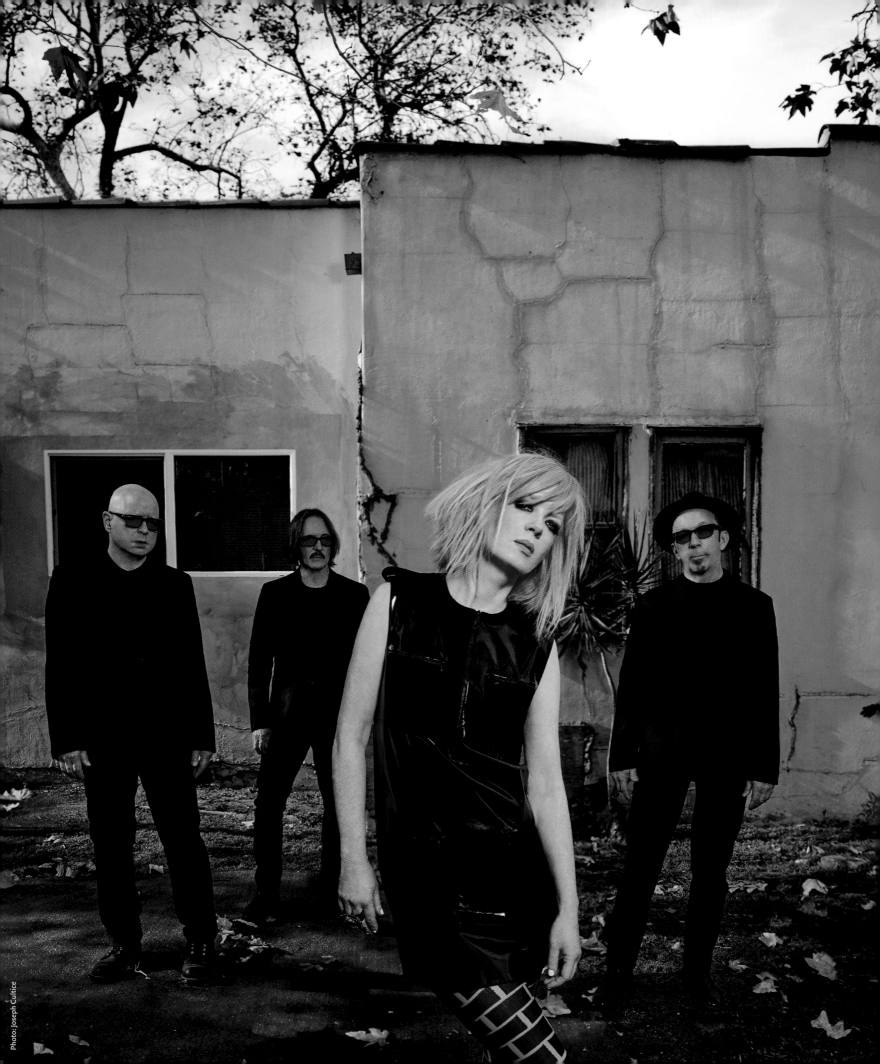

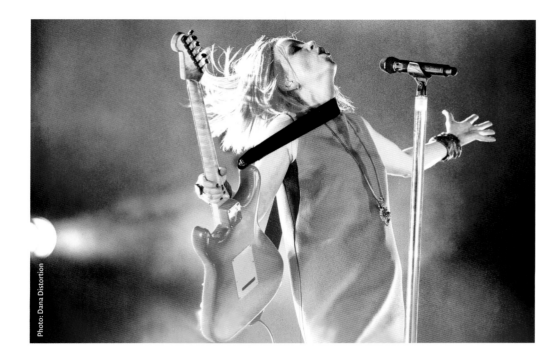

Photo: Dana Distortion

EPILOGUE

The second song was just starting when something went wrong. It was October 8, 2015, in Los Angeles. Garbage was onstage at the Greek Theatre, an outdoor venue in the hills above Los Feliz that holds nearly 6,000 people. This was the third show of the "20 Years Queer" tour, celebrating the twentieth anniversary of the band's first album.

The night was a time warp of a sort. Except for the encore, the songs all came from 1995 to 1996—album cuts and B-sides. There was, the band would find, tremendous power in digging into their past. Rediscovering how these old songs worked and seeing their effect played across the faces of audiences night after night sparked a reconnection with the impulses that had first galvanized the band, which Garbage would soon harness to make new music. But there was a reconnection with something else as well: the old technical problems.

The "20 Years Queer" shows opened with video footage from 1995 projected on a scrim in front of the stage: the band clowning around with each other two decades earlier, and other archival clips like old *MTV News* segments, a snippet of Bill Gates explaining the then-new idea of the Internet, and images of the O.J. Simpson verdict. When the footage was done, the music began, with Garbage playing behind the scrim, backlit to cast dramatic shadows. That night at the Greek Theatre, the first song was "Subhuman," and when the dreamy and dirty riff of "Supervixen" kicked in next, the scrim was pulled down to reveal the band.

"It was supposed to come straight down," says Marker. "Actually, it came straight down on me." For a few moments, until Marker freed himself, it looked like a ghost playing guitar beneath a giant white sheet. And in a callback to the glitches of the very first Garbage shows in 1995— when rock songs built around samples were a new and tricky thing to pull off live—there were more complications that night. "Right after that, all our computers went down," Marker continues. "We have vowed that the next time we go out we're not going to play a giant theater in Los Angeles the third night of the tour. Maybe give ourselves a *little* time to figure out the technical stuff."

But technical issues couldn't stop the band from connecting with the audience at the Greek. That night—like all of the tour's twenty-seven shows across ten countries—was a chance for both the band and the crowd to revisit a lifetime of shared experience. "It was intense," says Manson of the tour. "There were a lot of people crying. There were times when I had to choke back tears. We saw couples sobbing in each other's arms. You suddenly realize that songs have real meaning for people."

"It revitalized us," says Erikson, who had initially wondered if the idea of an entire show devoted to Garbage's first record was justified. "We're not U2 or the Beatles," he adds jokingly. "But once we were in it—rehearsing the material, doing the show—it just felt really good. It

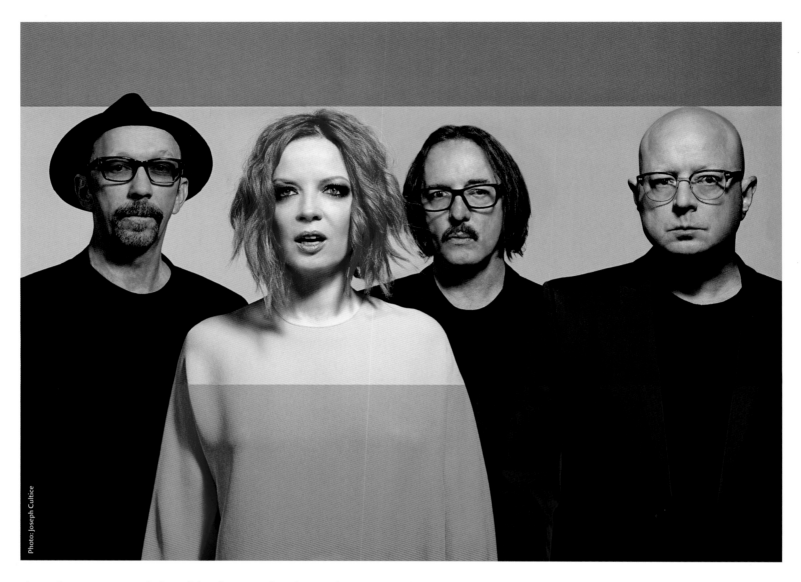

Photo: Joseph Cultice

showed us a new appreciation of that first record, and opened my eyes to what that record meant to those fans. You tend to forget that as the years go on."

"Certain songs have meant a lot to people at certain times in their lives," adds Marker. "People weren't there because there was nothing else to do that night. There were people crying, screaming along, pumping their fists. It wasn't a passive experience."

Not for the audience, or the band. "It all came together for us on that tour," says Manson. "I'd never been able to really appreciate what happened to us. I'm not a nostalgic person, and I was forced to be nostalgic—I remembered things that I'd completely forgotten. I felt a lot of amazement that all these fucking crazy things had happened to us in the chaos of success: meeting David Bowie, flying in a private jet, having Chef Nobu cook for you in Japan at his restaurant. Nutty fucking crazy shit that you are so busy, you're not even properly aware of or grateful for."

Except this time, she was: "It was an incredibly gratifying and joyous experience. It was so free of any kind of angst. From the very beginning of Garbage, we've always felt like we're fighting, we're proving, we're justifying. But we didn't have any anxiety at all. No record company to interfere or tamper with our joy. Everything was done on our terms."

"Not many people are able to revisit something they did twenty years ago," says Marker. "We're so grateful that there's still an audience for us, for what we do. We've been able to continue doing it, navigating the waters of incredible changes since we started."

X X X

When the "20 Years Queer" tour drew to a close on November 14, 2015, Garbage resumed work on their sixth album, *Strange Little Birds*. Sessions had actually begun in the spring of 2013,

Above: another PR shot for "20 Years Queer," but this time with no smoke; right: onstage during the *Strange Little Birds* tour, before Vig was sidelined with severe sinus problems.

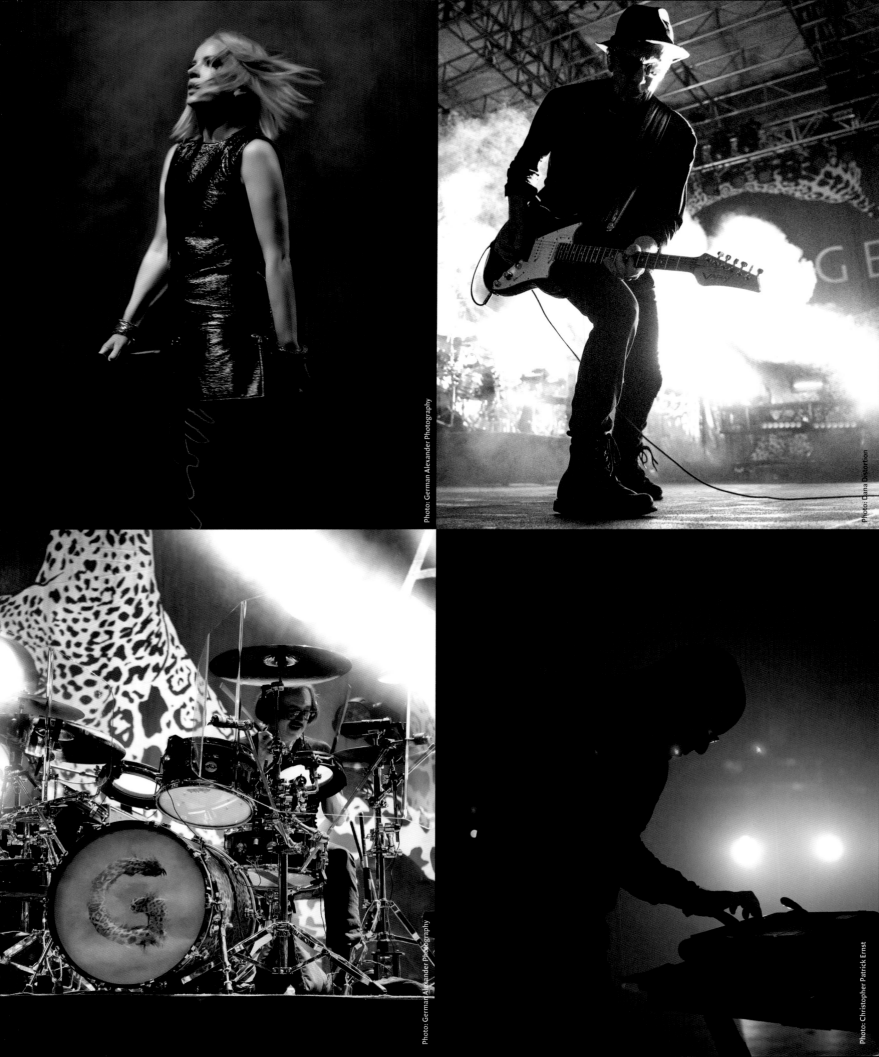

when the band came off the road for *Not Your Kind of People*, at Vig's home studio in Los Angeles—perhaps the least-elaborate home studio a multiplatinum producer has ever constructed.

"My home studio is my den—it's just a room where I watch Packers games," says Vig of the basement setup. "There's no soundproofing. It's just four walls of drywall. So it's got a bit of a trashy vibe." The band gathered there, with Erikson and Marker flying to LA for two-week work cycles a month or so apart, a system Garbage had developed for *Not Your Kind of People*. The germ of three or four tracks came together quickly. The band chased songs by playing together live and reworking musical ideas through repetition until they coalesced into something solid.

VIG: "Blackout" started with a jam in my home studio. I think our manager called and said, "Someone asked if Garbage wants to write a song for one of the vampire movies." We were drinking wine, and we went, "Sure!"

ERIKSON: We sat down and played, and followed one another. "Blackout" was just winging it.

MARKER: We were playing together for hours, recording that, and piecing something together. After so many years it was really important to go back to what made us want to make music in the first place.

VIG: "Blackout" was the first song we mixed. It set the tone for the record once we had that done.

That tone was "dark, symphonic, gothy," explains Vig. But the finished and mixed track came more than two years after that first spark. Vig had signed on to produce the Foo Fighters's *Sonic Highways*, a project that saw the Foos recording in studios all over the country in order to explore the musical heritage of different cities. This project took some ten months, from September 2013 to July 2014. Then came the anniversary tour.

When Garbage sessions resumed at Red Razor Sounds—Billy Bush's studio in LA's Atwater Village, not far from the Greek Theatre—the band took a back-to-basics approach. Except that Garbage—long known for their meticulous craftsmanship and obsessive tinkering—were going back to the basics for the first time. "We don't fuss over things as much we used to," says Vig. "I'll listen to *Version 2.0* or *Beautiful Garbage*—there are moments on those records where we'd lose ourselves and work on a track for a month. We didn't do that. A lot of the guitar parts and drums were done very quickly. Shirl's vocals too, sometimes first or second takes. We didn't go back and make her do a hundred takes."

"When the music started coming together, it was really exciting for me," says Manson. "Because it felt like, for better or for worse, what we're good at." Some of that may have been reexperiencing the power of the band's debut album during the "20 Years Queer" tour. "It's almost like back to our first song. It's getting back to that beginner's headspace. This record, funnily enough, has the most to do with the first record than any of the previous records."

Sometimes that beginner's headspace was in the sound itself, sometimes it was in the way the band approached making the sound.

"When you're a teenager you're in a warehouse somewhere with your band, and you don't know what you're doing, and you have to start somewhere," says Marker. "There has to be a spark. There's a lot of the teenagers that we were in this record."

"We tried not to overthink things too much," says Erikson. "If we found ourselves repeating ourselves, we'd quickly go down another path. We were being more free about it. Following ideas."

In the first writing sessions, Erikson had mentioned an idea for a song titled after the piano instruction book he'd had as a child, *Teaching Little Fingers to Play*. "I brought it up in conversation with Shirley," he says, "how it was sweet and funny and yet maybe hit something adult. She said, 'I love that. Write something to that.' I wrote the music and the melodies, and she wrote the lyrics."

"Teaching Little Fingers to Play" was a slow and brooding track, with a restrained beat that leaned toward trip-hop. The chorus addressed what Manson called the album's "adult themes": *I'm all grown up / No one around to fix me now / Doing it my own way / I'm changing things up like I'm teaching little fingers to play.*

"It's about being brave enough to throw away everything you know and start again," Manson says. "We're no spring chickens, and the idea that we can get back to the rudiments and a place of childlike play—I think that's really powerful."

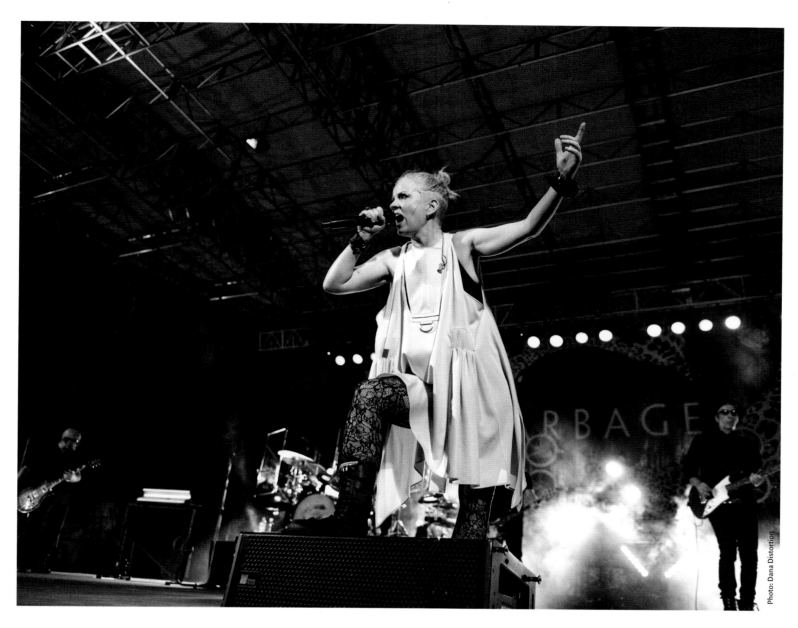

Powerful enough that "Teaching Little Fingers to Play" was one of the early titles for the album. "But Steve pointed out, quite rightly, that it might be misconstrued," says Manson, laughing. "The title that stood was *Strange Little Birds*—that's what we are."

The title was taken from a lyric in "Even Though Our Love Is Doomed," one of the last songs to be finished. "That's a song that Butch brought in almost in its entirety, including the lyrics," says Manson. "It gave me the chills when he played it for me."

"I came up with a chorus line in the car, with that lyric, and I sent her an e-mail," says Vig. "Over the course of a month I made three or four different-sounding demos: one electropop/ravey, one heavy rock, one that had almost a hip-hop groove. And I didn't like any of them. Shirl said, 'Bring in a really simple version, let me hear it.' The next morning I got up, I picked up the bass in my home studio, started playing this riff, and I wrote the whole song—all the lyrics— in ten minutes. It just came out. I put a scratch vocal down. Shirl heard it and said, 'I love it.' She did one take, and that's the version on the record. And that happened a lot on *Strange Little Birds*. We fell in love with immediacy."

"You can spend forever fixing things," says Marker. "At some point you start losing the mean- ing behind what you're doing. I've always fought to keep the imperfections. Because we are a real band, playing real instruments, much of the time."

"There's a tendency we've had to fill in all of the holes in a song, and just keep layering and layering and layering," adds Vig. "We avoided that. We wanted it to sound more primal and emotional."

MY FIVE FAVORITE GARBAGE SONGS

DUKE ERIKSON

"MILK" (from *Garbage*, 1995)
It was a quiet night at Smart. Butch and Steve were working on something in the studio, and Shirl and I were hanging in the lounge. There was one table lamp on, and she was sitting on the couch in the shadows, strumming two minor chords back and forth on an acoustic guitar, singing under her breath. The only words I could decipher were, "*I am milk.*" It was lovely. We sat and worked out a couple more chords, played it for the boys, and within half an hour we were in the studio, working with the lights low so we wouldn't lose the moment. Sometime soon after midnight, we pretty much had it recorded, done, and dusted. A memorable session, calm and exciting at the same time, and the mood and feel of that night is still in there, still in the song.

"VOW" (from *Garbage*, 1995)
Before Garbage had recorded a note, Butch had been muttering the line, "I can't use what I can't abuse," for weeks, like some kind of bizarre mantra. That line was a template for what was to come. In its earliest form, this was used as an audition song. Shirley spoke/sang the "abuse" line so well, we fell in love with her voice. By the time she'd joined the band, and we started fleshing out the arrangement, the song was becoming a focal point, and once we came up with the flashing guitar chords in the intro, we were off and running. The title came from a line for the bridge that never got used.

"YOU LOOK SO FINE" (from *Version 2.0*, 1998)
Shirl came up with the title and tossed it in my lap one day. I came up with a melody and the first few lines. She ran with it and finished the lyrics. Initially it was just a simple guitar under her vocals, but as was customary back then, it grew into this lavish production. For the Carpenteresque vocal chorus of "*aahs*" in the bridge, we created a keyboard instrument dubbed the Shirlatron, which was her voice on every key singing "*aah.*"

"THE TRICK IS TO KEEP BREATHING" (from *Version 2.0*, 1998)
The title itself told us a lot about how the song should sound and feel. Shirley told us the song was a letter to a friend who was having trouble. This one went through a lot of changes and rearrangements. We argued about how it should go, what should happen where, and so on. But it turned out to be a shining example of what four stubborn but creative people can come up with once they marshal their talents, join forces, and carry on—one of our best achievements in that way.

"CAN'T SEEM TO MAKE YOU MINE" (B-side to "When I Grow Up," 1999)
When we were looking for a B-side, I offered up this gem. The Seeds were the epitome of a sixties garage band, and this song was one of their best. I performed it in my band the British when I was just a kid, still learning how to play, and also with Spooner years later. Garbage had a blast recording it. One late afternoon, years later, Butch and I were at sound check with our fabulous cover band, the Know-It-All Boyfriends, preparing for a gig at Café Montmartre in Madison. A friend brought Sky Saxon by to say hello. He was on tour with a host of other sixties garage bands. We had a beer and then he joined us onstage for a twenty-minute version of "Pushin' Too Hard," the Seeds's big hit back in the day. As we thrashed away on the chords (all two of them), he guided us along, working the stage and going into long, ad-libbed verses. All of the six or seven people in the bar were thrilled! A bit exhausted and extremely delighted, we retired back to the bar, where Mr. Saxon told me how much he loved our cover of "Can't Seem to Make You Mine."

BUTCH VIG

"QUEER" (from *Garbage*, 1995)
One of the first tracks that defined us as a band. It has all these different sonic styles mashed together: a big, whoozy hip-hop beat; chiming guitars which become buzzing guitars; strange atmospheric loops; Shirley's seductive singing. Lyrically, it's a theme we touched on a lot: trying to feel comfortable in your own skin, showing empathy for the misfits, geeks, and freaks in this world. We consider ourselves part of that club.

"PUSH IT" (from *Version 2.0*, 1998)
Playing this song still gives me a rush of adrenaline. Shirley's vocal builds from a whisper to a scream, while Duke's and Steve's guitar playing is as stellar as it is unpredictable.

"BLEED LIKE ME" (from *Bleed Like Me*, 2005)
Another of our songs that speaks to the disenfranchised. Shirl's lyrics are like little Raymond Carver short stories, each character dealing with her unique personal demons. The blend of cello, vibes, and orchestral bits swelling over the hypnotic guitars is a bit of an anomaly for us, and I think that's one of the reasons I like the song so much. But it's the end—when Shirley sings, "*You should see my scars*"— that slays me every time.

"BAD BOYFRIEND" (from *Bleed Like Me*, 2005)
Dave Grohl brings power to this song, Duke's and Steve's guitars make it roar, and Shirley gives it swagger. Duke came up with the original song idea, but it languished for a while. We couldn't get the right vibe. Then I was hanging with Dave Grohl at a party in LA, and after a few beers I blurted out, "Dave, you gotta play drums on a new Garbage song!" He said, "Yeeeaaaah, dude, let's do it!" Cut to a few days later in the studio. He did a warm-up take, then asked, "Should I go for it?" "Yes, whatever that means, Dave Grohl, please go for it!" And he did. Now, whenever I see the song on our set list, I get waves of mild nausea as there's no way I can possibly play the drums as good as Dave Grohl. But I try, and I think sometimes I've gotten close.

"BATTLE IN ME" (from *Not Your Kind of People*, 2012)
This is the first track we wrote when we got back together after a long hiatus. It came from a mildly intoxicated noisy jam at a studio in Hollywood, and I think it surprised us in its ferocity. It was a wake-up call—it inspired us, gave us confidence, and it led us down the path to *NYKOP*. Duke's and Steve's guitars soar, then glitch and stutter over Eric Avery's pounding bass line. I get an image in my head of a wild night out in Vegas, those boys falling like dominos, unable to keep pace with Queen Helen.

SHIRLEY MANSON

"MILK" (from *Garbage*, 1995)
When I first started working on the debut album, I hadn't yet been invited to join the band as an equal partner. Consequently, they would take business meetings at Smart Studios with record executives that I was not expected to attend. Generally speaking, I remained upstairs reading books (*The Collected Works of Billy the Kid* by Michael Ondaatje, in this case) or watching TV. One afternoon I was idly strumming on a guitar whilst everyone was downstairs meeting with Gary Ashley of Mushroom Records. I came up with some super-basic chords with a really simple melody. When Duke came back upstairs, he worked up some more effective chord changes and insisted we record it right there and then. I sang it sitting on the couch in the control room with a hand-held mic, and I was just so bloody thrilled with the result. The night after we finished mixing it, I remember lying in my bed at the Edgewater Hotel and listening to it on repeat on my Discman. My entire body was quivering with excitement in the darkness. I just couldn't get enough of it. It remains one of my favorite songs to sing live.

"PUSH IT" (from *Version 2.0*, 1998)
Version 2.0 is my favorite of all our albums from start to finish. We were functioning so effortlessly as a unit, and "Push It" embodies the purest essence of our band. I can hear where each band member stamped their DNA on the recording whilst also leaving plenty of room in the sound for everyone else to shine. When the fans sing along to this one at concerts, I sometimes think my head is going to burst with joy. I confess that I often sneak peeks at the boys during this song and think, *This is what it means to be in the moment. This is what it means to be in love.*

"CHERRY LIPS (GO BABY GO!)" (from *Beautiful Garbage*, 2001)
At the time, I was in the middle of a dizzying e-mail relationship with the writer JT LeRoy. He (soon to be revealed in a bemusing scandal as a "she" by the *New York Times*) was often foremost in my mind during the recording sessions for *Beautiful Garbage*. Butch played me an instrumental piece he had been working on. It was uncharacteristically shiny and jaunty, and reminded me of my club days when I was a teenager. At first, I wanted to write a song about old-school disco dancers, but in the end it became an anthem for transgenders and in general for people to pursue their happiness. Steve had the idea to speed up the vocal to ape early Madonna records, and the final version has this very twisted sound to it—truly a mutated and mongrel type of approach to pop music of which I am very proud.

"CUP OF COFFEE" (from *Beautiful Garbage*, 2001)
I was going through a painful divorce during the recording of *Beautiful Garbage*. My emotions were all over the place. One day I wandered into the big live room downstairs at Smart, and Duke was sitting by himself playing the piano. I sat with him as he played, and all of a sudden the first line, "*You tell me you don't love me over a cup of coffee,*" came to me, and before we knew it the entire song was written in about ten minutes flat. It's the telling of something that happened when I was a much younger woman, but all the sadness I was feeling about my marriage poured out of me. When I sing it, it takes me right back to the first time I ever had my heart broken—the bleak emotional landscape of my youth—but I like to think of this song as an homage to Jacques Brel. I can just imagine his beautiful, tortured face singing it.

"TIME WILL DESTROY EVERYTHING" (B-side of "Girls Talk," 2014)
Steve came up with this piece of music during the sessions for *Not Your Kind of People*. I sang some rough vocals on it but we never got around to finishing it. In the end, it served as our intro tape for the *NYKOP* tour, and every time I heard it before stepping onstage, it would send a little shiver of excitement up my spine. We finished it in 2014 as a B-side to "Girls Talk" for a Record Store Day vinyl release, and when we got it back from mastering I swear I must have played it on repeat in my car every single day for about a year. It sounds to me just like *Blade Runner* looks: dark and apocalyptic, shiny and loud.

STEVE MARKER

"SUBHUMAN" (nonalbum single, 1995)
We did this before we knew what Garbage was going to be, so it's chaotic and sloppy and it makes no sense at all. I have no idea what the words are or what they mean, but these early days of the band were so much fun— put together some crazy drum loops, sample an acoustic bass off [redacted!], throw down the most distorted guitar riffs you can come up with, and head out onto the porch at Smart with some beers to write some lyrics in about five minutes. The way music should be done. Wrap it up in rubber and send it out. Become a darling of the press, play it in front of so many people. We had it good back then. Still do, come to think about it.

"STUPID GIRL" (from *Garbage*, 1995)
This one came together in an organic way. It's really just a good drum-loop groove (sampled from the Clash) with a good bass line and great atmospheric piano over the top, courtesy of Duke. I remember Shirley doing the vocal really fast on one of her first times at Smart before she had to run to the airport, and the rest of us doing a rough mix right after and grinning maniacally at how fantastic it sounded, how it felt— this idea for a band was going to work. Plus, the writing credits read, *Garbage/Strummer/Jones*—I mean, c'mon, what an honor.

"MEDICATION" (from *Version 2.0*, 1998)
One of Shirley's best early lyrics, and vocals too. Pretty and sad and everything else, all at once. I remember thinking we had really done something we could be proud of when we were finished with the guitars on this one. It just doesn't sound like anything else that we've done. I think that was one thing about us that confused people, and is also a reason why we're still going now: we never really had two songs that sounded completely like one another. Not on purpose, we just get bored easily.

"PARADE" (from *Beautiful Garbage*, 2001)
More fun guitar parts and another example of Shirley's talent at writing unique melodies matched to words that you can go back to time after time. I'm not sure what kind of music this is—it definitely didn't line up with anything that was going on at the time. That time was pretty weird for us and the world, but as we put this book together I'm realizing that there never was a time that wasn't completely off-kilter—for us or the world. Still isn't. We should definitely play "Parade" more often.

"NOT YOUR KIND OF PEOPLE" (from *Not Your Kind of People*, 2012)
The music started with Butch trying to write the saddest guitar riff of all time. Most of the rest of the song was done later that afternoon, but the last 10 percent probably took another six months. That's the Garbage way. It spoke to a lot of our fans, who had stuck with us for so long, and it was a rallying cry for us as we dusted ourselves off as a band touring the world again.

"Because as an artist you get to that point: 'Oh, I've done this before, and I want to try something new,'" says Manson. "But sometimes you go off on all these tangents, and you go off so far—that's when you get away from what you yourself are really brilliant at."

It had taken twenty years to get back to a point of trusting just that, to come full circle and feel comfortable enough with each other to simply be themselves. "We weren't trying to be something we're not," says Manson. *Strange Little Birds* debuted at #14 on the *Billboard* album chart, and #17 in the UK. "Their darkest, most intimate LP and the band's strongest effort in fifteen years," said *Pitchfork* in its review.

The eighty-seven-date world tour that followed started off with a bang, all too literally. The first show was a May 14 performance at the KROQ Weenie Roast, the annual summer bash thrown by America's most influential alternative rock station. Manson, for the first time in her career, partook of a rock and roll tradition and fell off the stage—a drop of nine feet. "It could have been absolutely brutal, but I was very lucky," she says. "My brain went into some strange mode where I was able to read everything in slow motion, right myself in midair, land on my feet like a ninja, and carry on singing without missing a beat. But it was terrifying. I could have broken my neck. So that was day one."

Day one—and, sadly, most of the tour—unfolded without Vig, who'd been sidelined with severe sinus problems that left him wracked with pain. Once again, Matt Walker came to Garbage's aid. Though Vig returned for a few shows, he eventually discovered he needed sinus surgery, and Eric Gardner—drummer for Gnarls Barkley and Dot Hacker—stepped in.

"It put a damper on what was otherwise a phenomenally successful and enjoyable tour," Manson says. "I felt like we were playing the best shows of our career." A combination, to hear her tell it, of Garbage doing things on their own terms, and also finding a mix of hard-won joy, strength, and vulnerability in keeping going—the sense that the road behind is longer than the road ahead. "We're all very, very aware of the longevity of our career and the fragility of life. To watch our idols start to fall—like losing David Bowie, who seemed indestructible to us—has been a very sobering experience."

MANSON: We have gone through a bizarre and quite unique career path. We had enormous success, then we plunged into an abyss, and somehow we managed to claw our way back up— back onto solid ground. And we haven't had our souls destroyed by that journey. Quite the opposite. We have found a renewed purpose. We have not felt defeated. We have felt motivated by our defeat.

MARKER: We've all had our difficulties getting along together in the past. We've figured out how to put that away and be grateful for the opportunity to do that.

MANSON: Very rarely in life do you share a common goal with people. That's very powerful whether you like it or not. I like being in a band. There's a romance for me in a band.

ERIKSON: Making music is a very personal thing, and when you share that with three other people for twenty years, they're gonna see sides of you no one else sees. You live on a bus and in hotels for years on end, see the world, perform in front of hundreds of thousands of people, then retreat to a dark studio for a few months—all with your bandmates by your side. You don't just go home and forget about them after all that. It's a rather weird family, but a family nonetheless. They're part of you and you're a part of them.

VIG: I'm not going to put a solo record out. I'm just not going to. At some point you always realize, *I need to work with my bandmates because there's something about the four of us working together that is really, really good.* Even if at some point we stop touring because we're just too damn old or whatever, I foresee us making music until we don't exist.

MANSON: I feel like we're making records for people like us—whoever that may be. We're not chasing the obsession that everyone seems to have with capturing the eyes and ears of the youth. I know that a lot of my peers are very despondent about their age, whereas I feel like it's fuel. The more that I see the clock ticking, it gives me more hunger and more drive. And all the things that I saw as faults in me when I was young, I see as weapons as I get older. All things you think aren't good can be used as powerful material to enhance your life.

Opposite: a Cultice shot for *Strange Little Birds* of the band reflected in a mirror-tiled wall; following pages, top and middle: Spooner, featuring Erikson and Vig; bottom: a poster for First Person, featuring Marker (second from left) and Vig (far right); following pages, clockwise from top left: a publicity photo for Spooner; Vig in 1980 playing drums in the Gearheads (and wearing gears on his head); Flying Saucers, featuring Marker (in doorway); a young Vig with a cake topped by the Beatles and drumsticks; Spooner in 1977; page 207: a tiny percentage of incredible gifts we have been given by fans.

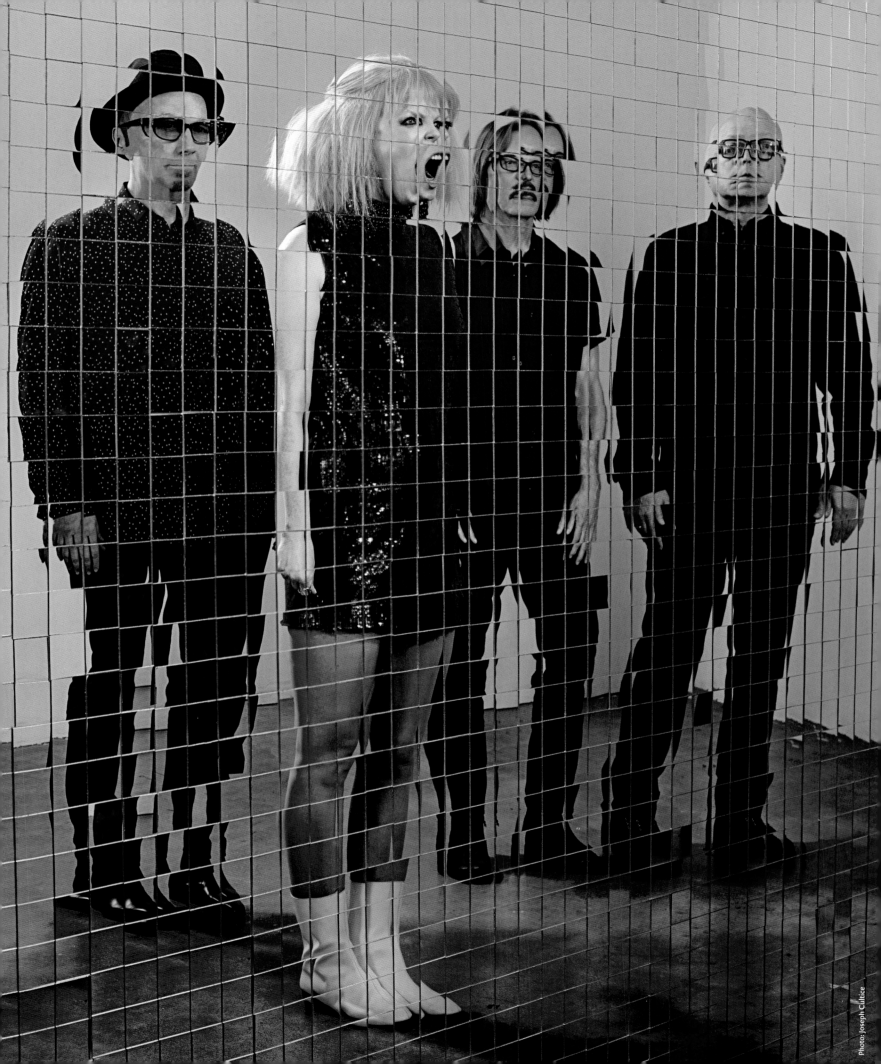

GARBAGE DISCOGRAPHY

ALBUMS

Garbage, 1995
Version 2.0, 1998
Beautiful Garbage, 2001
Bleed Like Me, 2005
Not Your Kind of People, 2012
Strange Little Birds, 2016

COMPILATIONS/REISSUE

Absolute Garbage, 2007
The Absolute Collection, 2012
Garbage 20th Anniversary Edition, 2015

SINGLES

Vow, 1995
Subhuman, 1995
Only Happy When It Rains, 1995
Queer, 1995
Stupid Girl, 1996
Milk, 1996
#1 Crush, 1997
Push It, 1998
I Think I'm Paranoid, 1998
Special, 1998
When I Grow Up, 1999
The Trick Is to Keep Breathing, 1999
You Look So Fine, 1999
The World Is Not Enough, 1999
Androgyny, 2001
Cherry Lips, 2002
Breaking Up the Girl, 2002
Shut Your Mouth, 2002
Why Do You Love Me, 2005
Sex Is Not the Enemy, 2005
Run Baby Run, 2005
Bleed Like Me, 2005
Tell Me Where It Hurts, 2007
Control, 2012
Big Bright World, 2012
Empty, 2016
Magnetized, 2016

RECORD STORE DAY RELEASES

Battle in Me, 2012
Blood for Poppies, 2012
Because the Night (with Screaming Females), 2013
Girls Talk (with Brody Dalle), 2014
The Chemicals (with Brian Aubert), 2015

PROMOTIONAL SINGLES

Supervixen, 1996
Temptation Waits, 1999
Automatic Systematic Habit, 2012

PROMOTIONAL EP

Special Collection, 2002

VARIOUS ARTISTS COMPILATIONS

Volume Twelve (Vow), 1994
Sweet Relief II: Gravity of the Situation (Kick My Ass), 1996
William Shakespeare's Romeo + Juliet: Music from the Motion Picture (#1 Crush), 1996
The Faculty: Music from the Dimension Motion Picture (Medication), 1998
Fire & Skill: The Songs of the Jam (The Butterfly Collector), 1999
Big Daddy—Music from the Motion Picture (When I Grow Up), 1999
Now That's What I Call Music! 3 (Special), 1999
The Best of the KROQ Almost Acoustic Christmas (Stupid Girl), 1999
The World Is Not Enough: Music from the MGM Motion Picture (The World Is Not Enough), 1999
We're a Happy Family: A Tribute to Ramones (I Just Wanna Have Something to Do), 2003
Songs for Tibet: The Art of Peace (All the Good in This Life), 2008
Give Listen Help (Witness to Your Love), 2008
Ăhk-toŏng Bāy-bi Covered, (Who's Gonna Ride Your Wild Horses), 2011
Music to Inspire: Artists UNited Against Human Trafficking (Where Do the Children Play?), 2017

VHS/DVD RELEASES

Garbage Video, 1996
Absolute Garbage, 2007
One Mile High . . . Live, 2013

For a complete discography of every Garbage release, go to garbage.com/officialdiscography

Discography by Jim Berkenstadt, Rock and Roll Detective, LLC

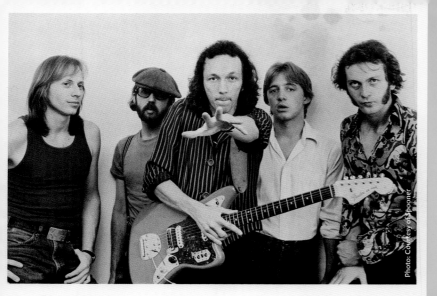

SPOONER.

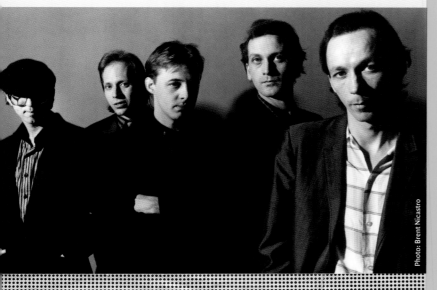

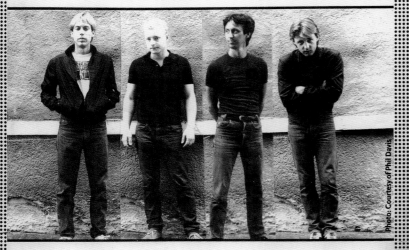

First Person

modern pop

THE BOYS AND THEIR BANDS

Butch Vig has a dictum: "You can't be in too many bands!" The men of Garbage have lived by this dictum since they were but boys in high school. A serial monogamist in comparison, Manson has confined herself to just three groups: Goodbye Mr. Mackenzie, Angelfish, and Garbage. (Though she has made appearances in Chris Connelly and Matt Walker's David Bowie cover band, Sons of the Silent Age.) Vig's dictum has been so closely adhered to over the years that this nearly exhaustive accounting of bands the Garbage boys have played in is still likely incomplete. But it certainly is long.

DUKE ERIKSON

THE BRITISH: my first band in high school

ONYX: I was the drummer in this metal band from Omaha. My fingers bled every night.

NICKELPLATE ROAD: a country/folk/rock college band

BLIND HOWLIN' WART'S BLUES BAND: a country/rock/blues outfit

SPOONER: Midwest pop at its finest

FIRE TOWN: heartland pop

KNOW-IT-ALL BOYFRIENDS: I play bass in this extraordinarily tasteful cover band.

THE DICKLE BROTHERS: an exciting amalgam of roadies and Garbage that has played all over the world

STEVE MARKER

HEEK SHAREEK AND THE MIDGET'S REVENGE: Sort of Mahavishnu Orchestra–lite. We explored the boundaries of jazz-rock with all the insight and talent that only a high school sophomore can possess.

FIREFLY: We played Yes and King Crimson songs at the high school dance in the gym. Now *that's* how you impress the ladies.

BOURGEOIS Z: My first punk band in college. I played bass, I think. Butch came to see us play at a house party, and his friend knocked our singer unconscious in the middle of a song. Not sure why.

FLYING SAUCERS: This rockabilly band was a blatant attempt to make money and exploit the lucrative Rockpile-soundalike market.

FIRST PERSON: I was a roadie for Duke and Butch's band Spooner, then got promoted to soundman, which meant an extra twenty-five dollars a night. That led to Butch and me starting this band with some friends as an excuse to write songs and record them. Still pretty much what we do today.

CATTLE PROD: Worked with these guys in the studio and ended up playing guitar with them for a while, on the Madison-Champaign/Urbana-Chicago-in-a-Ford-Econoline-van circuit.

RECTAL DRIP: An Oberheim DX drum machine through a distortion pedal, me on guitar, and Butch on vocals. Strangely not available on iTunes.

SNOT ATTACK: Butch and I learning how to record on my TEAC four-track

THE NEW UPSETTERS: No one remembers for sure who was in this band, but it included the guys from Gumball. The set list for our one gig at (the now-burned-down) Club de Wash: Pink Floyd's "Interstellar Overdrive," the Small Faces's "(Tell Me) Have You Ever Seen Me," then "Interstellar Overdrive" again.

KNERBLE KNERBLE: synth band featuring our friend Stu wearing a cow's pelvis as a mask

THE RAISINS: a Madison supergroup featuring parts of Sometimes Y and First Person

THE VOMIT RAISINS: A bunch of us drove to Viroqua because Butch's mom was making Thanksgiving dinner, and on the way back the next day we wrote all the lyrics, not printable here, for this band. The only band I was ever in that included a saxophone.

DENNIS NECHVATAL GROUP: My artist friend Dennis and I would do shows at art galleries where he would read his poetry and I would make weird guitar and computer sounds.

DOLL BURPER: like Snot Attack, but worse

THE SECRETS OF TERROR CASTLE: my friend Bill and me, with some of the Weeds, in a cowpunk scenario

THE DICKLE BROTHERS: Pretty much everybody in Garbage and our road crew has been in the Dickle Brothers except for notoriously reclusive lead singer Debbie Dickle, who, despite being provided with requisite wig, has always managed to not show up for our gigs. So far.

BUTCH VIG

RAT FINKS: sixth grade with my cousin and neighbor; played parents' parties

THE SCHLICTS: fifteen years old; played a couple high school dances

ECLIPSE: sixteen to seventeen years old; played the county fair and local taverns

SPOONER: three albums on indie labels, singles, EP; 1978–90

THE GEARHEADS: performance art/electronic music; 1980

MYLAR: performance art/electronic music; 1982

CLIFF BENZ AND THE POLKATEERS: 1980–85

FIRST PERSON: with Steve Marker, Fire Town's Phil Davis and Tom LaVarda; 1985; performed many opening gigs at Merlyn's

FIRE TOWN: two albums on Atlantic; 1986–89

KNERBLE KNERBLE: performed at a Not for Geeks concert

RECTAL DRIP: ten-song cassette released in 1986; songs in *Slumber Party Massacre*

SNOT ATTACK: performed on the *Vern and Evelyn Show* on Madison cable access TV

UPSETTERS (A.K.A. THE NEW UPSETTERS): performed with Don Fleming and Gumball at Club de Wash

VOMIT RAISINS (A.K.A. THE RAISINS): various members of Madison bands; performed at G.S. Vigs

SOMETIMES Y: produced their 1984 debut album, *one fell swoop*; performed live with them at G.S. Vigs

KIAB (A.K.A. KNOW-IT-ALL BOYFRIENDS): world's worst/best cover band; featuring hit single "Ramp It Up"; performed countless wedding gigs

VOLCANOS: performed several gigs in the UK

THE DICKLE BROTHERS: performed in shithole bars around the world

6 PACKERS: "Go Pack Go!" performed at Lambeau Field and on ESPN

EMPERORS OF WYOMING: released debut album in 2013; performed in 2014

5 BILLION IN DIAMONDS: debut album TBD

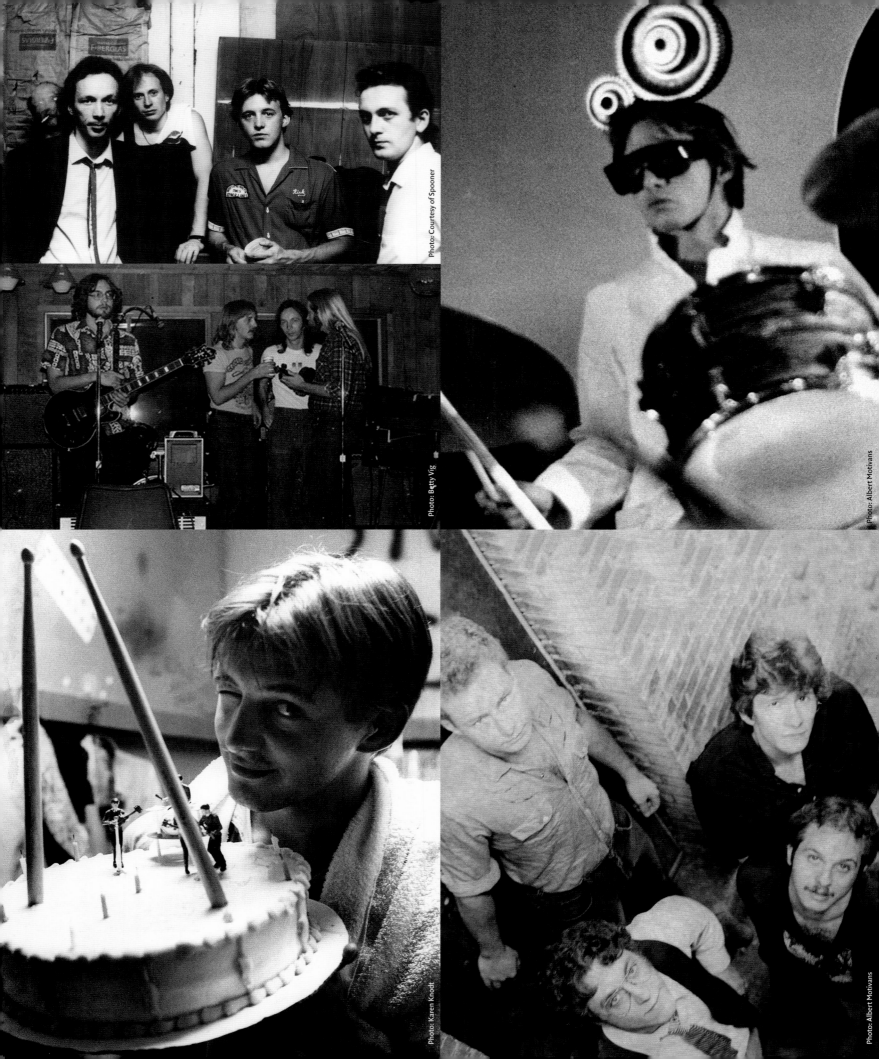

Photo: Courtesy of Spooner

Photo: Betty Vig

Photo: Albert Motivans

Photo: Karen Knodt

Photo: Albert Motivans

GARBAGE TOUR DATES

September 28, 1995—*Top of the Pops*, London, England
November 5, 1995—7th St Entry, Minneapolis, MN, USA
November 6, 1995—Shank Hall, Milwaukee, WI, USA
November 7, 1995—Cabaret Metro, Chicago, IL, USA
November 9, 1995—St. Andrew's Hall, Detroit, MI, USA
November 10, 1995—Opera House, Toronto, ON, Canada
November 11, 1995—Café Campus, Montreal, QC, Canada
November 13, 1995—Irving Plaza, New York, NY, USA
November 14, 1995—Axis, Boston, MA, USA
November 15, 1995—Theatre of Living Arts, Philadelphia, PA, USA
November 16, 1995—Black Cat, Washington, DC, USA
November 17, 1995—Peabody's Down Under, Cleveland, OH, USA
November 19, 1995—Exit/In, Nashville, TN, USA
November 20, 1995—The Point, Atlanta, GA, USA
November 22, 1995—MTV's *Most Wanted*, London, England
November 23, 1995—The Forum, London, England
November 25, 1995—Melkweg, Amsterdam, The Netherlands
November 27, 1995—Grosse Freiheit 36, Hamburg, Germany
November 28, 1995—Pumpehuset, Copenhagen, Denmark
November 30, 1995—VK Club, Brussels, Belgium
December 1, 1995—Salle Drumsport, Rennes Festival, France
December 3, 1995—Wappensaal, Munich, Germany
December 5, 1995—WBCN Holiday Show, Boston, MA, USA
December 6, 1995—WMRQ Holiday Show, The Sting, New Britain, CT, USA
December 7, 1995—WHFF Holiday Show, Washington, DC, USA
December 11, 1995—KNRK Holiday Show, Portland, OR, USA
December 12, 1995—Moe's, Seattle, WA, USA
December 14, 1995—Slim's, San Francisco, CA, USA
December 15, 1995—Live 105/KITS Green Christmas, Berkeley Community Theatre, Berkeley, CA, USA
December 16, 1995—KOME Almost Acoustic Christmas, SJSU Event Center, San Jose, CA, USA
December 17, 1995—KROQ Holiday Show, Los Angeles, CA, USA
December 18, 1995—KROQ Holiday Show, Los Angeles, CA, USA
December 20, 1995—Viper Room, Los Angeles, CA, USA
February 24, 1996—Deep Ellum Live, Dallas, TX, USA
February 26, 1996—Liberty Lunch, Austin, TX, USA
February 27, 1996—Numbers, Houston, TX, USA
February 28, 1996—The Howlin' Wolf, New Orleans, LA, USA
March 1, 1996—State Theatre, St. Petersburg, FL, USA
March 2, 1996—The Edge, Ft. Lauderdale, FL, USA
March 3, 1996—Renaissance, Orlando, FL, USA
March 4, 1996—Seville Quarter, Pensacola, FL, USA
March 6, 1996—Cat's Cradle, Chapel Hill, NC, USA
March 7, 1996—Baitshack, Norfolk, VA, USA
March 8, 1996—Metropol, Pittsburgh, PA, USA
March 9, 1996—Z100 "Sno-asis," Vernon Valley Ski Area, Vernon, NJ, USA
March 11, 1996—Newport Music Hall, Columbus, OH, USA
March 12, 1996—Bogart's, Cincinnati, OH, USA
March 13, 1996—Vogue, Indianapolis, IN, USA
March 14, 1996—Barrymore Theatre, Madison, WI, USA
March 19, 1996—Civic Hall, Wolverhampton, England
March 20, 1996—*Top of the Pops*, London, England
March 21, 1996—Barrowlands, Glasgow, Scotland
March 22, 1996—Apollo, Manchester, England
March 24, 1996—Brixton Academy, London, England
March 25, 1996—Corn Exchange, Cambridge, England
March 26, 1996—Town and Country Club, Leeds, England
March 27, 1996—Rock City, Nottingham, England
March 28, 1996—*TFI Friday*, London, England
March 30, 1996—Vooruit, Ghent, Belgium
April 1, 1996—Metropol, Berlin, Germany
April 2, 1996—*Nulle Part Ailleurs*, Canal +, Paris, France
April 3, 1996—Elysée Montmartre, Paris, France
April 4, 1996—Batschkapp, Frankfurt, Germany
April 6, 1996—Den Atelier, Luxembourg
April 7, 1996—Phillipshelter, Dusseldorf, Germany
April 9, 1996—Leeds Metropolitan University, Leeds, England
April 13, 1996—Saturday Night Special, Los Angeles, CA, USA
April 16, 1996—Le Spectrum de Montreal, Montreal, QC, Canada
April 17, 1996—Orpheum Theatre, Boston, MA, USA
April 18, 1996—Avalon Ballroom, Boston, MA, USA
April 19, 1996—Roseland, New York, NY, USA
April 21, 1996—Classic Amphitheatre, Richmond, VA, USA
April 22, 1996—9:30 Club, Washington, DC, USA
April 23, 1996—Theater of Living Arts, Philadelphia, PA, USA
April 24, 1996—Opera House, Toronto, ON, Canada
April 25, 1996—New York Nites, Rochester, NY, USA
April 27, 1996—The Rave, Milwaukee, WI, USA
April 28, 1996—Metro, Chicago, IL, USA
April 30, 1996—Ogden Theatre, Denver, CO, USA
May 1, 1996—DV8, Salt Lake City, UT, USA
May 3, 1996—DV8, Seattle, WA, USA
May 4, 1996—Vogue Theater, Vancouver, BC, Canada
May 5, 1996—La Luna, Portland, OR, USA
May 7, 1996—The Fillmore, San Francisco, CA, USA
May 9, 1996—The Glass House, Pomona, CA, USA
May 10, 1996—Soma, San Diego, CA, USA
May 11, 1996—The Palace, Los Angeles, CA, USA
May 12, 1996—Electric Ballroom, Phoenix, AZ, USA

May 25, 1996—93.7 EdgeFest Radio Show, Float Rite Park Amphitheater, Minneapolis, MN, USA
May 26, 1996—Q101 Jamboree, The World Music Theatre, Chicago, IL, USA
May 27, 1996—KPNT Pointfest 5, Riverport Amphitheater, St. Louis, MO, USA
May 29, 1996—Granada Theater, Lawrence, KS, USA
June 1, 1996—HFStival, RFK Stadium, Washington, DC, USA
June 8, 1996—MTV Movie Awards, Walt Disney Studios, Burbank, CA, USA
June 11, 1996—Teatro Metropólitan, Mexico City, Mexico
June 13, 1996—MTV Movie Awards Show, Walt Disney Studios, Burbank, CA, USA
June 14, 1996—Live 105 Radio Show, San Francisco, CA, USA
June 15, 1996—KROQ Weenie Roast, Los Angeles, CA, USA
June 16, 1996—Backstage, Santa Barbara, CA, USA
June 17, 1996—MTV Beach House taping, Long Beach, CA, USA
June 25, 1996—Wendler Arena, Saginaw, MI, USA, w/Smashing Pumpkins
June 27, 1996—Market Square Arena, Indianapolis, IN, USA, w/Smashing Pumpkins
June 29, 1996—Palace of Auburn Hills, Auburn Hills, MI, USA, w/Smashing Pumpkins
June 30, 1996—State Theater, Auburn Hills, MI, USA, w/Smashing Pumpkins
July 2, 1996—Memorial Auditorium, Buffalo, NY, USA, w/Smashing Pumpkins
July 3, 1996—Gund Arena, Cleveland, OH, USA, w/Smashing Pumpkins
July 5, 1996—Spectrum, Philadelphia, PA, USA, w/Smashing Pumpkins
July 6, 1996—Spectrum, Philadelphia, PA, USA, w/Smashing Pumpkins
July 7, 1996—Hampton Coliseum, Hampton, VA, USA, w/Smashing Pumpkins
July 9, 1996—USAir Arena, Washington, DC, USA, w/Smashing Pumpkins
July 10, 1996—USAir Arena, Washington, DC, USA, w/Smashing Pumpkins
July 11, 1996—*Late Show with David Letterman*, New York, NY, USA
July 14, 1996—An Evening of Sweet Relief, The Bottom Line, New York, NY, USA
August 2, 1996—Benicàssim Festival, Benicàssim, Spain
August 5, 1996—Water Festival, Stockholm, Sweden
August 6, 1996—Rockefeller Music Hall, Oslo, Norway
August 8, 1996—Grayhalle, Copenhagen, Denmark
August 10, 1996—Old Castle, Osnabrück, Germany
August 12, 1996—Easy Auensee, Leipzig, Germany
August 13, 1996—Modernes, Bremen, Germany
August 14, 1996—Docks, Hamburg, Germany
August 16, 1996—Festival D'Annecy, Annecy, France
August 17, 1996—Bizarre Festival, Cologne, Germany
August 18, 1996—Black Session Festival, Saint-Malo, France
August 20, 1996—Nachtwerk, Munich, Germany
August 21, 1996—Longhorn, Stuttgart, Germany
August 23, 1996—Pukkelpop Festival, Hasselt, Belgium
August 24, 1996—Reading Festival, Reading, England
August 25, 1996—Lowlands Festival, Biddinghuizen, The Netherlands
September 28, 1996—Harbour Pavilion, Singapore
October 3, 1996—Entertainment Centre, Adelaide, Australia
October 5, 1996—Livid Festival, Brisbane, Australia
October 7, 1996—Hordern Pavilion, Sydney, Australia
October 8, 1996—Festival Hall, Melbourne, Australia
October 9, 1996—The Palace, Melbourne, Australia
October 11, 1996—North Shore Stadium, Auckland, New Zealand
October 12, 1996—Queens Wharf Centre, Wellington, New Zealand
October 15, 1996—Club Quattro, Tokyo, Japan
October 16, 1996—Club Quattro, Tokyo, Japan
October 17, 1996—Club Quattro, Nagoya, Japan
October 18, 1996—Club Quattro, Osaka, Japan
October 23, 1996—Hilton Coliseum, Ames, IA, USA, w/Smashing Pumpkins
October 24, 1996—VH1 Fashion Awards, Madison Square Garden, New York, NY, USA
October 25, 1996—Assembly Hall, Champaign, IL, USA, w/Smashing Pumpkins
October 26, 1996—Mark of the Quad Cities, Moline, IL, USA, w/Smashing Pumpkins
October 29, 1996—Freedom Hall, Louisville, KY, USA, w/Smashing Pumpkins
October 30, 1996—Allen County Memorial Coliseum, Fort Wayne, IN, USA, w/Smashing Pumpkins
November 1, 1996—Hartford Civic Center, Hartford, CT, USA, w/Smashing Pumpkins
November 4, 1996—Cumberland Civic Center, Portland, ME, USA, w/Smashing Pumpkins
November 5, 1996—Fleet Center, Boston, MA, USA, w/Smashing Pumpkins
November 6, 1996—Centrum, Boston, MA, USA, w/Smashing Pumpkins
November 7, 1996—Beacon Theatre, New York, NY, USA, w/Smashing Pumpkins
November 11, 1996—Carolina Coliseum, Columbia, SC, USA, w/Smashing Pumpkins
November 12, 1996—Dean Smith Center, Chapel Hill, NC, USA, w/Smashing Pumpkins
November 14, 1996—MTV Europe Music Awards, Alexandra Palace, London, England
November 16, 1996—Lakeland Center, Lakeland, FL, USA, w/Smashing Pumpkins
November 17, 1996—Miami Arena, Miami, FL, USA, w/Smashing Pumpkins
November 19, 1996—The Omni, Atlanta, GA, USA, w/Smashing Pumpkins
November 22, 1996—Pyramid Arena, Memphis, TN, USA, w/Smashing Pumpkins
November 23, 1996—Myriad Arena, Oklahoma City, OK, USA, w/Smashing Pumpkins
November 24, 1996—Barton Coliseum, Little Rock, AR, USA, w/Smashing Pumpkins
November 26, 1996—Cajundome, Lafayette, LA, USA, w/Smashing Pumpkins
November 27, 1996—Mississippi Coast Coliseum, Biloxi, MS, USA, w/Smashing Pumpkins
November 29, 1996—Freeman Coliseum, San Antonio, TX, USA, w/Smashing Pumpkins
November 30, 1996—Frank Erwin Center, Austin, TX, USA, w/Smashing Pumpkins
December 1, 1996—Reunion Arena, Dallas, TX, USA, w/Smashing Pumpkins
December 3, 1996—The Summit, Houston, TX, USA, w/Smashing Pumpkins
December 4, 1996—Pan American Center, Las Cruces, NM, USA, w/Smashing Pumpkins
December 5, 1996—Tingley Coliseum, Albuquerque, NM, USA, w/Smashing Pumpkins
December 7, 1996—America West Arena, Phoenix, AZ, USA, w/Smashing Pumpkins
December 9, 1996—Arrowhead Pond, Anaheim, CA, USA, w/Smashing Pumpkins
December 10, 1996—Arrowhead Pond, Anaheim, CA, USA, w/Smashing Pumpkins
December 11, 1996—San Diego Sports Arena, San Diego, CA, USA, w/Smashing Pumpkins
December 13, 1996—Universal Amphitheatre, Los Angeles, CA, USA
December 14, 1996—Cow Palace, San Francisco, CA, USA, w/Smashing Pumpkins
December 16, 1996—San Jose Arena, San Jose, CA, USA, w/Smashing Pumpkins

December 17, 1996—Arco Arena, Sacramento, CA, USA, w/Smashing Pumpkins
December 18, 1996—Great Western Forum, Inglewood, CA, USA, w/Smashing Pumpkins
May 15, 1998—Ryan's Ballroom, Combined Locks, WI, USA
May 16, 1998—Thunderbird Theatre, Champaign-Urbana, IL, USA
May 18, 1998—Orbit Room, Grand Rapids, MI, USA
May 20, 1998—Warfield, San Francisco, CA, USA
May 21, 1998—The Palace, Los Angeles, CA, USA
May 24, 1998—Phoenix, Toronto, ON, Canada
May 26, 1998—Avalon, Boston, MA, USA
May 27, 1998—9:30 Club, Washington, DC, USA
May 28, 1998—Roseland, New York, NY, USA
June 1, 1998—Pinkpop Festival, Geleen, The Netherlands
June 2, 1998—*Nulle Part Ailleurs*, Canal +, Paris, France
June 3, 1998—Le Zénith, Paris, France
June 4, 1998—Brixton Academy, London, England
June 5, 1998—*TFI Friday*, London, England
June 6, 1998—Newport Centre, Newport, Wales
June 7, 1998—Provinssirock Festival, Seinäjoki, Finland
June 8, 1998—Wolverhampton Civic Hall, Wolverhampton, England
June 9, 1998—Guildhall, Portsmouth, England
June 11, 1998—Hultsfred Festival, Hultsfred, Sweden
June 13, 1998—Provinssirock Festival, Seinäjoki, Finland
June 16, 1998—Libro Festival, Vienna, Austria
June 17, 1998—Coliseum, Munich, Germany
June 18, 1998—Kongresshalle, Stuttgart, Germany
June 20, 1998—Loreley Festival, Loreley, Germany
June 21, 1998—Hurricane Festival, Scheessel, Germany
June 23, 1998—World Expo '98, Lisbon, Portugal
June 26, 1998—Roskilde Festival, Roskilde, Denmark
June 28, 1998—St. Gallen Festival, St. Gallen, Switzerland
June 30, 1998—Columbia Halle, Berlin, Germany
July 1, 1998—Forum, Nürnberg, Germany
July 2, 1998—Open Air Arena, Nancy, France
July 4, 1998—Tourhout Festival, Tourhout, Belgium
July 5, 1998—Rock Werchter Festival, Werchter, Belgium
July 7, 1998—Festa Dell'Unita, Correggio, Italy
July 10, 1998—Doctor Music Festival, Escalarre, Spain
July 11, 1998—Big Day Out, Castlegar, Galway, Ireland
July 12, 1998—T in the Park, Balado, Scotland
July 17, 1998—*TFI Friday*, London, England
July 24, 1998—MGD Blind Date, Aragon Ballroom, Chicago, IL, USA
August 1, 1998—Fuji Rock Festival, Tokyo, Japan
August 23, 1998—Summersault Festival, Barrie, ON, Canada
August 27, 1998—Barrowlands, Glasgow, Scotland
August 28, 1998—Barrowlands, Glasgow, Scotland
August 30, 1998—Reading Festival, Reading, England
September 4, 1998—Pepsi Chart Show, London, England
September 5, 1998—*TFI Friday*, London, England
September 5, 1998—MTV Europe, London, England
September 17, 1998—Mammoth Event Center, Denver, CO, USA
September 18, 1998—Wasatch Events Center, Salt Lake City, UT, USA
September 20, 1998—Amory, Salem, OR, USA
September 21, 1998—Plaza of Nations, Vancouver, BC, Canada
September 22, 1998—Paramount Theatre, Seattle, WA, USA
September 23, 1998—KNDD FM 107.7, Seattle, WA, USA
September 24, 1998—Freeborn Hall, Davis, CA, USA
September 25, 1998—Event Center, San Jose, CA, USA
September 26, 1998—Hollywood Palladium, Los Angeles, CA, USA
September 28, 1998—KROQ Kevin & Bean in the Morning, King's Head Pub, Santa Monica, CA, USA
September 28, 1998—Hollywood Palladium, Los Angeles, CA, USA
September 30, 1998—Kern County Fair, Bakersfield, CA, USA
October 1, 1998—RIMAC Arena, La Jolla, CA, USA
October 2, 1998—Rainbow Ballroom, Fresno, CA, USA
October 3, 1998—Santa Barbara Bowl, Santa Barbara, CA, USA
October 5, 1998—Hayden Square, Tempe, AZ, USA
October 6, 1998—The Joint, Las Vegas, NV, USA
October 8, 1998—The Zone, Albuquerque, NM, USA
October 9, 1998—Pan American Center, Las Cruces, NM, USA
October 11, 1998—Pan Liquid 2000, Lubbock, TX, USA
October 12, 1998—Cain's Ballroom, Tulsa, OK, USA
October 13, 1998—Diamond Ballroom, Oklahoma City, OK, USA
October 15, 1998—Bronco Bowl, Dallas, TX, USA
October 16, 1998—Austin Music Hall, Austin, TX, USA
October 17, 1998—Bayou Place, Houston, TX, USA
October 19, 1998—USF Special Events Center, Tampa, FL, USA
October 20, 1998—Sunrise Musical Theatre, Sunrise, FL, USA
October 21, 1998—House of Blues, Lake Buena Vista, FL, USA
October 23, 1998—Tabernacle, Atlanta, GA, USA
October 24, 1998—The Ritz, Raleigh, NC, USA
October 25, 1998—Bender Arena, Washington, DC, USA
October 26, 1998—Y100 Sonic Session, Philadelphia, PA, USA
October 27, 1998—Electric Factory, Philadelphia, PA, USA
October 28, 1998—The Palladium, Worcester, MA, USA
October 29, 1998—*Late Show with David Letterman*, New York, NY, USA
October 30, 1998—Howard Stern Show, New York, NY, USA
October 30, 1998—Roseland, New York, NY, USA
October 31, 1998—Paramount Theatre, Asbury Park, NJ, USA
November 1, 1998—Lupo's Heartbreak Hotel, Providence, RI, USA
November 3, 1998—Chapin Theatre, South Hadley, MA, USA
November 5, 1998—Metropolis, Montreal, QC, Canada
November 6, 1998—Musiqueplus, Montreal, QC, Canada
November 7, 1998—The Lyric, Kitchener, ON, Canada
November 8, 1998—The Warehouse, Toronto, ON, Canada
November 10, 1998—Agora Theatre, Cleveland, OH, USA
November 12, 1998—State Theatre, Detroit, MI, USA
November 13, 1998—Bogart's, Cincinnati, OH, USA
November 14, 1998—Newport Music Hall, Columbus, OH, USA
November 16, 1998—State Theatre, Kalamazoo, MI, USA
November 17, 1998—Egyptian Theatre, Indianapolis, IN, USA
November 18, 1998—Dane County Expo Center, Madison, WI, USA
November 20, 1998—Memorial Hall, Kansas City, KS, USA
November 21, 1998—American Theatre, St. Louis, MO, USA
November 22, 1998—Sokol Hall, Omaha, NE, USA
November 24, 1998—Eagles Ballroom, Milwaukee, WI, USA
November 25, 1998—Riviera Nightclub, Chicago, IL, USA
November 27, 1998—Orpheum, Minneapolis, MN, USA
November 28, 1998—Weidner Center, University of Wisconsin, Green Bay, WI, USA
November 29, 1998—WMAD, Madison, WI, USA
December 1, 1998—WBCN XMAS Rave, Boston, MA, USA
December 2, 1998—WMRQ Jingle Bell Jam, Hartford, CT, USA
December 4, 1998—Y100 Festival, Philadelphia, PA, USA
December 5, 1998—HFMAS, Fairfax, VA, USA
December 6, 1998—WXDX Festival, Pittsburgh, PA, USA
December 8, 1998—KNRK Snowball, Portland, OR, USA
December 9, 1998—KNDD Deck the Hall Ball, Key Arena, Seattle, WA, USA
December 10, 1998—Live 105 Not So Silent Night, San Jose, CA, USA
December 11, 1998—*Tonight Show with Jay Leno*, NBC Studios, Los Angeles, CA, USA
December 12, 1998—KROQ Almost Acoustic Christmas, Los Angeles, CA, USA
December 15, 1998—Teatro Metropólitan, Mexico City, Mexico
December 18, 1998—Q101's Twisted 5, Chicago, IL, USA
December 19, 1998—KZNZ Radio Show, Target Center, Minneapolis, MN, USA
December 20, 1998—The Night 89X Stole Christmas, Joe Louis Arena, Detroit, MI, USA
January 14, 1999—The Point, Dublin, Ireland
January 15, 1999—King's Hall, Belfast, Northern Ireland
January 17, 1999—NEC Arena, Birmingham, England
January 18, 1999—The Dome, Doncaster, England
January 19, 1999—Rivermead Centre, Reading, England
January 20, 1999—Wembley Arena, London, England
January 21, 1999—Friday Night's All Wright, London, England
January 22, 1999—Manchester Evening News Arena, Manchester, England
January 23, 1999—SECC, Glasgow, Scotland
January 25, 1999—Forest National, Brussels, Belgium
January 26, 1999—Ahoy, Rotterdam, The Netherlands
January 27, 1999—Le Zénith, Paris, France
January 28, 1999—*Nulle Part Ailleurs*, Canal +, Paris, France
January 29, 1999—Valby-Hallen, Copenhagen, Denmark
January 30, 1999—Lisebergshallen, Gothenburg, Sweden
January 31, 1999—Annexet, Stockholm, Sweden
February 2, 1999—Old Icehall, Helsinki, Finland
February 3, 1999—Jubilee Hall, St. Petersburg, Russia
February 5, 1999—*Top of the Pops*, London, England
February 7, 1999—Palladium, Cologne, Germany
February 8, 1999—Le Transbordeur, Lyon, France
February 10, 1999—Zeleste, Barcelona, Spain
February 11, 1999—La Riviera, Madrid, Spain
February 16, 1999—The Crown, Cincinnati, OH, USA w/ Alanis Morisette
February 18, 1999—Nassau Coliseum, Uniondale, NY, USA, w/Alanis Morissette
February 19, 1999—Continental Arena, East Rutherford, NJ, USA, w/Alanis Morissette
February 21, 1999—Bryce Jordan Center, State College, University Park, PA, USA, w/Alanis Morissette
February 22, 1999—Fleet Center, Boston, MA, USA, w/Alanis Morissette
March 7, 1999—Target Center, Minneapolis, MN, USA, w/Alanis Morissette
March 9, 1999—Rosemont Horizon, Chicago, IL, USA, w/Alanis Morissette
March 10, 1999—Palace of Auburn Hills, Detroit, MI, USA, w/Alanis Morissette
March 11, 1999—Market Square Arena, Indianapolis, IN, USA, w/Alanis Morissette
March 14, 1999—Kiel Center, St. Louis, MO, USA, w/Alanis Morissette
March 15, 1999—Kemper Arena, Kansas City, MO, USA, w/Alanis Morissette
March 17, 1999—Reunion Arena, Dallas, TX, USA, w/Alanis Morissette
March 20, 1999—*Saturday Night Live*, New York, NY, USA
March 21, 1999—Blockbuster Desert Sky Pavilion, Phoenix, AZ, USA, w/Alanis Morissette
March 23, 1999—McNichols Sports Arena, Denver, CO, USA, w/Alanis Morissette
March 24, 1999—E Center, Salt Lake City, UT, USA, w/Alanis Morissette
March 26, 1999—Idaho Center, Boise, ID, USA, w/Alanis Morissette
March 27, 1999—Yakima Valley SunDome, Yakima, WA, USA, w/Alanis Morissette
March 29, 1999—Key Arena, Seattle, WA, USA, w/Alanis Morissette
March 30, 1999—Rose Garden, Portland, OR, USA, w/Alanis Morissette
April 1, 1999—Arena, San Jose, CA, USA, w/Alanis Morissette
April 2, 1999—*Tonight Show with Jay Leno*, Los Angeles, CA, USA
April 3, 1999—Cox Arena, San Diego, CA, USA
April 4, 1999—House of Blues, Las Vegas, NV, USA
April 6, 1999—Arrowhead Pond, Anaheim, CA, USA, w/Alanis Morissette
April 7, 1999—Universal Amphitheatre, Los Angeles, CA, USA
May 15, 1999—*Later with Jools Holland*, London, England
May 19, 1999—Libro Festival, Vienna, Austria
May 20, 1999—Ani Stadion Slavie, Prague, Czech Republic
May 21, 1999—Rock im Park, Nürnberg, Germany
May 22, 1999—Rock am Ring Festival, Nürburgring
May 24, 1999—Spodek, Katowice, Poland
May 28, 1999—Palacio de los Deportes, Grenada, Spain
May 29, 1999—Música sí, Spain
May 29, 1999—Bullring, Murcia, Spain
May 30, 1999—Polideportivo Anoeta, San Sebastián, Spain
June 3, 1999—Gala Regazza, Madrid, Spain
June 4, 1999—*Top of the Pops*, London, England
June 11, 1999—*TFI Friday*, London, England
June 13, 1999—Tibetan Freedom Concert, RAI Parkhal, Amsterdam, The Netherlands
June 15, 1999—Bitan 11, Tel Aviv, Israel
June 16, 1999—Bitan 11, Tel Aviv, Israel
June 17, 1999—University, Be'er Sheva, Israel

June 19, 1999—Imola Festival, Imola, Italy
June 22, 1999—Laugardalls, Reykjavik, Iceland
July 1, 1999—Princes St. Gardens, Edinburgh, Scotland
July 3, 1999—De Oosterpoort, Groningen, The Netherlands
July 6, 1999—Quart Festival, Kristiansand, Norway
July 9, 1999—Midtfyns Festival, Ringe, Denmark
July 10, 1999—Jazz & More Festival, Hamburg, Germany
July 11, 1999—Highfield Festival, Erfurt, Germany
July 14, 1999—Rockwave Festival, Athens, Greece
July 16, 1999—Yapi Kredi Festival, Istanbul, Turkey
July 17, 1999—Axion Beach Festival, Zeebrugge, Belgium
July 18, 1999—Super Bock, Lisbon, Portugal
July 20, 1999—Les Voix du Gaou, Six-Four-les-Plages, France
July 21 1999—Paléo Festival, Nyon, Switzerland
July 29, 1999—Standard Band Arena, Johannesburg, South Africa
July 31, 1999—Three Arts Theatre, Cape Town, South Africa
August 2, 1999—Three Arts Theatre, Cape Town, South Africa
October 1, 1999—The Supertop, Auckland, New Zealand
October 2, 1999—Livid Festival, Brisbane, Australia
October 3, 1999—The Palace, Melbourne, Australia
October 5, 1999—Entertainment Centre, Perth, Australia
October 7, 1999—Entertainment Centre, Adelaide, Australia
October 8, 1999—Melbourne Park, Melbourne, Australia
October 9, 1999—Melbourne Park, Melbourne, Australia
October 11, 1999—National Indoor Stadium, Sydney, Australia
October 12, 1999—*Hey Hey It's Saturday*, Sydney, Australia
October 13, 1999—AIS Arena, Canberra, Australia
October 14, 1999—Superdome, Sydney, Australia
October 15, 1999—Entertainment Centre, Wollongong, Australia
October 16, 1999—Entertainment Centre, Newcastle, Australia
October 20, 1999—Magness Arena, University of Denver, Denver, CO, USA
October 22, 1999—Western Hall, Macomb, IL, USA
October 23, 1999—Mandell Hall, University of Chicago, Chicago, IL, USA
October 24, 1999—Central Missouri State University, Warrensburg, MO, USA
October 25, 1999—Hulman Center, Indiana State University, Terre Haute, IN, USA
October 27, 1999—Regional Special Events Center, Murray State University, Murray, KY, USA
October 28, 1999—Civic Arena, Marshall University, Huntington, WV, USA
October 29, 1999—Stabler Arena, Lehigh University, Bethlehem, PA, USA
October 30, 1999—Farrell Hall Gym, State University of New York, Delhi, NY, USA
November 1, 1999—*Late Show with David Letterman*, New York, NY, USA
November 2, 1999—Fisher Auditorium, Indiana University of Pennsylvania, Indiana, PA, USA
November 3, 1999—Goldstein Auditorium, Syracuse University, Syracuse, NY, USA
November 4, 1999—Bob Carpenter Center, University of Delaware, Newark, DE, USA
November 5, 1999—West Gym, State University of New York, Binghamton, NY, USA
November 7, 1999—Waldo S. Tippin Gymnasium, Clarion University, Clarion, PA, USA
November 9, 1999—Burruss Auditorium, Virginia Tech University, Blacksburg, VA, USA
November 10, 1999—Halton Arena, UNCC, Charlotte, NC, USA
November 12, 1999—UNF Arena, Jacksonville University, Jacksonville, FL, USA
November 14, 1999—McAlister Auditorium, Tulane University, New Orleans, LA, USA
November 16, 1999—Starplex Amphitheatre, Dallas, TX, USA
November 17, 1999—William R Johnson Coliseum, Stephen F Austin State University, Nacogdoches, TX
November 20, 1999—Centennial Hall, University of Arizona, Tucson, AZ, USA
November 22, 1999—Cal Poly Events Center, San Luis Obispo, CA, USA
November 23, 1999—Rimac Arena, UCSD, San Diego, CA, USA
November 24, 1999—Bren Center, UC Irvine, Irvine, CA, USA
September 22, 2001—*cd:uk*, The London Studios, London, England
September 23, 2001—Popworld, London, England
October 2, 2001—Virgin Megastore, Chicago, IL, USA
October 8, 2001—*Late Show with David Letterman*, New York, NY, USA
October 10, 2001—Notre Dame Joyce Center, South Bend, IN, USA, w/U2
October 12, 2001—Molson Centre, Montreal, QC, Canada, w/U2
October 13, 2001—Copps Coliseum, Hamilton, ON, Canada, w/U2
October 15, 2001—United Center, Chicago, IL, USA, w/U2
October 16, 2001—United Center, Chicago, IL, USA, w/U2
October 24, 2001—Madison Square Garden, New York, NY, USA, w/U2
November 2, 2001—Student Festival, Trondheim, Norway
November 3, 2001—Oslo Spektrum, Oslo, Norway
November 4, 2001—Vega Musikkens Hus, Copenhagen, Denmark
November 5, 2001—Grosse Freiheit 36, Hamburg, Germany
November 8, 2001—Élysée Montmartre, Paris, France
November 9, 2001—Halles de Schaerbeek, Brussels, Belgium
November 14, 2001—*Later with Jools Holland*, London, England
November 14, 2001—The Astoria, London, England
November 27, 2001—Kemper Arena, Kansas City, MO, USA, w/U2
November 28, 2001—Savvis Center, St. Louis, MO, USA, w/U2
November 30, 2001—Philips Arena, Atlanta, GA, USA, w/U2
December 1, 2001—Ice Palace, Tampa, FL, USA, w/U2
December 2, 2001—American Airlines Arena, Miami, FL, USA, w/U2
December 8, 2001—*Tonight Show with Jay Leno*, Los Angeles, CA, USA
December 12, 2001—*Tonight Show with Jay Leno*, NBC Studios, Los Angeles, CA, USA
December 13, 2001—Star 98.7 Not So Silent Night, Shrine Auditorium, Los Angeles, CA, USA
January 5, 2002—*cd:uk*, The London Studios, London, England
January 6, 2002—Popworld, London, England
January 8, 2002—Pepsi Chart Show, London, England
January 18, 2002—Big Day Out Festival, Ericsson Stadium, Auckland, New Zealand
January 20, 2002—Big Day Out Festival, Gold Coast Parklands, Gold Coast, Australia
January 22, 2002—Hordern Pavilion, Sydney, Australia
January 24, 2002—Channel V, Fox Studios, Sydney, Australia
January 26, 2002—Big Day Out Festival, RAS Showgrounds, Sydney, Australia
January 28, 2002—Big Day Out Festival, Royal Showgrounds, Melbourne, Australia
January 29, 2002—Metro Nightclub, Melbourne, Australia
February 1, 2002—Big Day Out Festival, Royal Showgrounds, Adelaide, Australia
February 3, 2002—Big Day Out Festival, Royal Showgrounds, Perth, Australia
February 6, 2002—Zepp Osaka, Osaka, Japan

February 8, 2002—Zepp Tokyo, Tokyo, Japan
February 9, 2002—Zepp Tokyo, Tokyo, Japan
February 12, 2002—Zepp Tokyo, Tokyo, Japan
March 15, 2002—*cd:uk*, The London Studios, London, England
March 31, 2002—*Re:covered*, London, England
April 1, 2002—Guildhall, Portsmouth, England
April 2, 2002—Colston Hall, Bristol, England
April 3, 2002—Wolverhampton Civic Hall, Wolverhampton, England
April 4, 2002—Liquid Rooms, Edinburgh, Scotland
April 5, 2002—Corn Exchange, Edinburgh, Scotland
April 6, 2002—Apollo, Manchester, England
April 7, 2002—Brixton Academy, London, England
April 8, 2002—Hackney Ocean, London, England
April 10, 2002—Palladium, Cologne, Germany
April 11, 2002—Heineken Music Hall, Amsterdam, The Netherlands
April 13, 2002—Bourges Festival, Bourges, France
April 19, 2002—Kool Haus, Toronto, ON, Canada
April 20, 2002—Agora Theater, Cleveland, OH, USA
April 21 2002—State Theatre, Detroit, MI, USA
April 23, 2002—The Vanderbilt, Long Island, NY, USA
April 24, 2002—Roseland Ballroom, New York, NY, USA
April 26, 2002—Electric Factory, Philadelphia, PA, USA
April 27, 2002—92.9 WBOS EarthFest Morning Radio Show, Boston, MA, USA
April 27, 2002—Avalon, Boston, MA, USA
April 29, 2002—9:30 Club, Washington, DC, USA
April 30, 2002—9:30 Club, Washington, DC, USA
May 1, 2002—The NorVa, Virginia Beach, VA, USA
May 2, 2002—House of Blues, Myrtle Beach, SC, USA
May 4, 2002—Riverstages, Nashville, TN, USA
May 5, 2002—Music Midtown, Atlanta, GA, USA
May 8, 2002—Promo West Pavilion, Columbus, OH, USA
May 9, 2002—Riviera Theatre, Chicago, IL, USA
May 10, 2002—First Avenue, Minneapolis, MN, USA
May 11, 2002—Eagles Ballroom, Milwaukee, WI, USA
May 13, 2002—Pageant Theater, St. Louis, MO, USA
May 14, 2002—Uptown Theatre, Kansas City, MO, USA
May 16, 2002—Verizon Wireless Amphitheatre, Houston, TX, USA
May 17, 2002—Bronco Bowl, Dallas, TX, USA
May 18, 2002—Music Hall, TX, USA
May 20, 2002—Paramount Theatre, Denver, CO, USA
May 23, 2002—Microsoft E3-Xbox Party, Park Plaza Hotel, Los Angeles, CA, USA
May 24, 2002—Moore Theatre, Seattle, WA, USA
May 25, 2002—Roseland, Portland, OR, USA
May 27, 2002—Warfield Theatre, San Francisco, CA, USA
May 28, 2002—The Joint, Las Vegas, NV, USA
May 29, 2002—Mesa Amphitheatre, Mesa, AZ, USA
May 31, 2002—SDSU Open Air Amphitheatre, San Diego, CA, USA
June 1, 2002—Wiltern Theatre, Los Angeles, CA, USA
June 2, 2002—Wiltern Theatre, Los Angeles, CA, USA
June 3, 2002—*Tonight Show with Jay Leno*, Los Angeles, CA, USA
June 6, 2002—Mexico National Auditorium, Mexico City, Mexico
June 11, 2002—Würtburg, Salamanca, Spain
June 12, 2002—La Riviera, Madrid, Spain
June 13, 2002—Pavilion La Casilla, Bilbao, Spain
June 14, 2002—Razzmatazz, Barcelona, Spain
June 16, 2002—Heineken Jammin' Festival, Imola, Italy
June 17, 2002—Idroscalo, Milan, Italy
June 19, 2002—Nikaia, Nice, France
June 20, 2002—Halle Tony Garnier, Lyon, France
June 22, 2002—Hurricane Festival, Scheessel, Germany
June 23, 2002—Southside Festival, Neuhausen, Germany
June 24, 2002—*TV Total*, Cologne, Germany
June 25, 2002—Zénith Arena, Lille, France
June 26, 2002—Le Zénith, Paris, France
June 28, 2002—Glastonbury Festival, Pilton, England
June 29, 2002—Skelleftea Festival, Skelleftea, Sweden
June 30, 2002—Roskilde Festival, Roskilde, Denmark
July 2, 2002—Ice Palace, St. Petersburg, Russian Federation
July 3, 2002—DS Luzhniki, Moscow, Russian Federation
July 6, 2002—Seat Beach Rock, Ostend, Belgium
July 7, 2002—Solidays Festival, Paris, France
July 10, 2002—Montreux Jazz Festival, Montreux, Switzerland
July 12, 2002—Espárrago Rock, Granada, Spain
August 27, 2002—*Kerrang!* Awards, London, England
August 28, 2002—Camden Electric Ballroom, London, England
August 29, 2002—*Top of the Pops*, London, England
August 29, 2002—Camden Electric Ballroom, London, England
September 15, 2002—The Joint, Las Vegas, NV, USA
October 5, 2002—M-One Festival, ANZ Stadium, Brisbane, Australia
October 7, 2002—M-One Festival, Olympia Park Showgrounds, Sydney, Australia
October 8, 2002—Rove Live, Melbourne, Australia
October 10, 2002—M-One Festival, Memorial Drive, Adelaide, Australia
October 12, 2002—M-One Festival, Telstra Dome, Melbourne, Australia
October 15, 2002—Ryan Center, University of Rhode Island, Kingston, RI, USA, w/No Doubt & The Distillers
October 17, 2002—First Union Spectrum, Philadelphia, PA w/No Doubt & The Distillers
October 20, 2002—The Centrum, Worcester, MA, USA, w/No Doubt & The Distillers
October 21, 2002—Nassau Coliseum, Uniondale, NY, USA, w/No Doubt & The Distillers
October 23, 2002—Continental Airlines Arena, East Rutherford, NJ, USA, w/No Doubt & The Distillers
October 24, 2002—Baltimore Arena, Baltimore, MD, USA, w/No Doubt & The Distillers
October 27, 2002—UNF Arena, Jacksonville, FL, USA, w/No Doubt & The Distillers
October 29, 2002—National Car Rental Center, Fort Lauderdale, FL, USA, w/No Doubt & The Distillers
October 30, 2002—TD Waterhouse Centre, Orlando, FL, USA, w/No Doubt & The Distillers
November 1, 2002—Reliant Arena, Houston, TX, USA, w/No Doubt & The Distillers
November 2, 2002—Voodoo Music Experience, New Orleans City Park, New Orleans, LA, USA

November 4, 2002—Smirnoff Music Centre, Dallas, TX, USA, w/No Doubt & The Distillers
November 6, 2002—Denver Coliseum, Denver, CO, USA, w/No Doubt & The Distillers
November 8, 2002—Idaho Center, Nampa, ID, USA, w/No Doubt & The Distillers
November 9, 2002—Rose Garden Arena, Portland, OR, USA, w/No Doubt & The Distillers
November 11, 2002—Key Arena, Seattle, WA, USA, w/No Doubt & The Distillers
November 13, 2002—ARCO Arena, Sacramento, CA, USA, w/No Doubt & The Distillers
November 14, 2002—Compaq Center, San Jose, CA, USA, w/No Doubt & The Distillers
November 15, 2002—101.5 Jamz, Phoenix, AZ, USA
November 16, 2002—Cricket Pavilion, Phoenix, AZ, USA, w/No Doubt & The Distillers
November 19, 2002—Pan American Center, Las Cruces, NM, USA, w/No Doubt & The Distillers
November 20, 2002—Tingley Coliseum, Albuquerque, NM, USA, w/No Doubt & The Distillers
November 22, 2002—Long Beach Arena, Long Beach, CA, USA, w/No Doubt & The Distillers
November 23, 2002—Long Beach Arena, Long Beach, CA, USA, w/No Doubt & The Distillers
November 25, 2002—Centennial Garden, Bakersfield, CA, USA, w/No Doubt & The Distillers
November 26, 2002—Cox Arena, San Diego, CA, USA, w/No Doubt & The Distillers
November 29, 2002—Long Beach Arena, Long Beach, CA, USA, w/No Doubt & The Distillers
December 10, 2002—Degree Gel Party in Hell, Hell, Grand Cayman, Cayman Islands
February 21, 2003—NARAS MusicCares Honors Bono, Marriott Marquis, New York, NY, USA
March 23, 2005—XFM, London, England
March 24, 2005—*20h10 Pétantes*, Paris, France
March 25, 2005—*Trafic.musique*, Paris, France
March 26, 2005—Napster Live, London, England
March 27, 2005—Popworld, London, England
March 28, 2005—Canal+, Paris, France
March 29, 2005—Olympia Theatre, Paris, France
March 30, 2005—La Scala, London, England
March 31, 2005—Jonathan Ross, London, England
April 1, 2005—*Top of the Pops*, London, England
April 3, 2005—Palladium, Cologne, Germany
April 4, 2005—Radio Fritz, Berlin, Germany
April 10, 2005—The Warfield, San Francisco, CA, USA
April 11, 2005—The Wiltern, Los Angeles, CA, USA
April 14, 2005—Tabernacle, Atlanta, GA, USA
April 16, 2005—Theatre of Living Arts, Philadelphia, PA, USA
April 17, 2005—Avalon, Boston, MA, USA
April 19, 2005—Hammerstein Ballroom, New York, NY, USA
April 20, 2005—*Comp'd*, Fuse Studios, New York, NY, USA
April 21, 2005—DC101, Washington, DC, USA
April 21, 2005—9:30 Club, Washington, DC, USA
April 23, 2005—MusiquePlus, Montreal, QC, Canada
April 24, 2005—Metropolis, Montreal, QC, Canada
April 25, 2005—Kool Haus, Toronto, ON, Canada
April 27, 2005—State Theatre, Detroit, MI, USA
April 28, 2005—Eagles Ballroom, Milwaukee, WI, USA
April 29, 2005—First Avenue, Minneapolis, MN, USA
May 1, 2005—Orpheum Theater, Madison, WI, USA
May 3, 2005—WXRT, Chicago, IL, USA
May 4, 2005—Metro, Chicago, IL, USA
May 6, 2005—Ryman Auditorium, Nashville, TN, USA
May 7, 2005—Madison Theatre, Cincinnati, OH, USA
May 9, 2005—Newport Music Hall, Columbus, OH, USA
May 10, 2005—Xtreme Sessionz, WKRK-FM, Cleveland, OH, USA
May 10, 2005—Agora Theatre, Cleveland, OH, USA
May 12, 2005—*Late Show with David Letterman*, New York, NY, USA
May 14, 2005—HFStival, M&T Stadium, Baltimore, MD, USA
June 1, 2005—KB Hall, Copenhagen, Denmark
June 2, 2005—Paradiso, Amsterdam, The Netherlands
June 4, 2005—Rock am Ring, Nürburgring, Germany
June 5, 2005—Rock im Park, Nürnberg, Germany
June 9, 2005—Brixton Academy, London, England
June 10, 2005—Download Festival, Donington Park, Leicestershire, England
June 11, 2005—Heineken Jammin' Festival, Imola, Italy
June 14, 2005—Razzmatazz, Barcelona, Spain
June 15, 2005—La Riviera, Madrid, Spain
June 16, 2005—Ciudad de las Artes y las Ciencas, Valencia, Spain
June 18, 2005—Europe 2 Radio, Parc des Princes, Paris, France
June 19, 2005—T4 on the Beach, Weston-super-Mare, England
June 21, 2005—Rockistanbul Festival, Istanbul, Turkey
June 24, 2005—Rock Wave, Athens, Greece
June 25, 2005—Le Rock Dans Tous Ses Etats, Évreux, France
June 26, 2005—Glastonbury Festival, Pilton, England
June 29, 2005—Olimpiyskiy Hall, Moscow, Russia
July 1, 2005—Rock Werchter Festival, Werchter, Belgium
July 2, 2005—Les Eurockéennes, Belfort, France
July 3, 2005—Montreux Jazz Festival, Montreux, Switzerland
July 5, 2005—Rock for People, Cesky Brod, Prague, Czech Republic
July 6, 2005—Petofi Csarnok Open Air, Budapest, Hungary
July 8, 2005—Exit Festival, Novi Sad, Serbia
July 9, 2005—Solidays Festival, Paris, France
July 11, 2005—The Rhythm of the Lake Festival, Villa Erra, Como, Italy
July 14, 2005—Isle of MTV Festival, Trieste, Italy
July 15, 2005—Bazant Pohoda, Trencín, Slovakia
July 16, 2005—Weissen Festival, Vienna, Austria
July 27, 2005—Orange County Fair, Pacific Amphitheatre, Costa Mesa, CA, USA
July 28, 2005—*Tonight Show with Jay Leno*, NBC Studios, Los Angeles, CA, USA
July 29, 2005—Street Scene, San Diego, CA, USA
August 3, 2005—Foro Alterno, Guadalajara, Mexico
August 5, 2005—Sports Palace, Mexico City, Mexico
August 7, 2005—Audotorio Coca Cola, Monterrey, Mexico
August 13, 2005—Underground Atlanta, Atlanta, GA, USA
August 20, 2005—Amsterjam, Randall's Island, New York, USA
August 22, 2005—Vic Theatre, Chicago, IL, USA
August 23, 2005—Soundstage, WTTW Studio, Chicago, IL, USA
August 25, 2005—Burton Cummings Theatre, Winnipeg, MB, Canada

August 27, 2005—MacEwan Hall, Calgary, AB, Canada
August 28, 2005—Red's Entertainment Complex, Edmonton, AB, Canada
August 30, 2005—Commodore Ballroom, Vancouver, BC, Canada
September 2, 2005—Bumbershoot Festival, Seattle, WA, USA
September 3, 2005—Arlene Schnitzer Concert Hall, Portland, OR, USA
September 6, 2005—Hilton Amphitheater, Reno, NV, USA
September 7, 2005—The Catalyst, Santa Cruz, CA, USA
September 8, 2005—Ex'pression Session, KXSC FM, Sunnyvale, CA, USA
September 10, 2005—Warfield Theatre, San Francisco, CA, USA
September 11, 2005—Rainbow Ballroom, Fresno, CA, USA
September 12, 2005—Dodge Theatre, Phoenix, AZ, USA
September 14, 2005—SOMA, San Diego, CA, USA
September 15, 2005—The Joint, Las Vegas, NV, USA
September 17, 2005—KROQ Inland Invasion, Los Angeles, CA, USA
September 21, 2005—Royal Theatre, Canberra, Australia
September 23, 2005—Hordern Pavilion, Sydney, Australia
September 24, 2005—Convention Centre, Brisbane, Australia
September 26, 2005—Palais Theatre, St. Kilda, Australia
September 28, 2005—Forum, Melbourne, Australia
September 29, 2005—Festival Theatre, Adelaide, Australia
October 1, 2005—Burswood Theatre, Perth, Australia
January 31, 2007—Beat It Wally! Benefit, Alex Theatre, Glendale, CA, USA
April 6, 2012—Bootleg Theater, Los Angeles, CA, USA
April 9, 2012—El Rey, Los Angeles, CA, USA
April 10, 2012—El Rey, Los Angeles, CA, USA
April 14, 2012—Pearl Concert Theater, Las Vegas, NV, USA
April 16, 2012—92.1 KFMA, The Playground, Tucson, AZ, USA
April 16, 2012—The Rialto Theater, Tucson, AZ, USA
April 17, 2012—The Marquee, Phoenix, AZ, USA
April 22, 2012—Edgefest 22, FC Dallas Stadium, Dallas, TX, USA
May 5, 2012—KROQ Weenie Roast, Los Angeles, CA, USA
May 9, 2012—Troxy, London, England
May 11, 2012—Jubilenyi Hall, St. Petersburg, Russia
May 12, 2012—Crocus City Hall, Moscow, Russia
May 14, 2012—*TV Total*, Cologne, Germany
May 15, 2012—Album de la Semaine, Paris, France
May 16, 2012—Olympia Theater, Paris, France
May 18, 2012—*Late Night with Jimmy Fallon*, New York, NY, USA
May 21, 2012—Radio 104.5 FM, Philadelphia, PA, USA
May 22, 2012—Webster Hall, New York, NY, USA
May 23, 2012—9:30 Club, Washington, DC, USA
May 25, 2012—House of Blues, Atlantic City, NJ, USA
May 26, 2012—Paradiso Rock Club, Boston, MA, USA
May 28, 2012—Phoenix Concert Theatre, Toronto, ON, Canada
May 30, 2012—Roxy Theatre, Los Angeles, CA, USA
May 31, 2012—The Hollywood Tower, Los Angeles, CA, USA
June 1, 2012—KJEE Summer Round Up, Santa Barbara, CA, USA
June 2, 2012—Live 105 BFD 2012, Shoreline Amphitheater, Mountain View, CA, USA
June 3, 2012—X-Fest, Cricket Wireless Amphitheatre, Chula Vista, CA, USA
June 9, 2012—Orange Warsaw Festival, Warsaw, Poland
June 11, 2012—Rock on the Volga Festival, Samara, Russia
June 12, 2012—Prosto Rock Festival, Odessa, Ukraine
June 16, 2012—Hultsfred Festival, Hultsfred, Sweden
June 17, 2012—Northside Festival, Aarhus, Denmark
June 19, 2012—Melkweg, Amsterdam, The Netherlands
June 22, 2012—Southside Festival, Tuttlingen, Germany
June 23, 2012—Hurricane Festival, Scheessel, Germany
June 24, 2012—Solidays Festival, Paris, France
June 27, 2012—Den Atelier, Luxembourg
June 28, 2012—Rock Werchter Festival, Werchter, Belgium
June 29, 2012—Main Square Festival, Arras, France
July 1, 2012—Brixton Academy, London, England
July 2, 2012—Wolverhampton Civic Hall, Wolverhampton, England
July 3, 2012—Manchester Academy, Manchester, England
July 4, 2012—Barrowlands, Glasgow, Scotland
July 6, 2012—B'estfest Festival, Bucharest, Romania
July 8, 2012—Festival Beauregard, Hérouville-Saint-Clair, France
July 11, 2012—10 Giorni Suoanti Festival, Vigevano, Italy
July 12, 2012—Ippodromo delle Capanelle, Rome, Italy
July 14, 2012—Bilbao BBK Live Festival, Bilbao, Spain
July 15, 2012—Musilac Festival, Aix-les-Bains, France
July 17, 2012—Les Escales du Cargo, Arles, France
July 19, 2012—Festival Marés Vivas 2012, Porto, Portugal
August 4, 2012—Osheaga Festival, Montreal, QC, Canada
August 7, 2012—Metro, Chicago, IL, USA
August 8, 2012—Buzz under the Stars, Berkley Riverfront Park, Kansas City, MO, USA
August 9, 2012—Pondamonium, Warner Park, Madison, WI, USA
August 11, 2012—Maha Music Festival, Omaha, NE, USA
August 15, 2012—Taipei World Trade Center Hall 2, Taipei, Taiwan
August 18, 2012—Summer Sonic Festival, Osaka, Japan
August 19, 2012—Summer Sonic Festival, Tokyo, Japan
August 21, 2012—Fort Canning Park, Singapore
September 12, 2012—MTV World Stage, Monterrey, Mexico
September 14, 2012—The National, Richmond, VA, USA
September 15, 2012—Jiffy Lube Live, Bristow, VA, USA
September 16, 2012—Verizon Wireless Amphitheatre, Charlotte, NC, USA
September 22, 2012—Music Midtown, Atlanta, GA, USA
September 26, 2012—Showbox SoDO, Seattle, WA, USA
September 27, 2012—Roseland Theater, Portland, OR, USA
September 29, 2012—The Centre in Vancouver for Performing Arts, Vancouver, BC, Canada
October 1, 2012—Warfield Theatre, San Francisco, CA, USA
October 2, 2012—Hollywood Palladium, Los Angeles, CA, USA
October 3, 2012—*Jimmy Kimmel Live*, Los Angeles, CA, USA
October 5, 2012—The Venue, Salt Lake City, UT, USA

October 6, 2012—Ogden Theatre, Denver, CO, USA
October 9, 2012—House of Blues, Houston, TX, USA
October 10, 2012—La Zona Rosa, Austin, TX, USA
October 15, 2012—Teatro Caupolicán, Santiago, Chile
October 17, 2012—Teatro de Verano, Montevideo, Uruguay
October 18, 2012—Pepsi Music Festival, Buenos Aires, Argentina
October 20, 2012—Planeta Terra Festival, São Paulo, Brazil
October 24, 2012—Conmebol Bourbon Convention Center, Asuncion, Paraguay
October 27, 2012—Planeta Terra Festival, Bogotá, Columbia
October 31, 2012—Ivan Urgant show, Moscow, Russia
November 1, 2012—Milo Concert Hall, Kazan, Russia
November 2, 2012—Milo Club, Nizhny Novgorod, Russia
November 4, 2012—Tele-Club, Yekaterinburg, Russia
November 5, 2012—Club Otdyh, Novosibirsk, Russia
November 7, 2012—Izvestia Hall, Moscow, Russia
November 9, 2012—A2 Club, St. Petersburg, Russia
November 12, 2012—Sports Palace, Kiev, Ukraine
November 13, 2012—Sports Palace, Minsk, Belarus
November 14, 2012—Palladium, Riga, Latvia
November 16, 2012—Klub Kwadrat, Kraków, Poland
November 18, 2012—Atelier Babylon, Bratislava, Slovakia
November 20, 2012—Paradiso, Amsterdam, The Netherlands
November 22, 2012—Le Zénith, Paris, France
November 23, 2012—Transbordeur, Lyon, France
November 25, 2012—Ancienne Belgique, Brussels, Belgium
November 26, 2012—E-werk, Cologne, Germany
November 27, 2012—Huxleys Neue Welt, Berlin, Germany
December 6, 2012—KROQ, San Manuel Indian Bingo & Casino, San Bernardino, CA, USA
December 7, 2012—*Tonight Show with Jay Leno*, Los Angeles, CA, USA
December 8, 2012—KROQ Almost Acoustic Christmas, Gibson Amphitheatre, Los Angeles, CA, USA
February 19, 2013—Michael Fowler Centre, Wellington, New Zealand
February 20, 2013—Auckland Civic Theatre, Auckland, New Zealand
February 23, 2013—Soundwave Festival, RNA Showgrounds, Brisbane, Australia
February 25, 2013—Metro Theatre, Sydney, Australia
February 27, 2013—Forum Theatre, Melbourne, Australia
March 1, 2013—Soundwave Festival, Melbourne Showgrounds, Melbourne, Australia
March 2, 2013—Soundwave Festival, Bonython Park, Adelaide, Australia
March 3, 2013—Soundwave Festival, Claremont Showgrounds, Perth, Australia
March 6, 2013—Star Event Centre, Sydney, Australia
March 19, 2013—*Late Show with David Letterman*, New York, NY, USA
March 20, 2013—Wellmont Theater, Montclair, NJ, USA
March 22, 2013—Terminal 5, New York, NY, USA
March 23, 2013—Electric Factory, Philadelphia, PA, USA
March 24, 2013—The Fillmore, Silver Spring, MD, USA
March 26, 2013—House of Blues, Boston, MA, USA
March 27, 2013—Metropolis, Montreal, QC, Canada
March 28, 2013—The Sound Academy, Toronto, ON, Canada
March 30, 2013—Majestic Theater, Detroit, MI, USA
March 31, 2013—House of Blues, Cleveland, OH, USA
April 2, 2013—LC Pavilion, Columbus, OH, USA
April 3, 2013—Riviera Theatre, Chicago, IL, USA
April 5, 2013—Mill City Night, Minneapolis, MN, USA
April 6, 2013—Eagles Ballroom, Milwaukee, WI, USA
April 7, 2013—Orpheum Theater, Madison, WI, USA
April 9, 2013—The Pageant, St. Louis, MO, USA
April 10, 2013—Harrah's, North Kansas City, MO, USA
April 12, 2013—Pearl Concert Theater, Las Vegas, NV, USA
April 16, 2013—Arena Monterrey, Monterrey, Mexico
April 18, 2013—Arena de la Ciudad de Mexico, Mexico City, Mexico
November 13, 2013—TeleHit Awards 2013, Mexico City, Mexico
March 15, 2015—Vive Latino Festival, Mexico City, Mexico
April 25, 2015—Pa'l Norte Rock Festival, Monterrey, Mexico
October 1, 2015—KROQ, Red Bull Sound Studio, Los Angeles, CA, USA
October 6, 2015—Humphrey's Concerts by the Bay, San Diego, CA, USA
October 7, 2015—Fox Theatre, Oakland, CA, USA
October 8, 2015—Greek Theatre, Los Angeles, CA, USA
October 10, 2015—Boulevard Pool @ Cosmopolitan Hotel, Las Vegas, NV, USA
October 13, 2015—Bayou Music Center, Houston, TX, USA
October 14, 2015—Stubb's Waller Creek Amphitheatre, Austin, TX, USA
October 15, 2015—South Side Ballroom, Dallas, TX, USA
October 17, 2015—The Riviera Theatre, Chicago, IL, USA
October 18, 2015—Orpheum, Madison, WI, USA
October 19, 2015—Royal Oak Theater, Royal Oak, MI, USA
October 21, 2015—Orpheum, Boston, MA, USA
October 23, 2015—The Space @ Westbury, Westbury, NY, USA
October 24, 2015—Kings Theater, Brooklyn, NY, USA
October 26, 2015—Phoenix Concert Theater, Toronto, ON, Canada
October 28, 2015—9:30 Club, Washington, DC, USA
October 29, 2015—9:30 Club, Washington, DC, USA
October 31, 2015—Palladium, Cologne, Germany
November 1, 2015—Train, Aarhus, Denmark
November 2, 2015—Store Vega, Copenhagen, Denmark
November 4, 2015—013 Poppodium, Tilburg, The Netherlands
November 5, 2015—Forest National, Brussels, Belgium
November 7, 2015—Le Zénith, Paris, France
November 8, 2015—Brixton Academy, London, England
November 9, 2015—Brixton Academy, London, England
November 11, 2015—Crocus City Hall, Moscow, Russia
November 13, 2015—Manchester Academy, Manchester, England
November 14, 2015—Usher Hall, Edinburgh, Scotland
May 14, 2016—KROQ Weenie Roast, Irvine Meadows Amphitheatre, Irvine, CA, USA
May 17, 2016—EastWest Studios, Los Angeles, CA, USA
May 18, 2016—EastWest Studios, Los Angeles, CA, USA
May 19, 2016—*Jimmy Kimmel Live*, Los Angeles, CA, USA

May 24, 2016—La Cartonnerie, Reims, France
May 25, 2016—*C à Vous*, France 5 TV, Paris, France
May 26, 2016—Rock im Revier, Dortmund, Germany
May 27, 2016—Women of the World Festival, Alte Oper, Frankfurt, Germany
May 28, 2016—Rockavaria Festival, Olympiapark, Munich, Germany
May 30, 2016—Paradiso, Amsterdam, The Netherlands
May 31, 2016—Den Atelier, Luxembourg
June 1, 2016—Caribana Festival, Crans-près-Céligny, Switzerland
June 3, 2016—Le Radiant, Lyon, France
June 5, 2016—La Belle Electrique, Grenoble, France
June 7, 2016—Center Urbane Kulture Kino Siska, Ljubljana, Slovenia
June 8, 2016—Fabrique, Milan, Italy
June 10, 2016—Nova Rock Festival, Nickelsdorf, Austria
June 13, 2016—Troxy, London, England
June 14, 2016—Nottingham Rock City, Nottingham, England
June 16, 2016—Mad Cool Festival, Madrid, Spain
June 18, 2016—101WKQX PIQNIQ, Chicago, IL, USA
July 6, 2016—Summerfest, Milwaukee, WI, USA
July 7, 2016—Skyway Theatre, Minneapolis, MN, USA
July 8, 2016—SumTur Amphitheater, Omaha, NE, USA
July 10, 2016—Uptown Theatre, Kansas City, MO, USA
July 12, 2016—The Pageant, St. Louis, MO, USA
July 13, 2016—Z104.5 The Edge 21 Birthday Bash, Brady Theater, Tulsa, OK, USA
July 15, 2016—Egyptian Room, Indianapolis, IN, USA
July 16, 2016—The Fillmore, Detroit, MI, USA
July 17, 2016—PromoWest Fest, Columbus, OH, USA
July 19, 2016—The Mill & Mine, Knoxville, TN, USA
July 20, 2016—Ryman Auditorium, Nashville, TN, USA
July 22, 2016—The Tabernacle, Atlanta, GA, USA
July 23, 2016—Fillmore Charlotte, Charlotte, NC, USA
July 25, 2016—The National, Richmond, VA, USA
July 27, 2016—Starland Ballroom, Sayreville, NJ, USA
July 28, 2016—House of Blues, Boston, MA, USA
July 30, 2016—The Fillmore, Philadelphia, PA, USA
July 31, 2016—Rams Head Live!, Baltimore, MD, USA
August 1, 2016—Summerstage, New York, NY, USA
August 3, 2016—The Lincoln Theater, Washington, DC, USA
August 6, 2016—River Nights, Rheinfelden, Switzerland
August 8, 2016—Lokerse Feesten, Lokeren, Belgium
August 10, 2016—A Summer's Tale, Luhmühlen, Germany
August 12, 2016—Fête du Bruit, Landerneau, France
August 14, 2016—Kubana Festival, Riga, Latvia
August 16, 2016—Zappa Amphi Shuni, Binyamina, Israel
August 17, 2016—Zappa Amphi Shuni, Binyamina, Israel
August 20, 2016—Parkenfestivalen, Bodø, Norway
September 4, 2016—Teatro Diana, Guadalajara, Mexico
September 5, 2016—Arena Monterrey, Monterrey, Mexico
September 7, 2016—Arena Ciudad de Mexico, Mexico City, Mexico
September 9, 2016—Revention Music Center, Houston, TX, USA
September 10, 2016—South Side Ballroom, Dallas, TX, USA
September 11, 2016—Majestic Theatre, San Antonio, TX, USA
September 14, 2016—Belly Up, Aspen, CO, USA
September 15, 2016—Fillmore Auditorium, Denver, CO, USA
September 16, 2016—The Complex, Salt Lake City, UT, USA
September 18, 2016—Roseland Theater, Portland, OR, USA
September 19, 2016—Paramount Theatre, Seattle, WA, USA
September 22, 2016—The Foundry SLS, Las Vegas, NV, USA
September 23, 2016—Jack FM Radio Show, Verizon Amphitheater, Irvine, CA, USA
September 24, 2016—Masonic, San Francisco, CA, USA
October 20, 2016—Ventura Theatre, Ventura, CA, USA
October 21, 2016—Hollywood Forever, Los Angeles, CA, USA
October 27, 2016—Arizona State Fair, Phoenix, AZ, USA
November 2, 2016—Obihall, Florence, Italy
November 3, 2016—Gran Teatro Geox, Padova, Italy
November 5, 2016—Salle Pleyel, Paris, France
November 7, 2016—Sentrum Scene, Oslo, Norway
November 8, 2016—Posten, Odense, Denmark
November 9, 2016—Vega, Copenhagen, Denmark
November 11, 2016—Cirque Royal, Brussels, Belgium
November 13, 2016—Stereo Plaza, Kiev, Ukraine
November 15, 2016—A2 Club, St. Petersburg, Russia
November 17, 2016—Yotaspace, Moscow, Russia
November 18, 2016—Yotaspace, Moscow, Russia
November 19, 2016—Tele-Club Yekaterinburg, Russia
November 24, 2016—Regent Theatre, Melbourne, Australia
November 26, 2016—Rochford Wines, Yarra Valley, Australia
November 27, 2016—Thebarton Theatre, Adelaide, Australia
November 29, 2016—Kings Park & Botanic Garden, Perth, Australia
December 2, 2016—Hordern Pavilion, Sydney, Australia
December 3, 2016—Bimbadgen, Hunter Valley, Australia
December 4, 2016—Sirromet Wines, Mount Cotton, Australia
December 10, 2016—Tropical Butantã, São Paulo, Brazil
December 11, 2016—Circo Voador, Rio de Janeiro, Brazil
December 13, 2016—Luna Park, Buenos Aires, Argentina
December 14, 2016—Teatro Caupolican, Santiago, Chile
December 15, 2016—Teatro Caupolican, Santiago, Chile
December 17, 2016—Vivo X El Rock Festival, Lima, Peru

OUR CAST OF CHARACTERS

7th St Entry, Minneapolis, Tom Abraham, Acetone, Sarah Adams, Jenna Adler, Marco Aimo, Butch Allen, Almost Human, Herb Alpert, Ancora Coffee, Jason Anderson, Angelfish, Loreto Anton, David Arnold, Charles Arron, Gary Ashley, Brian Aubert, Matthew Austin, Eric Avery, Simon Ayton, Agnès B, Janet Baker, Stu Baker, William Baker, Brantley Bardin, Peter Baron, Sam Bayer, Kent Belden, LeRoy Bennett, Jim Berkenstadt, Bill Berrol, Veronique Beufils, *Big Daddy*, Don Black, Christopher Bock, Gary Borman, Bob Bortnick, Paul Boswell, Brendan Bourke, Edith Bowman, Kelsey Boyd, Ade Britteon, Brian Bumbery, Carl Burnett, Cliff Burnstein, Billy Bush, Lindsey Byrnes, the late great Café Montmartre, Renato Campora, Gerado Carton, Laurent Castanie, Eric Cathcart, Murray Chalmers, Matt Chamberlain, Sharon Chatten, Jamie Cheek, *Chelsea Lately*, Warren Christensen, Cigarettes After Sex, Collin Citron, Ellen Citron, Sam Citron, Steve Chivers, Vincent Clery-Melin, Curtis Clyde, Jason Cohen, Marco Collins, Todd Confessore, Ernie Conner, Kristin Control, Graham Cooper, Ryan Corey, Meredith Cork, Colleen Creighton, Justin Crew, Crystal Method, Joseph Cultice, Brody Dalle, Harold Danker, Phil Danneman, David Letterman Show, Mirelle Davis, Janet Dawes, *Dazed & Confused*, *Details* magazine, Brian Diaz, Tony DiCiocchio, Jennifer Dickinson, the Dickle Brothers, the Distillers, Brad Divens, Timothy Doyle, Jancee Dunn, Dutch Uncles, Laurie Earl, The City of Edinburgh, Scotland, Malcolm Edwards, Josh Eells, Mika El-Baz, the Elevator Drops, Jennifer Elster, India England, Carrie and Elwin Erickson, Roxy Erickson, Roy Erickson, *The Face*, Craig Ferguson, Gail Fine, Amy Finnerty, Russell Fischer, Flood, Bumstead, McCready & McCarthy, Inc., Tom Ford, Chris Frantz, *Fraulein* magazine, Lance Freed, Elfi Frequin, Nancy, Chip, Ben & Julianna Friedl, Nina Friekberg, Mary Jane Frost, Fun Lovin' Criminals, Hank Fusspot, Eric Gardner, Andrea Giacobbe, Girls Against Boys, Jennifer Graham, Jane, Mark, & Mark Grein, Michael & Sue Gudinski, Mark Haines, Mandy Hale, Rob Hall, Beth Halper, Hanna Hanra, Jay Harmon, Mandy Harris, Debbie Harry, Adel Hattem, Mark Haworth, Robert Hayden, Clyde Haygood, Jeri Heiden, Pam Hughes, Scott Hull, James Hunter, Clay Hutson, Chrissie Hynde, *ID* magazine, Ioecho, Matt Irwin, Janine Israel, Heather Mary Jackson, Marc Jacobs, *Tonight Show with Jay Leno*, Rob Jefferson, Cindy Kahn, Akiko Kanazawa, Greg Kaplan, Mike Kashou, Brian Keefe, Sarah Manson and Gordon Kerr, Sydney and Georgie Kerr, *Kerrang!* magazine, Kevin & Bean, Jake Kincaid, Calvin Klein, Bruce Knight, Kobalt, Harald Kohl, Paul Kremen, KROQ, Shirley Kurata, Gary Kurfirst, Steve Lamacq, Candice Lambert, Emmanuel Landoys, Jenny Larsson, Emily Lazar, Nicky Lee, Valjean Leiker, Anna Leocha, Frank and Samia Lepaysan, Julie Leveque, Joe Levy, Jeff Light, Lit, Michael Loeffler, Chris Lopes, Baz Luhrmann, Rob Lynch, Valerie Lynch, Laura Macdougall, Billy Macleod, Bernard MacMahon, The City of Madison, WI, Craig McLean, *Melody Maker*, Marjan Malakpour, Lindy-Jayne Manson, Muriel and Mitchell Manson, Judy and Bob Marker, Ruby Marker, Marni, Korda Marshall, Carlo Martelli, Michael Masley, Eleanor McKay, Jim Meehan, Justin Meldal-Johnsen, Molly Meldrum, Peter Mensch, Jim Merlis, Metro Chicago, Ann Michel, Malcolm Michiles, Micro, Kylie Minogue, Robert Minzner, Steve Moir, Robert Mollett, Moloko, Gina Monaci, Rob Moore, Caitlin Moran, Jay Moran, Gina Morris, Alanis Morrisette, Jerry Moss, MTV, Bill Mullen, Sophie Muller, Michelle Munz, MusiCares,

Shawn Nasseri, Lonya Nenashev, *NME*, No Doubt, *Nylon* magazine, Frank Ockenfels 3, Dawn Odins, Doug Olsen, Shannon O'Reilley, Julie Orser, Shannon O'Shea, Rosemary Ostrowski, Akiko Ozawa, Ashley Page, Aaron Paustian, Peter Paterno, the Pearl Harts, Oliver Peoples, Alex Perez, Barton Perreira, Jason Pettigrew, Pie, Mathieu Pinaud, Matt Pinfield, Placebo, the Pulsars, Purity, Q Prime Management, David Quantick, Queen Helen, *Queen Helen* fanzine, T. Cole Rachael, Radioactive Records, Bill Rahmy, Rankin, David Ravden, Paul Rees, Regular Music, John Reiser, RIP, Lisa Robinson, Rock and Roll Detective, LLC, *Rolling Stone*, Matthew Rolston, Brenda Romano, Charlie Rose, Pauli Ryan, Warwick Saint, Gerard Schlaghecke, Wendy Schneider, Randy Schnitman, Andrew Schroeder, Phil Schuster, Marvin Scott-Jarrett, Screaming Females, Stephane Sednaoui, Dawn Shadforth, Bill Shaw, Daniel and Lisa Shulman, Shuttle Boy, Dave Simpson, Donald Simrock, Talvin Singh, Kelly Slater, Billy Sloan, Smart Studios, Smashing Pumpkins, SMOG, Sneaker Pimps, *SNL*, Gaby Solzneck, Michael Souder, Olivia Souder, *Sounds*, The Sou'wester Artist Residency Program, Spaceboy, Craig Spaulding, *SPIN*, Star Liquor, Paul Starr, Sticha Brothers, Stick 1, Stick 2, Phillip Stoelzl, Strathberry of Scotland, Clyde Stubblefield, Scott and Kris Stuckey, Gabriel Stulman (Montmartre), Anna Sui, Superbus, Sweet Relief, T Boy Confessore, Les Thimmig, Howard Thompson, *Top of the Pops*, The Tornado Room, Torres, Jason Trabue, Tricky, Marlene Tsuchii, U2, Adrienne Uselman, Christina Utzon, Versace, Betty and Doc Vig, Bo Violet Vig, Renee, Mike, and Harry Vig, Ted Volk, Matt Walker, Jason Ware, Rob Watson, Kevin Weatherly, Jenn Webb, Howie Weinberg, Steven Wells, Wez Westley, Vivienne Westwood, Chris Weymouth, Tina Weymouth, Autumn de Wilde, Jo Wiley, Patti Wilson, Torsten Witte, Darren Wolf, Peak Woo, Lisa Worden, Brian Worthen, Emma Wyman, Dana (Distortion) Yavin, Puffi Ami Yumi, Chad "Zaemo" Zaemisch, Ross Zapin, Mike Zirkel, and Christophe Zubillaga.

A huge hand of thanks to everyone who has made this book a reality. In particular we would like to take great care in thanking: All the talented photographers who have so graciously allowed us to reprint their work here. The incredible video directors we have had the great honor of working with. The stylists, the makeup artists, the designers, and the hairstylists who transformed us into unicorns. The crews we have been blessed with. The bus drivers who have kept us safe. The magical music journalists of old who captured lightning in their bottles. The unsung heroes at the record labels, our management teams, and art designers. The promoters, our press officers, the agents, the lawyers, the accountants, the radio directors, the DJs, the VJs, the programmers, the listeners, and all the fans. We are eternally grateful to you all. Without you we are just four ordinary people dreaming our lives away.

While we have made every effort here to acknowledge those who have gone out of their way to help us over the years, our career has been long, our minds can be fuzzy. If we left you off of this list, please accept our sincere apology and deepest thanks.

Every effort has been made to trace the original ownership of all copyrighted material. Please contact the publisher regarding any inaccuracy or oversight and it will be corrected in subsequent printings.

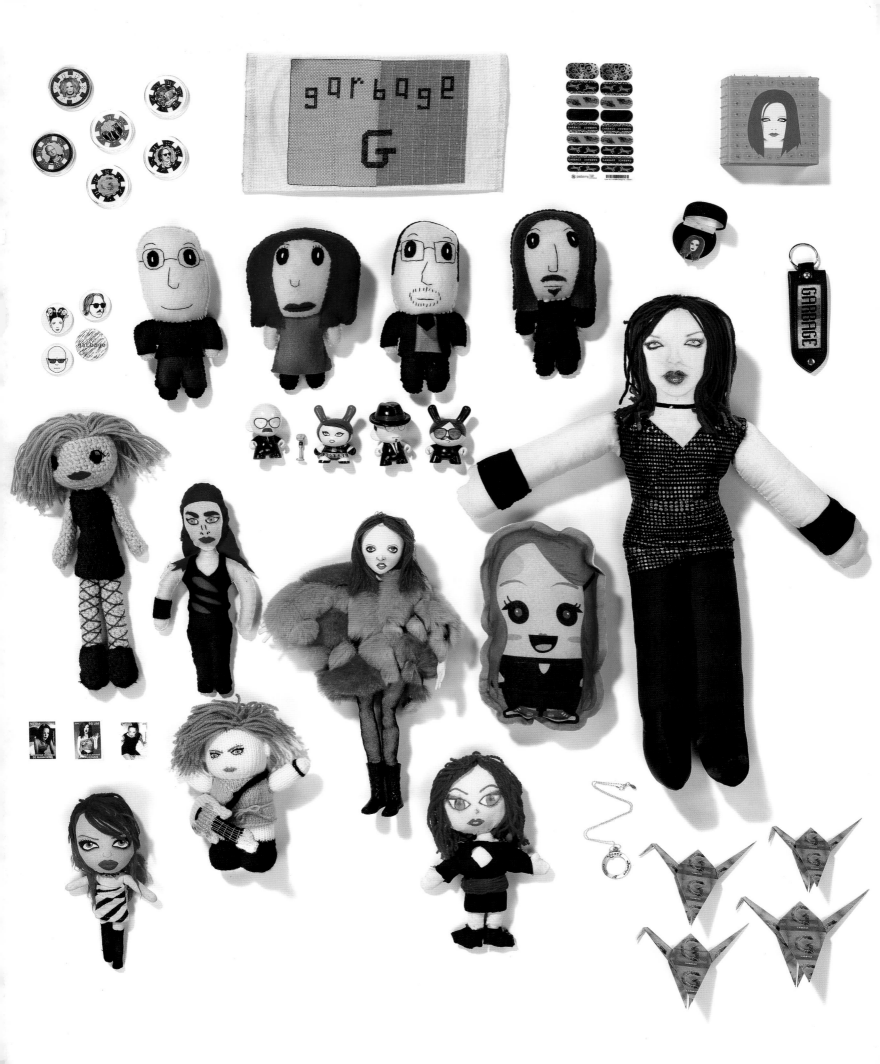